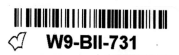

THE DORÉ BIBLE ILLUSTRATIONS

241 Illustrations by GUSTAVE DORÉ

With a New Introduction
by Millicent Rose

DOVER PUBLICATIONS, INC., NEW YORK

Published in Canada by General Publishing Company, Ltd.,
30 Lesmill Road, Don Mills, Toronto, Ontario.

The Doré Bible Illustrations is a new work, published for
the first time by Dover Publications, Inc., in 1974. Two hun-
dred twenty-nine illustrations are reproduced from *The Holy
Bible, with Illustrations by Gustave Doré,* published in parts
by Cassell, Petter, and Galpin, in London and New York,
about 1866. Twelve additional illustrations (Plates 14, 21, 31, 68,
128, 162, 169, 177, 198, 202, 238, and 240) are reproduced from
the sixth printing of *Die Heilige Schrift Alten und Neuen
Testaments verdeutscht von D. Martin Luther. Mit zweihun-
dert und dreissig Bildern von Gustav Doré,* published in two
volumes by the Deutsche Verlags-Anstalt, in Stuttgart, Leip-
zig, Berlin, Vienna, about 1875. For the Dover edition, Biblical
quotations to accompany the plates have been selected from
the Authorized (King James) Version of the Bible. A new
introduction, written by Millicent Rose especially for the
Dover edition, has also been added.

DOVER *Pictorial Archive* SERIES

International Standard Book Number: 0-486-23004-X

Library of Congress Catalog Card Number: 73-87048

Manufactured in the United States of America
Dover Publications, Inc.
31 East 2nd Street
Mineola, N.Y. 11501

Introduction to the Dover Edition

The Bible as illustrated by Gustave Doré was first published in the French version in 1865, and within the next few years other editions followed, in all the main European languages and in Hebrew. This work is of prime importance in the history of nineteenth-century art: in a period when illustrated books flourished as never before, the most famous of illustrators was working on the great best-seller. In the mid-1860's Doré was at the height of his fame and his extraordinary fecundity. As he worked on the two hundred forty-one plates for the Book of Books, he called forth his highest powers.

Gustave Doré (1832–1883), born in Alsace at Strasbourg, son of a civil engineer, began his career in Paris at the age of sixteen, as a contributor to Philipon's new comic paper, *Le Journal pour rire.* He was immediately popular, and "le gamin de génie," as Théophile Gautier called him, rapidly became celebrated. His father insisted on his completing his schooling and there was no opportunity for an academic training in art; he snatched time for unorthodox study in the galleries of the Louvre and the streets of Paris. He was gifted with an extraordinary visual memory and learned by looking.

He soon became, with the death of his father, the chief support of his mother and two brothers, taking on all the work he could get: pictorial journalism, travel books, fiction of varying quality. Though much of his early work was topical caricature, the stinging understanding of his older contemporary Daumier was quite outside his range—he was no politician.

He started work in the year of revolutions, 1848, and it was in the reactionary period that followed, the Second Empire, that he became famous. He found life enjoyable in this society, a society so luxurious at the top and so readily accepting of him. He worked incredibly hard, earned a fortune and spent it lavishly. Doré's work of the 1850's is more energetic and vivacious than that of anyone else, full of a sense of fun, brilliant and fantastic and sometimes extremely horrid, with a streak of grotesque cruelty. His illustration of the classics began with a delightful Rabelais (1854), and increasingly he cut down on his journalism, to specialize in illustrating the world's great literature. During the 1860's he developed a special style of illustrated book, and the publications of this decade include the *Divine Comedy* and *Paradise Lost,* the *Fables* of La Fontaine, *Don Quixote,* Perrault's *Contes,* *The Adventures of Baron Münchausen,* Chateaubriand's *Atala,* and *The Idylls of the King.* The new electrotype process made it possible for the expensive wood blocks for these works, once cut, to be duplicated indefinitely without loss of quality, and they were used for editions all over the world.

Doré's Bible is of the same period as all these notable books, but stands apart from the main current of his life. *La Sainte Bible* was commissioned not by Hachette, who sponsored so much of the work of the 1860's, but by the firm of Alfred Mame et fils of Tours. Mame produced prayer books, *livres de piété,* school prizes and presentation copies of the classics: their great printing works and bindery at Tours employed more than a thousand men, women and child apprentices, under conditions of unusual care for welfare. They prided themselves on their illustrated books, and among their activities was a school of wood-engraving, for with the development of the electrotype, woodcut had once more become the most important method of reproduction.

A Bible from Doré's hand was essential to Mame's prestige. It was an unusually costly production, selling at 200 francs (8 pounds) a copy, but Jerrold reports that three thousand copies were sold within a month and a second edition called for within the year.

For *La Sainte Bible,* Doré did not rely on the Mame school of engravers; he had by now his own team of expert craftsmen. Doré would draw upon the wood blocks, often using both pencil and brush and with dark washes building up the masses which characterize each design. For night scenes he often used a black ground and drew into it with

white. In his early days Doré had constantly raged at the ineptitude of the engravers; now, after years of collaboration, the best of them knew exactly how to realize the artist's intentions. The engravers' names balance Doré's own at the bottom of each design. His lifelong friend H. Pisan was the most admired of them and was entrusted with the most impressive scenes; characteristic of him is the last scene of all, in white on black, in which the Angel shows Saint John the New Jerusalem.

The firm of Cassell bought the English rights to *La Sainte Bible* in the next year, 1866, and it was through Cassell that the Doré Bible became known throughout the English-speaking world. Cassell, Petter, and Galpin (to give the firm their full name) were in their educational and religious activities a sort of English Mame. Mame stood for the clerical establishment in Catholic France, and the welfare services for their workers were in the hands of nuns. John Cassell, founder of the English firm, was a Methodist with roots in the nonconformist and radical tradition and as a militant teetotaler had combined his early publishing ventures with dealing in tea, coffee and other non-alcoholic beverages. Still mixing ideals and business, from the 1850's onwards the firm produced popular educational handbooks on every conceivable subject: "Elocution and Oratory, Letter-writing, the Civil Service, Natural Philosophy, Amusing and instructive experiments, Investments, Book-keeping, Etiquette, Chess . . ." —the list comes from a Cassell paper cover. Many of their publications were for the newly literate masses, in this period of the new board schools and on the eve of universal education in England. The publications came out as cheaply as possible, in weekly or monthly parts. Other books were in more solid format and intended for all classes, always of a serious nature, books on travel and the arts, dictionaries and grammars, novels by, among others, Mrs. Henry Wood. At various times there were several periodicals, among them a magazine called the *Quiver,* the idea behind the name being that its articles were darts as ammunition for the battle against evil.

Cassell's had already become the English publishers of a major work by Doré when in 1864 they brought out *Don Quixote,* earlier published in France by Hachette. It appeared in twenty-one parts at one shilling a part, with a total of four hundred illustrations. Cassell's later commissioned the illustrations to *Paradise Lost.*

The firm had already produced a great Bible in four volumes, *Cassell's Illustrated Family Bible,* 1859–1863. This was a marvelous undertaking which appeared in various forms, the individual parts costing from a penny upwards, according to the quality of the paper and the quantity of pages. For sixpence one could buy forty large pages, in an olive-green paper cover, and there was at least one picture on every page-spread. The text was the Authorized (King James) Version and was illustrated by scenes which were the work of an international range of artists, among whom Castelli is the most prominent. Doré himself was employed by Cassell for a few of the scenes. Below the illustrated text ran a stream of notes, copiously supplied with maps and with pictures of the landscape, flora and fauna of the Bible lands, their cities, art and architecture, the costumes, tools and techniques of those times. Publication coincided with the founding of an American branch of Cassell's, and enthusiastic colporteurs took the four bound volumes to all parts of the world. One admires their stamina! The books are almost too heavy to lift.

The *Illustrated Family Bible* continued to sell for many years; it is advertised on the covers of Cassell's *Doré Gallery* (early 1870's) where we are told that "it attained a circulation of nearly HALF A MILLION: and not in this land alone, but in America, and throughout our Colonies, it was eagerly sought after, whilst Missionaries availed themselves of its graphic Illustrations to enforce the truth upon their native hearers."

The appeal of Doré's Bible was quite different from that of the *Illustrated Family Bible,* though both were supplied with special decorated pages for a Family Register, and intended partly as heirlooms. There was room for both in Cassell's remarkable list.

Doré's Bible was published in various styles, all, by Cassell's standards, decidedly costly. In parts, it was four shillings per paper-covered number, and the total of sixty-four parts could then be bound in two "handsome cloth cases" at nine shillings each. It was also available complete, at prices from eight to fifteen pounds. It was intended as a family possession, a gilt-edged treasure, sumptuous, magnificent. The popular *Family Bible* with its pictures by dozens of different art-

ists necessarily lacked a homogeneous style. The new Cassell's publication, on the other hand, was the work of one artist, a Frenchman of genius. (The worship of foreigners, in matters of art, was much alive in Victoria's England). For the bourgeois nineteenth century, to possess Doré's Bible was like owning a great cycle of masterpieces, like having a copy of Giotto's Arena Chapel in the family.

An article in the *Quiver* (April 7, 1866) offers a clue to the special appeal of his Bible for Doré's age. It is quoted with veneration by Blanche Roosevelt, the gushing American lady whose life of her friend Doré is, with that by Blanchard Jerrold, the main source of information about the artist:

> The old masters, with scarcely an exception— French, Italian, Spanish, Flemish, Dutch — misrepresent the sacred story. There is some glaring inconsistency, some palpable blunder, in the scene itself or in its accessories. Even with our extended knowledge of Oriental archaeology and antiquities, it is only at rare intervals that we get anything like what we may suppose to be a faithful picture of the recorded event. The traditions of art have too often been made superior to the canon of Scripture. Not so with Gustave Doré. He is evidently well acquainted with the text he illustrates. He grasps its meaning: he is moved by the circumstances by which his characters were surrounded: he sees them "in his mind's eye" as they were, and not as they are misrepresented on miles of canvas, or caricatured by Academy models. They are men and women, moved by the same passions, subject to the same infirmities, impressed by the same grandeur, cast down by the same sorrows, and elated by the same joys as ourselves. There is an intense vitality in his pictures, that gives to them a realism unapproached in the works of any other artist. His Eastern pictures are a-glow with oriental splendour. His priests and soldiers are robed and harnessed in the costume of their age; the buildings are such as those common to the East in ancient times: and the trees and plants, the camel, oxen, sheep, all the lower animals, are such as we may find in Syria at this day. Without adopting a dry or harsh mannerism, without overloading his pictures with critical information, Doré becomes a valuable and suggestive commentator on the text.

This, then, was Doré's attraction for his vast public. He gave them the sacred story with "a realism unapproached in the works of any other artist." During the centuries of the Christian era, artists in stone and wood, in fresco, mosaic, all the available media, had told and retold the Bible stories as part of a continuous tradition, with an established iconography and settings inspired by the landscape, architecture and customs of the artist's own land. Jerusalem, as portrayed by Giotto, has Romanesque architecture and her people are dressed as in the Tuscany of the early fourteenth century. Doré's Jerusalem was based on photographs and views of the actual spot. Though he himself had never visited the Holy Land (he hated traveling), he could make a journalist's use of all the substitutes for travel that had recently become available. In Napoleon's time and afterwards, the French looked toward the Levant as their sphere of influence, and the 1860's were the time of work on the Suez Canal (opened 1869). The museums of Paris were filled with the Egyptian, Assyrian and other antiquities brought home by archaeologists and empire builders. When retelling the story of Israel in Egypt, Doré could draw upon the magnificent Egyptian collection in the Louvre. And to modern archaeological knowledge he added psychological realism, human beings as seen by a contemporary of the great novelists and the new photographers. However diligent the research, however up-to-date the approach, history painting and historical novels and other attempts to recreate the past inevitably become, a hundred years after, not "reality" but costume drama. But to Doré's public his representations did indeed seem "a faithful picture of the recorded event."

Even in his own day, of course, some viewers criticized Doré's version of Biblical times and places. Ruskin, as might have been expected, found fault with his geology. The French art critics, says Blanchard Jerrold, "objected to his illustrations in the Bible that they are too theatrical . . . suggestive of 'blue fire and stage carpentry.'" Theatrical Doré certainly was. He loved the stage, he knew many people of the theatre, and leading figures in opera—Rossini, Christine Nilsson, Adelina Patti — were among his intimates. One of his social accomplishments was a gift for arranging charades and *tableaux vivants,* and in 1864, while working on the Bible, he paid a visit to Compiègne as the guest of Napoleon III and there created for the pleasure of Emperor and Empress, a series of tableaux of which "the Queen of Sheba paying a visit to Solomon" was outstandingly gorgeous. The Queen was represented by the "loveliest of all the Empress's ladies of honour," says Blanche Roosevelt.

> Madame de Poilly's costume of oriental stuff, broidered with jewels that the Empress herself might

have worn, reminded one of those vestures that clothed princesses of the Arabian Nights tales. This set off her beauty, as did Solomon's kingly robes Count Niewerkerke's distinction . . .

If Doré was theatrical enough to delight in such spectacles (not unlike an actor enthusiastic about a new dramatic part), we must remember that the Bible itself is a highly theatrical book. The plagues of Egypt, Samson pulling down the pillars, Elijah's chariot of fire, the Apocalypse— these were events that drew upon Doré's fiery imagination and knowledge and produced some of his best work. Here the dramatic material and the artist seem perfectly matched.

His Bible was a turning point in Doré's career. In making it he suppressed the sense of fun that is still so delightfully present in *Don Quixote*, the major work that immediately preceded it, and he was never again so lighthearted. The Bible took hold of him; he studied the text, choosing the scenes and rethinking them with great intensity. He did not follow the accepted iconography, but always reimagined from the text, as will become obvious whenever a Doré scene is compared with the Bible story on the one hand and the old masters' versions on the other.

See for instance "Susanna in the Bath" (Plate 146), a favourite subject with the Dutch and Flemish masters, who made this an opportunity for painting the nude. Doré's Susanna clutches about her a thick sheet of toweling which covers her completely; all that is visible is her head with its long hair and one bare foot. It is easy to smile and say "Victorian prudery!"—but reread the story and look again. Doré has chosen a later moment than the one usually represented; this is a terrified wife and mother, whose marriage is being threatened by the two powerful elders. They, instead of goggling at her lasciviously as in a painting by Jordaens, assume a hypocritical dignity.

A similarly interesting interpretation is that of "Jesus at the House of Martha and Mary" (Plate 181). Here, in a simple, earth-floored house, evening sunlight dapples the door-jamb and there is a bright yet hazy view of palm trees and distant mountains. Mary sits relaxed on the doorstep, Martha pauses with her back to us, a heavy waterpot balanced on her hip. Here in the figure of Jesus we see not the Christ of the theologians but the carpenter's son from Nazareth.

The success of the Bible brought Doré to England. To publicize the new work he made large paintings of some of the scenes and these were exhibited at Cassell's premises in Belle Sauvage Yard in the City of London. They drew great crowds and there was nearly a scandal, for one of them represented the Deity, a subject at that time regarded as inadmissible in art in England. The canvas was hurriedly withdrawn and Doré, not at all pleased, joked wryly: "It did not resemble either my French or my English publisher."

These paintings led to the foundation in 1868 of the Doré Gallery in Bond Street, where for the rest of his life and long after there was a continually changing exhibition of his work. For this gallery he painted many scriptural scenes, amplifying the original treatment, especially of the first chapters of Genesis, which he had been obliged to treat briefly, as the pictures had to be spread more or less evenly through the book. He also repeated again and again details which particularly appealed to him and to his public, such as the head of Christ from "The Crown of Thorns."

I am told that the atmosphere of the Doré Gallery in its last days (it closed only with the outbreak of war in 1914) was that of a place of pilgrimage. In one corner was a sort of *prie-dieu* where purchasers could write their cheques.

So Doré, who at the height of his fame in France had always been deeply hurt that in his own country the critics acclaimed him as draughtsman while the painter was despised, enjoyed in his last years success as a painter in England. The defeat of France in 1871 was a great sorrow to him, bringing as it did the end of the Second Empire and the separation of Alsace. He now came every year to London and there found friends in high society and among the eminent churchmen who were attracted to his treatment of subjects from Scripture. He had never been deeply religious and he was of course a Catholic, but his open nature responded warmly to these friendly and flattering advances. Canon Harford of Westminster Abbey became a close friend in these last years and discussed with him, before they were exhibited, the huge paintings on New Testament themes that were a feature of the Gallery. They also talked about English poetry and especially about Shakespeare, on a complete edition of whose plays Doré was working when he died. Among the books of

ix

the 1870's are two from English sources: *The Rime of the Ancient Mariner* (1875) and *London, a Pilgrimage* (1872), with text by Blanchard Jerrold, both Dover reprints. The latter, monumental book, grand, but not at all gay, is today generally considered Doré's masterpiece.

Doré's illustrations of Old and New Testament scenes became the formative visions of Scripture in innumerable homes, especially in the New World. Egypt, Babylon, Jerusalem, the barefoot multitudes in their homespun, Esther and Jael and Judith in their exotic draperies, Philistine and Hebrew warriors and Roman soldiers, priests and rulers, city and mountain, lake and desert and, for the children, the Biblical animals, Daniel's lions, the dogs who ate Jezebel, the she bears who punished the small boys who made fun of Elisha, all were brought to life in convincing form.

Even when the Doré Bibles themselves became difficult to obtain, the visual imagery of Doré continued to have remarkable influence. It is impossible, for instance, to conceive of the development of films, particularly those of D. W. Griffith and Cecil B. DeMille, without taking into consideration the Babylonian backgrounds, the winged beasts, or monumental crowd scenes of Doré. Similar influences can be seen in architecture, painting, and book illustration.

For us, today, there can be little doubt that these engravings, seen separately, have fixed the iconography of the Bible in our minds. We can hardly think of certain events—Jesus blessing the children, the death of Abel, the Nativity, the miraculous draught of fishes—without thinking of them as Doré pictured them. It is especially fitting therefore, at a time when recent reissues of Doré have revived interest in his work, to have these splendid illustrations of the Bible again made available.

The basis for the plates in the present Dover edition is *The Holy Bible, with Illustrations by Gustave Doré*, published in parts by Cassell, Petter, and Galpin, in London and New York, about 1866. Three additional plates ("The Expulsion of Ishmael and His Mother," Plate 14; "The Destruction of Leviathan," Plate 128; and "The Crowned Virgin: A Vision of John," Plate 238) do not appear in the English Bible but were taken from *Die Heilige Schrift... Mit·... Bildern von Gustav Doré*, published in two volumes by the Deutsche Verlags-Anstalt, in Stuttgart and other cities, about 1875. We have also selected nine other plates from the German Bible—two are better impressions than the English print ("Entry of Jesus into Jerusalem," Plate 198, and "The Last Supper," Plate 202), and seven exist in different states: ("Jacob's Dream," Plate 21; "The Finding of Moses," Plate 31; "The Levite Bearing Away the Body of the Woman," Plate 68; "The Nativity," Plate 162; "The Temptation of Jesus," Plate 169; "Mary Magdalene Repentant," Plate 177; "The Last Judgment," Plate 240).

MILLICENT ROSE

London, 1973

List of Plates

THE OLD TESTAMENT

xiii

List of Plates

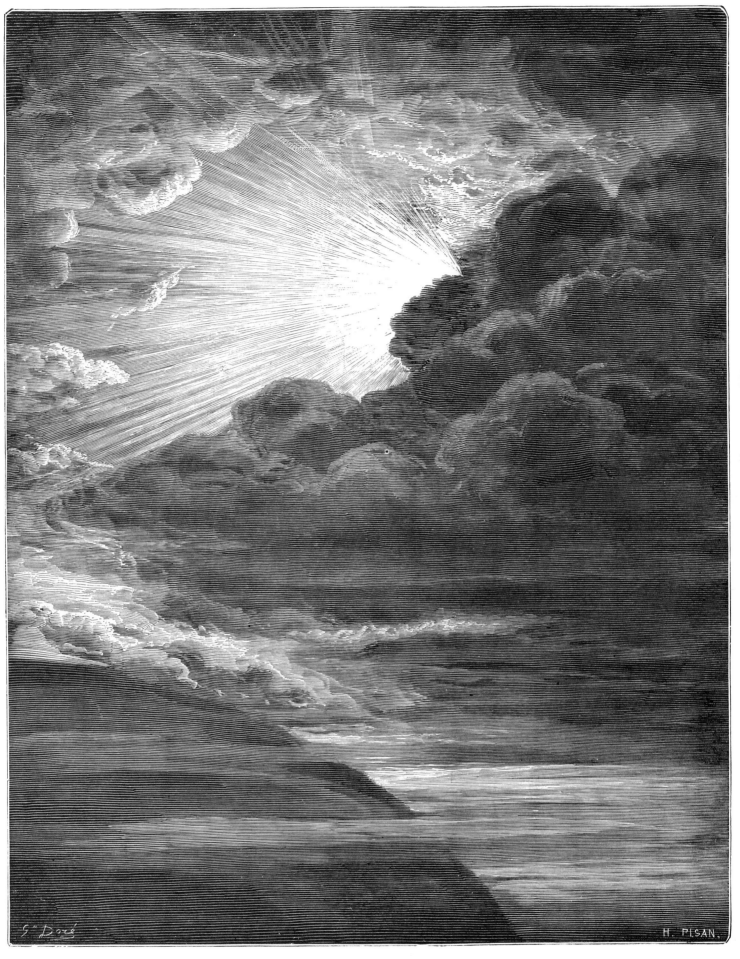

THE CREATION OF LIGHT
And the earth was without form, and void . . . (Genesis 1: 2)

1

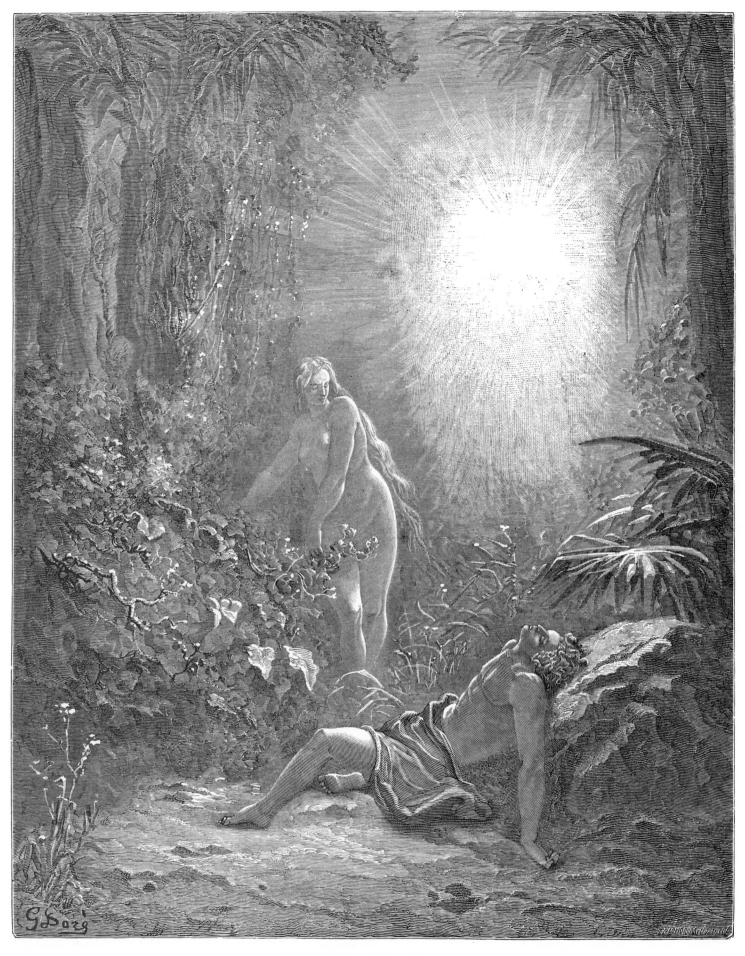

THE FORMATION OF EVE

She shall be called Woman, because she was taken out of Man . . . (Genesis 2: 23)

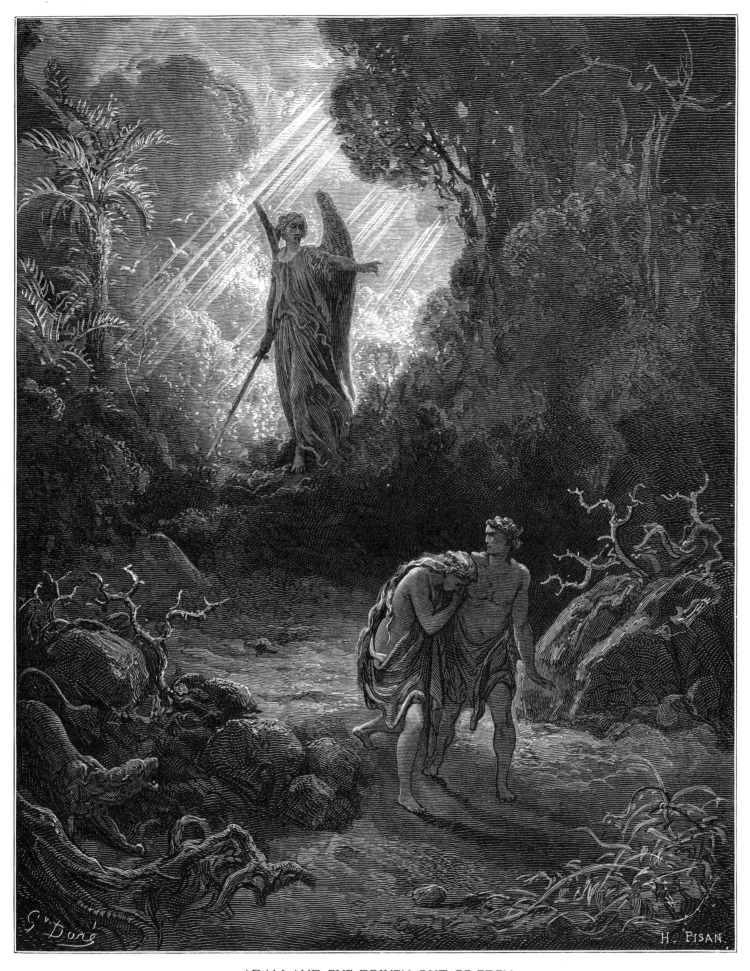

ADAM AND EVE DRIVEN OUT OF EDEN

And he placed at the east of the Garden of Eden Cherubims, and a flaming sword which
turned every way, to keep the way of the tree of life . . . (Genesis 3: 24)

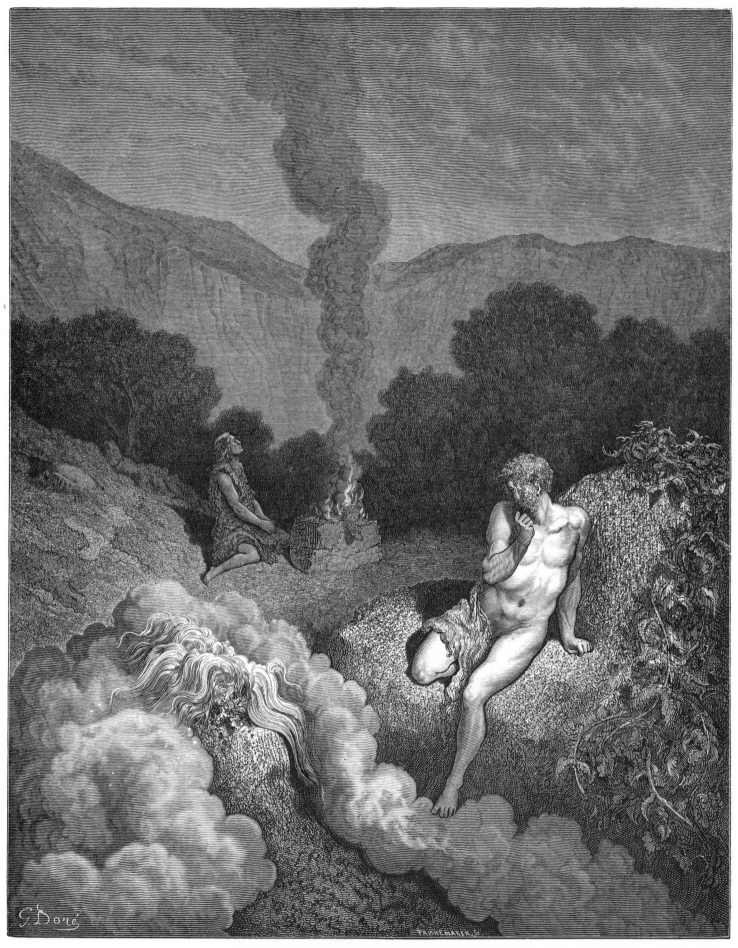

CAIN AND ABEL OFFERING THEIR SACRIFICES

And Abel was a keeper of sheep, but Cain was a tiller of the ground... And the Lord
had respect unto Abel and to his offering: but unto Cain and his offering he had not
respect ... (Genesis 4: 2-5)

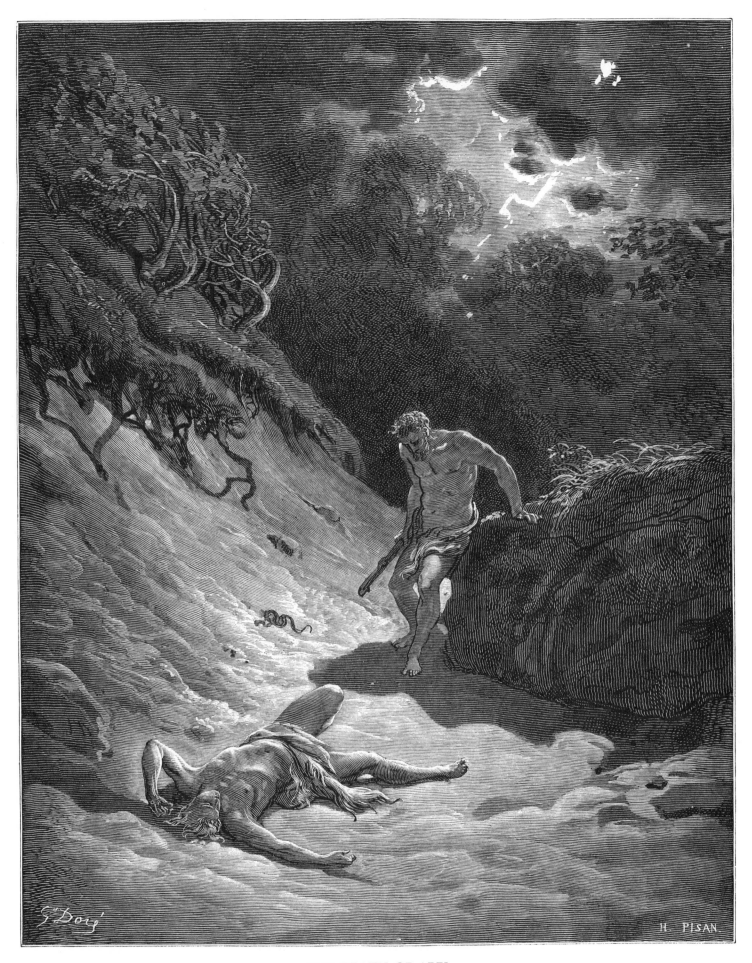

THE DEATH OF ABEL

And it came to pass...Cain rose up against Abel his brother, and slew him.
And the Lord said unto Cain, Where is Abel thy brother? And he said, I know not:
Am I my brother's keeper?... (Genesis 4: 8,9)

5

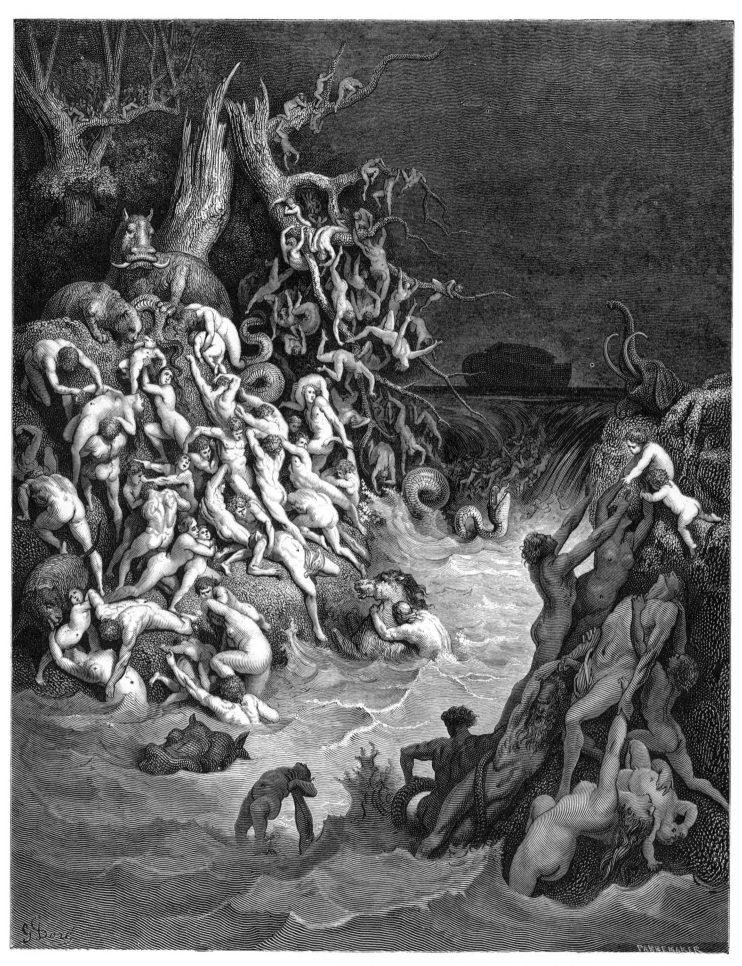

THE WORLD DESTROYED BY WATER

And the Lord said, I will destroy man whom I have created from the face of the earth; both man, and beast, and the creeping thing, and the fowls of the air; for it repenteth me that I have made them . . . (Genesis 6: 7)

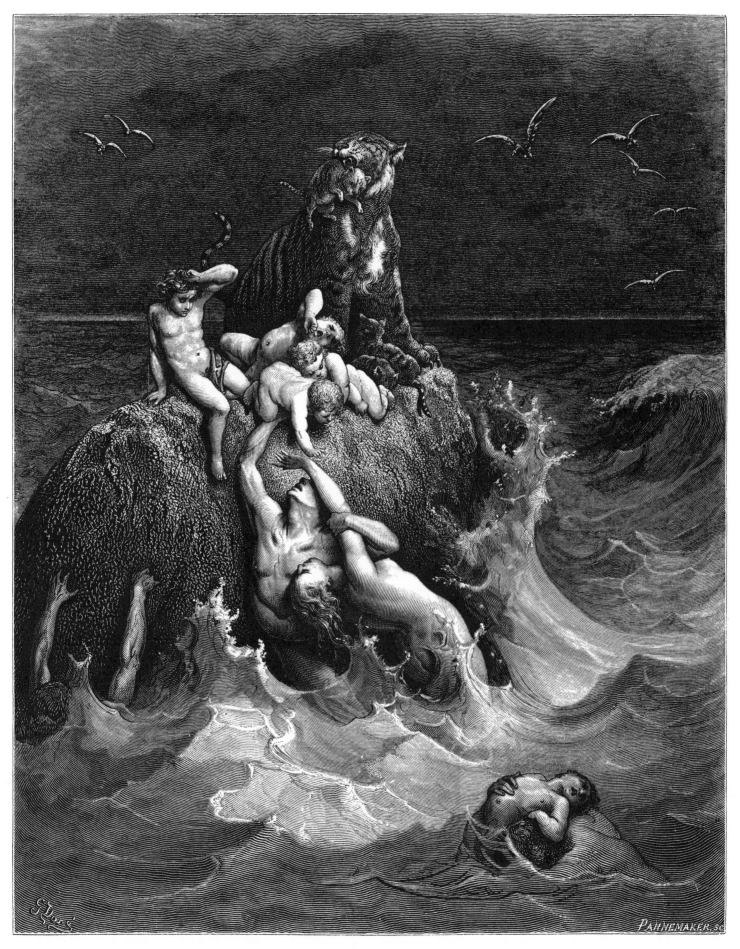

THE DELUGE

And every living substance was destroyed which was upon the face of the ground,
both man, and cattle, and the creeping things, and the fowl of the heaven; and they
were destroyed from the earth: and Noah only remained alive, and they that were
with him in the ark . . . (Genesis 7: 23)

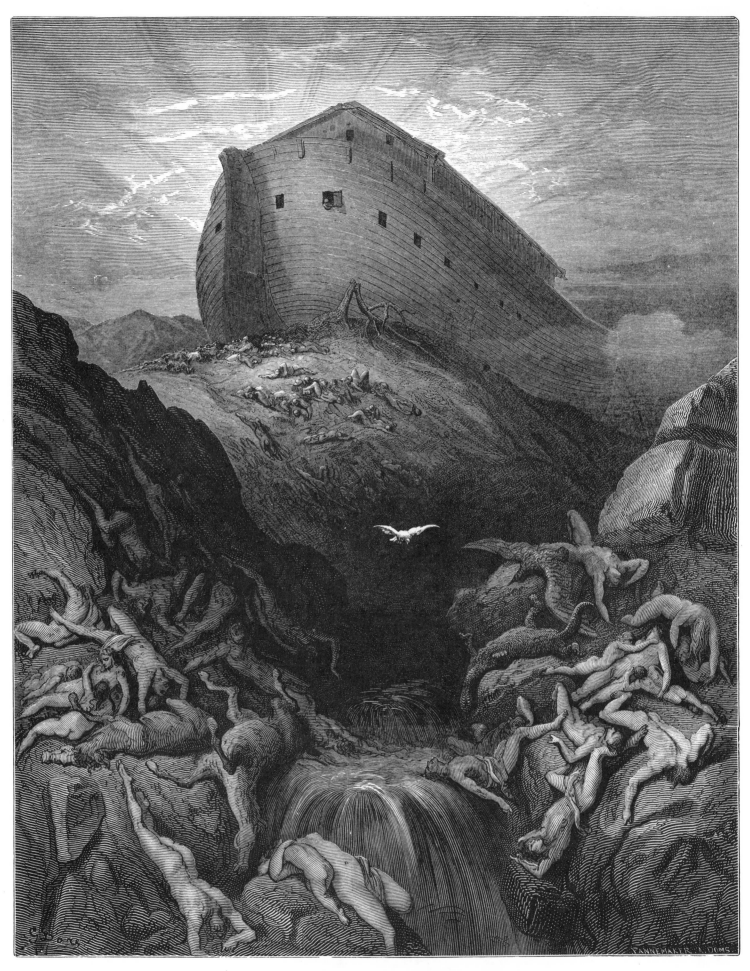

THE DOVE SENT FORTH FROM THE ARK

And the dove came in to him in the evening; and lo, in her mouth was an olive
leaf pluckt off; so Noah knew that the waters were abated from off the earth . . .
(Genesis 8: 11)

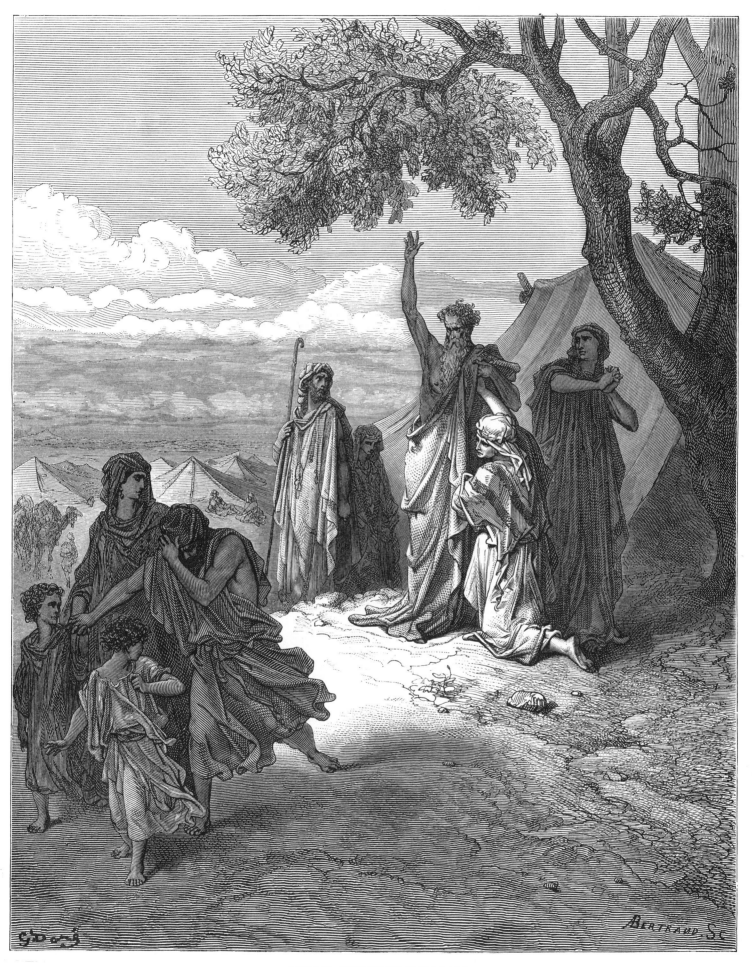

NOAH CURSING CANAAN

And Ham, the father of Canaan, saw the nakedness of his father . . . And Noah awoke
from his wine . . . And he said, Cursed be Canaan; a servant of servants shall he be
to his brethren . . . (Genesis 9: 22-25)

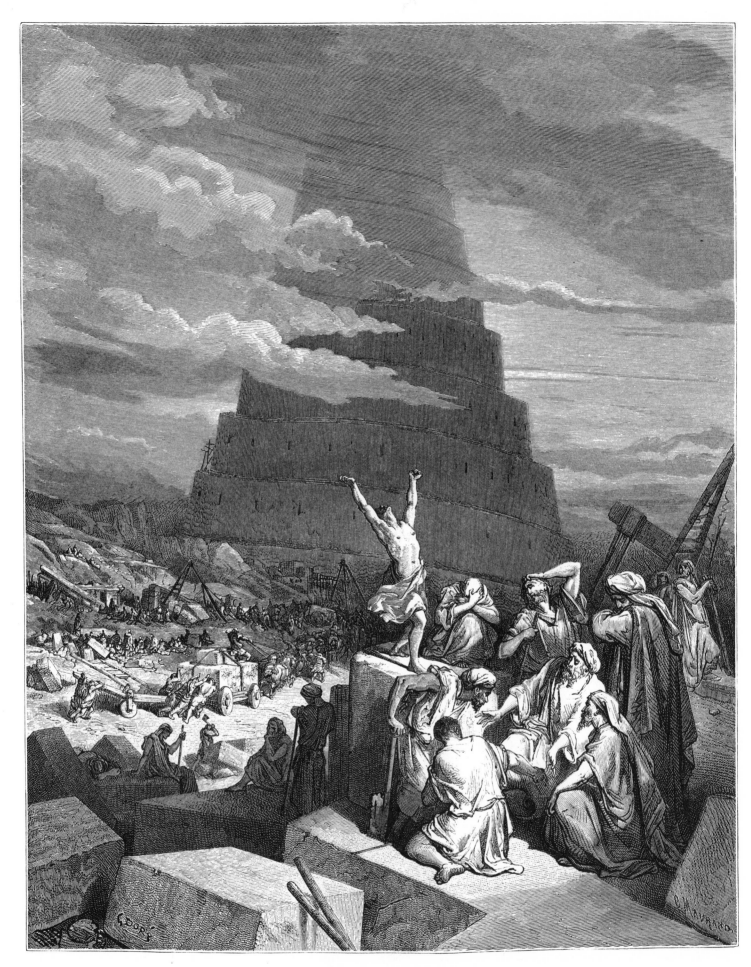

THE CONFUSION OF TONGUES

And they said, Go to, let us build us a city and a tower, whose top may reach
unto heaven . . . So the Lord scattered them abroad from thence upon the face of all
the earth . . . (Genesis 11: 4,8)

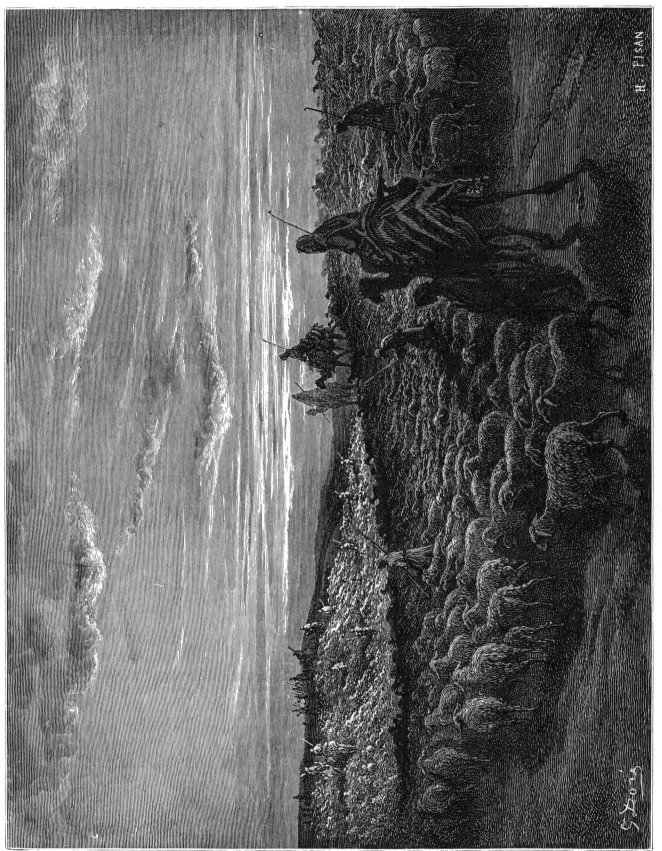

ABRAHAM JOURNEYING INTO THE LAND OF CANAAN

Now the Lord had said unto Abram, Get thee out of thy country, and from thy kindred, and from thy father's house, unto a land that I will shew thee: And I will make of thee a great nation, and I will bless thee, and make thy name great...
(Genesis 12: 1-2)

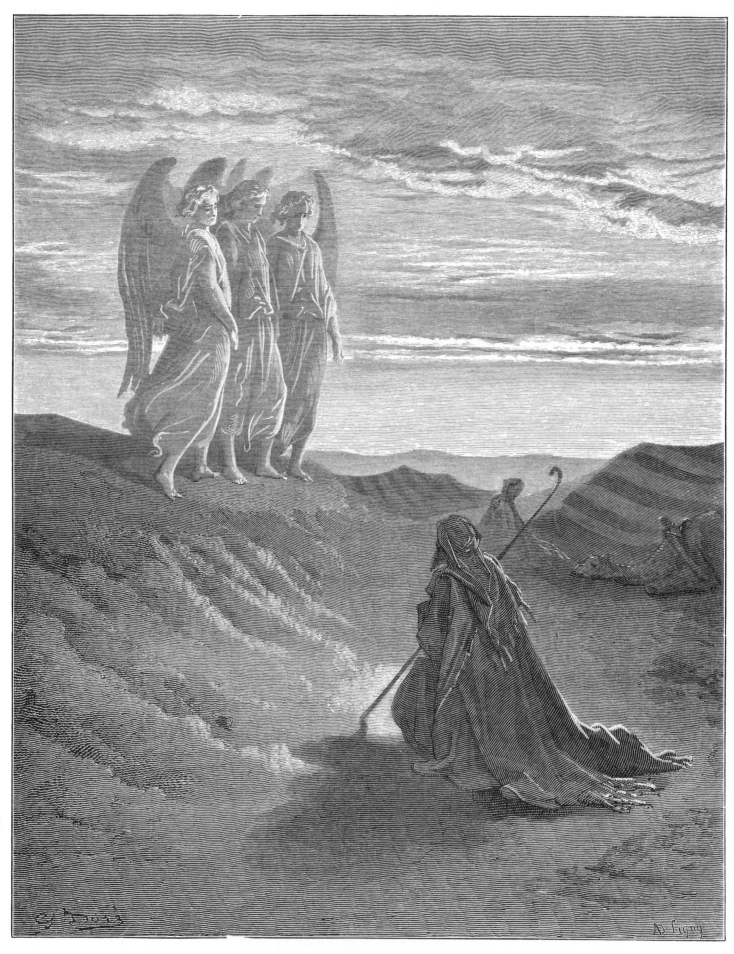

ABRAHAM AND THE THREE ANGELS

And they said unto him, Where is Sarah thy wife? . . . Sarah thy wife shall have
a son . . . (Genesis 18: 9,10)

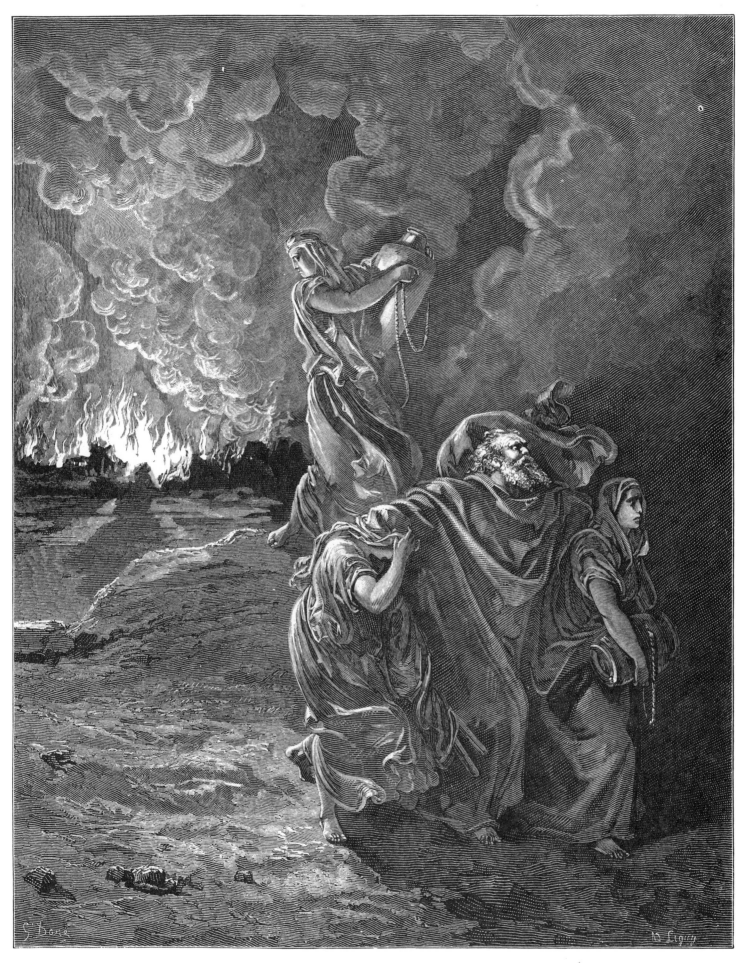

THE FLIGHT OF LOT

Then the Lord rained upon Sodom and upon Gomorrah brimstone and fire from the Lord out of heaven...his [Lot's] wife looked back from behind him, and she became a pillar of salt...(Genesis 19: 24, 26)

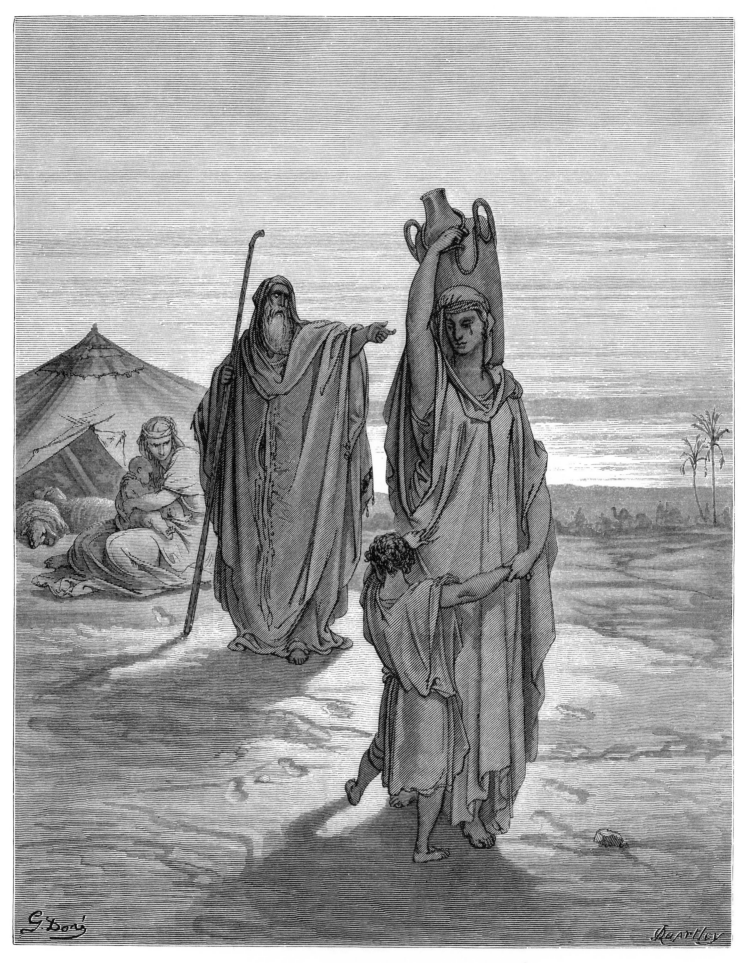

THE EXPULSION OF ISHMAEL AND HIS MOTHER

And Abraham rose up early in the morning, and took bread, and a bottle of water,
and gave it unto Hagar . . . and the child, and sent her away . . . (Genesis 21: 14)

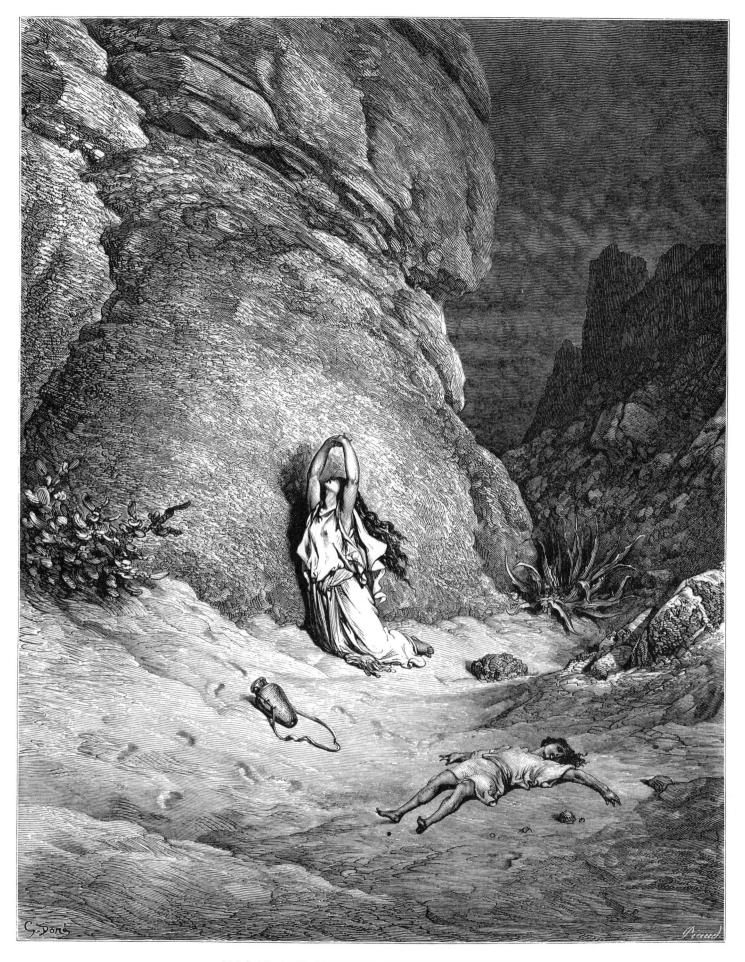

HAGAR AND ISHMAEL IN THE WILDERNESS

And the angel of God called to Hagar . . . Arise, lift up the lad, for I will make him
a great nation . . . (Genesis 21: 17, 18)

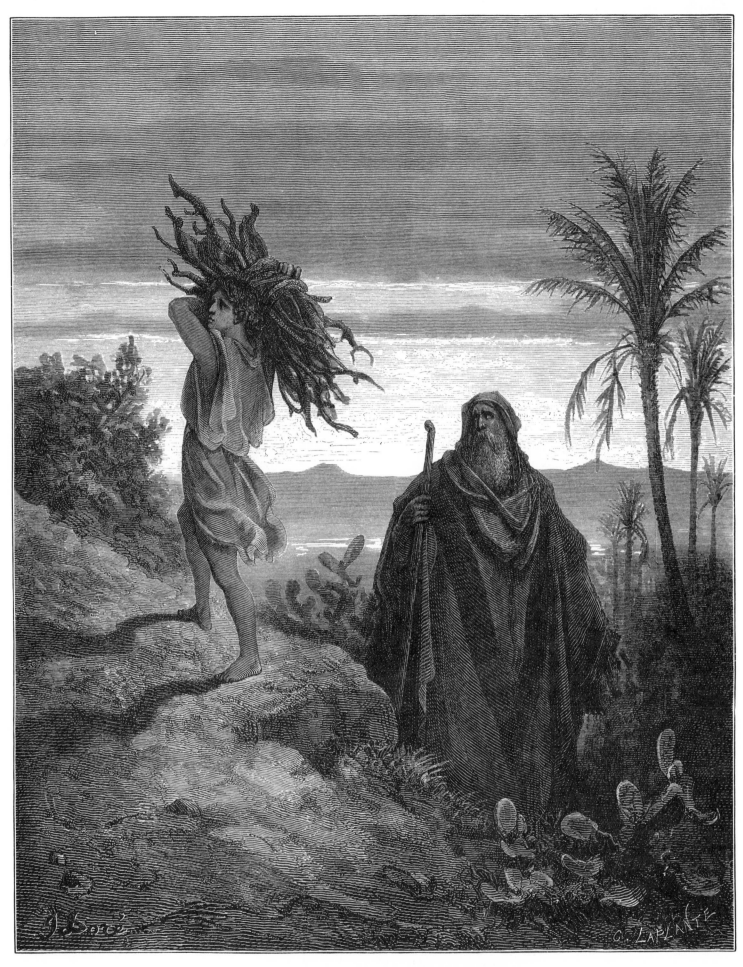

THE TRIAL OF ABRAHAM'S FAITH

And the angel of the Lord called unto him out of heaven . . . Lay not thine hand
upon the lad . . . for now I know that thou fearest God, seeing thou hast not withheld
thy son, thine only son from me . . . (Genesis 22: 11-12)

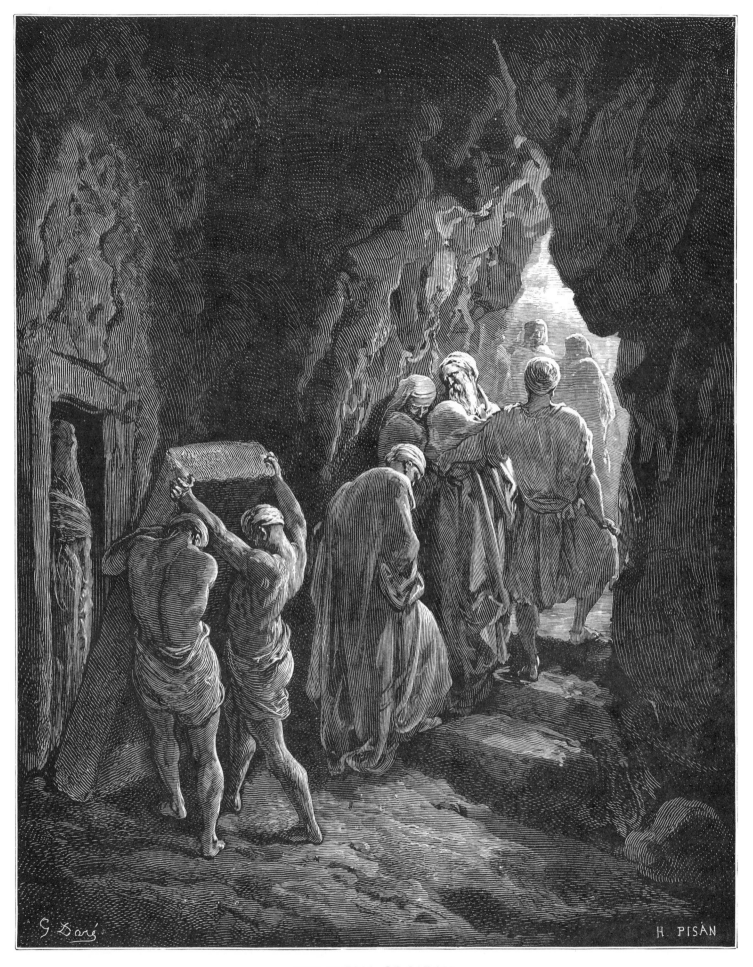

THE BURIAL OF SARAH

And . . . Abraham buried Sarah his wife in the cave of the field of Machpelah . . .
And Abraham was old, and well stricken in age . . . (Genesis 23: 19; 24: 1)

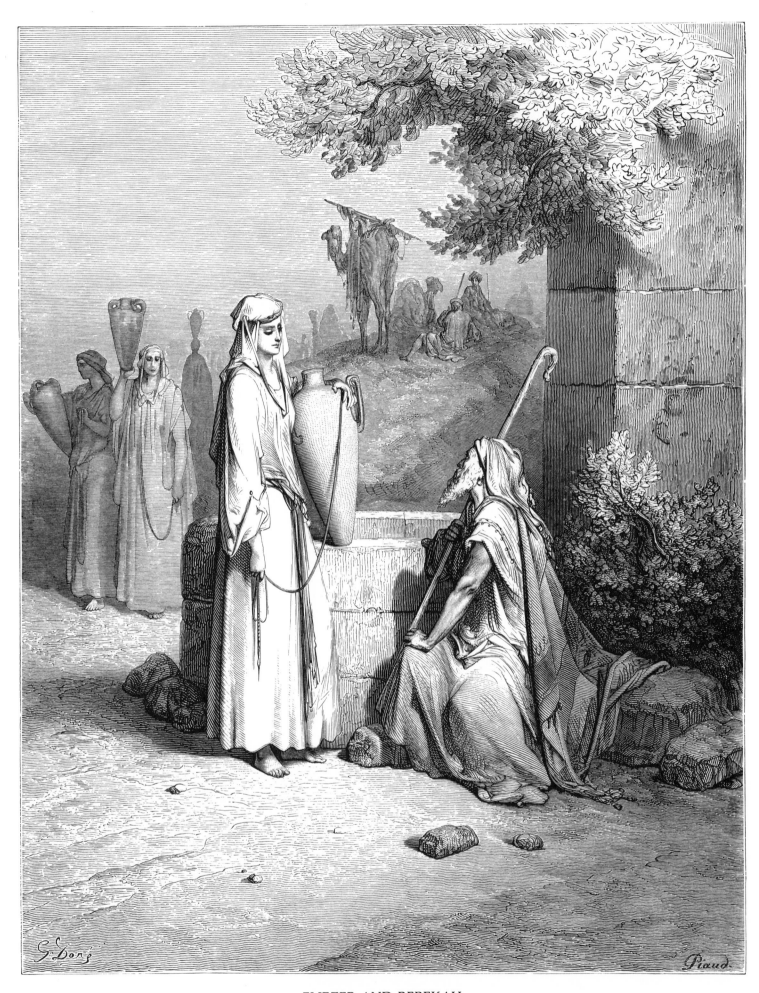

ELIEZER AND REBEKAH

And the damsel was very fair to look upon...and she went down to the well, and
filled her pitcher... (Genesis 24: 16)

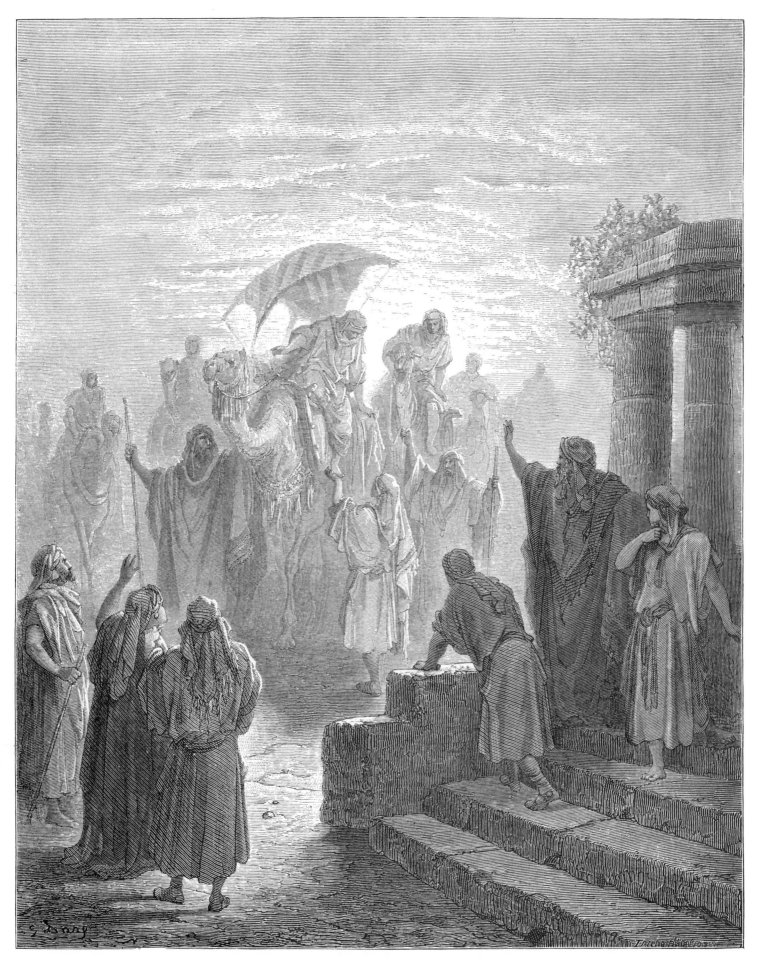

THE MEETING OF ISAAC AND REBEKAH

For she had said unto the servant, What man is this that walketh in the field to
meet us? And the servant had said, It is my master: therefore she took a vail, and
covered herself . . . (Genesis 24: 65)

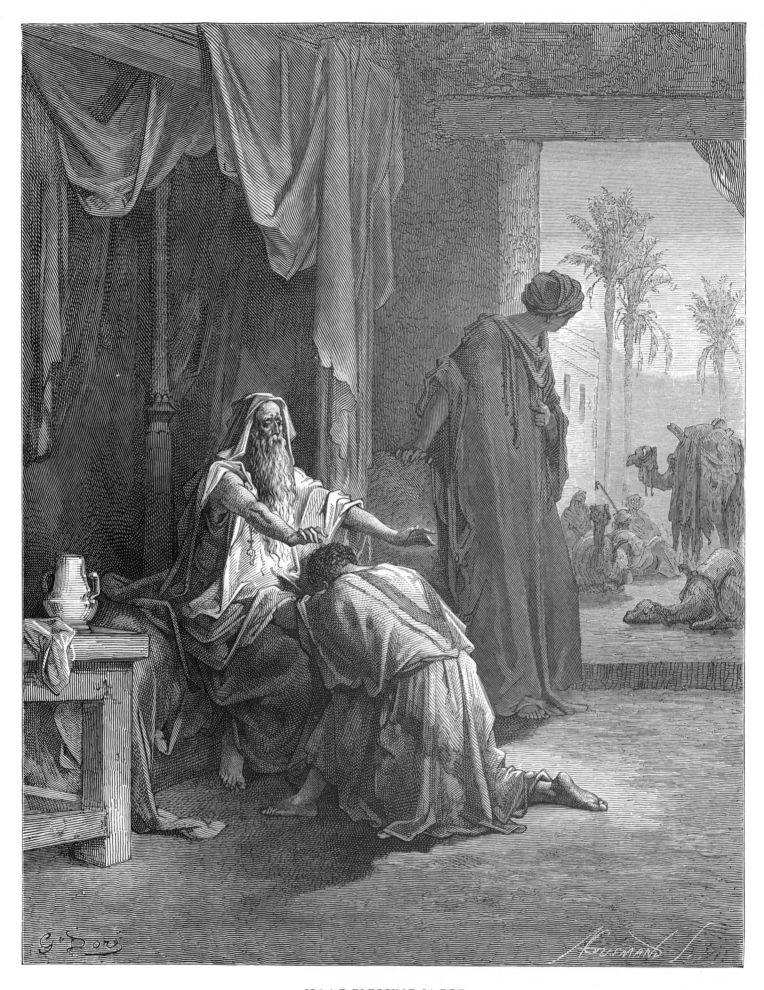

ISAAC BLESSING JACOB

And Jacob went near unto Isaac his father; and he felt him, and said, The voice
is Jacob's voice, but the hands are the hands of Esau . . . (Genesis 27: 22)

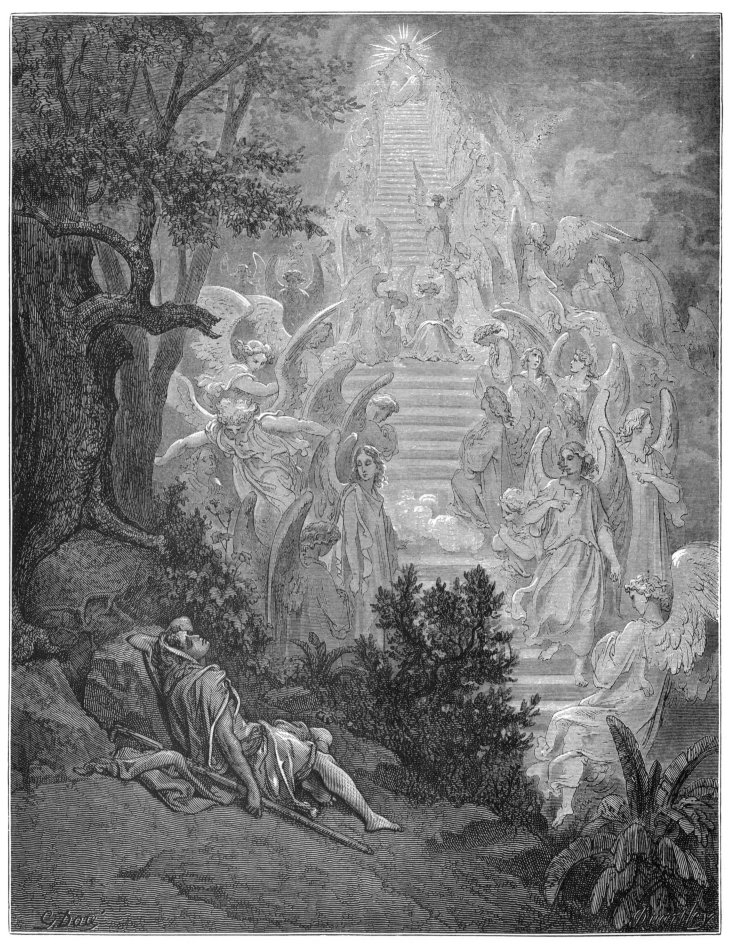

JACOB'S DREAM

And he dreamed, and behold a ladder set up on the earth, and the top of it reached
to heaven: and behold the angels of God ascending and descending on it
. . . (Genesis 28: 12)

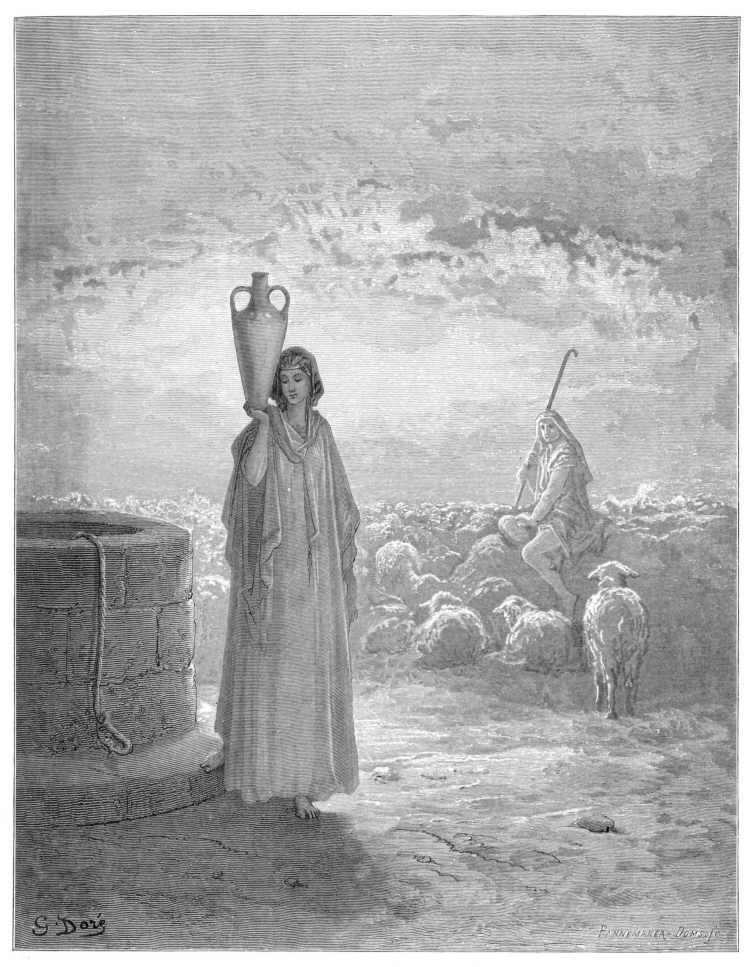

JACOB KEEPING LABAN'S FLOCKS

And Jacob served seven years for Rachel; and they seemed unto him but a few
days, for the love he had to her . . . (Genesis 29: 20)

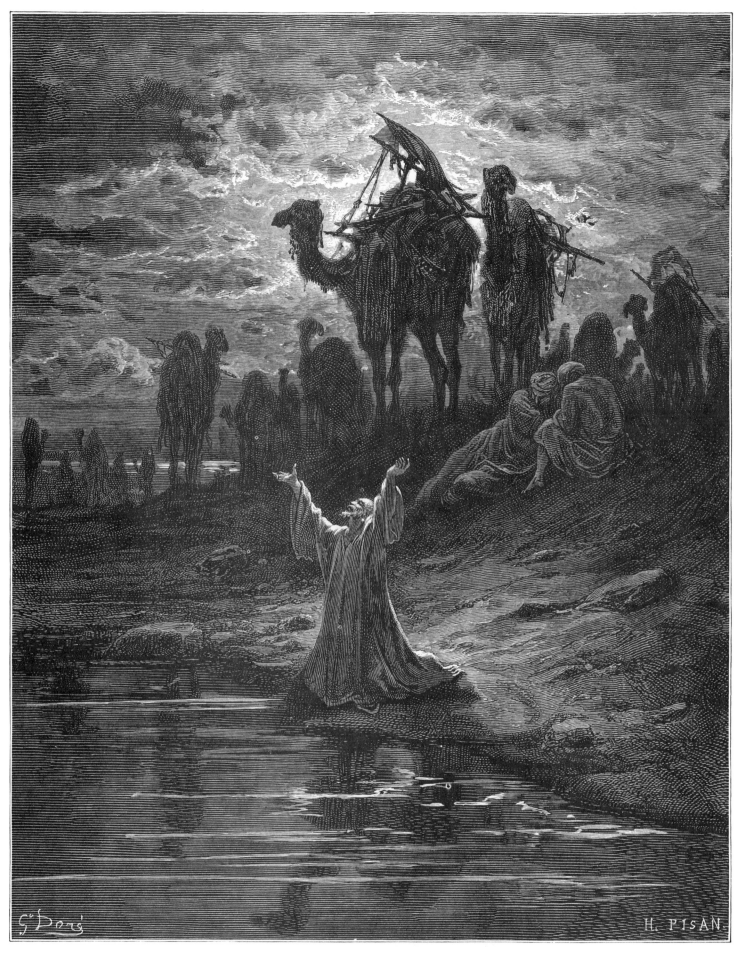

THE PRAYER OF JACOB

And Jacob said, O God of my father Abraham, and God of my father Isaac . . .
Deliver me, I pray thee, from the hand of my brother, from the hand of Esau . . .
(Genesis 32: 9, 11)

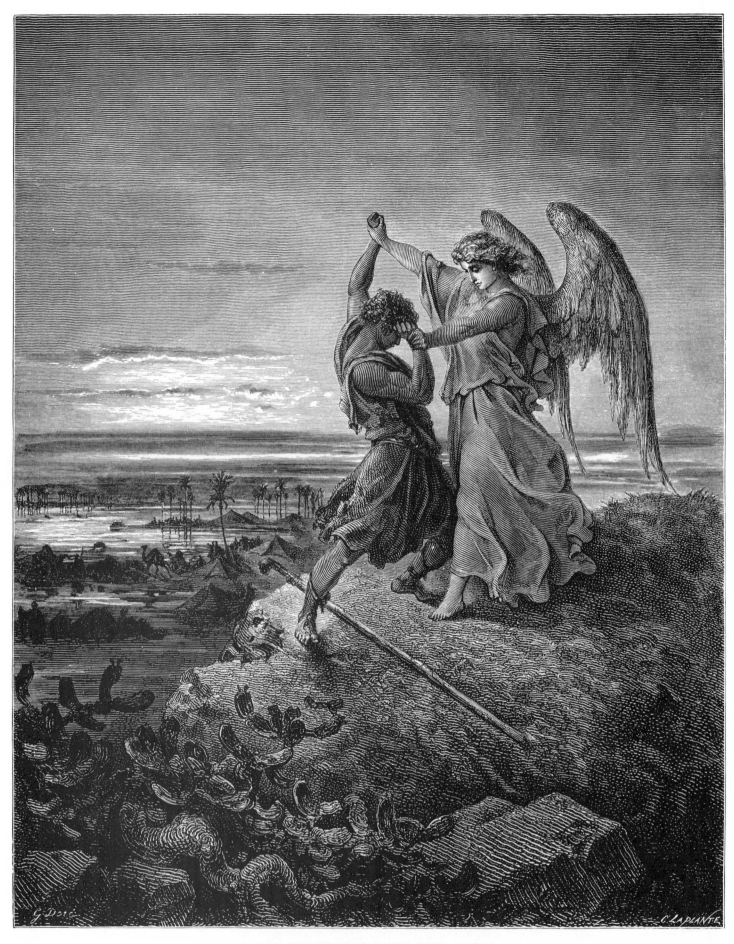

JACOB WRESTLING WITH THE ANGEL

And Jacob was left alone; and there wrestled a man with him until the breaking
of the day . . . And Jacob called the name of the place Peniel: for I have seen God
face to face . . . (Genesis 32: 24, 30)

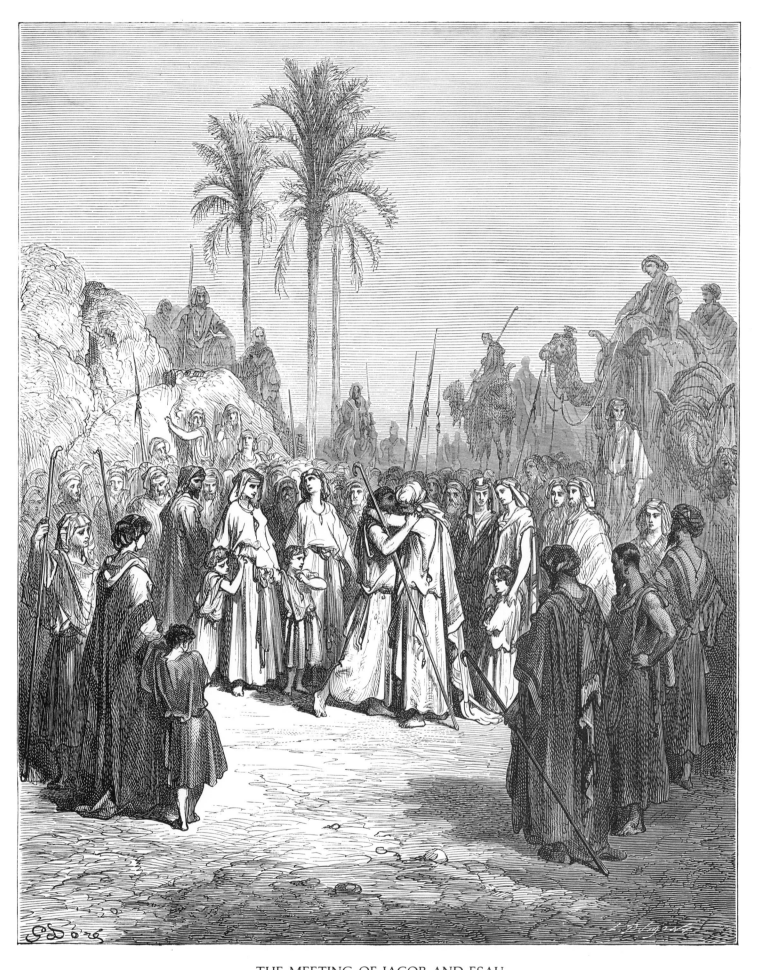

THE MEETING OF JACOB AND ESAU

And Esau ran to meet him, and embraced him, and fell on his neck, and kissed
him: and they wept . . . (Genesis 33: 4)

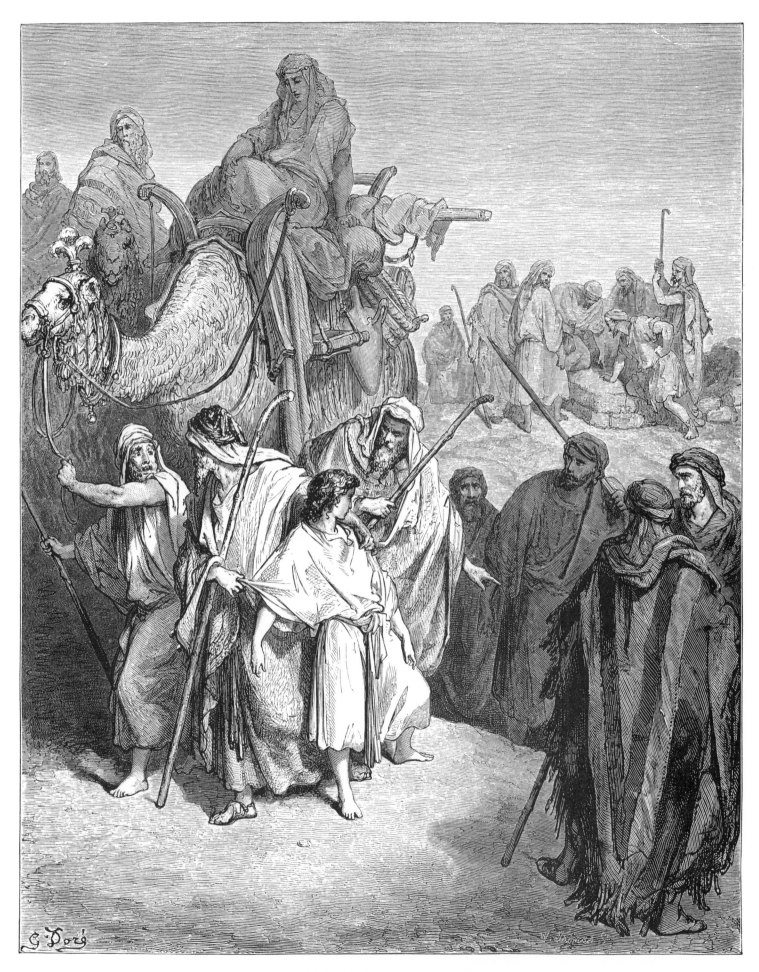

JOSEPH SOLD BY HIS BRETHREN

Then there passed by Midianites merchantmen; and they drew and lifted up Joseph
out of the pit, and sold Joseph to the Ishmeelites for twenty pieces of silver . . .
(Genesis 37: 28)

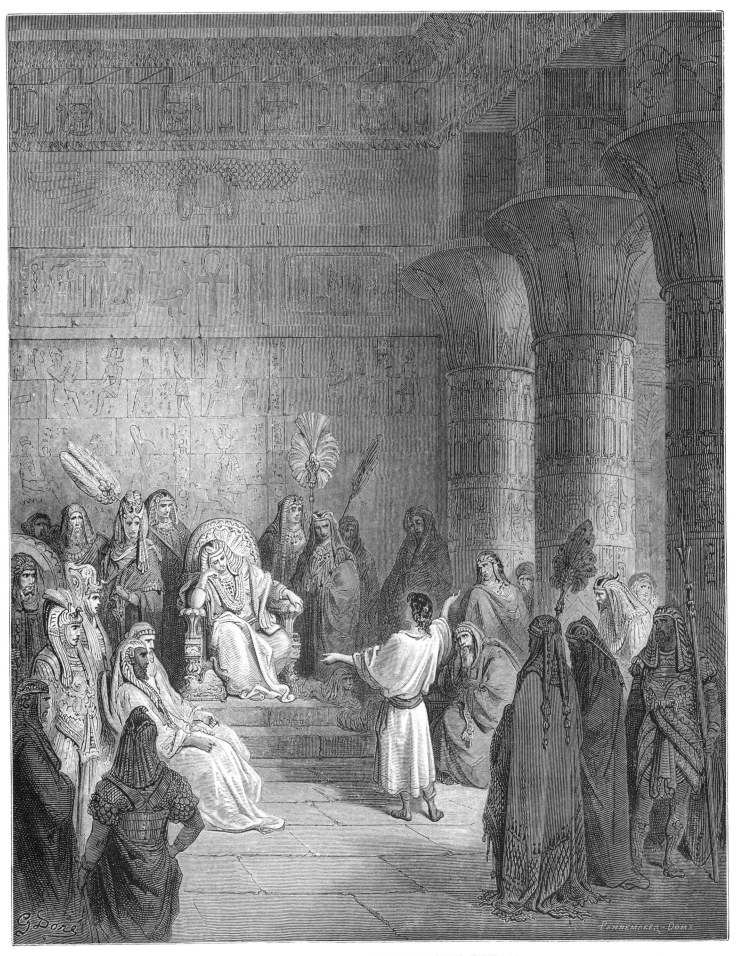

JOSEPH INTERPRETING PHARAOH'S DREAM

And Joseph said unto Pharaoh, The dream of Pharaoh is one: God hath shewed
Pharaoh what he is about to do . . . (Genesis 41: 25)

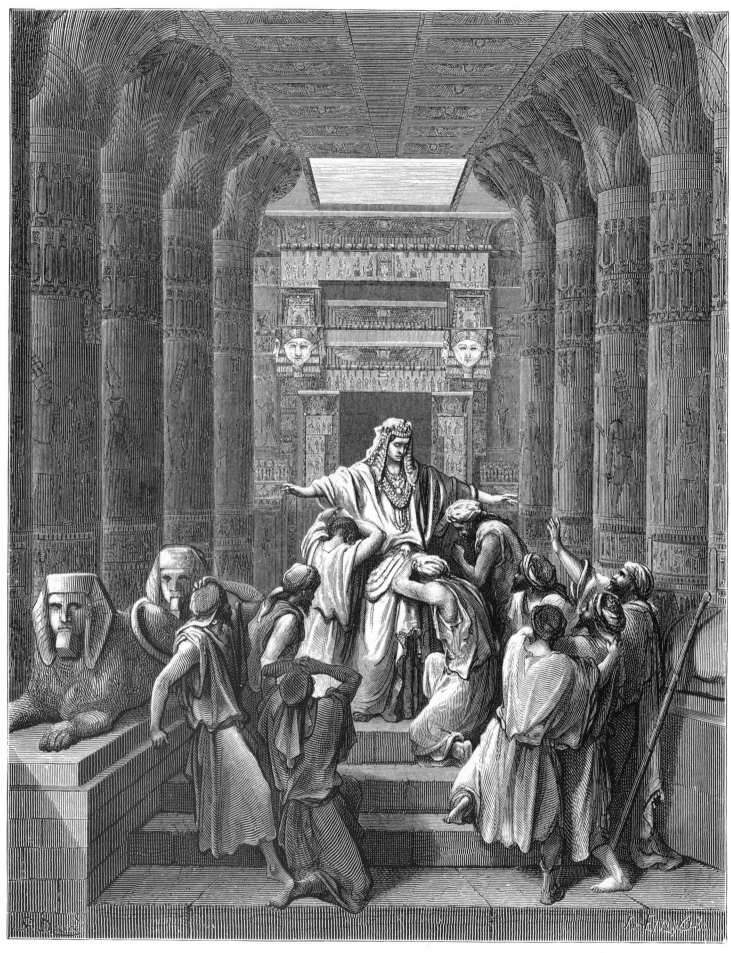

JOSEPH MAKES HIMSELF KNOWN TO HIS BRETHREN

Then Joseph could not refrain himself before all them that stood by him . . .
And he wept aloud . . . And he said, I am Joseph your brother, whom ye sold into
Egypt . . . (Genesis 45: 1, 2, 4)

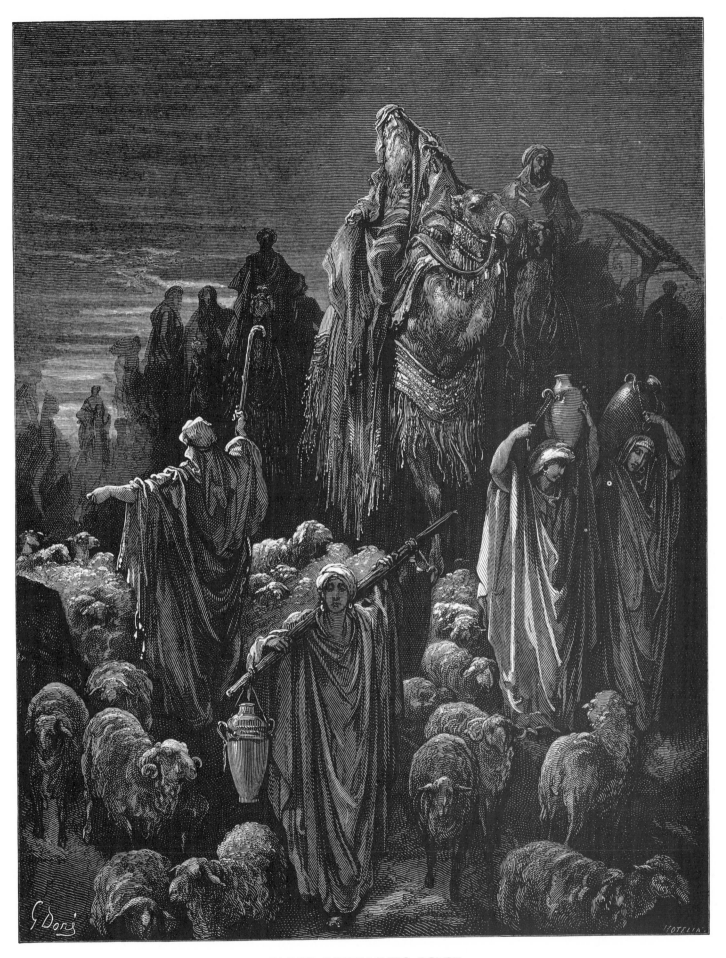

JACOB GOETH INTO EGYPT

And Jacob rose up from Beer-sheba: and the sons of Israel carried Jacob their
father, and their little ones, and their wives, in the wagons which Pharaoh had sent
to carry him . . . (Genesis 46: 5)

THE CHILD MOSES ON THE NILE

And when she could not longer hide him, she took for him an ark of bulrushes, and daubed it with slime and with pitch, and put the child therein; and she laid it in the flags by the river's brink. And his sister stood afar off, to wit what would be done to him . . . (Exodus 2: 3, 4)

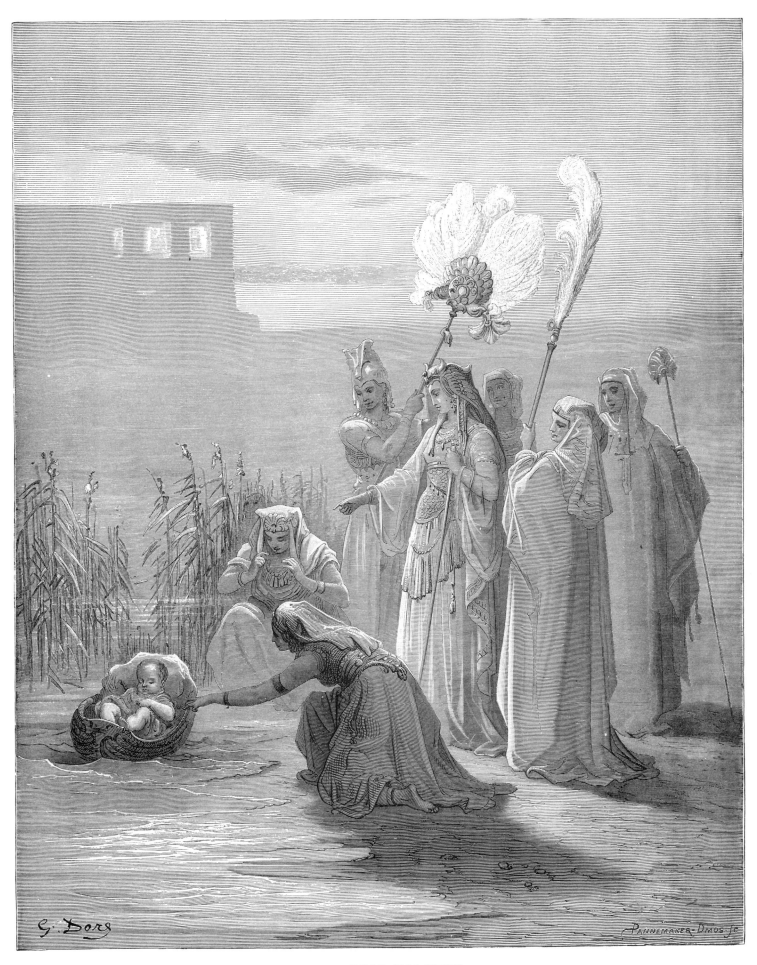

THE FINDING OF MOSES

And when she [the daughter of Pharaoh] had opened it, she saw the child: and, behold,
the babe wept. And she had compassion on him, and said, This is one of the Hebrews'
children . . . (Exodus 2: 6)

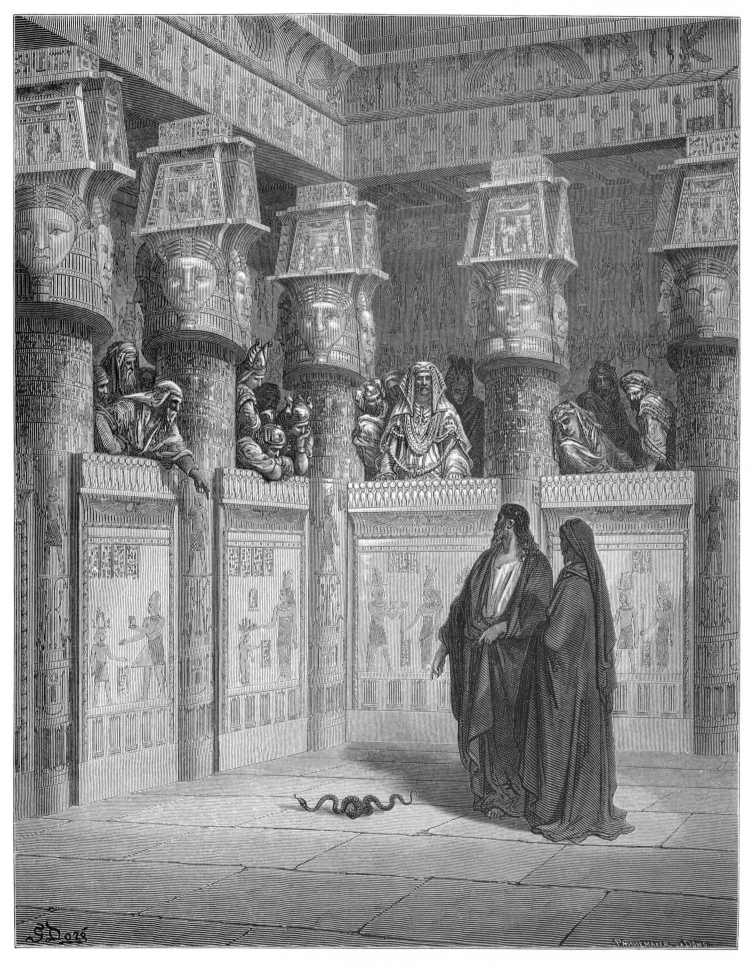

MOSES AND AARON BEFORE PHARAOH

And Aaron cast down his rod before Pharaoh, and before his servants, and it be-
came a serpent . . . (Exodus 7: 10)

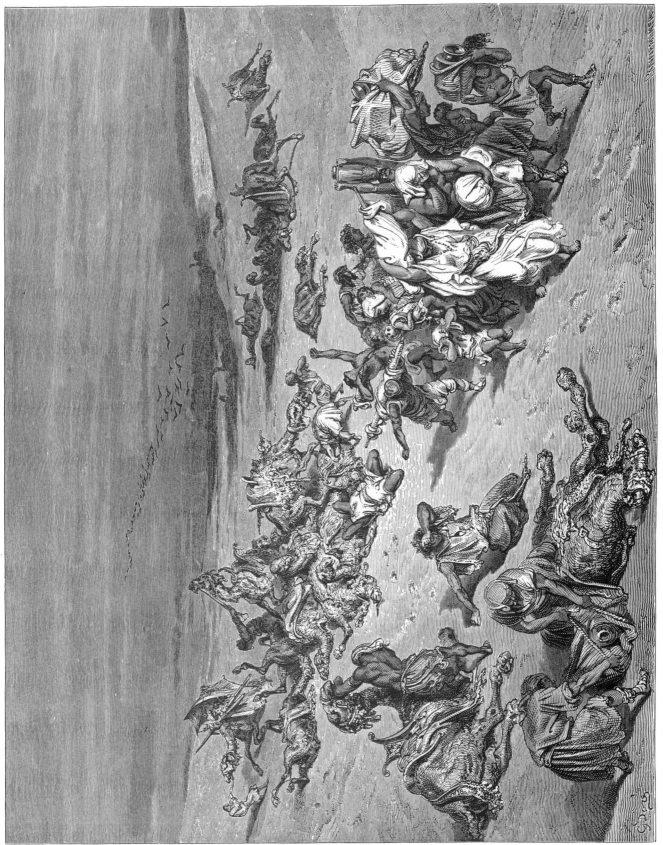

THE MURRAIN OF BEASTS

If thou refuse to let them go . . . Behold, the hand of the Lord is upon thy cattle . . . upon the horses, upon the asses, upon the camels, upon the oxen, and upon the sheep . . . (Exodus 9: 2, 3)

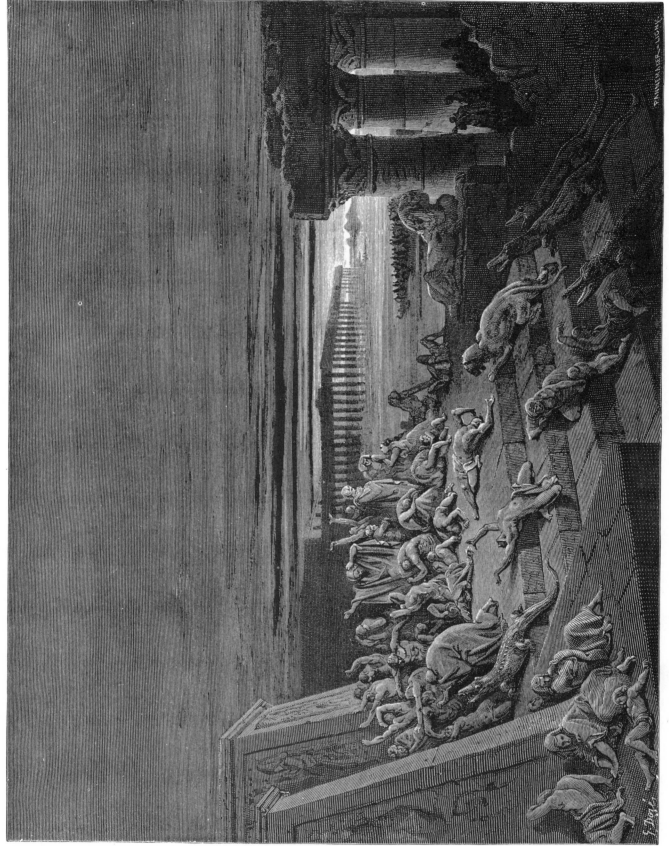

THE PLAGUE OF DARKNESS

And Moses stretched forth his hand toward heaven; and there was a thick darkness
in all the land of Egypt three days . . . (Exodus 10: 22)

34

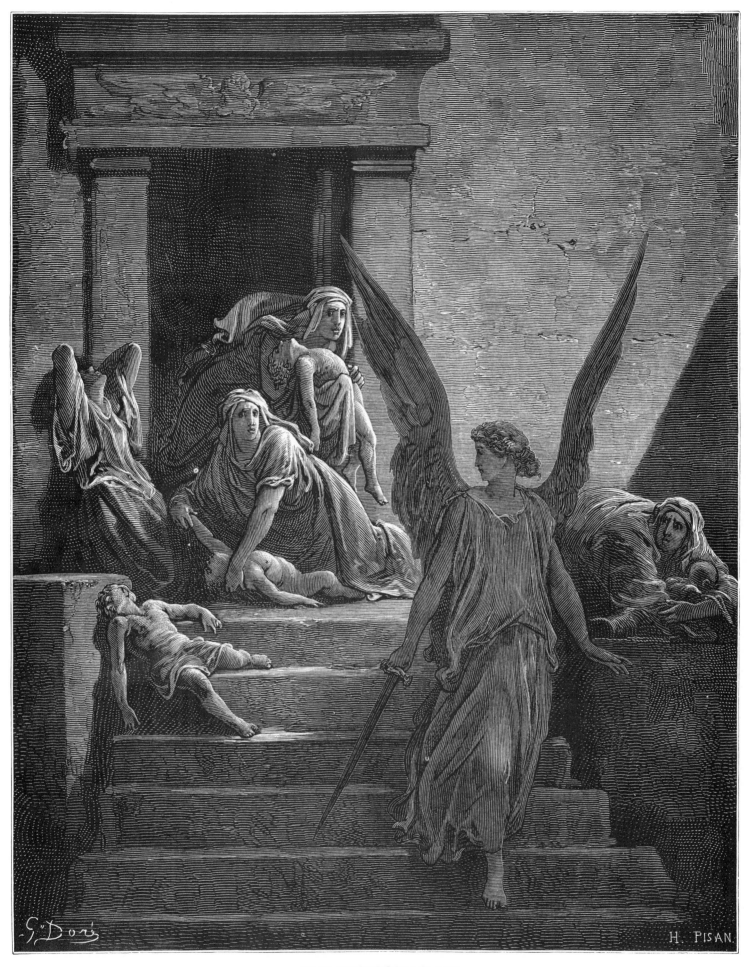

THE FIRSTBORN SLAIN

And it came to pass, that at midnight the Lord smote all the firstborn in the land
of Egypt . . . And Pharaoh rose up in the night . . . and there was a great cry in
Egypt; for there was not a house where there was not one dead . . . (Exodus 12: 29-30)

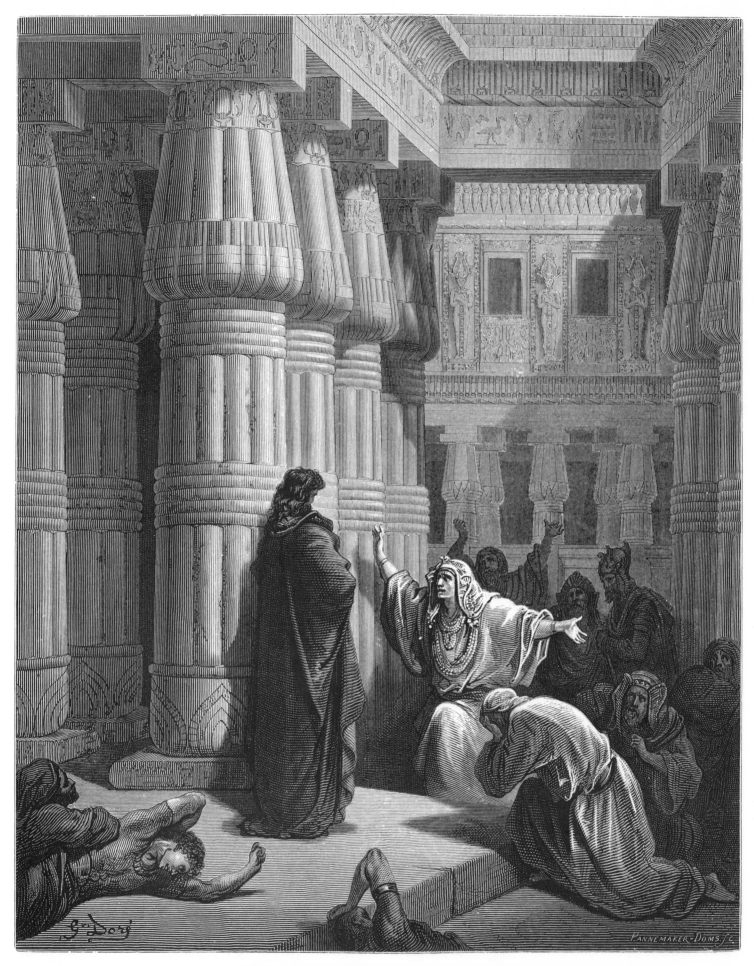

THE EGYPTIANS URGE MOSES TO DEPART

And he [Pharaoh] called for Moses and Aaron by night, and said, Rise up, and get
you forth from among my people, both ye and the children of Israel; and go, serve
the Lord, as ye have said . . . (Exodus 12: 31)

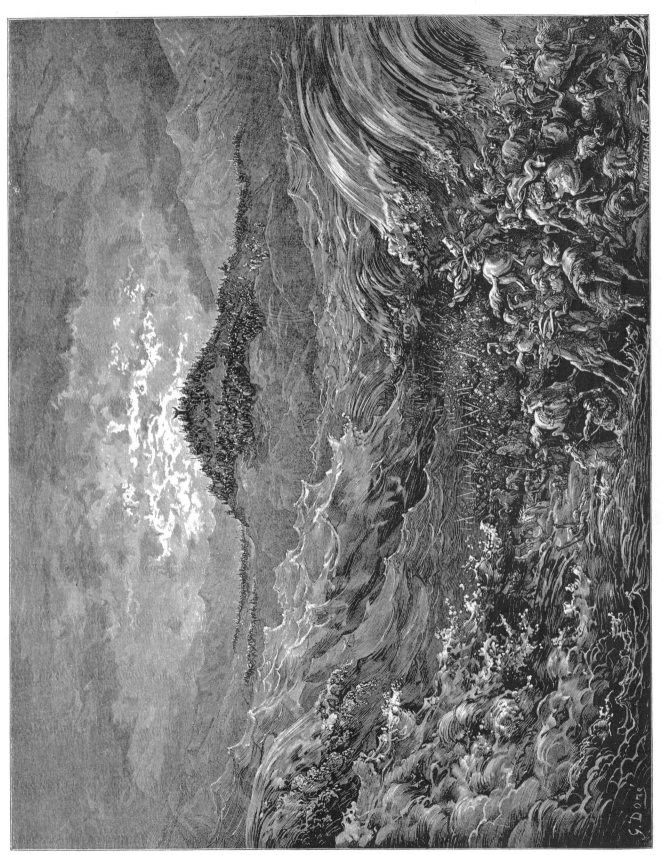

THE EGYPTIANS DROWNED IN THE RED SEA

And Moses stretched forth his hand . . . And the waters returned, and covered the chariots, and the horsemen, and all the host of Pharaoh that came into the sea after them; there remained not so much as one of them . . . (Exodus 14: 27, 28)

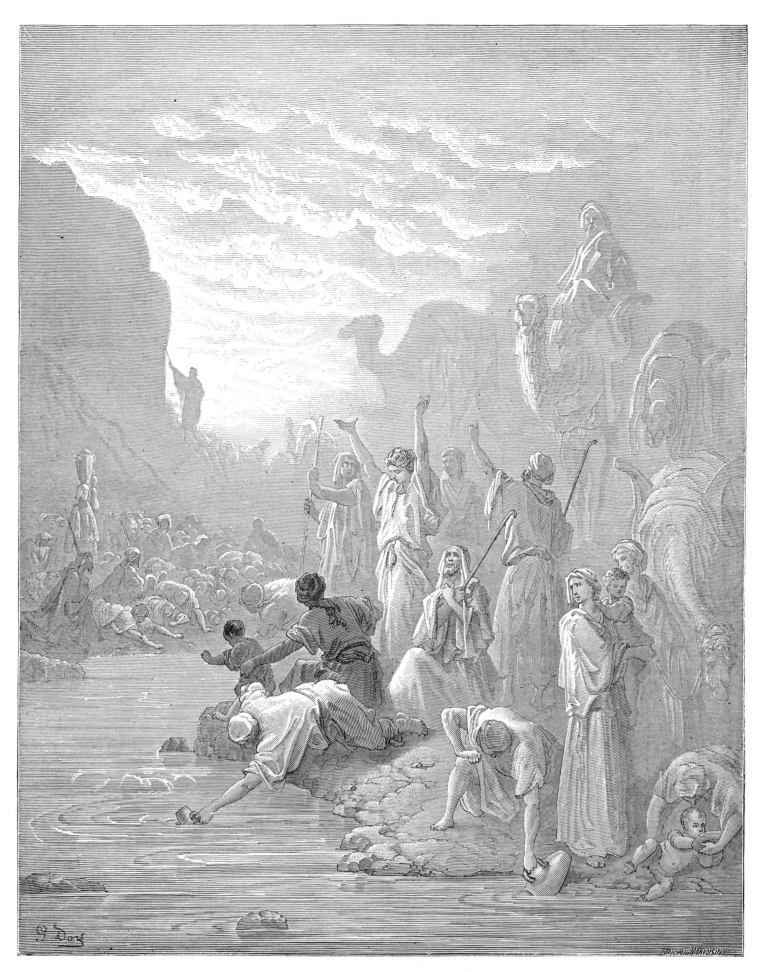

MOSES STRIKING THE ROCK IN HOREB

And the Lord said unto Moses, Go on before the people, and take with thee . . . thy
rod . . . Behold, I will stand before thee there upon the rock in Horeb; and thou
shalt smite the rock, and there shall come water out of it. And Moses did so in the
sight of the elders of Israel . . . (Exodus 17: 5, 6)

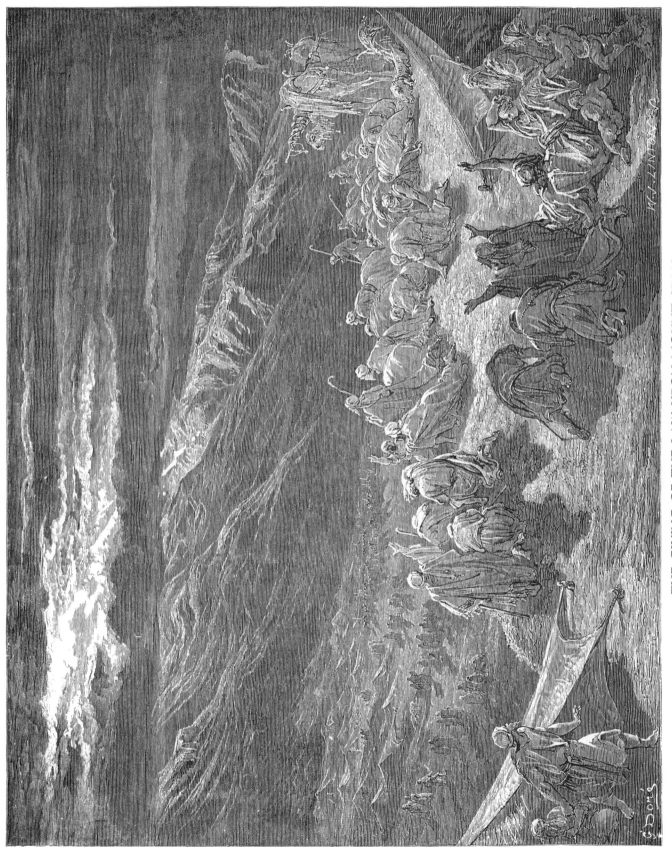

THE GIVING OF THE LAW UPON MOUNT SINAI

And it came to pass on the third day in the morning, that there were thunders and lightnings, and a thick cloud upon the mount, and the voice of the trumpet exceeding loud; so that all the people that was in the camp trembled . . . (Exodus 19: 16)

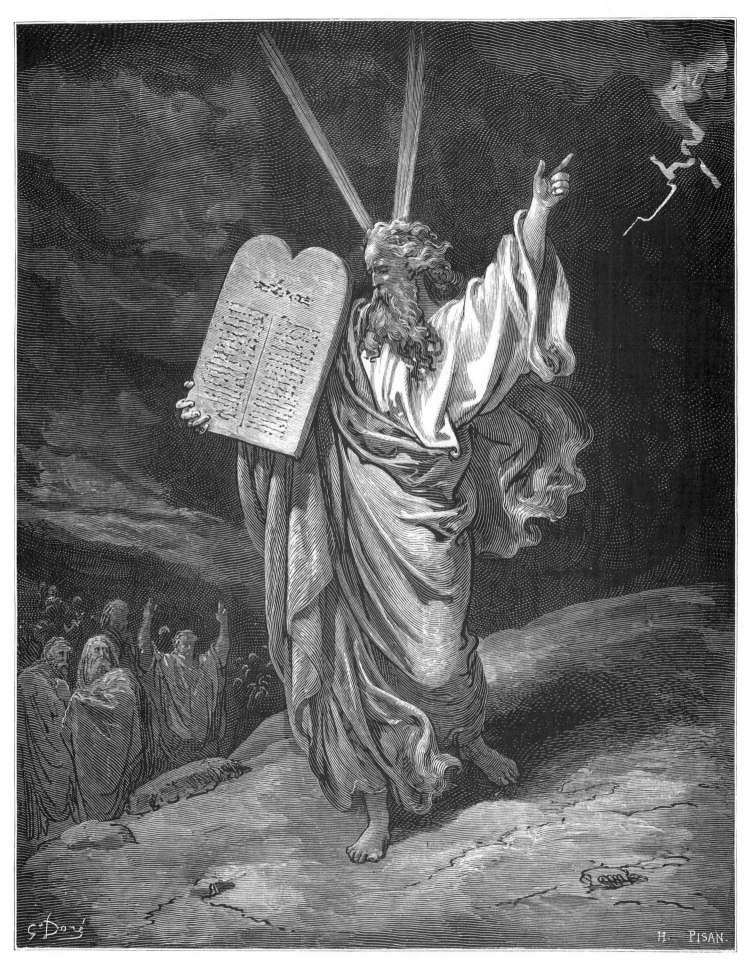

MOSES COMING DOWN FROM MOUNT SINAI

And Moses turned, and went down from the mount, and the two tables of the testi-
mony were in his hand ... And the tables were the work of God ... (Exodus 32: 15, 16)

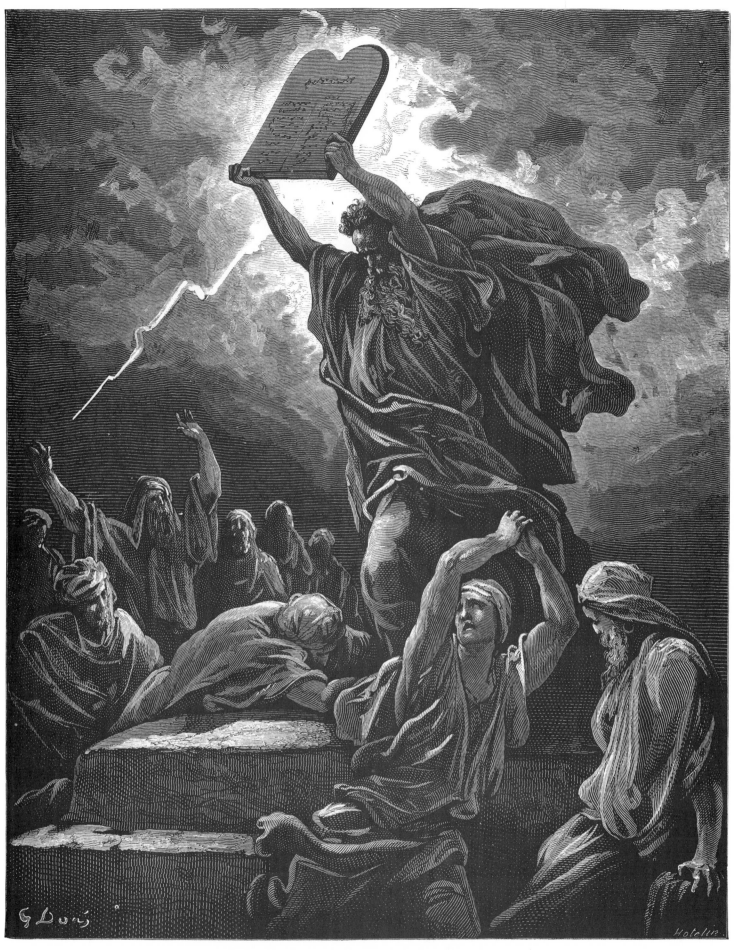

MOSES BREAKING THE TABLES OF THE LAW

And it came to pass, as soon as he came nigh unto the camp, that he saw the calf, and the dancing: and Moses' anger waxed hot, and he cast the tables out of his hands, and brake them . . . (Exodus 32: 19)

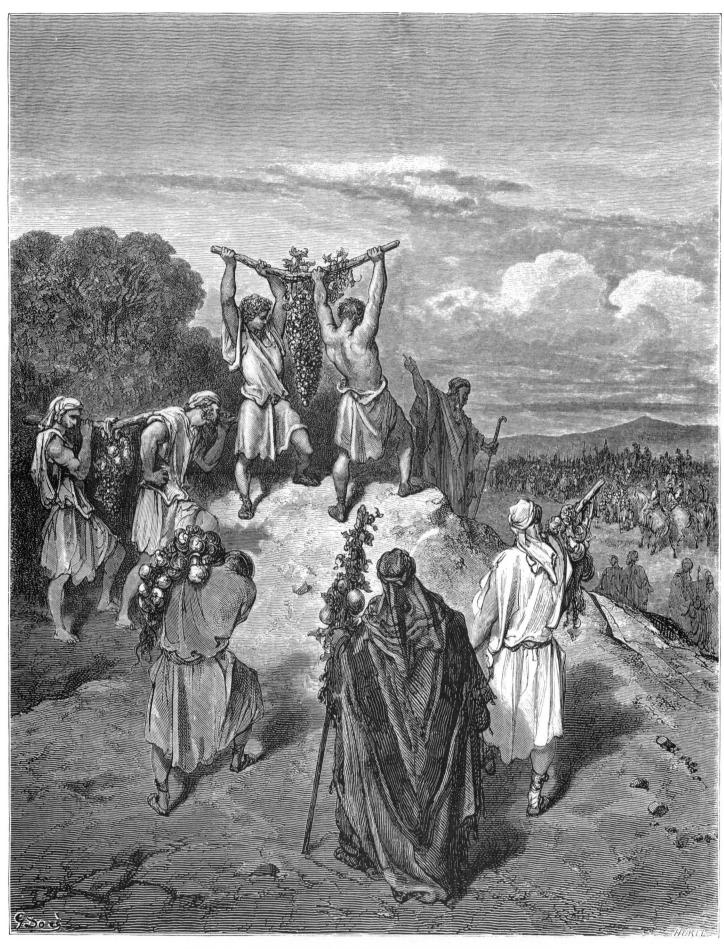

RETURN OF THE SPIES FROM THE LAND OF PROMISE

And they went and came unto Moses . . . and said, We came unto the land whither
thou sentest us, and surely it floweth with milk and honey; and this is the fruit of
it . . . (Numbers 13: 26, 27)

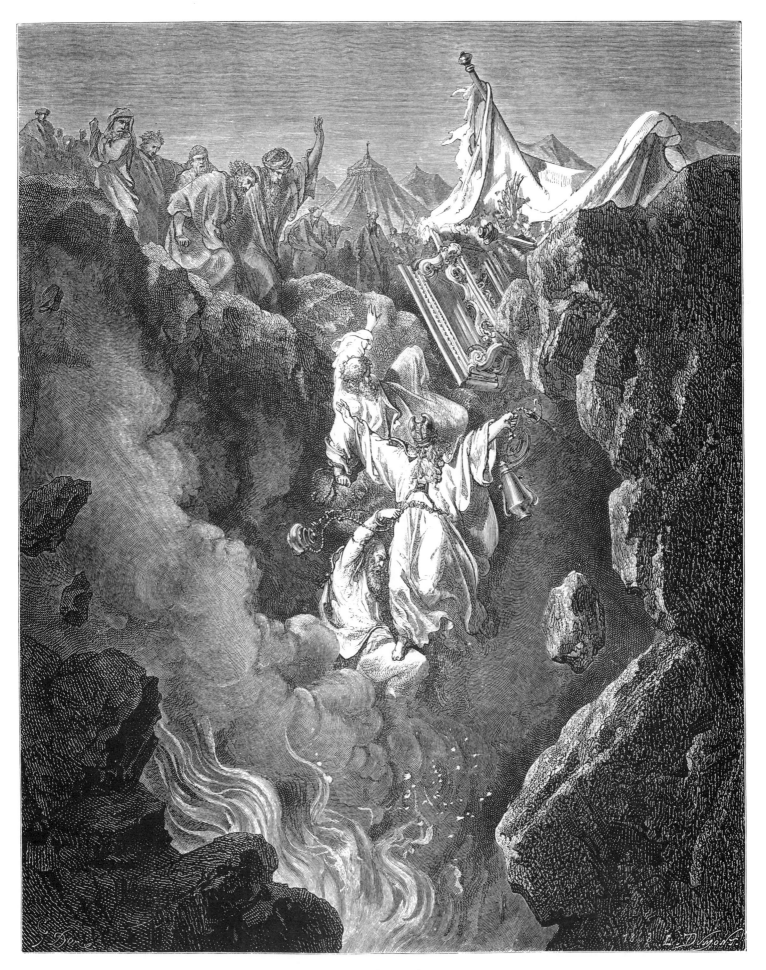

DEATH OF KORAH, DATHAN, AND ABIRAM

And it came to pass, as he had made an end of speaking . . . the ground clave asunder that was under them: And the earth opened her mouth, and swallowed them up, and their houses, and all the men that appertained unto Korah, and all their goods. . . . (Numbers 16: 31, 32)

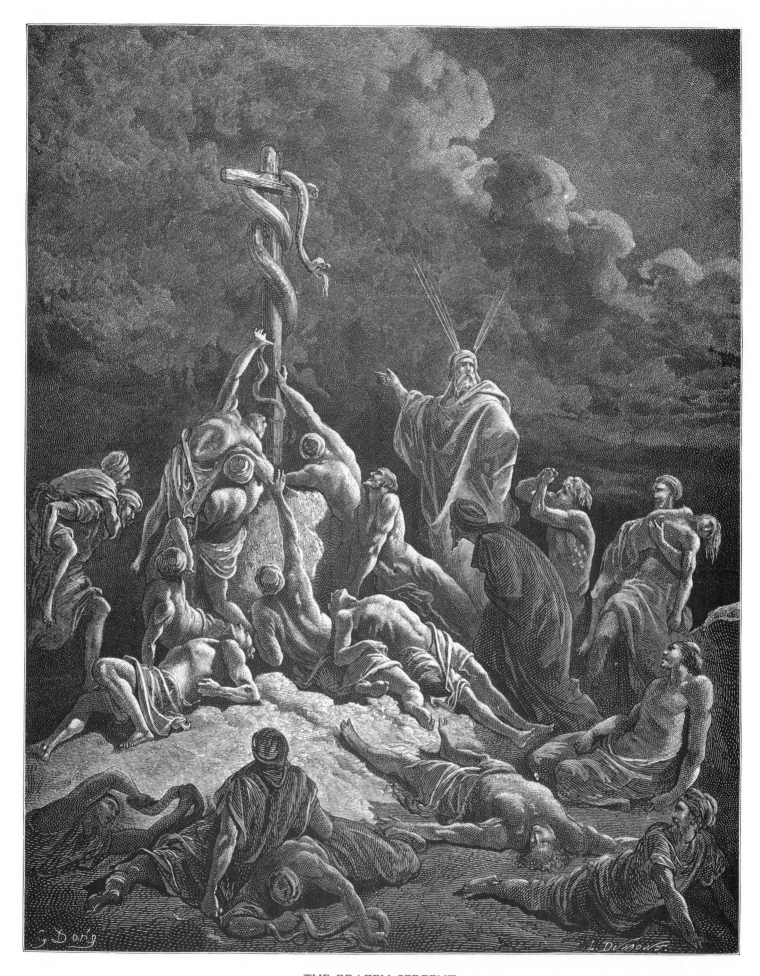

THE BRAZEN SERPENT

And Moses made a serpent of brass, and put it upon a pole, and it came to pass,
that if a serpent had bitten any man, when he beheld the serpent of brass, he lived.
. . . (Numbers 21: 9)

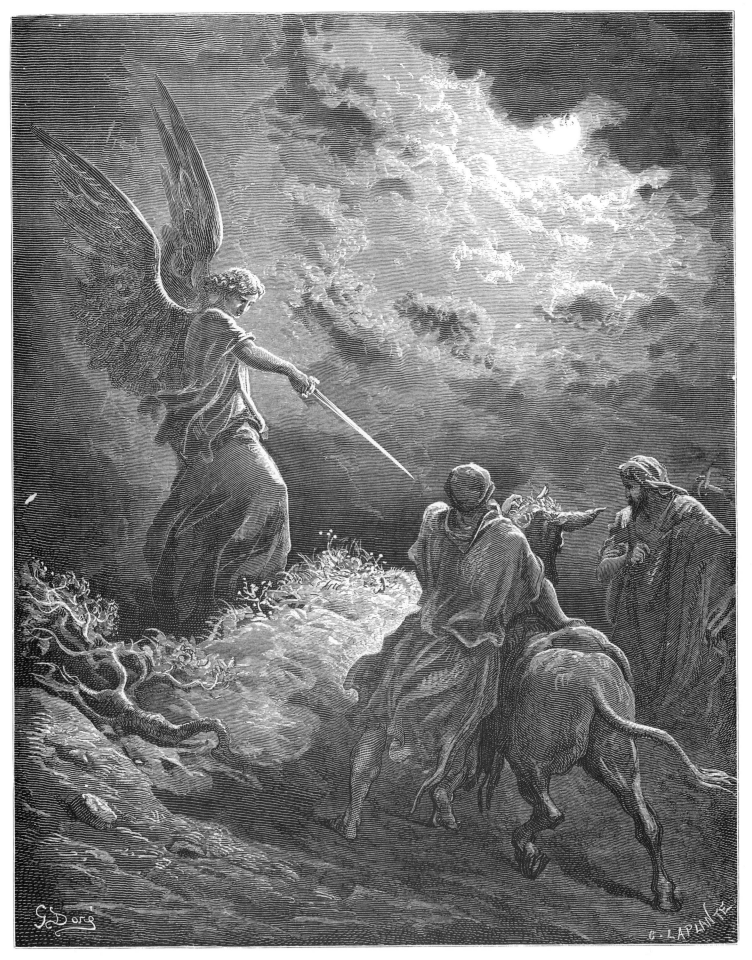

THE ANGEL APPEARING TO BALAAM

And the ass saw the angel of the Lord standing in the way, and his sword drawn
in his hand: and the ass turned aside out of the way, and went into the field: and
Balaam smote the ass, to turn her into the way . . . (Numbers 22: 23)

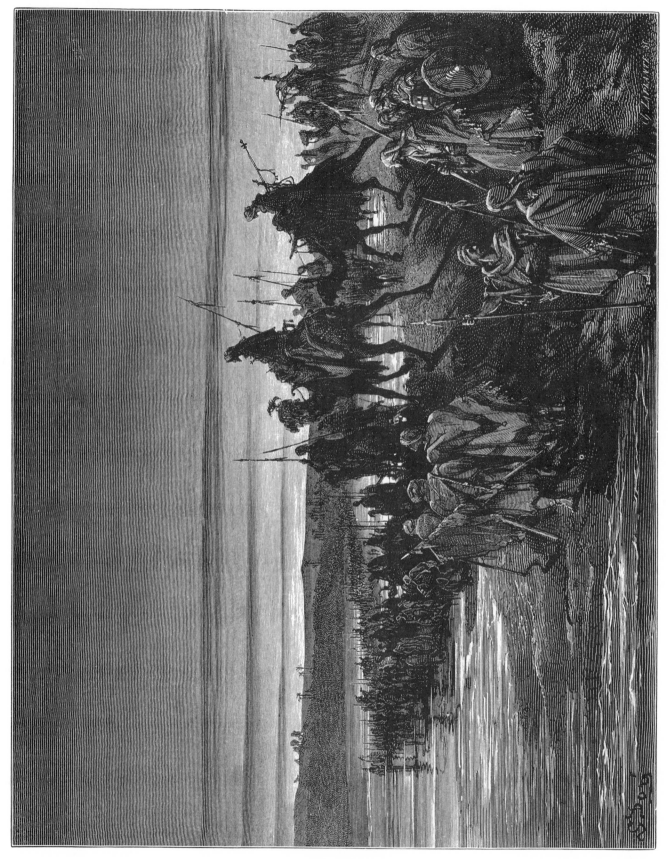

THE CHILDREN OF ISRAEL CROSSING JORDAN

And it came to pass...as they...bare the ark...unto Jordan...the waters
which came down from above stood and rose up upon an heap...And the priests
that bare the ark of the covenant...stood firm on dry ground...(Joshua 3: 14-17)

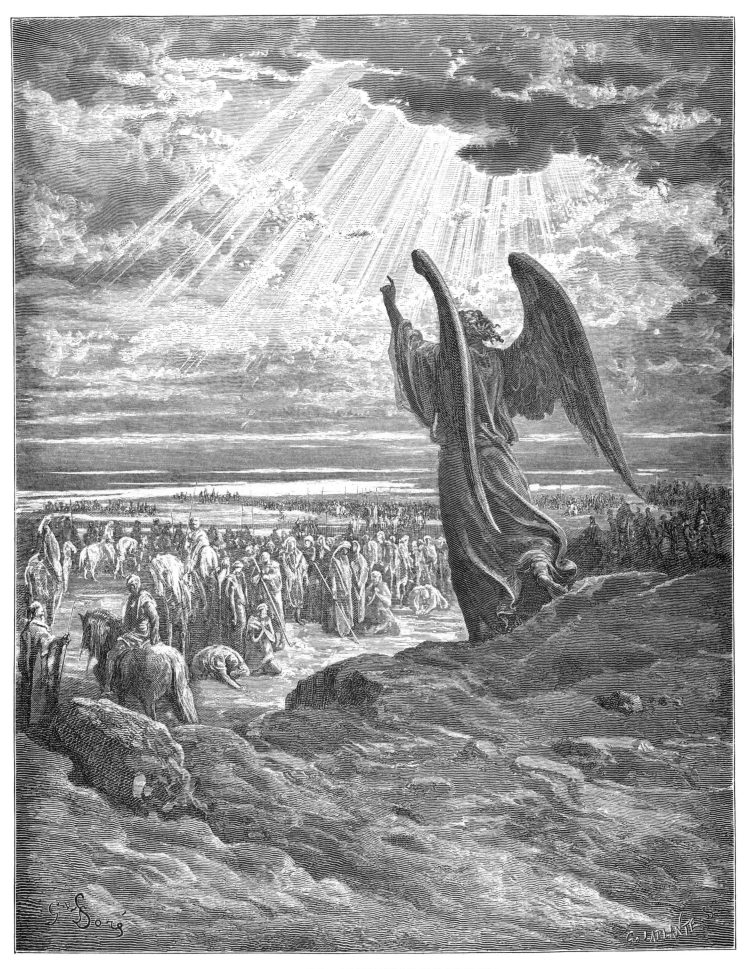

THE ANGEL APPEARING TO JOSHUA

And the captain of the Lord's host said unto Joshua, Loose thy shoe from off thy
foot; for the place whereon thou standest is holy . . . (Joshua 5: 15)

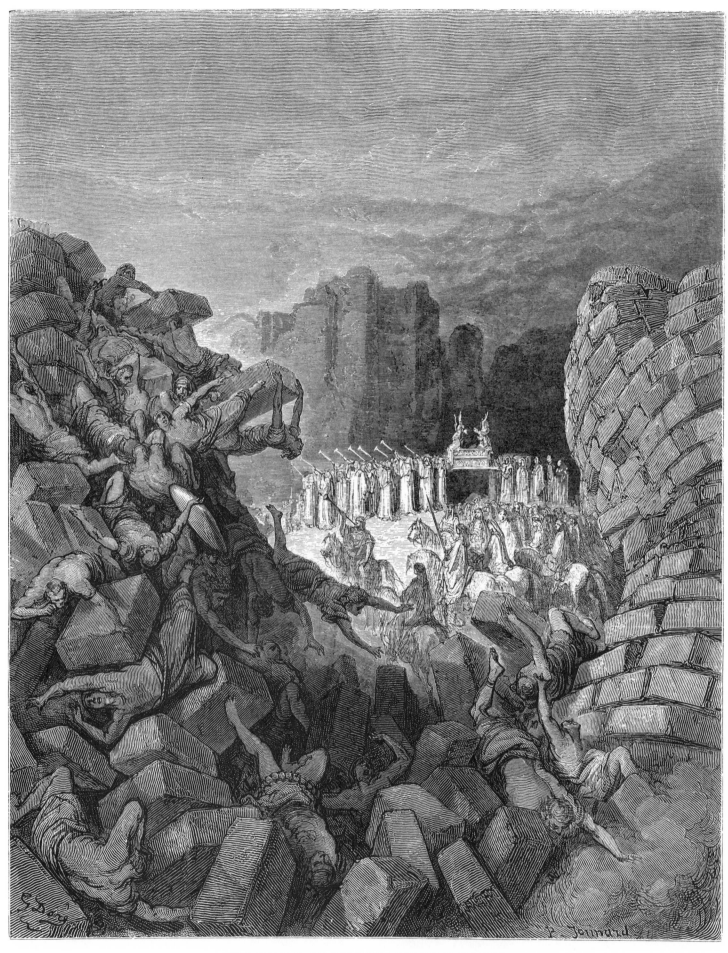

THE WALLS OF JERICHO FALLING DOWN

So the people shouted when the priests blew with the trumpets: and it came to
pass, when the people heard the sound of the trumpet, and the people shouted with
a great shout, that the wall fell down flat . . . (Joshua 6: 20)

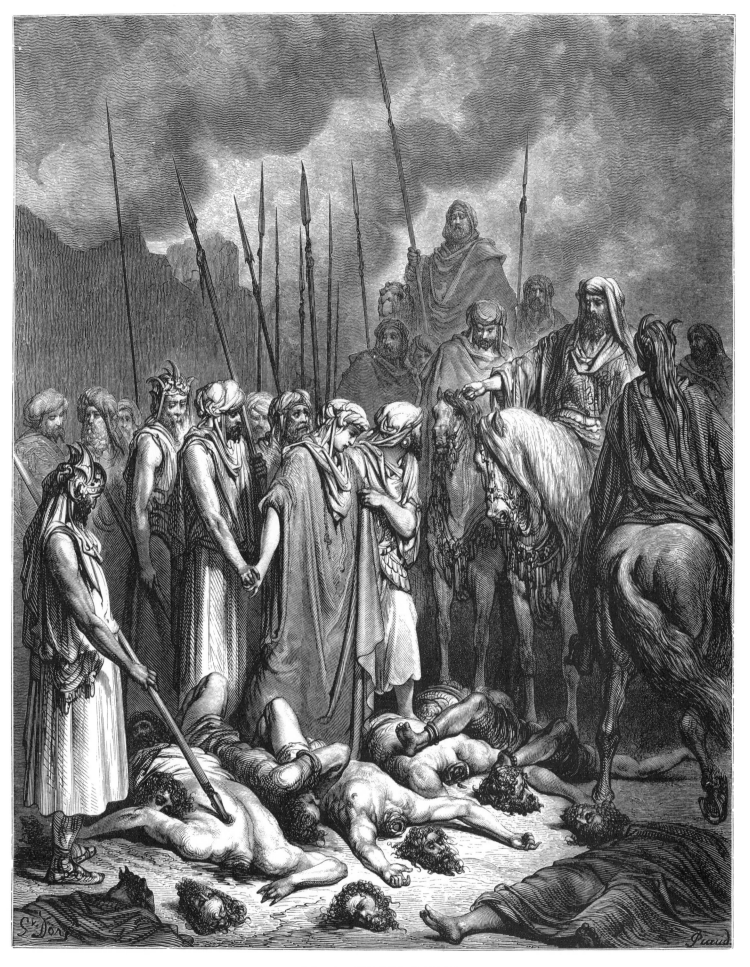

JOSHUA SPARES RAHAB

And Joshua saved Rahab the harlot alive, and her father's household . . . because
she hid the messengers, which Joshua sent to spy out Jericho . . . (Joshua 6: 25)

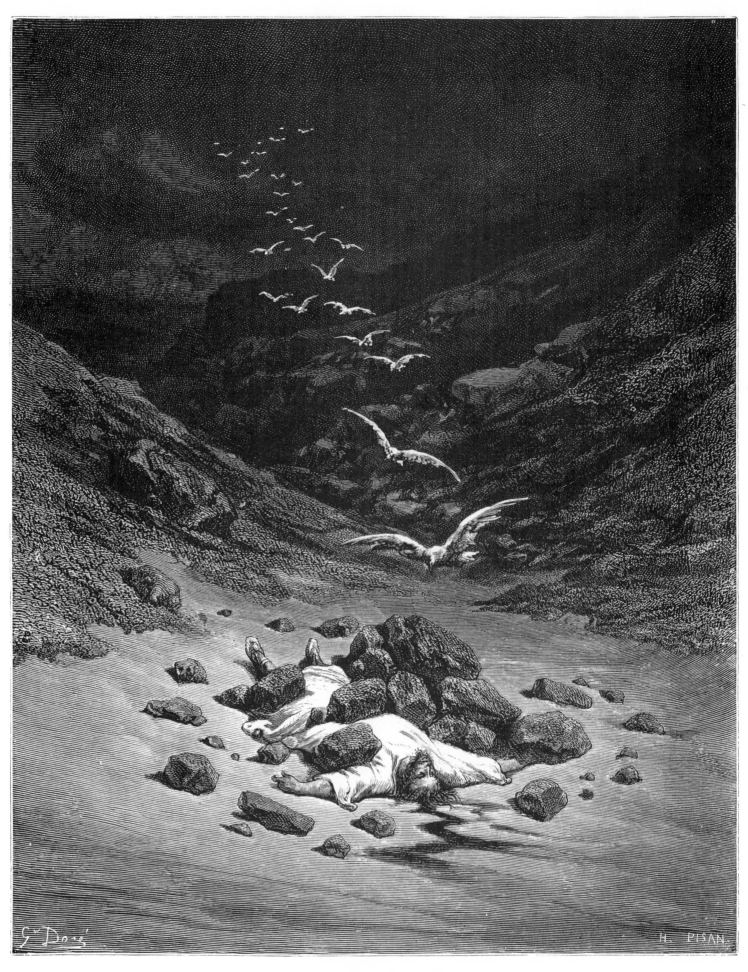

THE STONING OF ACHAN

Neither will I be with you any more, except ye destroy the accursed thing from among you ... And Joshua ... took Achan the son of Zerah, and the silver, and the garment ... and ... stoned them ... (Joshua 7: 12, 24, 25)

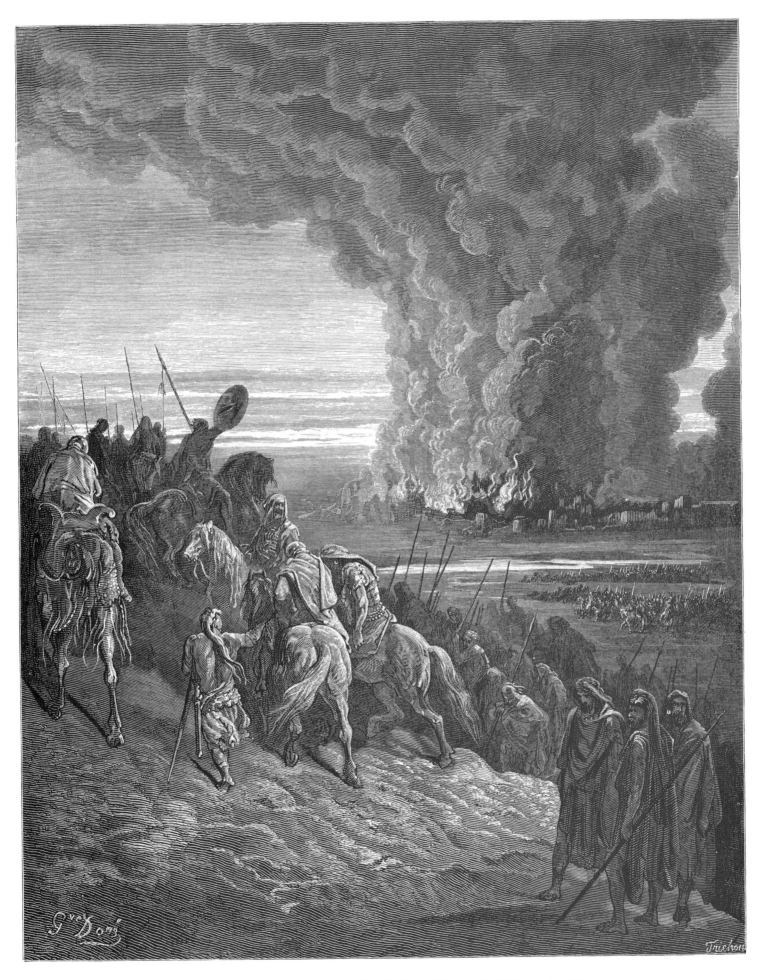

JOSHUA COMMITTING THE TOWN OF AI TO THE FLAMES

And the Lord said unto Joshua, Stretch out the spear that is in thy hand toward
Ai...And the ambush arose quickly out of their place...and...entered into the
city and took it...(Joshua 8: 18, 19)

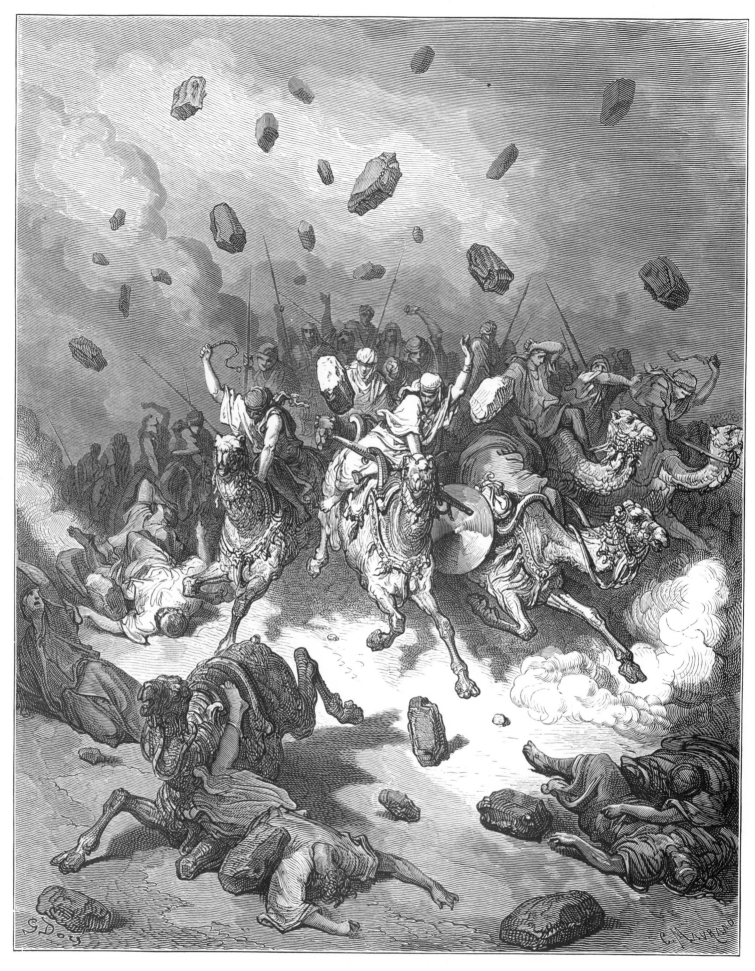

DESTRUCTION OF THE ARMY OF THE AMORITES

And . . . the Lord cast down great stones from heaven upon them unto Azekah,
and they died: they were more which died with hailstones than they whom the chil-
dren of Israel slew with the sword . . . (Joshua 10: 11)

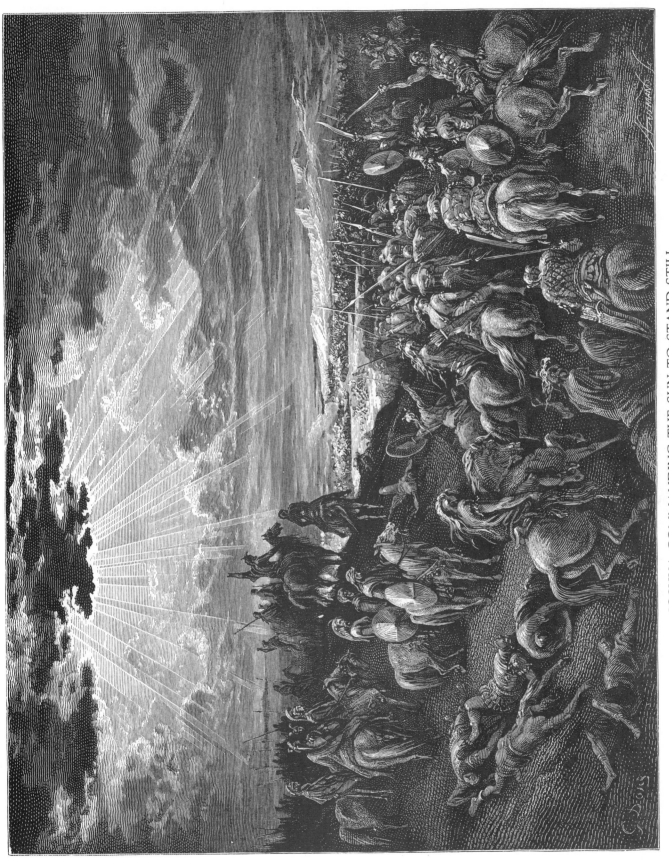

JOSHUA COMMANDING THE SUN TO STAND STILL

Then spake Joshua to the Lord in the day when the Lord delivered up the Amorites before the children of Israel, and he said in the sight of Israel, Sun, stand thou still upon Gibeon; and thou, Moon, in the valley of Ajalon . . . (Joshua 10: 12)

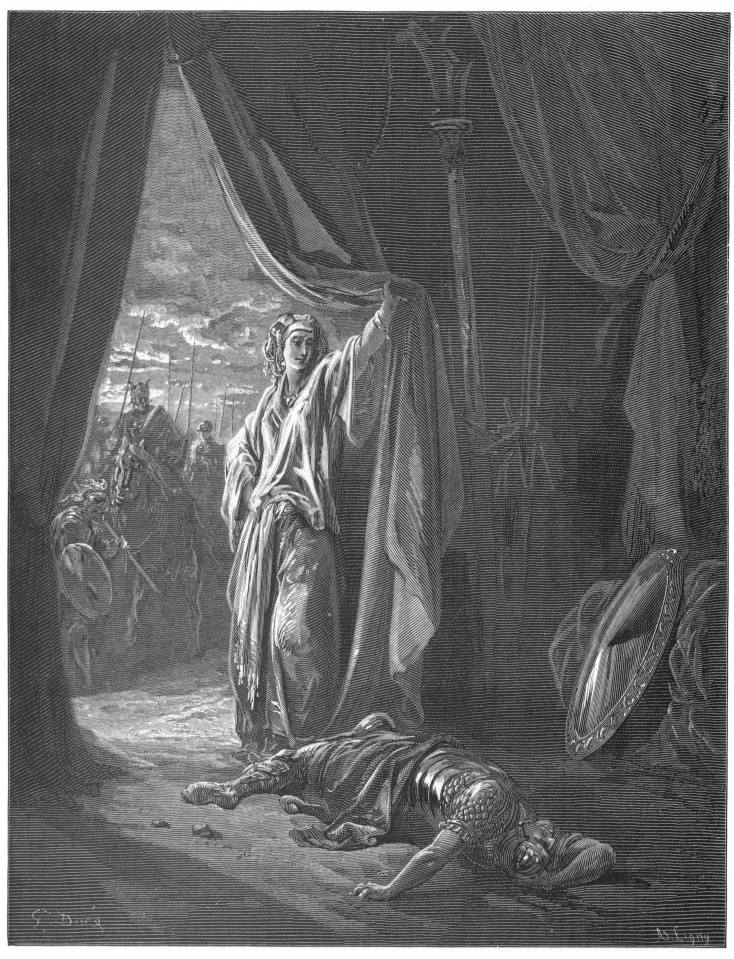

JAEL AND SISERA

Then Jael, Heber's wife, took a nail of the tent, and took an hammer in her hand,
and went softly unto him, and smote the nail into his temples, and fastened it into
the ground: for he was fast asleep and weary. So he died . . . (Judges 4: 21)

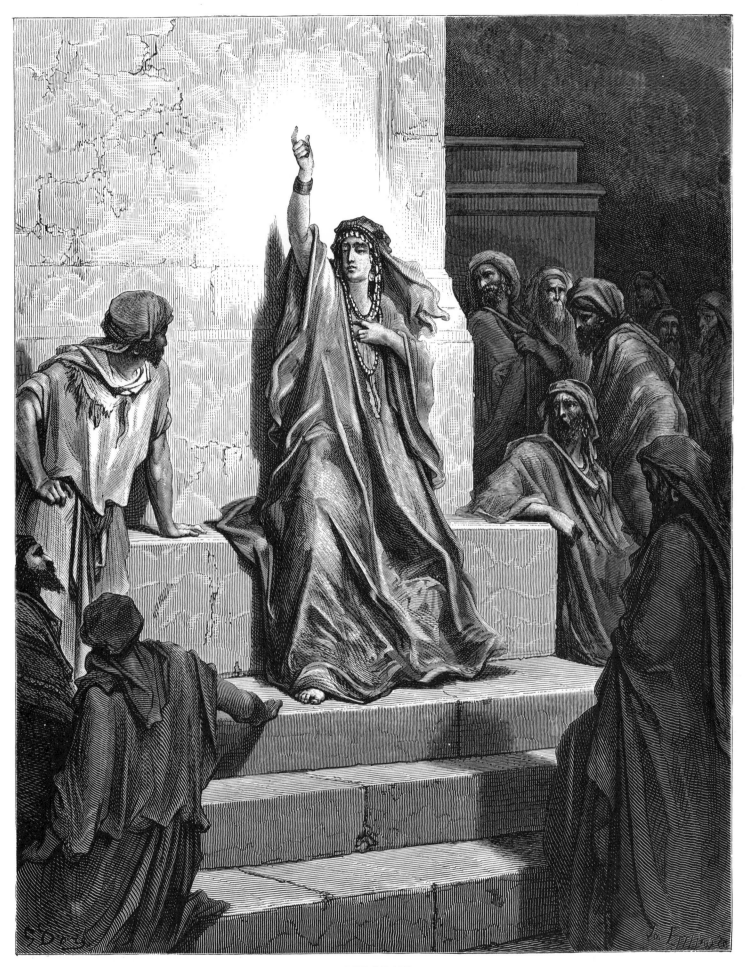

DEBORAH

Then sang Deborah and Barak . . .: Blessed above women shall Jael . . . be . . .
she smote Sisera . . . At her feet he bowed, he fell, he lay down . . . So let all thine
enemies perish, O Lord . . . (Judges 5: 1, 24, 26, 27, 31)

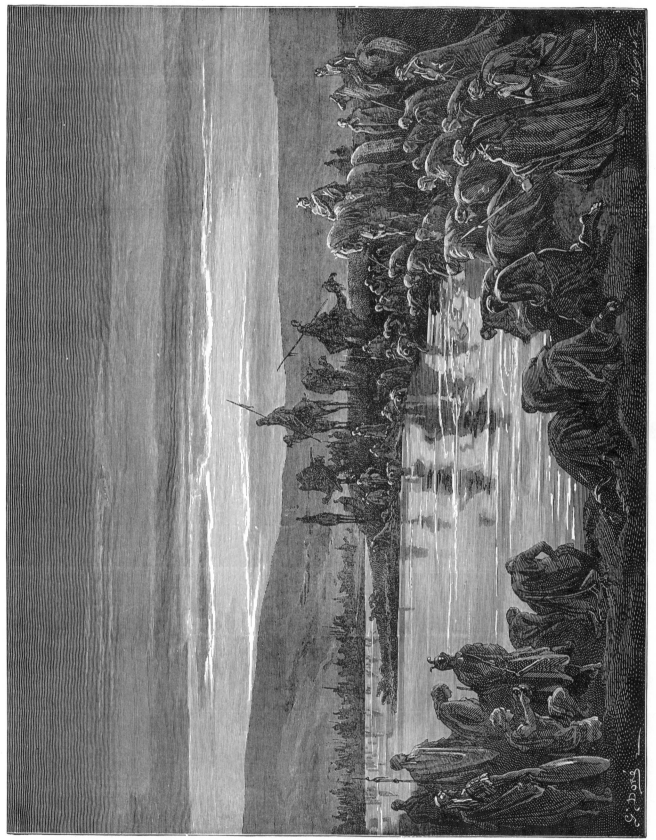

GIDEON CHOOSING HIS SOLDIERS

So he brought down the people unto the water: and the Lord said unto Gideon,
Every one that lappeth of the water with his tongue, as a dog lappeth, him shalt thou
set by himself . . . By the three hundred men that lapped will I save you . . .

(Judges 7: 5, 7)

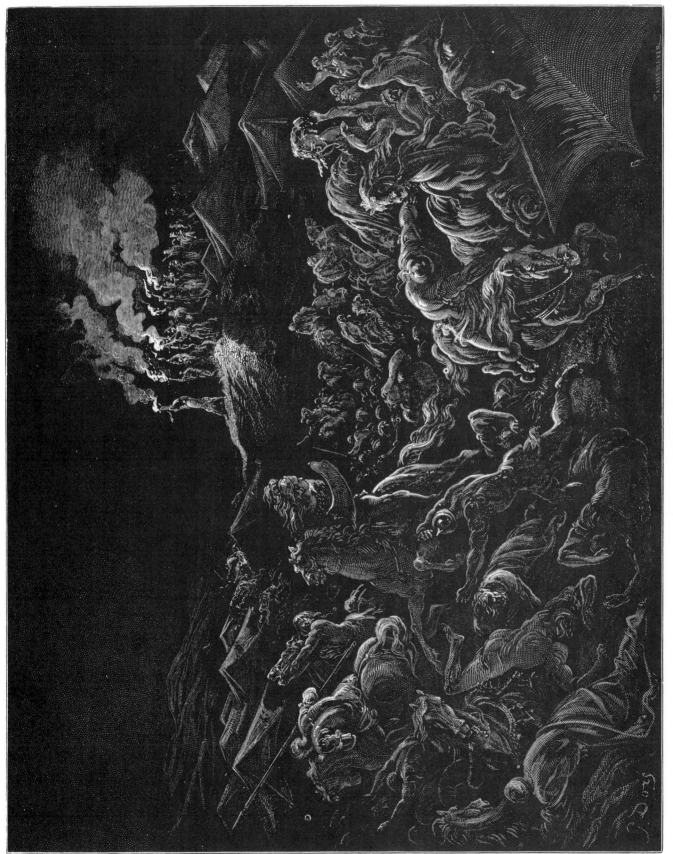

THE MIDIANITES PUT TO FLIGHT

And the three companies blew the trumpets, and brake the pitchers, and held the
lamps in their left hands, and the trumpets in their right hands to blow withal: and
they cried, The sword of the Lord, and of Gideon . . . (Judges 7: 20)

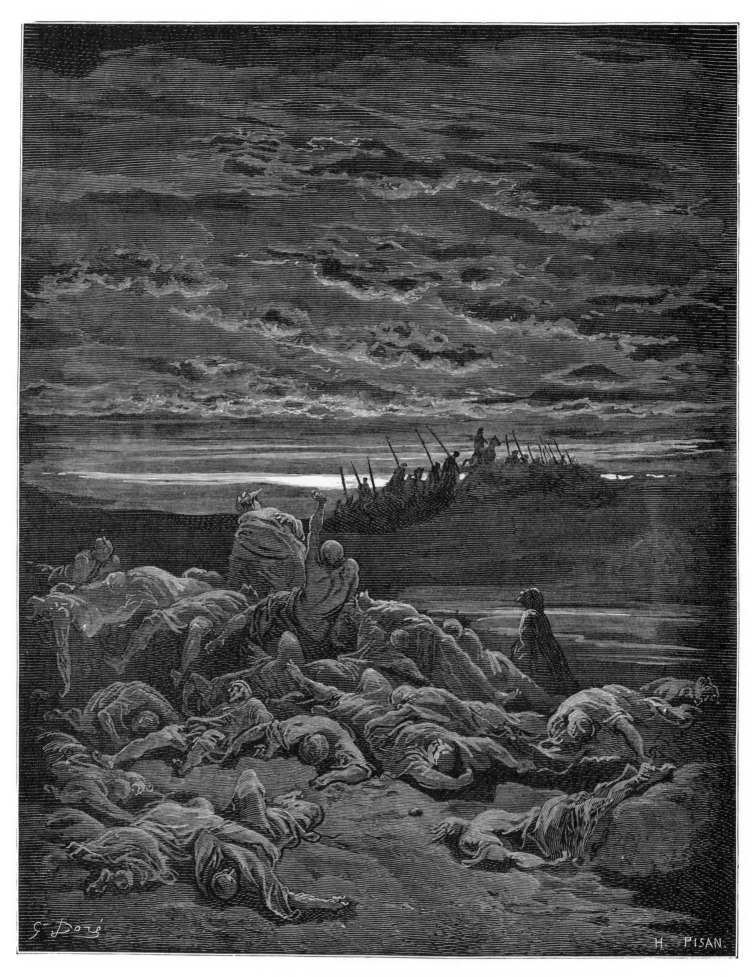

DEATH OF THE SONS OF GIDEON

And he went unto his father's house at Ophrah, and slew his brethren...being
threescore and ten persons . . . notwithstanding yet Jotham the youngest . . . for he
hid himself . . . (Judges 9: 5)

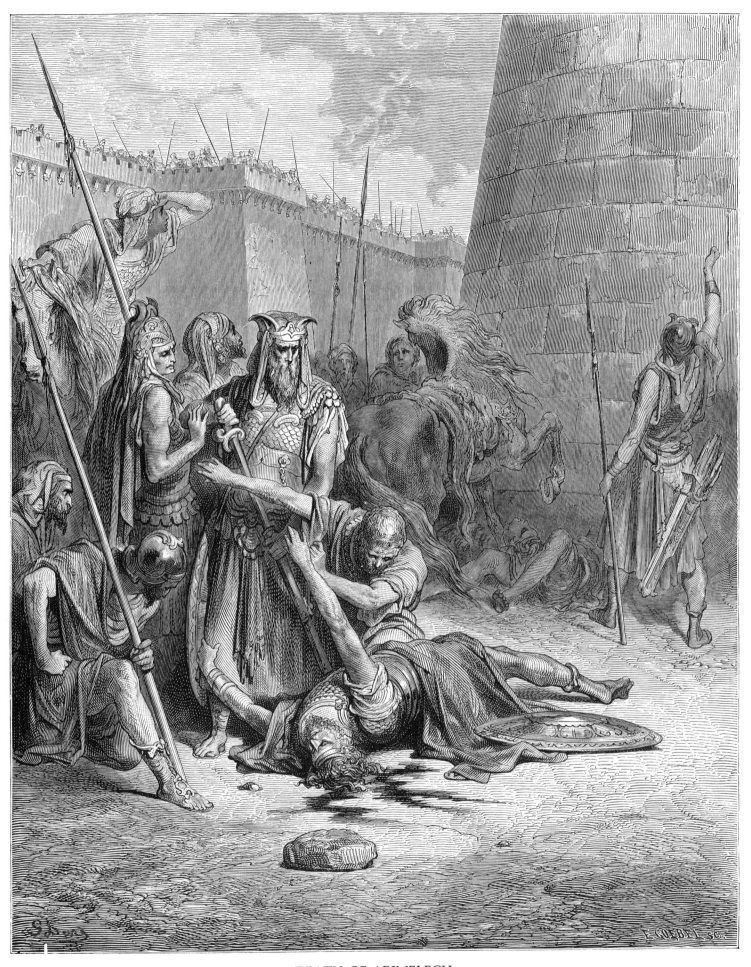

DEATH OF ABIMELECH

Then he called hastily unto the young man his armourbearer, and said unto him,
Draw thy sword, and slay me, that men say not of me, A woman slew him . . .
(Judges 9: 54)

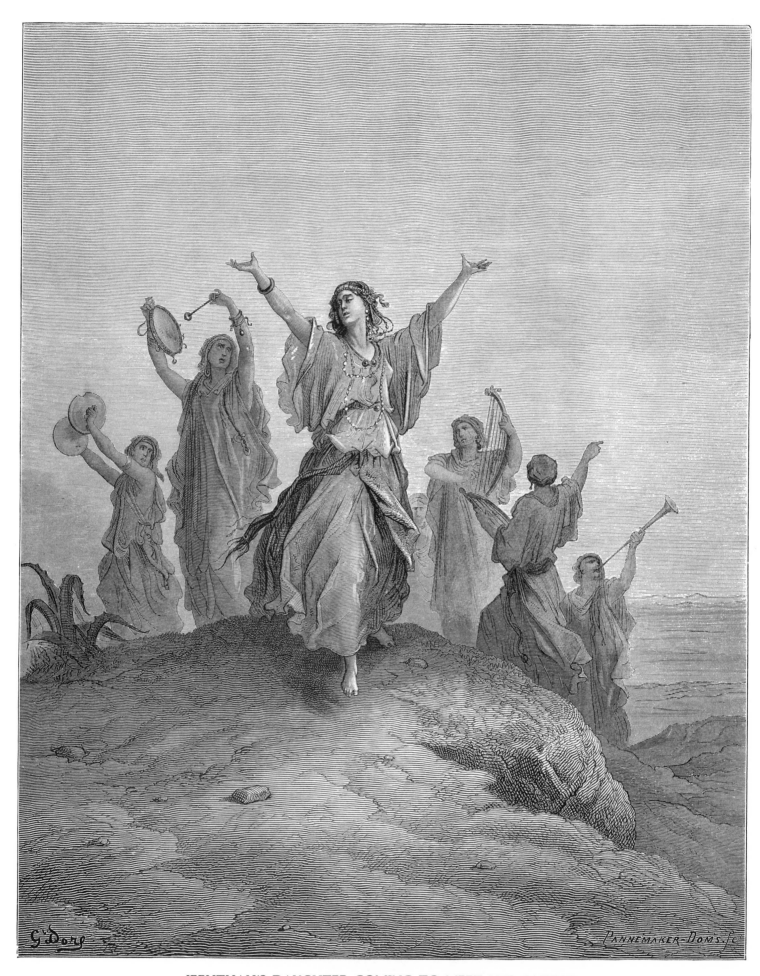

JEPHTHAH'S DAUGHTER COMING TO MEET HER FATHER

And Jephthah vowed . . . whatsoever cometh forth of the doors of my house to
meet me, when I return in peace . . . shall surely be the Lord's, and I will offer it
up for a burnt offering . . . And . . . behold, his daughter came out . . . and she was
his only child . . . (Judges 11: 30, 31, 34)

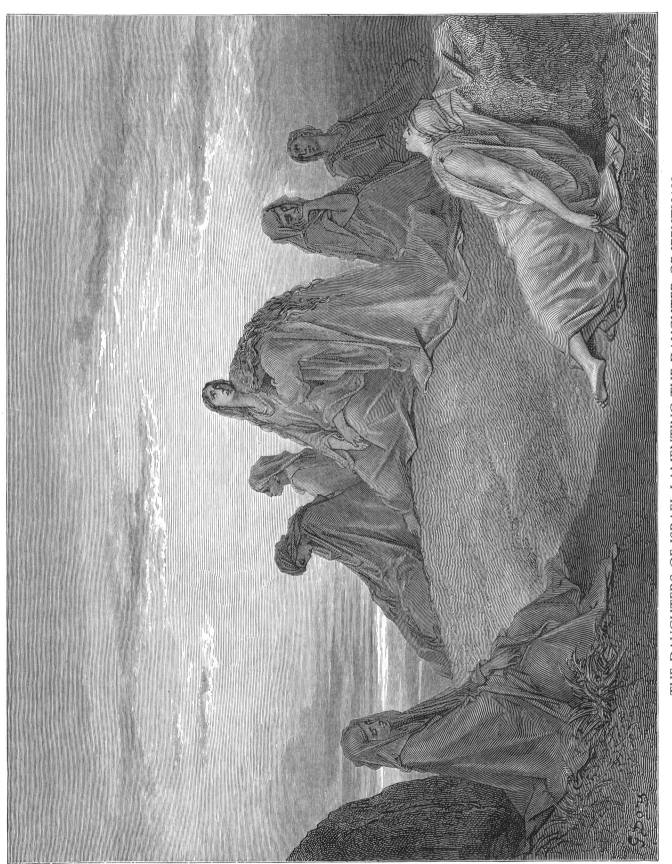

THE DAUGHTERS OF ISRAEL LAMENTING THE DAUGHTER OF JEPHTHAH

Let this thing be done for me: let me alone two months, that I may go up and down
upon the mountains, and bewail my virginity . . . And . . . she returned unto her fa-
ther, who did with her according to his vow . . . And . . . the daughters of Israel went
yearly to lament the daughter of Jephthah . . . four days in a year . . .
(Judges 11: 37, 39, 40)

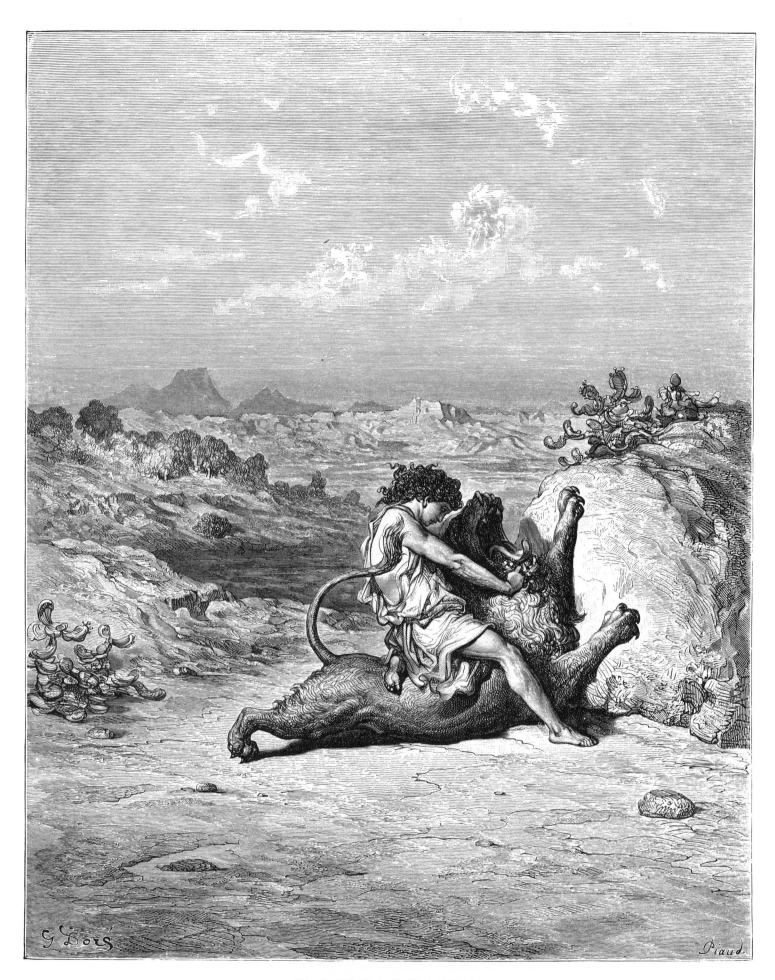

SAMSON SLAYING A LION

And, behold, a young lion roared against him. And the Spirit of the Lord came
mightily upon him, and he rent him as he would have rent a kid, and he had nothing
in his hand: but he told not his father or his mother what he had done . . .
(Judges 14: 5, 6)

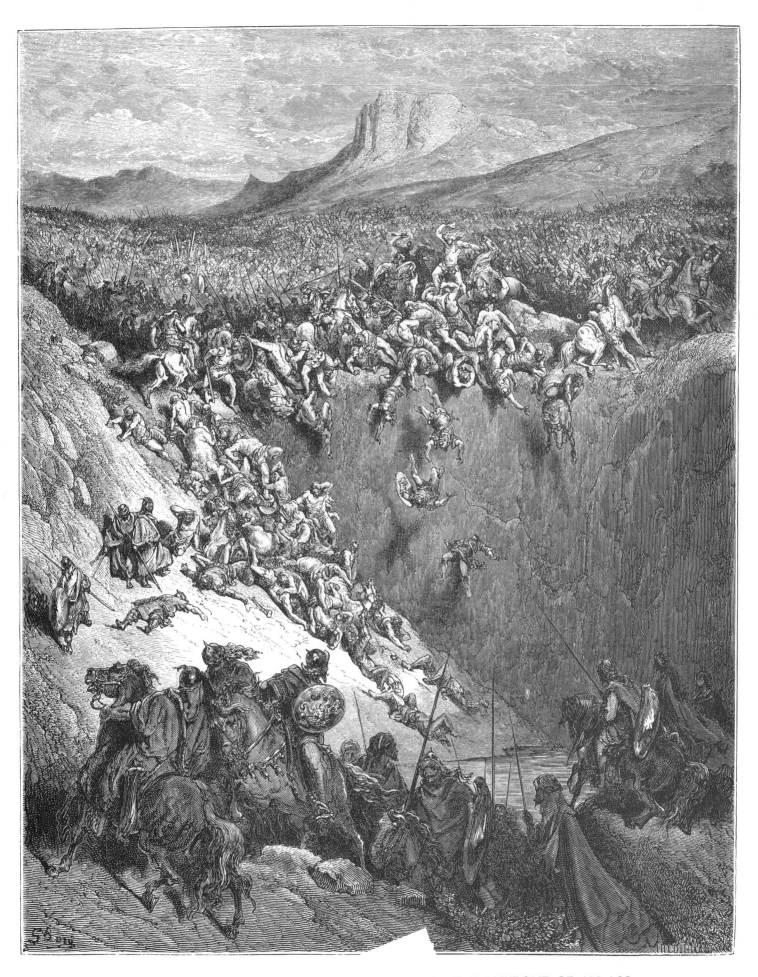

SAMSON DESTROYING THE PHILISTINES WITH THE JAWBONE OF AN ASS

And he found a new jawbone of an ass, and put forth his hand, and took it, and
slew a thousand men therewith . . . (Judges 15: 15)

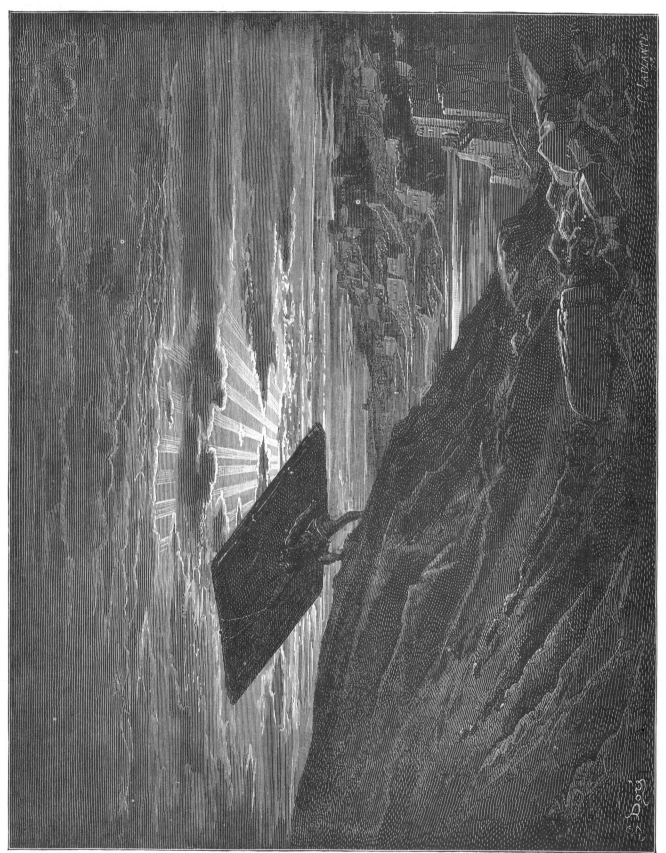

SAMSON CARRYING AWAY THE GATES OF GAZA

And Samson . . . arose at midnight, and took the doors of the gate of the city, and the
two posts, and went away with them . . . and put them upon his shoulders . . .
(Judges 16: 3)

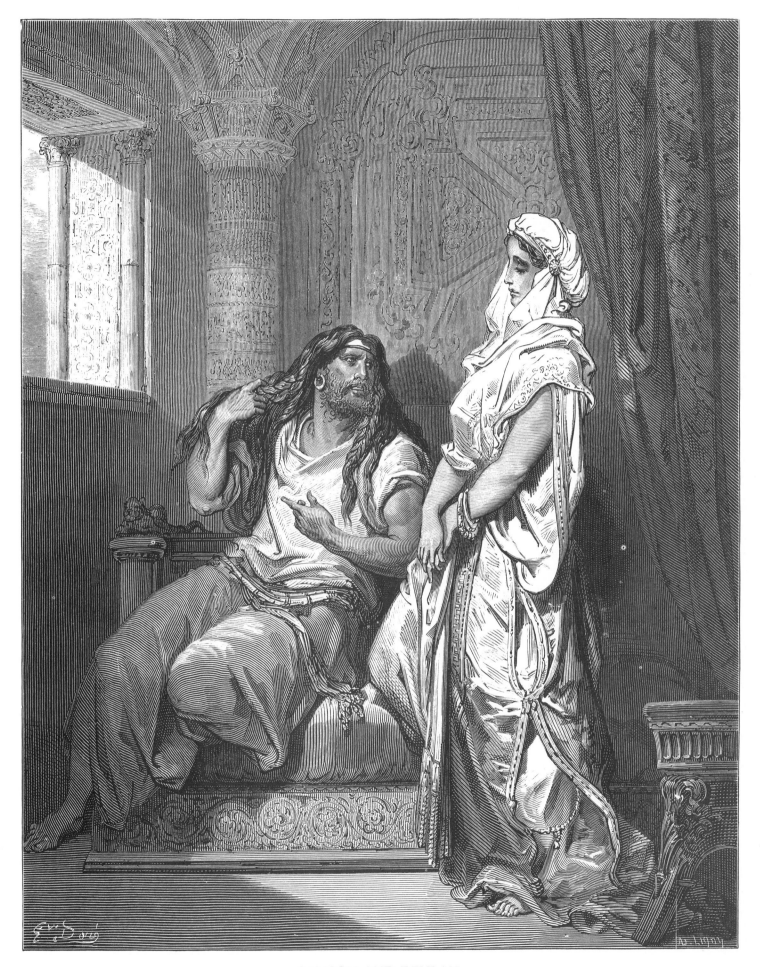

SAMSON AND DELILAH

And it came to pass, when she pressed him daily with her words...he told her
...There hath not come a rasor upon mine head; for I have been a Nazarite unto
God from my mother's womb: if I be shaven, then my strength will go from me...
(Judges 16: 16, 17)

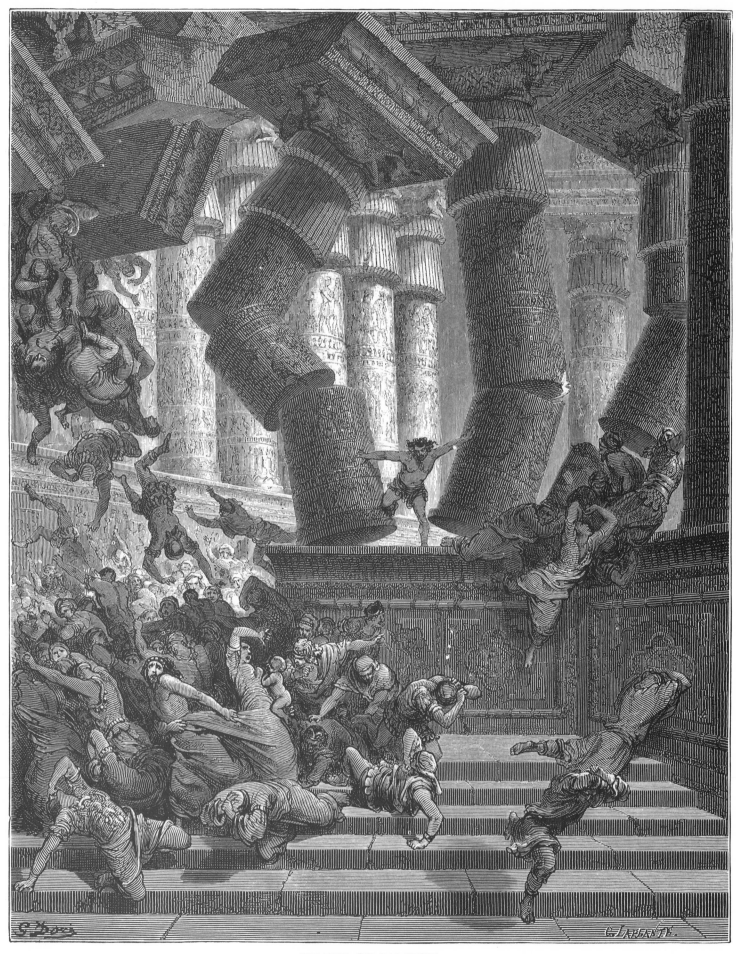

DEATH OF SAMSON

So the dead which he slew at his death were more than they which he slew in his
life . . . (Judges 16: 30)

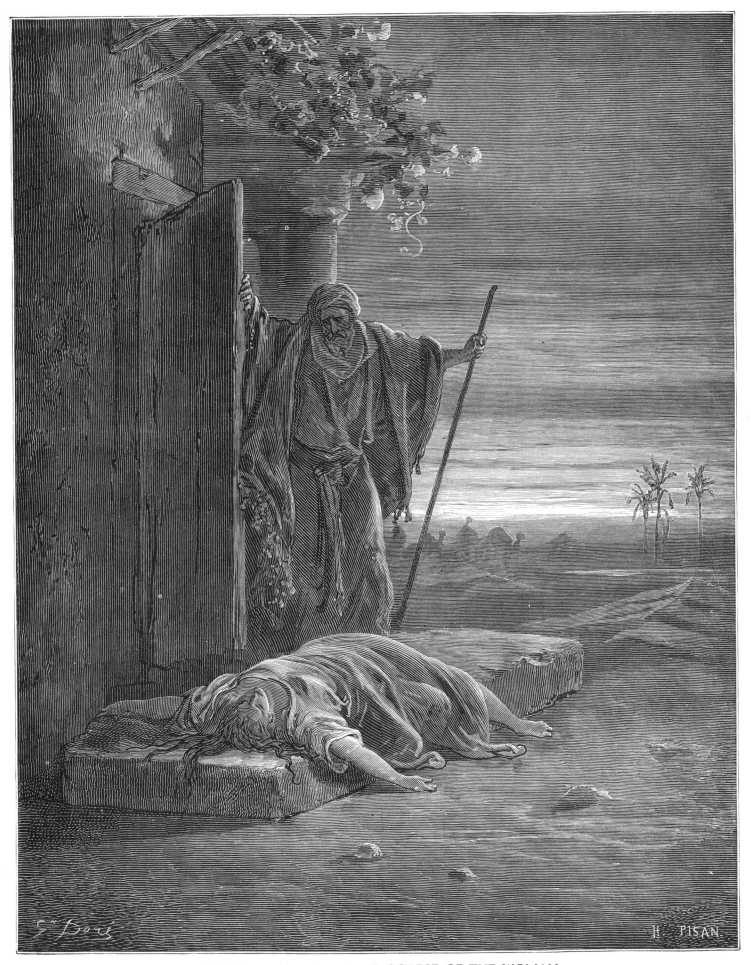

THE LEVITE FINDING THE CORPSE OF THE WOMAN

Then came the woman in the dawning of the day, and fell down at the door of the
man's house where her lord was . . . and her hands were upon the threshold . . .
(Judges 19: 26, 27)

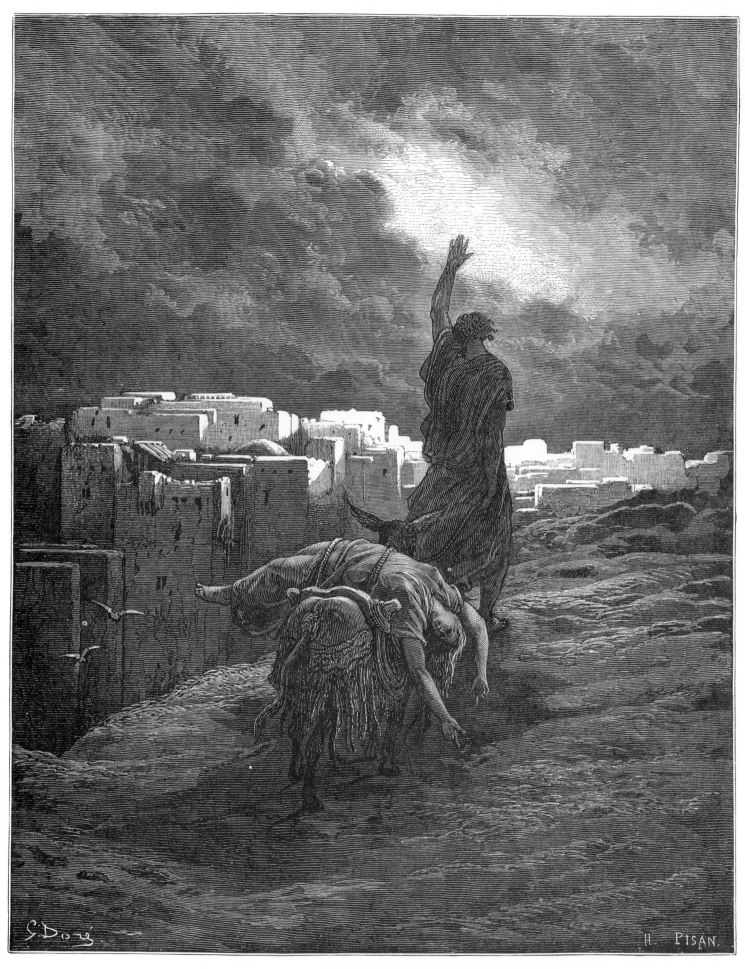

THE LEVITE BEARING AWAY THE BODY OF THE WOMAN

Then the man took her up upon an ass, and the man rose up, and gat him unto his
place . . . (Judges 19: 28)

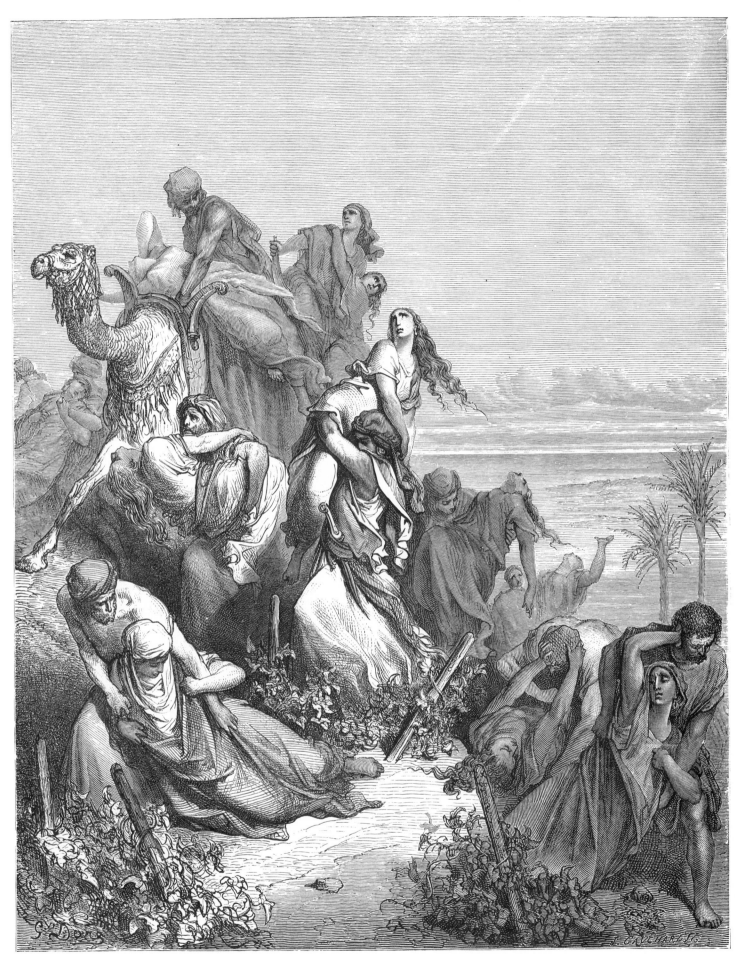

THE CHILDREN OF BENJAMIN
CARRYING OFF THE VIRGINS OF JABESH-GILEAD

And they found among the inhabitants of Jabesh-gilead four hundred young virgins,
that had known no man . . . and they brought them unto the camp to Shiloh . . .
(Judges 21: 12)

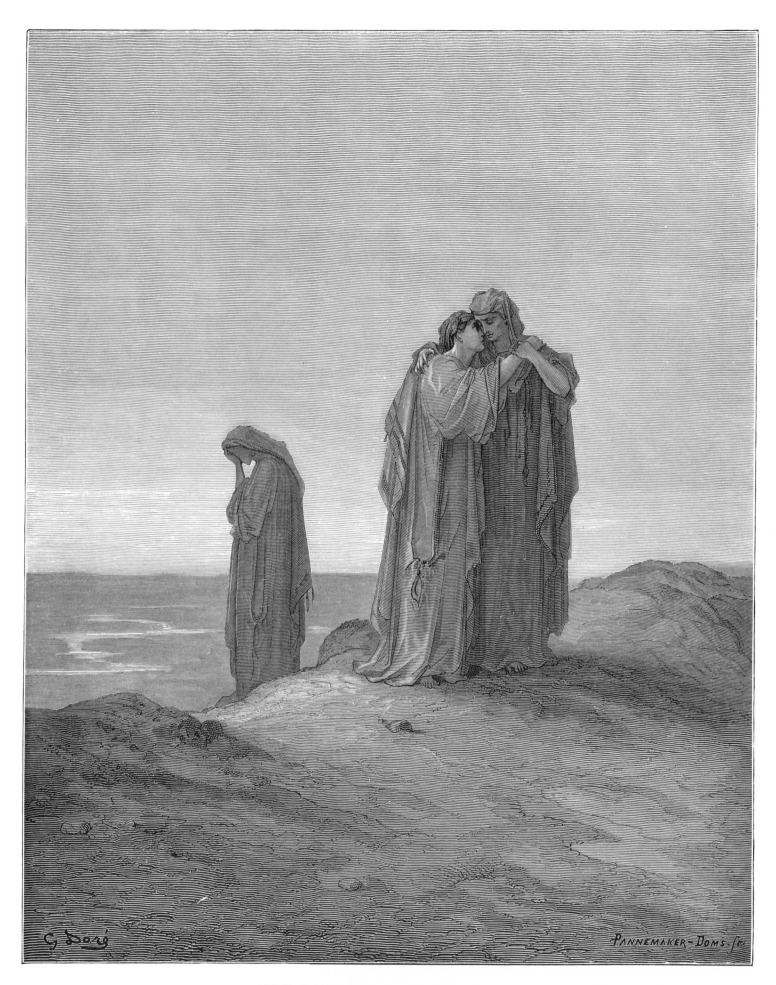

NAOMI AND HER DAUGHTERS-IN-LAW

And Ruth said, Intreat me not to leave thee, or to return from following after thee: for whither thou goest, I will go; and where thou lodgest, I will lodge: thy people shall be my people, and thy God my God . . . (Ruth 1: 16)

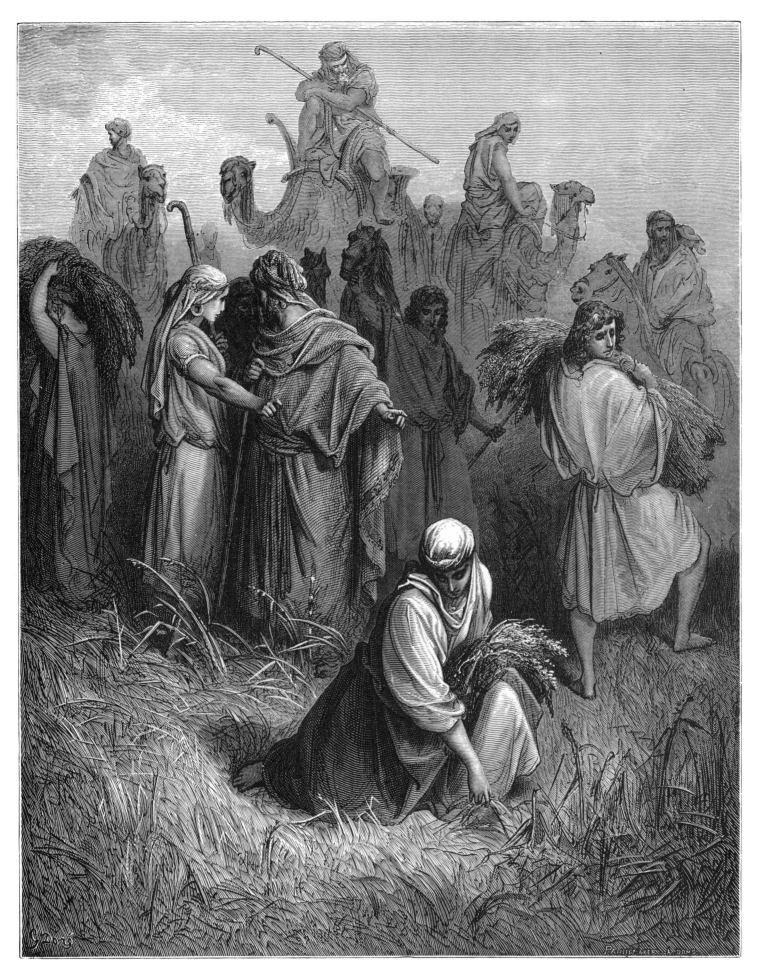

BOAZ AND RUTH

Boaz commanded his young men, saying, Let her glean even among the sheaves,
and reproach her not: And let fall also some of the handfuls of purpose for her, and
leave them, that she may glean them...(Ruth 2: 15, 16)

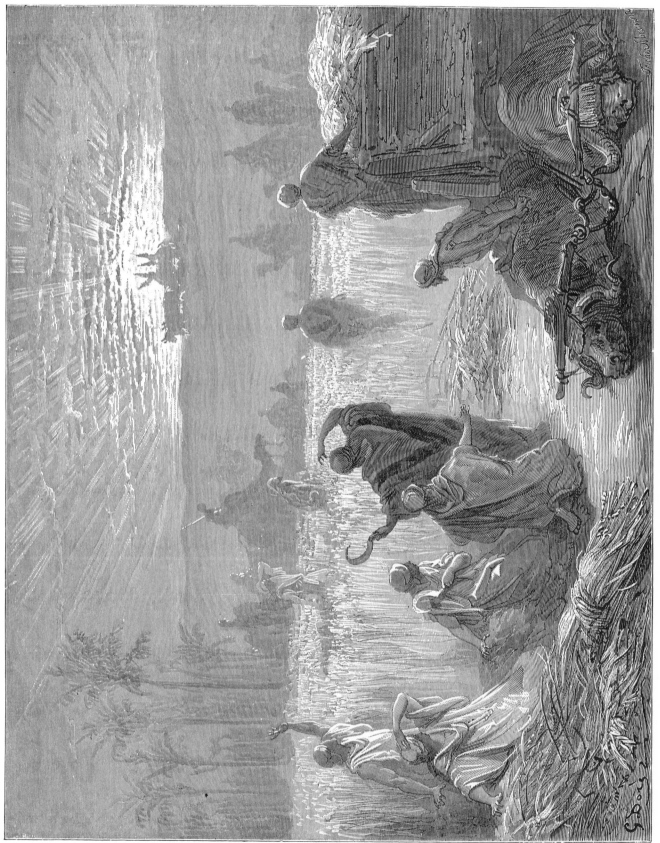

RETURN OF THE ARK TO BETH-SHEMESH

And they of Beth-shemesh were reaping their wheat harvest in the valley: and
they lifted up their eyes, and saw the ark, and rejoiced to see it . . . (I Samuel 6: 13)

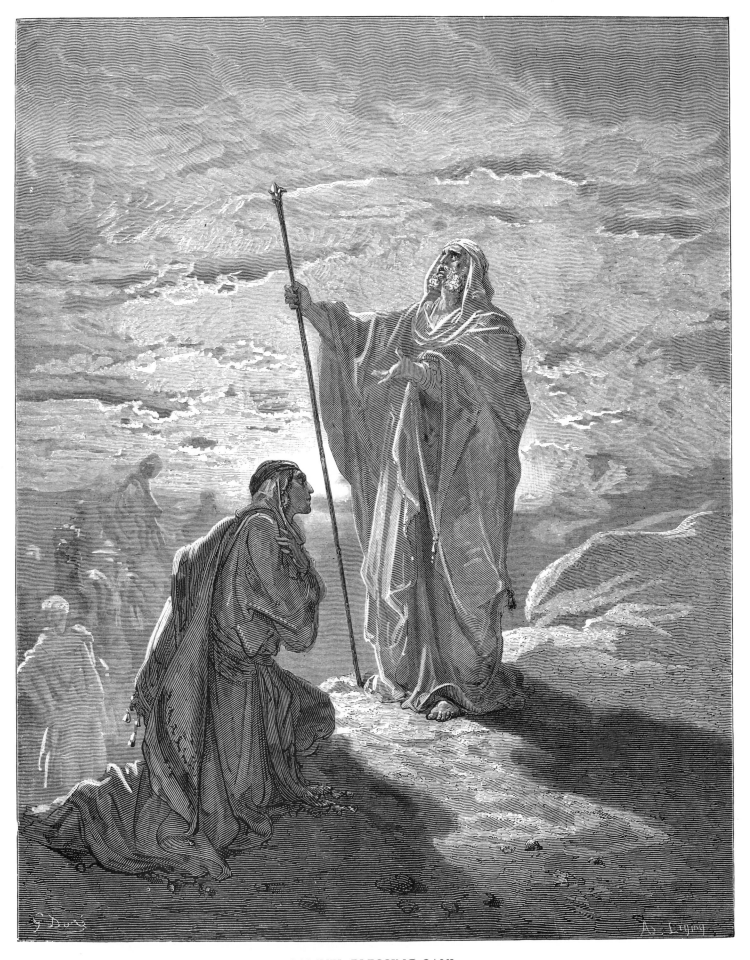

SAMUEL BLESSING SAUL

And when Samuel saw Saul, the Lord said unto him, Behold the man whom I spake
to thee of! this same shall reign over my people . . . (I Samuel 9: 17)

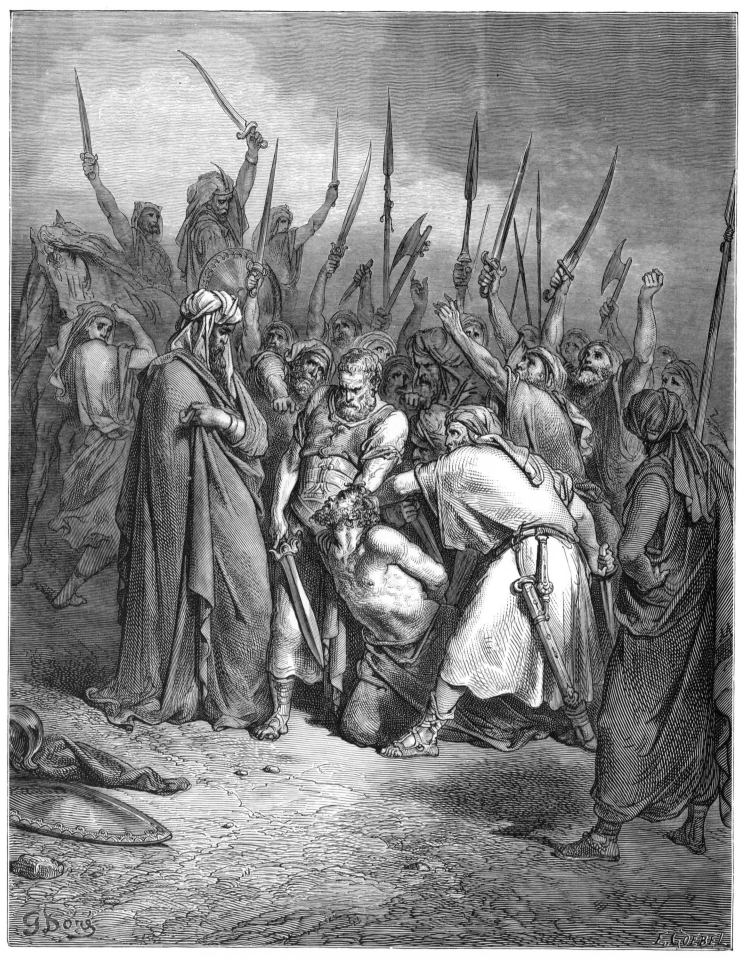

DEATH OF AGAG

And Samuel said, As thy sword hath made women childless, so shall thy mother
be childless among women. And Samuel hewed Agag in pieces before the Lord in
Gilgal . . . (I Samuel 15: 33)

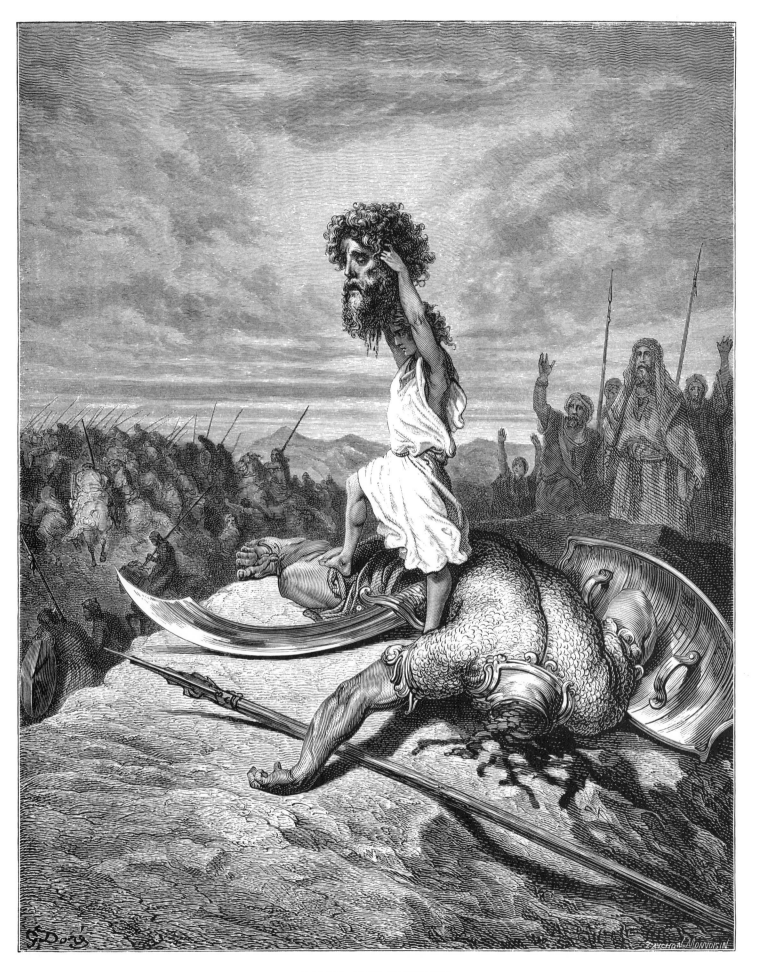

DAVID AND GOLIATH

And David put his hand in his bag, and took thence a stone, and slang it, and smote
the Philistine in his forehead . . . David ran, and stood upon the Philistine, and took
his sword . . . and slew him . . . (I Samuel 17: 49, 51)

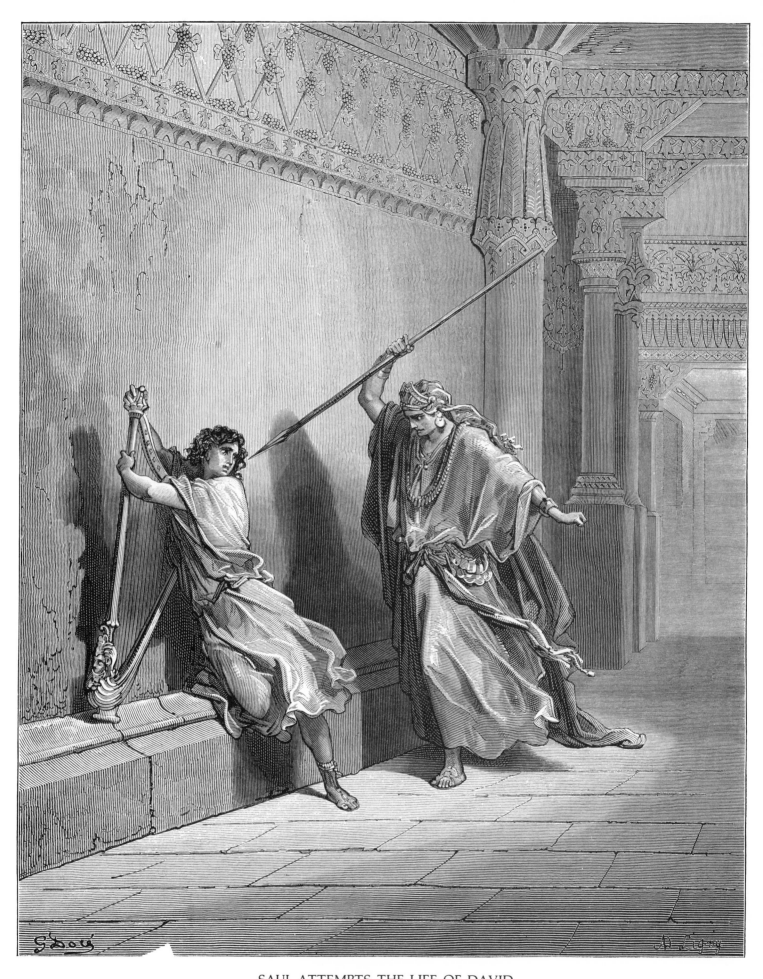

SAUL ATTEMPTS THE LIFE OF DAVID
And Saul cast the javelin; for he said, I will smite David even to the wall with
it . . . (I Samuel 18: 11)

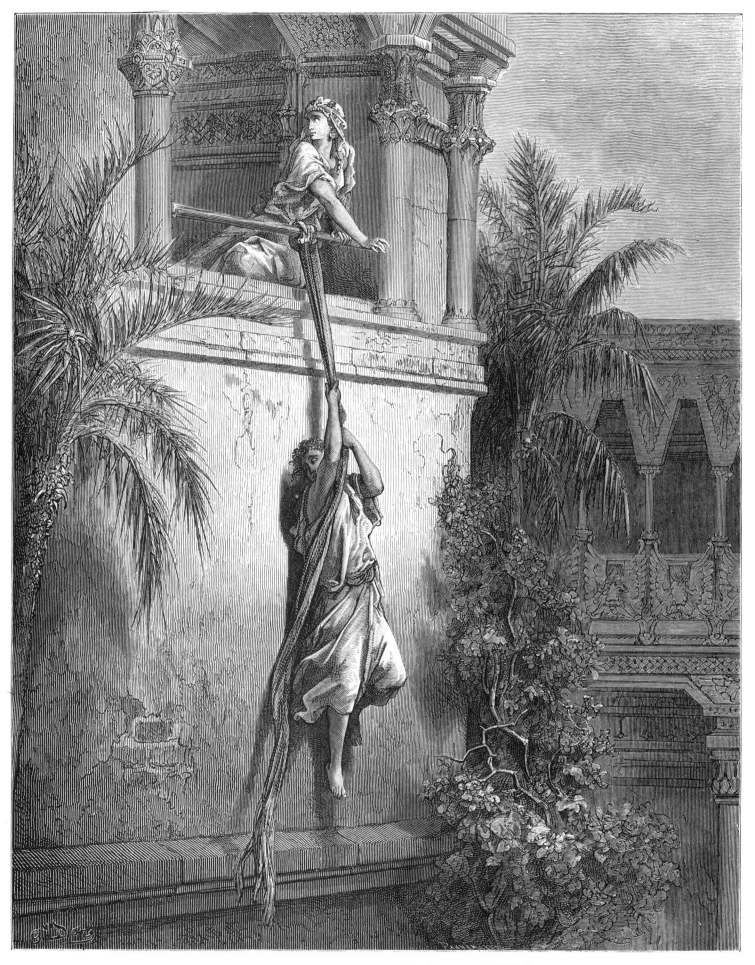

THE ESCAPE OF DAVID THROUGH THE WINDOW

So Michal let David down through a window: and he went, and fled, and escaped.
. . . (I Samuel 19: 12)

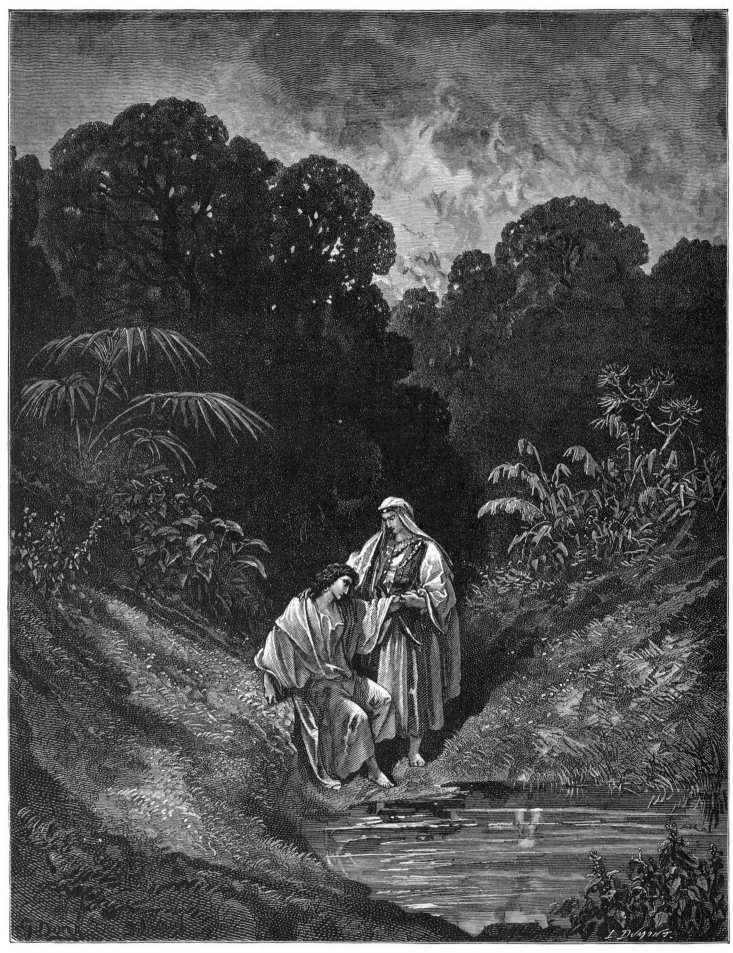

DAVID AND JONATHAN

And Jonathan said to David, Go in peace . . . The Lord be between me and thee,
and between my seed and thy seed for ever . . . (I Samuel 20: 42)

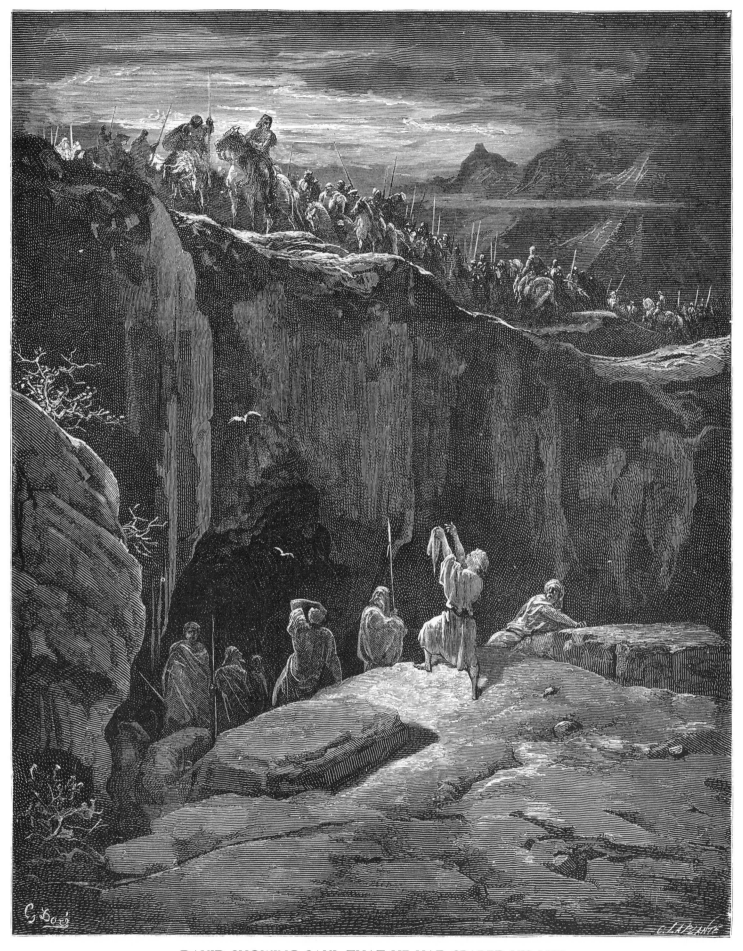

DAVID SHOWING SAUL THAT HE HAD SPARED HIS LIFE

For in that I cut off the skirt of thy robe, and killed thee not . . . I have not sinned
against thee; yet thou huntest my soul to take it . . . (I Samuel 24: 11)

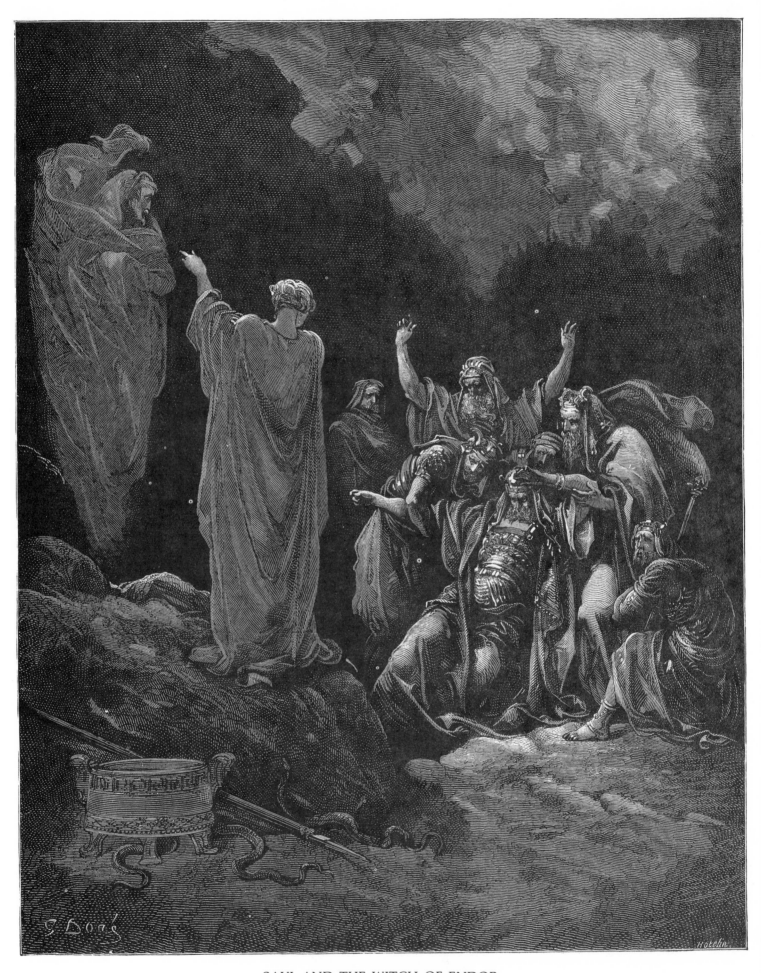

SAUL AND THE WITCH OF ENDOR

Then said the woman, Whom shall I bring up unto thee? And he said, Bring me up
Samuel . . . (I Samuel 28: 11)

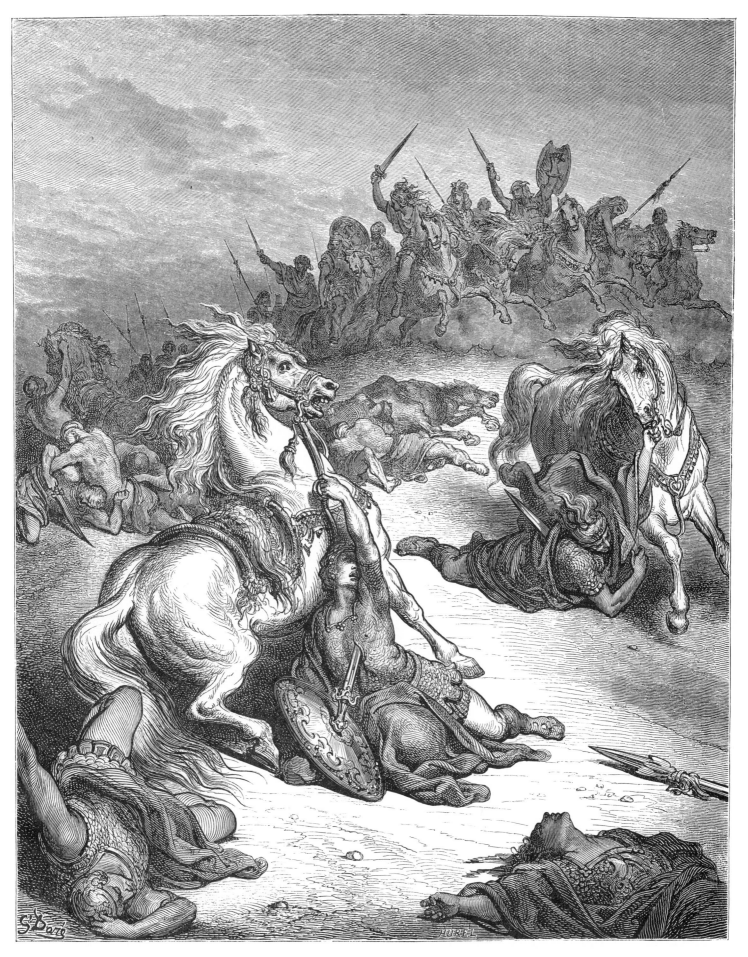

DEATH OF SAUL

Then said Saul unto his armourbearer, Draw thy sword, and thrust me through
therewith . . . But his armourbearer would not . . . Therefore Saul took a sword, and
fell upon it. And when his armourbearer saw that Saul was dead, he fell likewise
upon his sword, and died with him . . . (I Samuel 31: 4, 5)

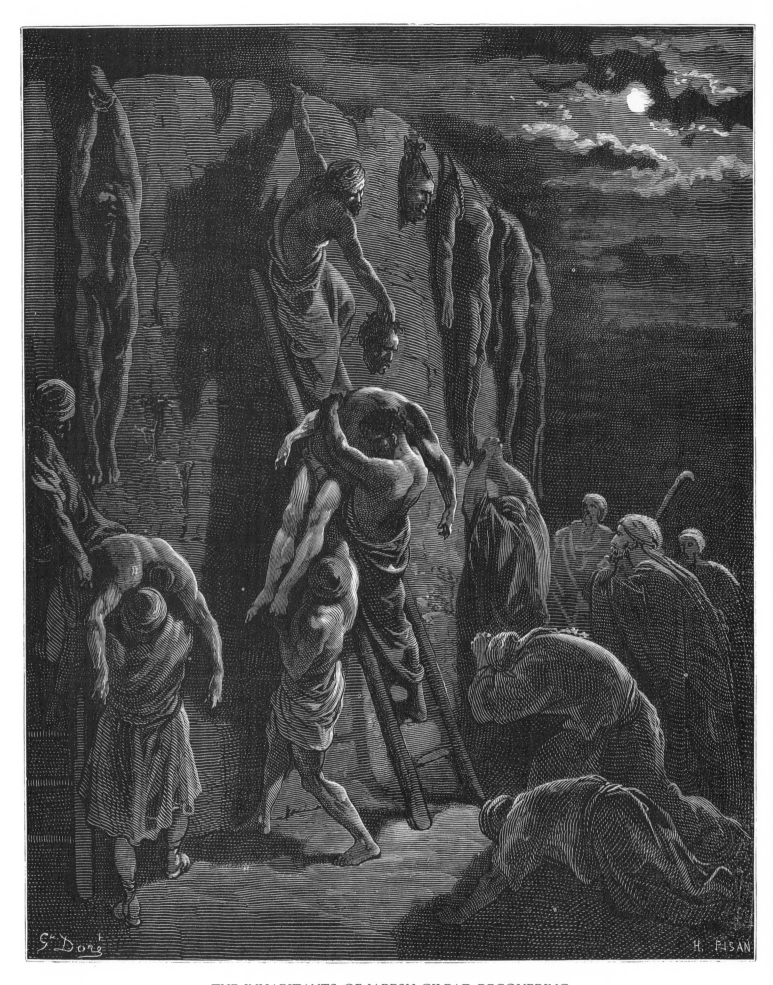

THE INHABITANTS OF JABESH-GILEAD RECOVERING
THE BODIES OF SAUL AND HIS SONS

And when all Jabesh-gilead heard all that the Philistines had done to Saul, they
arose . . . and took away the body of Saul, and the bodies of his sons, and brought
them to Jabesh, and buried their bones under the oak in Jabesh, and fasted seven
days . . . (I Chronicles 10: 11, 12)

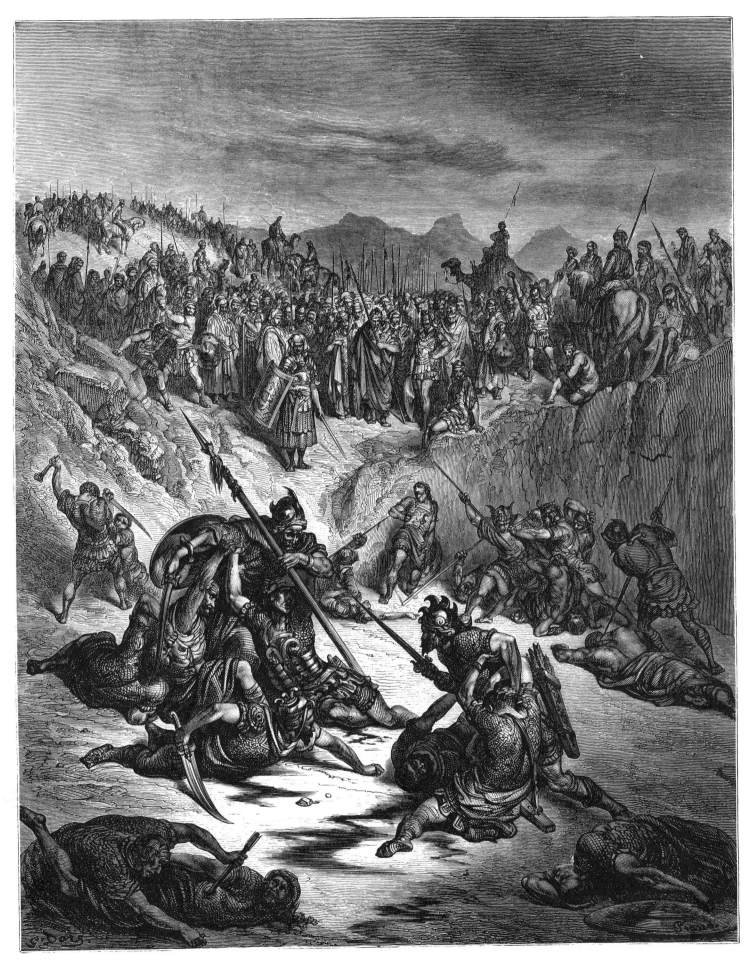

COMBAT BETWEEN THE CHAMPIONS OF ISH-BOSHETH AND DAVID

Then there arose and went over...twelve...which pertained to Ish-bosheth the
son of Saul, and twelve of the servants of David. And they caught every one his fellow
by the head, and thrust his sword in his fellow's side; so they fell down together . . .
And there was a very sore battle that day . . . (II Samuel 2: 15, 16, 17)

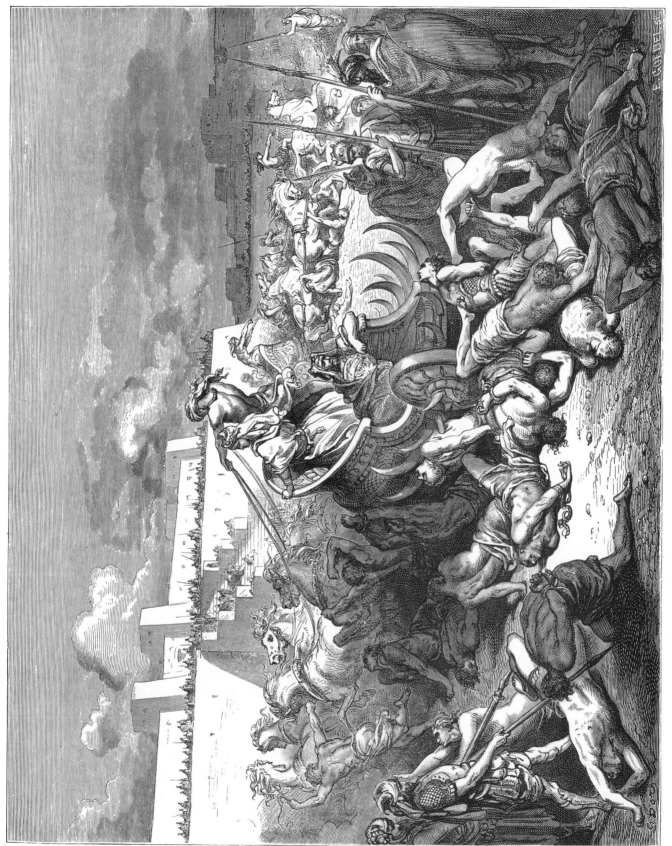

DAVID PUNISHING THE AMMONITES

And Joab sent messengers to David, and said, I have fought against Rabbah, and
have taken the city of waters. Now therefore gather the rest of the people together,
and encamp against the city, and take it: lest I take the city, and it be called after
my name (II Samuel 12: 27, 28)

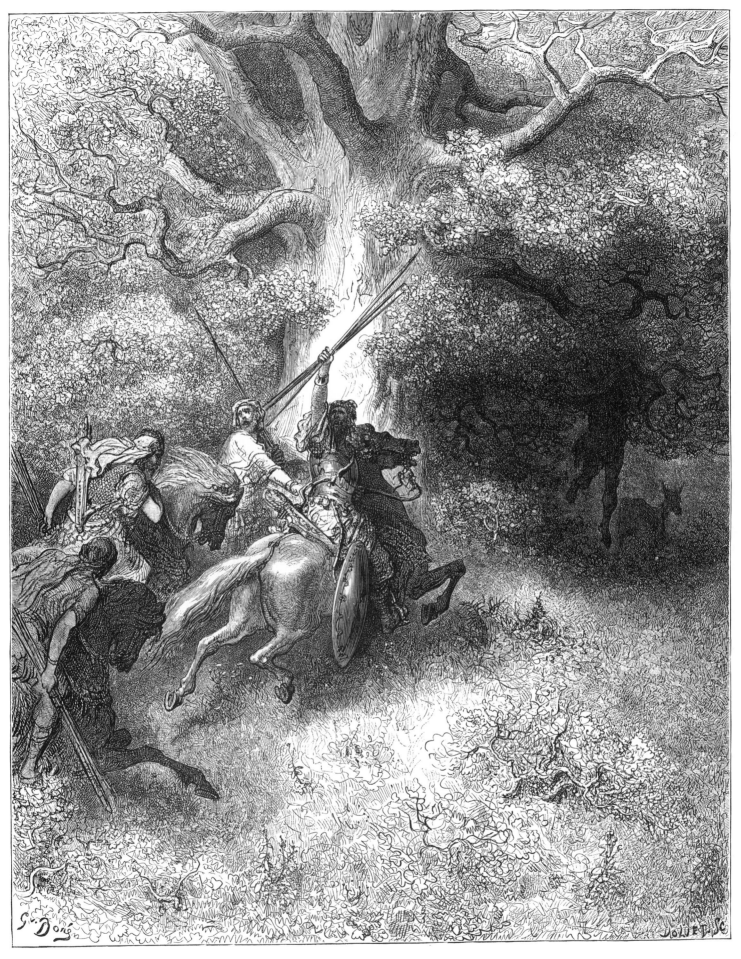

DEATH OF ABSALOM

And Absalom rode upon a mule, and the mule went under the thick boughs of a
great oak, and his head caught hold of the oak, and he was taken up between the
heaven and the earth...And he [Joab] took three darts...and thrust them through
the heart of Absalom...(II Samuel 18: 9, 14)

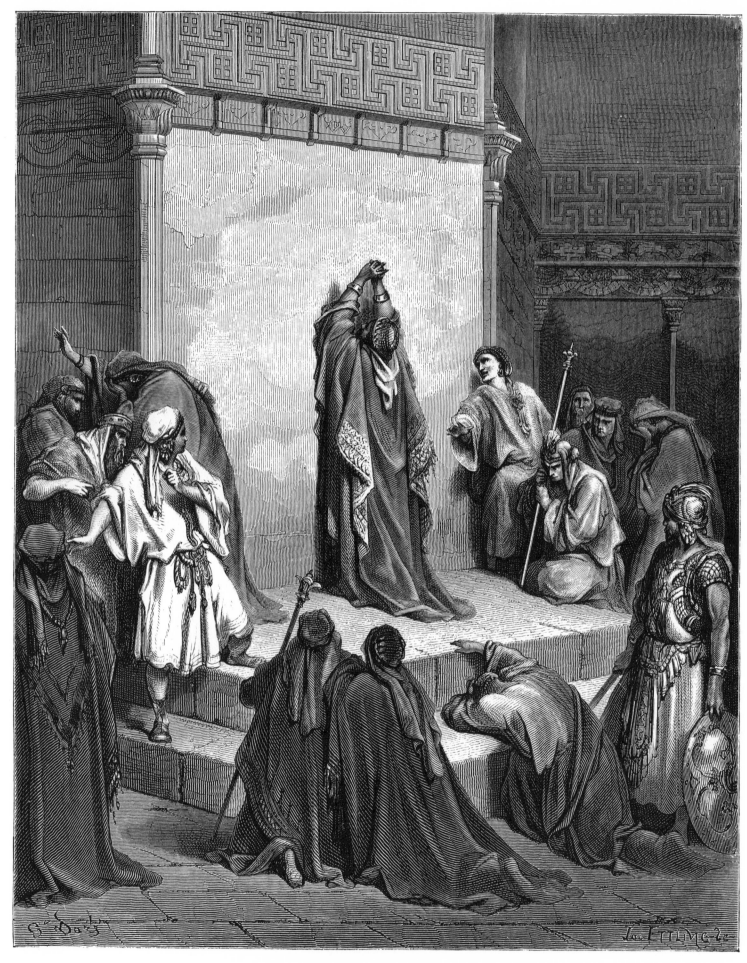

DAVID MOURNING THE DEATH OF ABSALOM

And the king was much moved, and went up to the chamber over the gate, and
wept: and as he went, thus he said, O my son Absalom, my son, my son Absalom!
would God I had died for thee, O Absalom, my son, my son! . . . (II Samuel 18: 33)

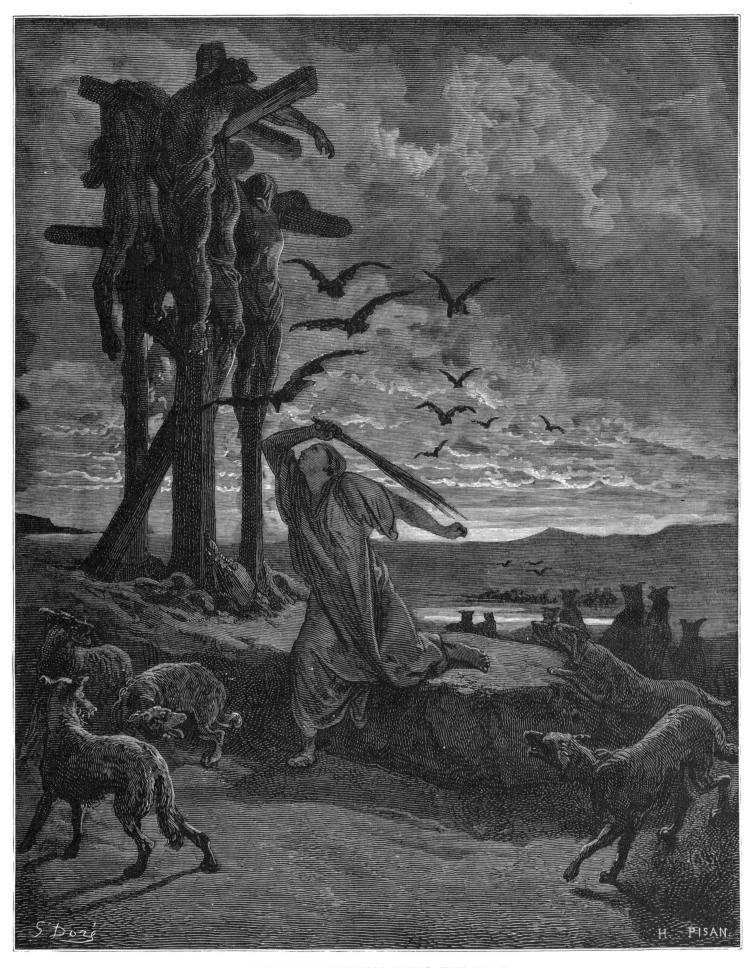

RIZPAH'S KINDNESS UNTO THE DEAD

And Rizpah the daughter of Aiah . . . suffered neither the birds of the air to rest
on them by day, nor the beasts of the field by night . . . (II Samuel 21: 10)

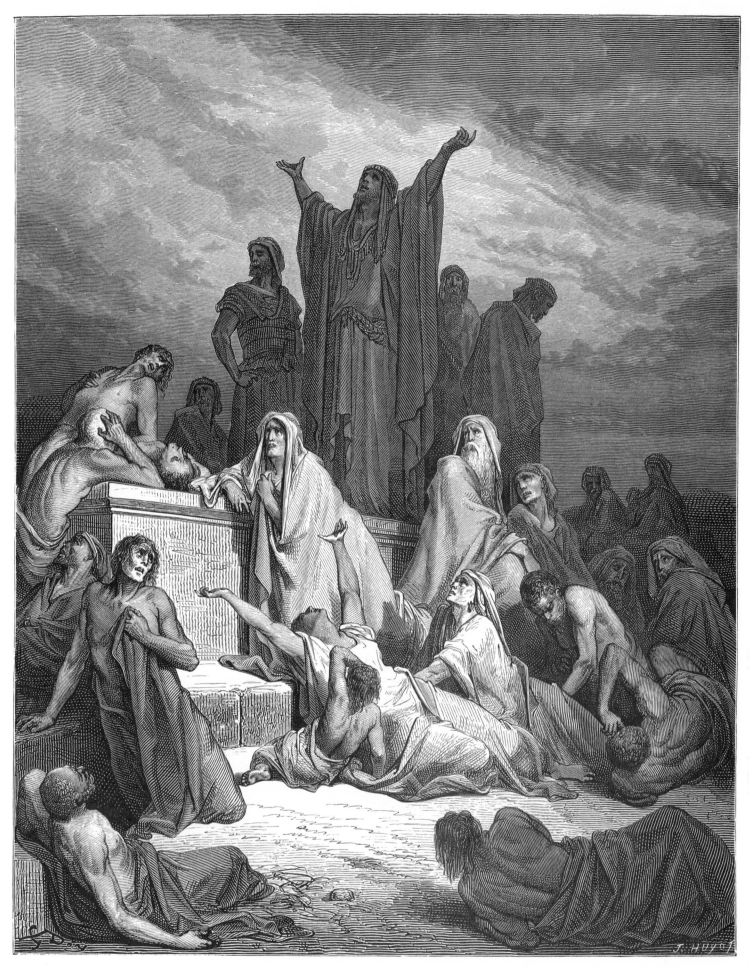

PLAGUE OF JERUSALEM

And God sent an angel unto Jerusalem to destroy it: and as he was destroying,
the Lord beheld, and he repented him of the evil, and said to the angel that destroyed,
It is enough, stay now thine hand . . . (I Chronicles 21: 15)

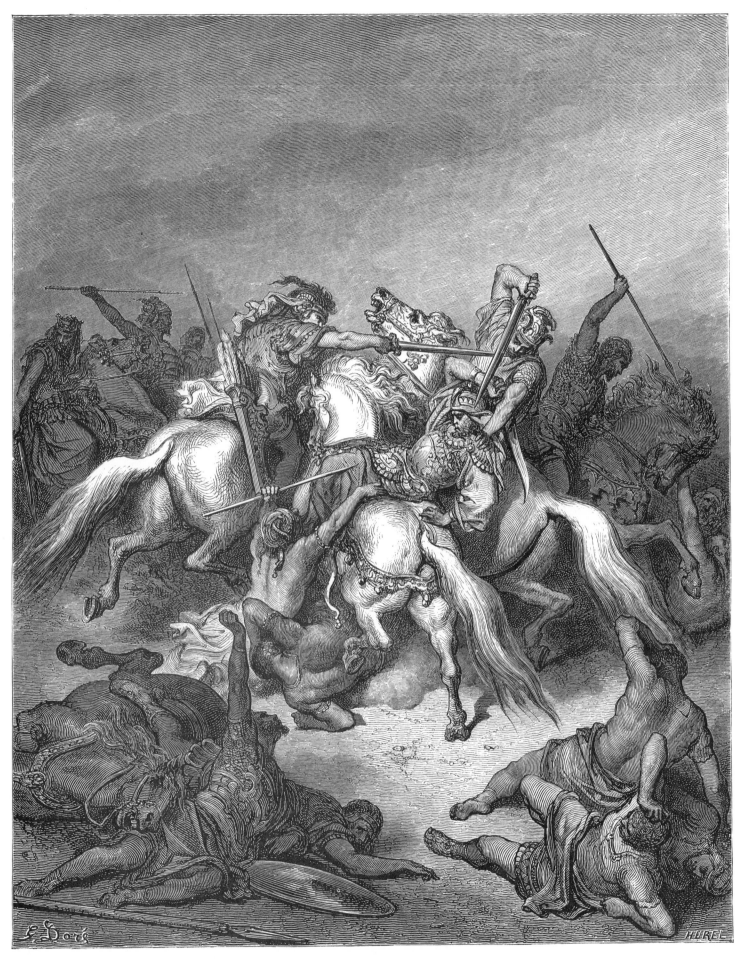

ABISHAI SAVES THE LIFE OF DAVID

Abishai . . . smote the Philistine, and killed him. Then the men of David sware
unto him, saying, Thou shalt go no more out with us to battle, that thou quench not the
light of Israel . . . (II Samuel 21: 17)

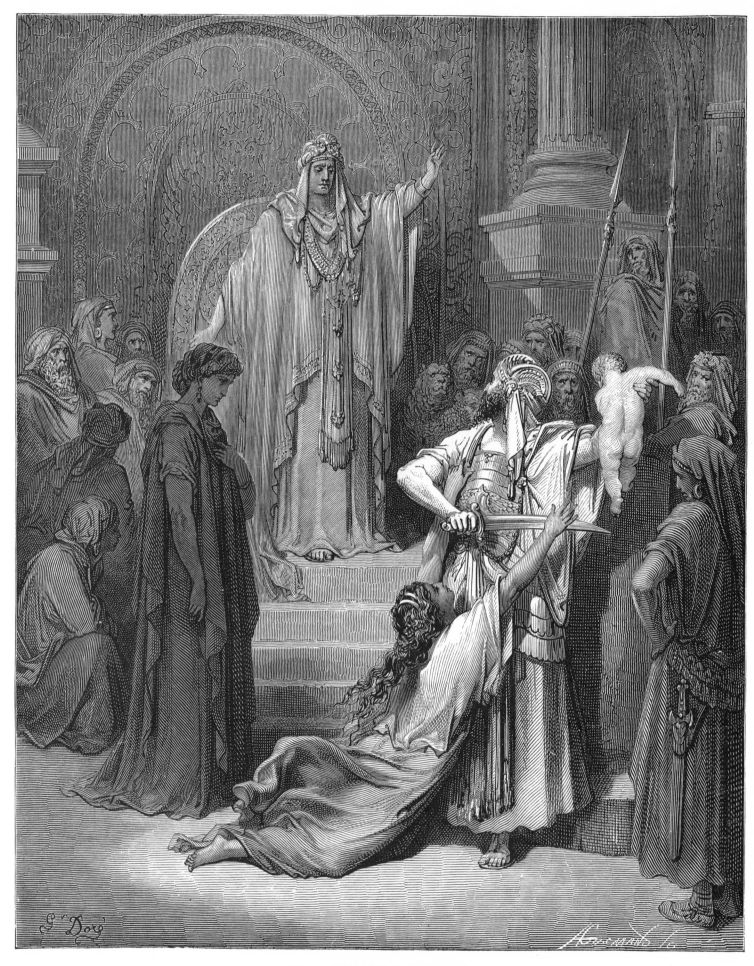

JUDGMENT OF SOLOMON

Then the king answered and said, Give her the living child, and in no wise slay it: she is
the mother thereof . . . (I Kings 3: 27)

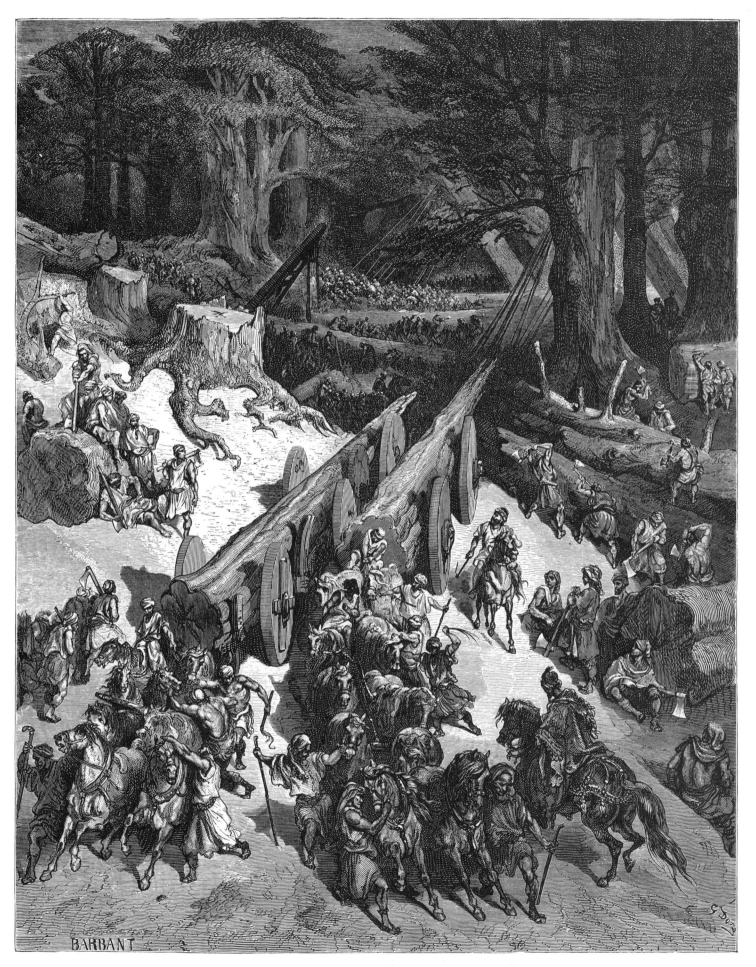

CUTTING DOWN CEDARS FOR THE CONSTRUCTION
OF THE TEMPLE

And, behold, I purpose to build an house unto the name of the Lord my God . . .
Now therefore command thou that they hew me cedar trees out of Lebanon . . .
(I Kings 5: 5, 6)

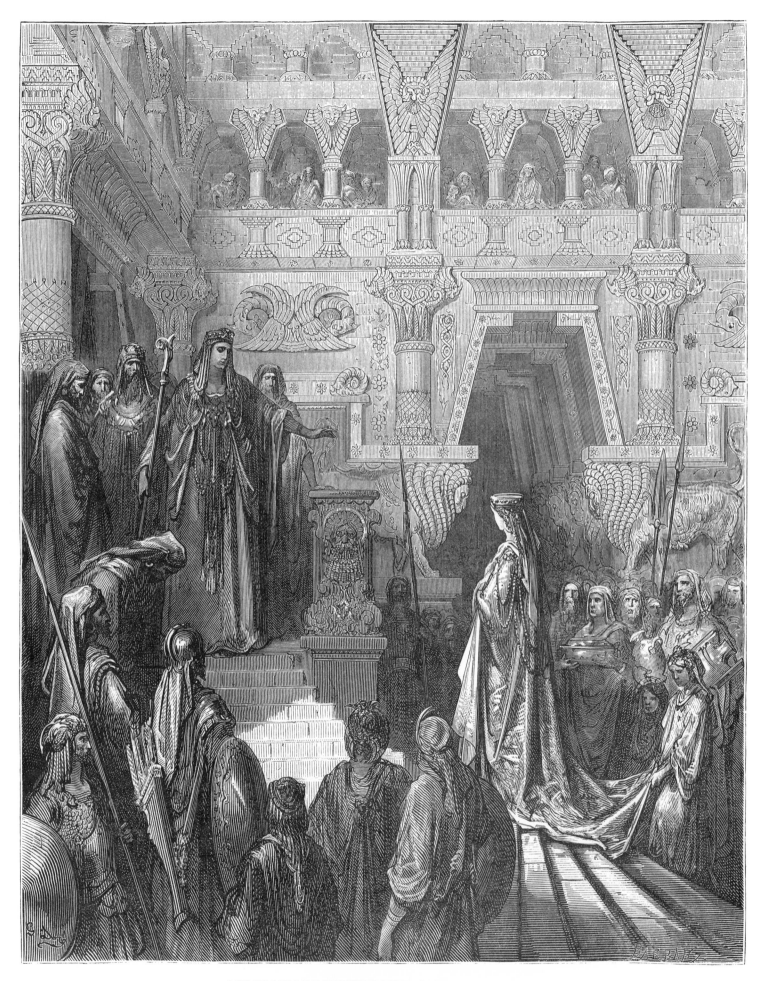

SOLOMON RECEIVING THE QUEEN OF SHEBA

And when the Queen of Sheba heard of the fame of Solomon, she came to . . . Jerusalem, with a very great company, and camels that bare spices, and gold in abundance, and precious stones . . . (II Chronicles 9: 1)

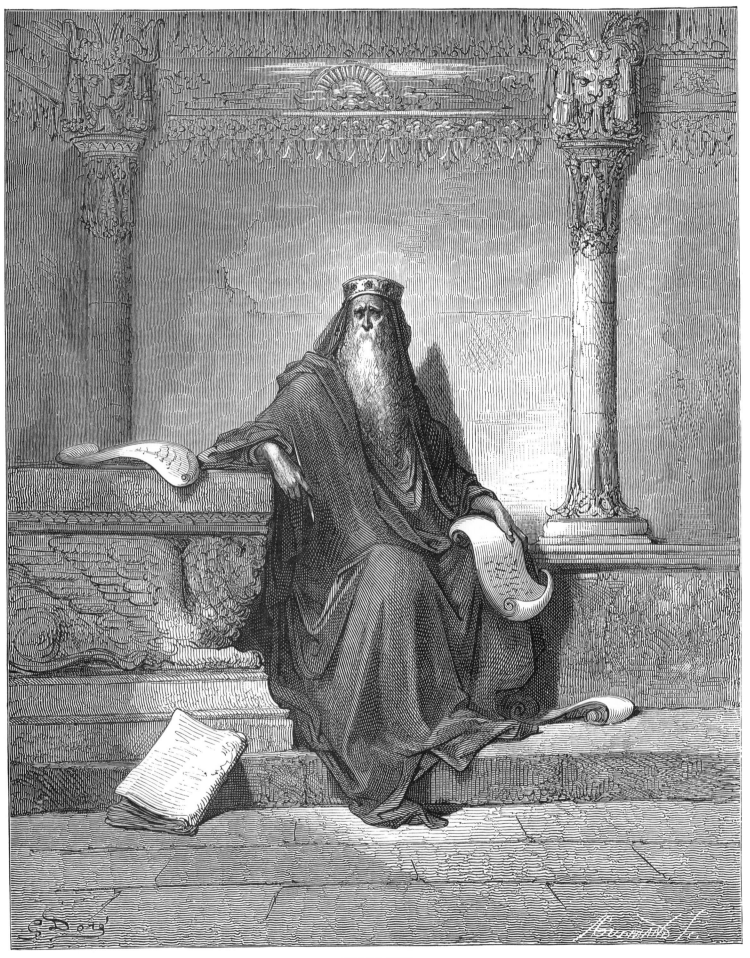

SOLOMON

Give me now wisdom and knowledge, that I may go out and come in before this
people . . . (II Chronicles 1: 10)

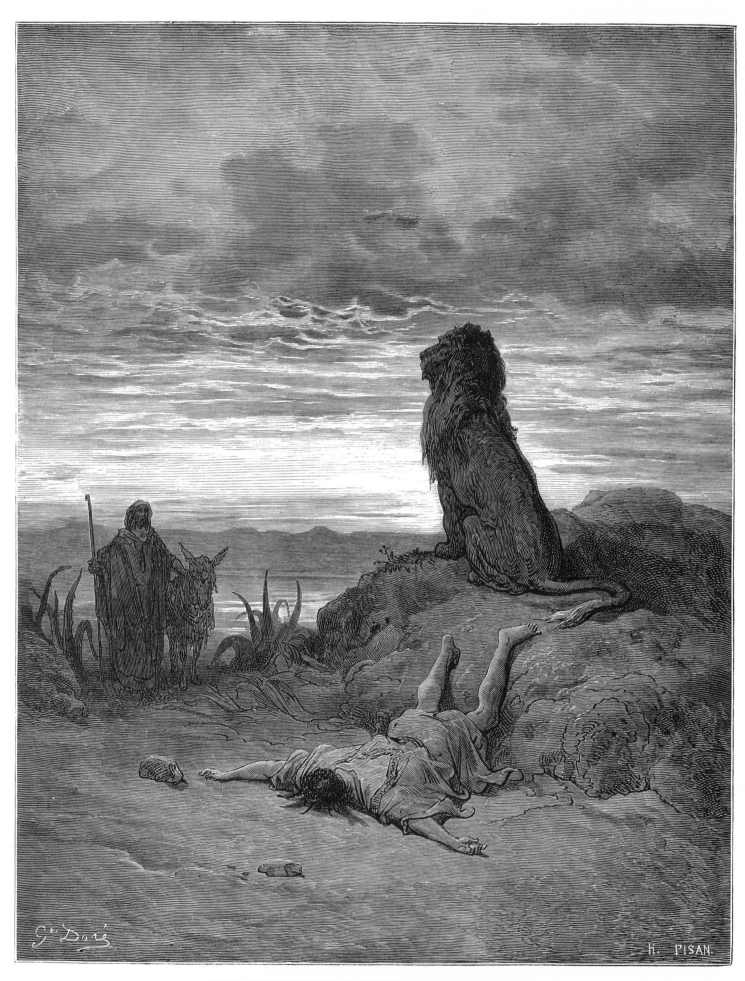

THE DISOBEDIENT PROPHET SLAIN BY A LION
And when he was gone, a lion met him by the way, and slew him: and his carcase
was cast in the way, and . . . the lion also stood by the carcase . . . (I Kings 13: 24)

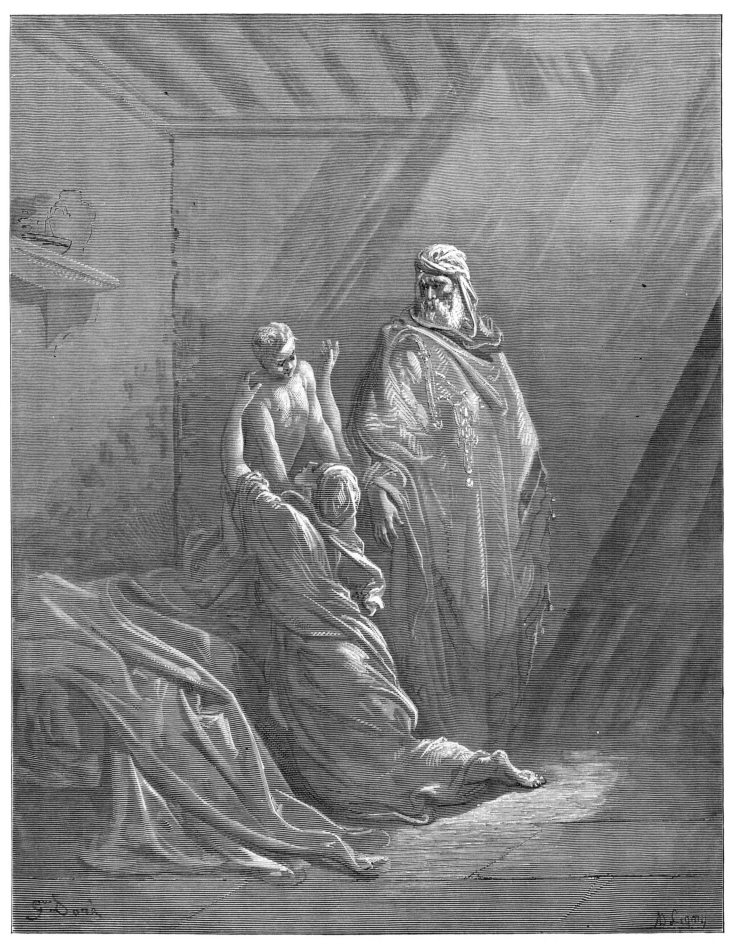

ELIJAH RAISETH THE SON OF THE WIDOW OF ZAREPHATH

And Elijah took the child, and brought him down out of the chamber into the house,
and delivered him unto his mother: and Elijah said, See, thy son liveth . . .
(I Kings 17: 23)

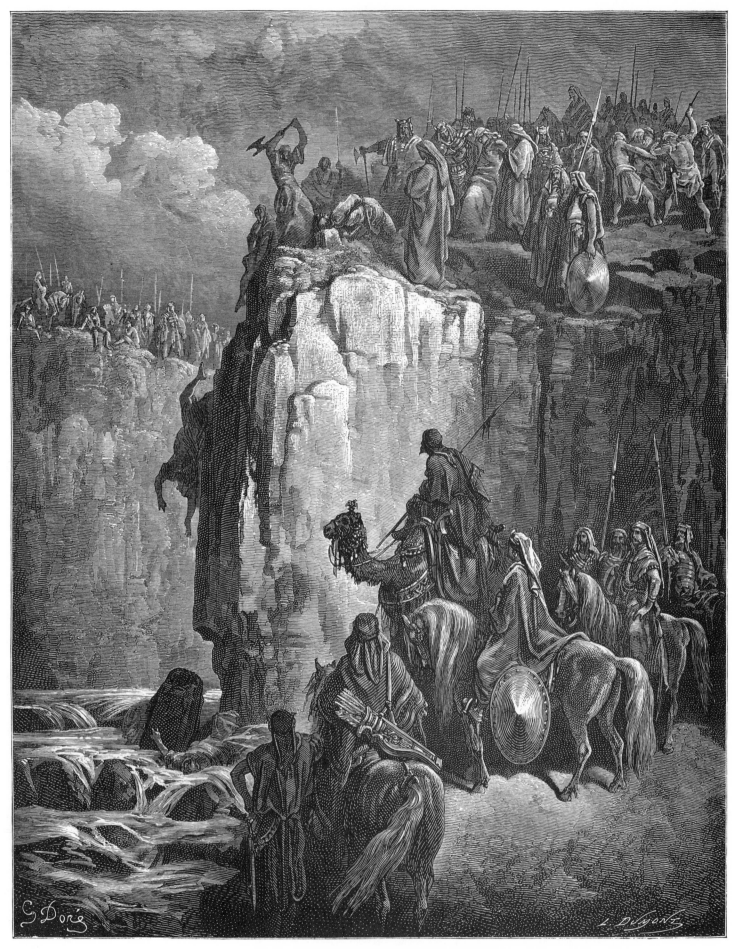

SLAUGHTER OF THE PROPHETS OF BAAL

And Elijah said unto them, Take the prophets of Baal; let not one of them escape.
And they took them: and Elijah brought them down to the brook Kishon, and slew
them . . . (I Kings 18: 40)

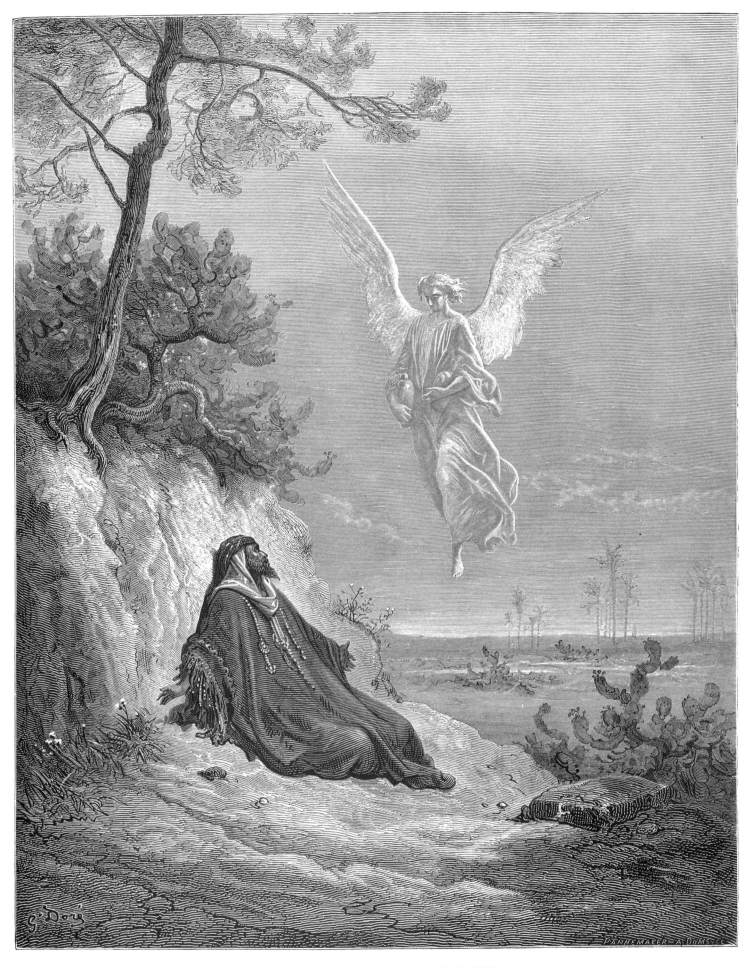

ELIJAH NOURISHED BY AN ANGEL

And as he lay and slept under a juniper tree, behold, then an angel touched him,
and said unto him, Arise and eat . . . (I Kings 19: 5)

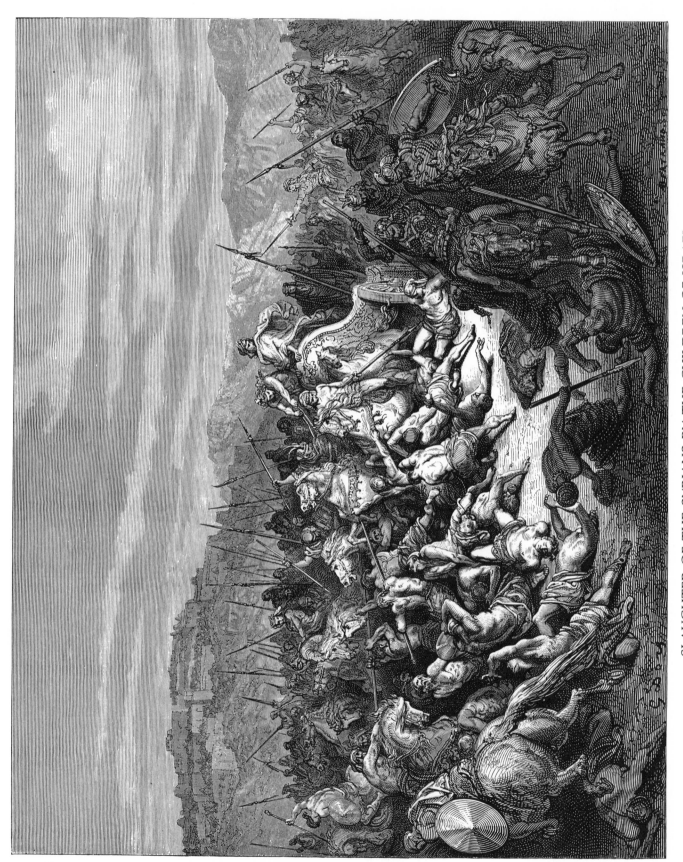

SLAUGHTER OF THE SYRIANS BY THE CHILDREN OF ISRAEL

And so it was, that in the seventh day the battle was joined: and the children of
Israel slew of the Syrians an hundred thousand footmen in one day . . . (I Kings 20: 29)

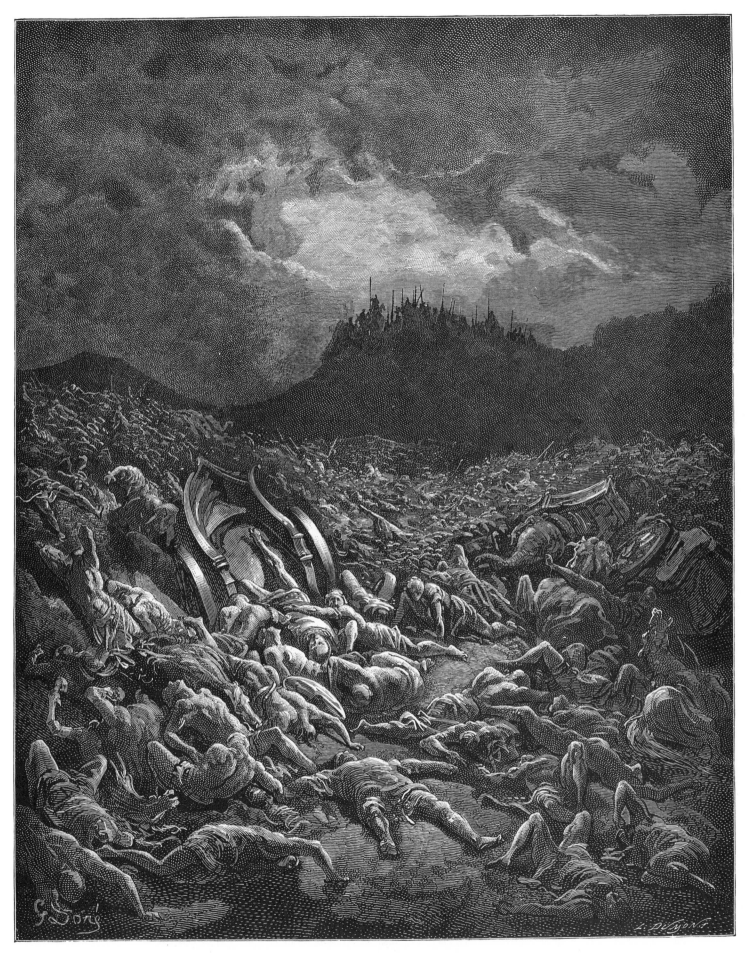

THE DESTRUCTION OF THE ARMIES OF THE
AMMONITES AND MOABITES

And when Judah came toward the watch tower in the wilderness, they looked unto
the multitude, and, behold, they were dead bodies fallen to the earth, and none
escaped . . . (II Chronicles 20: 24)

99

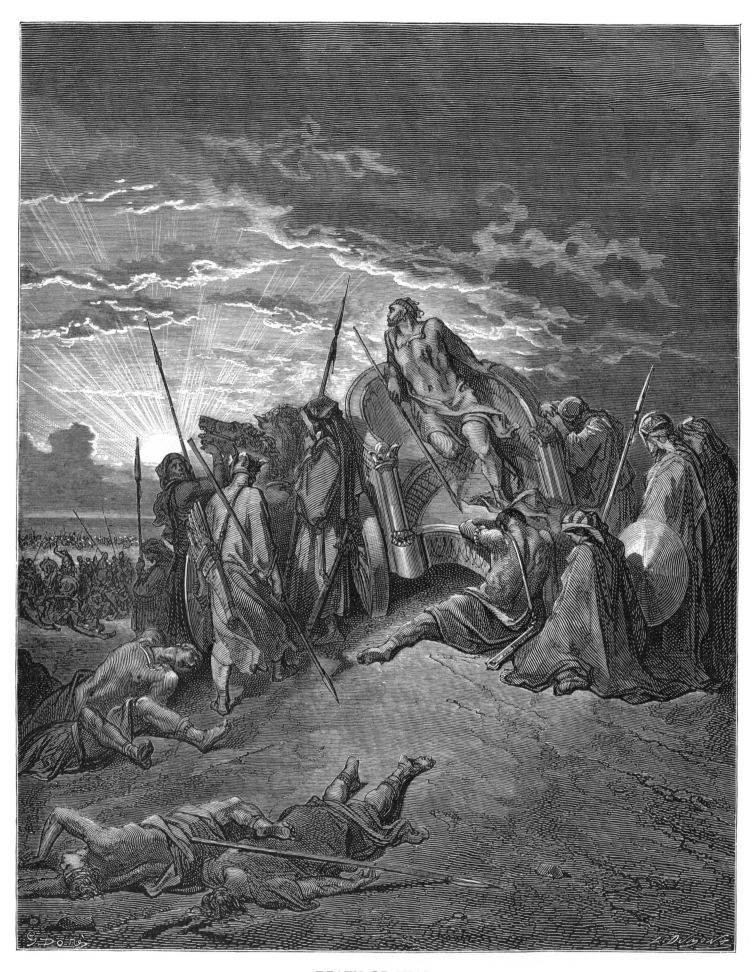

DEATH OF AHAB

And a certain man drew a bow at a venture, and smote the king of Israel between
the joints of the harness: wherefore he said unto the driver of his chariot, Turn thine
hand, and carry me out of the host; for I am wounded . . . (I Kings 22: 34)

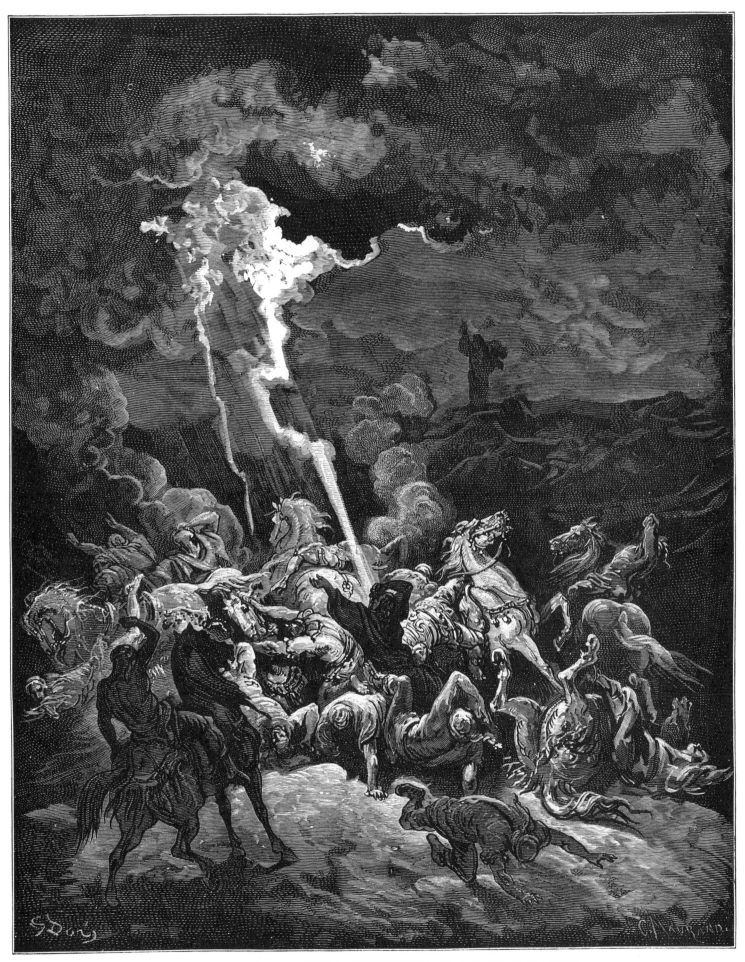

ELIJAH DESTROYS THE MESSENGERS OF AHAZIAH BY FIRE

And Elijah answered and said to the captain of fifty, If I be a man of God, then let
fire come down from heaven, and consume thee and thy fifty. And there came down
fire from heaven . . . (II Kings 1: 10)

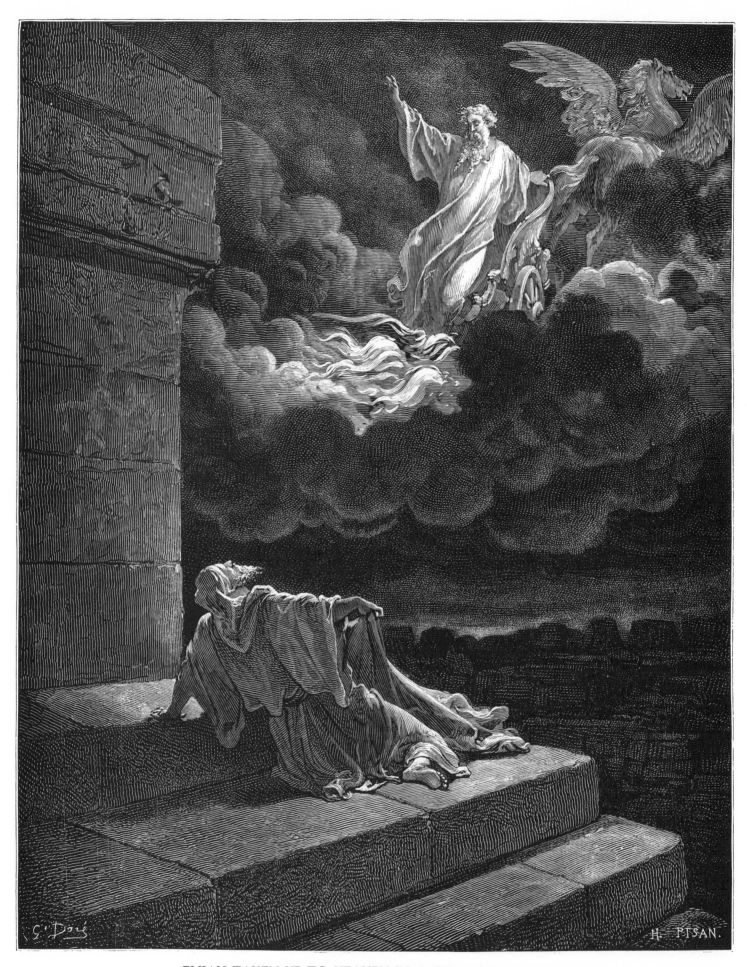

ELIJAH TAKEN UP TO HEAVEN IN A CHARIOT OF FIRE

Behold, there appeared a chariot of fire, and horses of fire, and parted them both
asunder; and Elijah went up by a whirlwind into heaven. And Elisha saw it, and he
cried, My father, my father, the chariot of Israel, and the horsemen thereof. And he
saw him no more . . . (II Kings 2: 11, 12)

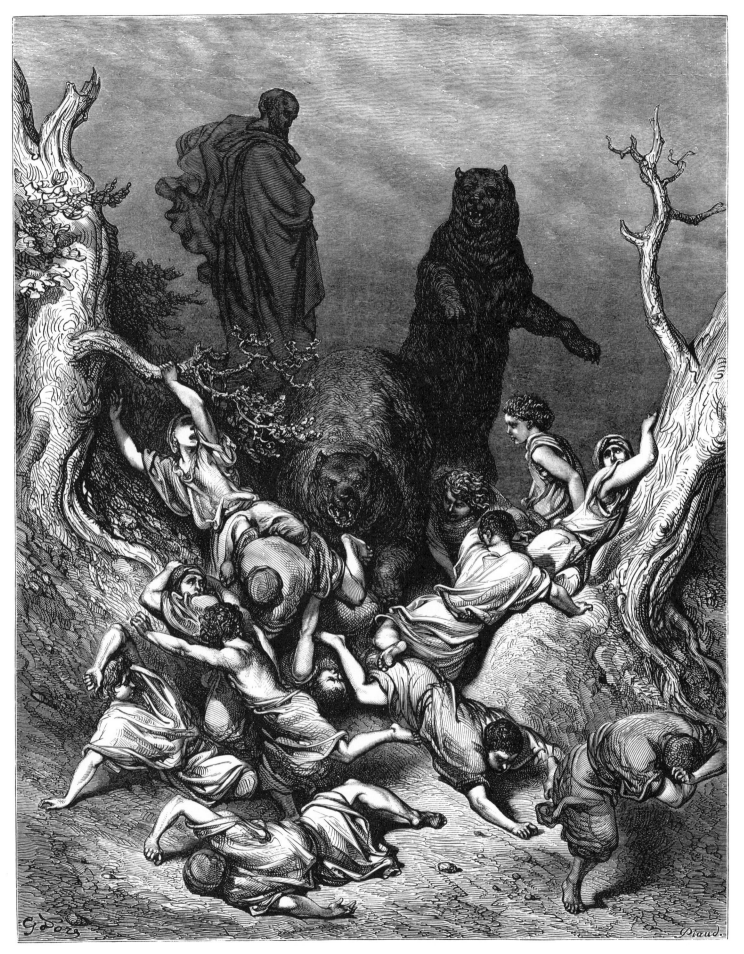

THE CHILDREN DESTROYED BY BEARS

As he [Elisha] was going up by the way, there came forth little children out of the city,
and mocked him, and said unto him, Go up, thou bald head . . . And he . . . cursed
them in the name of the Lord. And there came forth two she bears out of the wood,
and tare forty and two children of them . . . (II Kings 2: 23, 24)

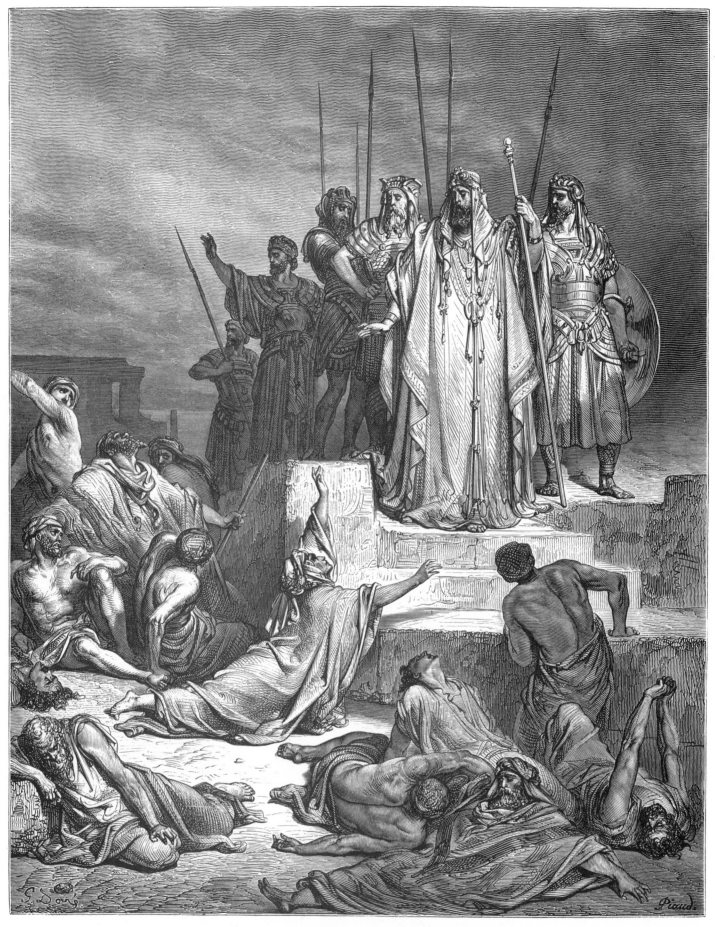

THE FAMINE IN SAMARIA

And the king said unto her, What aileth thee? And she answered, This woman said unto me, Give thy son, that we may eat him to day, and we will eat my son to morrow...When the king heard the words...he rent his clothes...(II Kings 6: 28, 30)

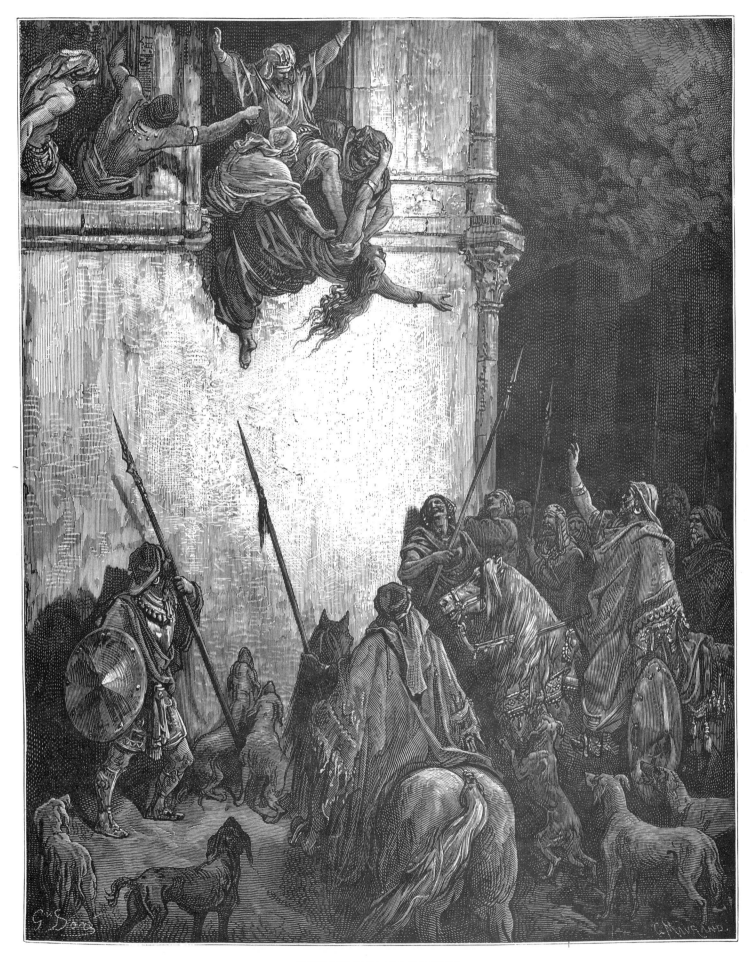

THE DEATH OF JEZEBEL

And he [Jehu] said, Throw her down. So they threw her down: and some of her blood
was sprinkled on the wall, and on the horses: and he trode her under foot . . .
(II Kings 9: 33)

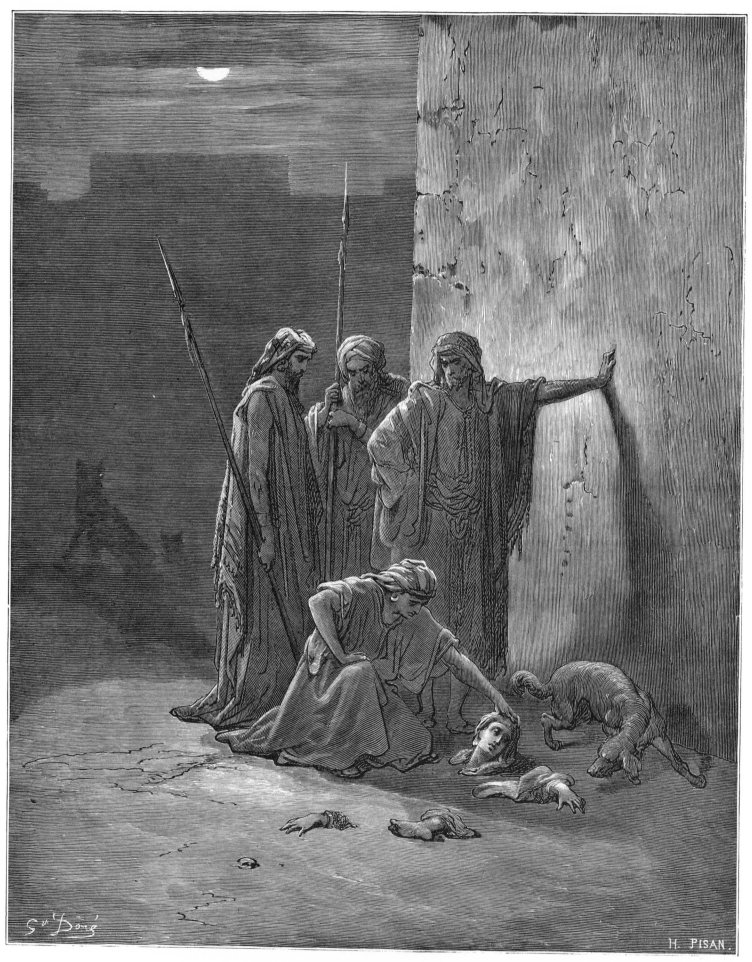

JEHU'S COMPANIONS FINDING THE REMAINS OF JEZEBEL

And they went to bury her: but they found no more of her than the skull, and the
feet, and the palms of her hands . . . And he said, This is the word of the Lord, which
he spoke by his servant Elijah: . . . In the portion of Jezreel shall dogs eat the flesh
of Jezebel . . . (II Kings 9: 35, 36)

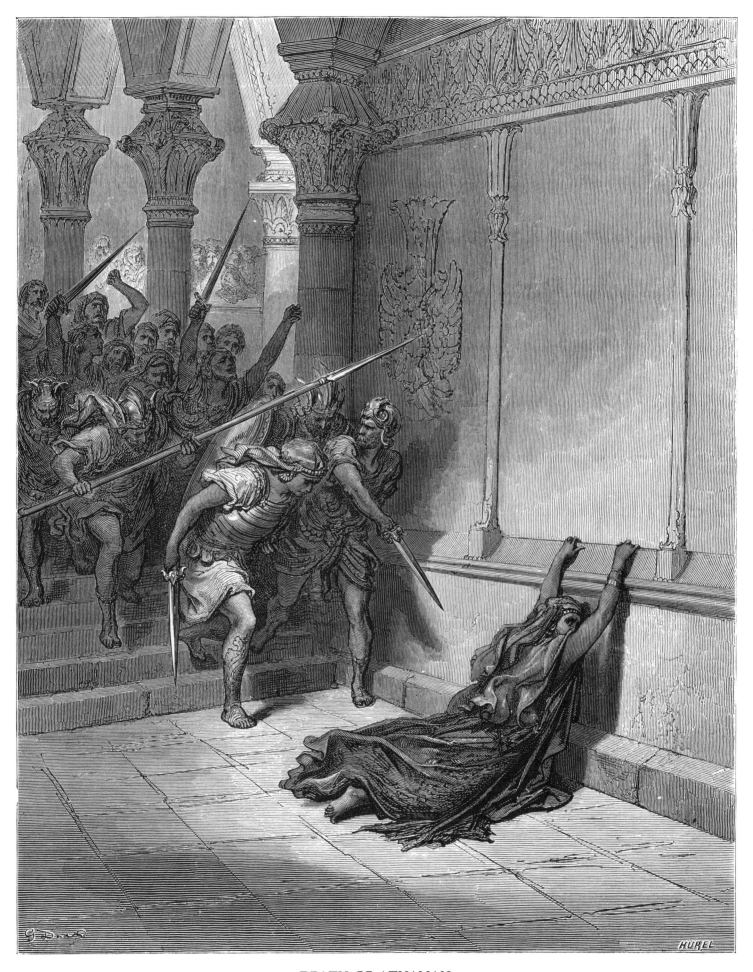

DEATH OF ATHALIAH

Athaliah . . . arose and destroyed all the seed royal of the house of Judah . . . So
they laid hands on her; and when she was come to the entering of the horse gate . . .
they slew her there . . . (II Chronicles 22: 10; 23: 15)

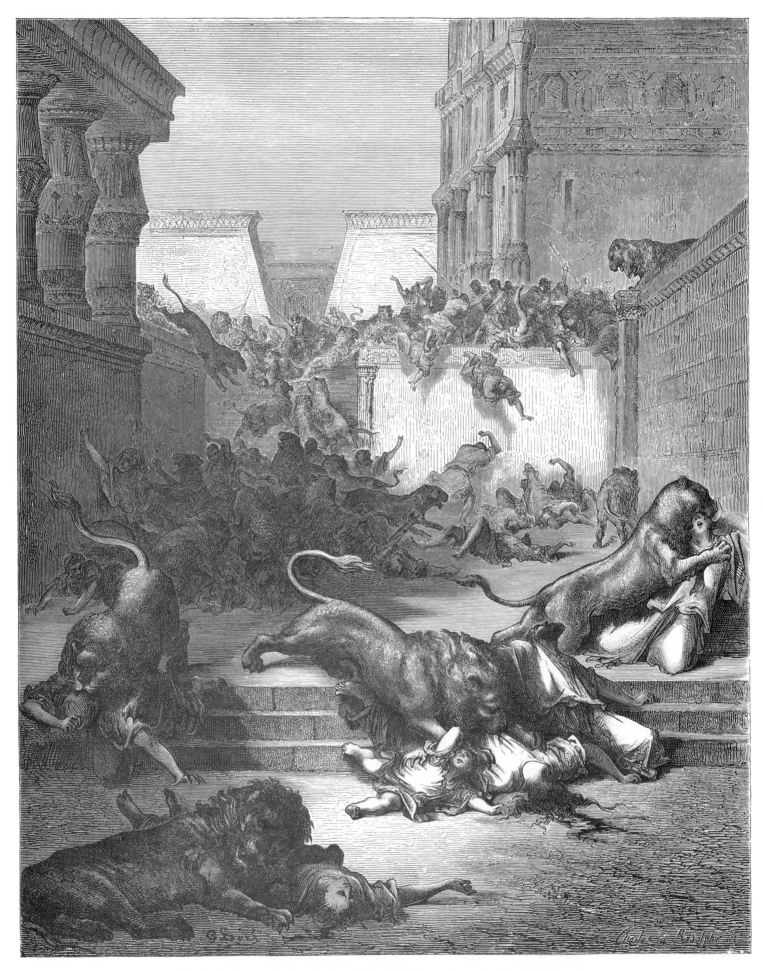

THE STRANGE NATIONS SLAIN BY THE LIONS OF SAMARIA

The nations which thou hast removed, and placed in the cities of Samaria, know
not the manner of the God of the land: therefore he hath sent lions among them . . .
(II Kings 17: 26)

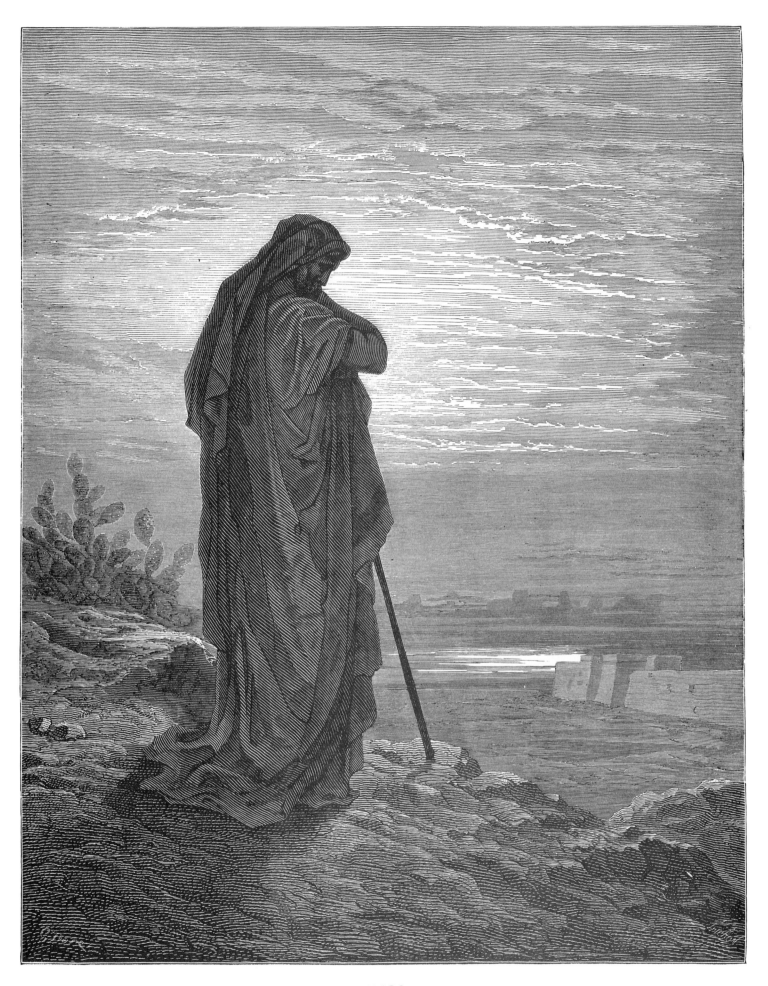

AMOS

The words of Amos, who was among the herdmen of Tekoa . . . Thus saith the Lord;
For three transgressions of Damascus, and for four, I will not turn away the punish-
ment thereof . . . (Amos 1: 1, 3)

109

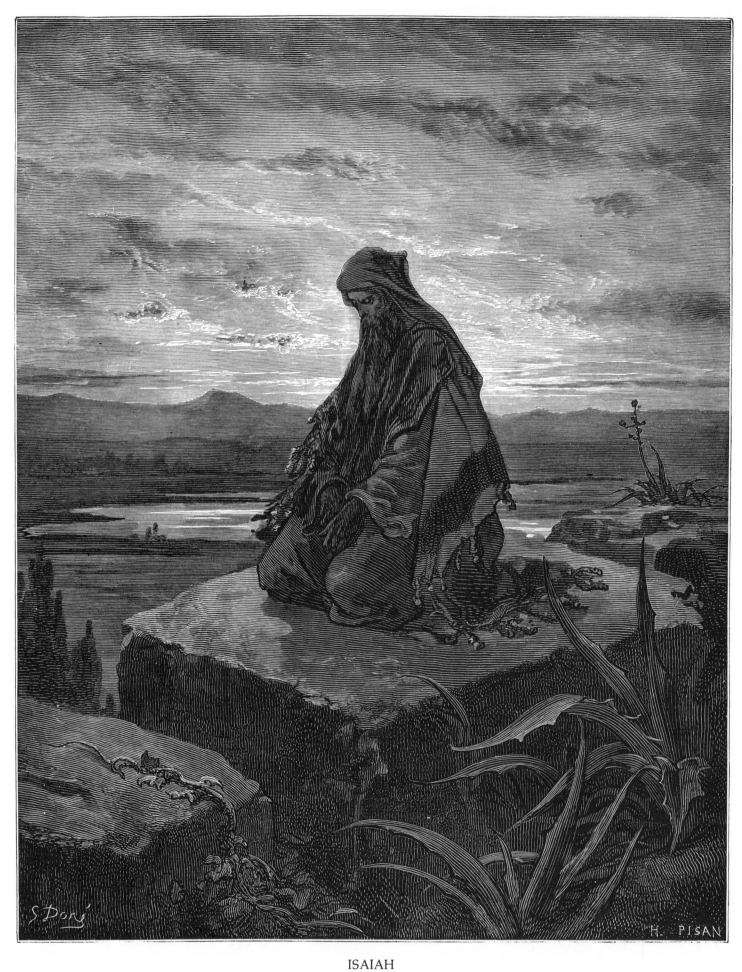

ISAIAH

Also I heard the voice of the Lord, saying, Whom shall I send, and who will go for
us? Then said I, Here am I; send me . . . (Isaiah 6: 8)

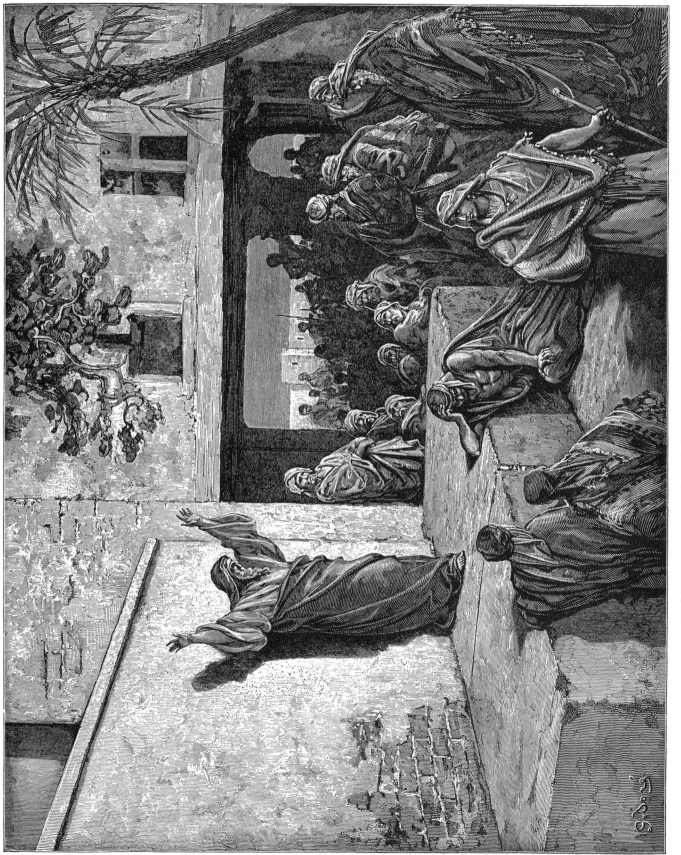

MICAH EXHORTING THE ISRAELITES TO REPENTANCE

They shall beat their swords into plowshares, and their spears into pruninghooks
. . . And what doth the Lord require of thee, but to do justly, and to love mercy, and
to walk humbly with thy God? . . . (Micah 4: 3; 6: 8)

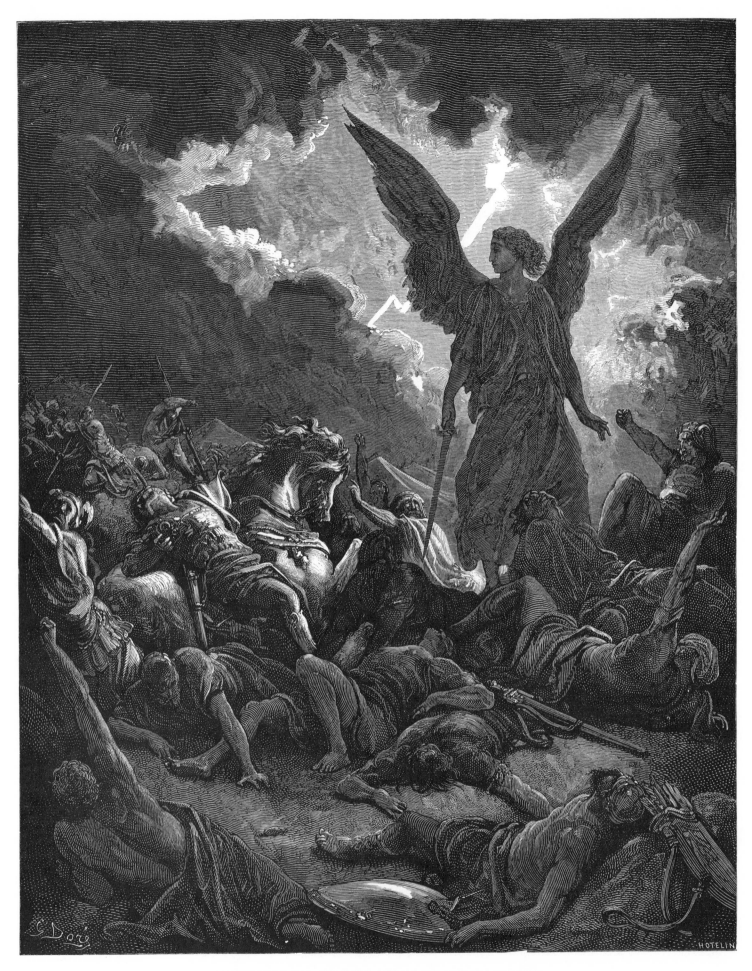

DESTRUCTION OF THE ARMY OF SENNACHERIB

And it came to pass that night, that the angel of the Lord went out, and smote in
the camp of the Assyrians an hundred fourscore and five thousand . . . So Sennacherib
king of Assyria departed . . . (II Kings 19: 35, 36)

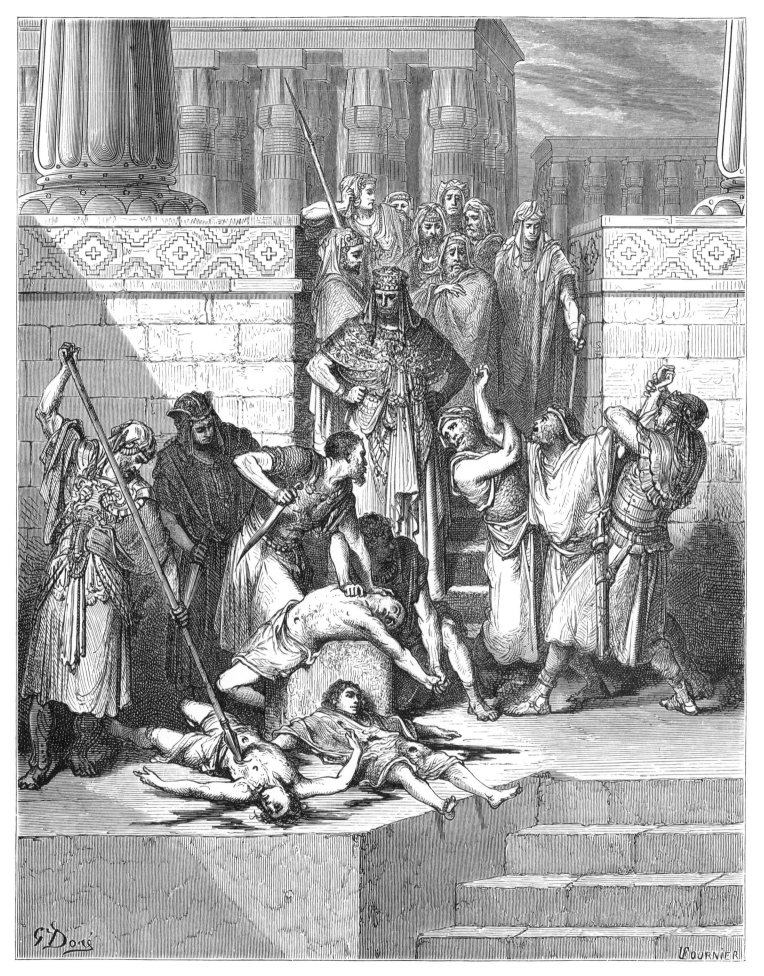

SLAUGHTER OF THE SONS OF ZEDEKIAH BEFORE THEIR FATHER
And they slew the sons of Zedekiah before his eyes, and put out the eyes of Zede-
kiah, and bound him with fetters of brass, and carried him to Babylon . . .
(II Kings 25: 7)

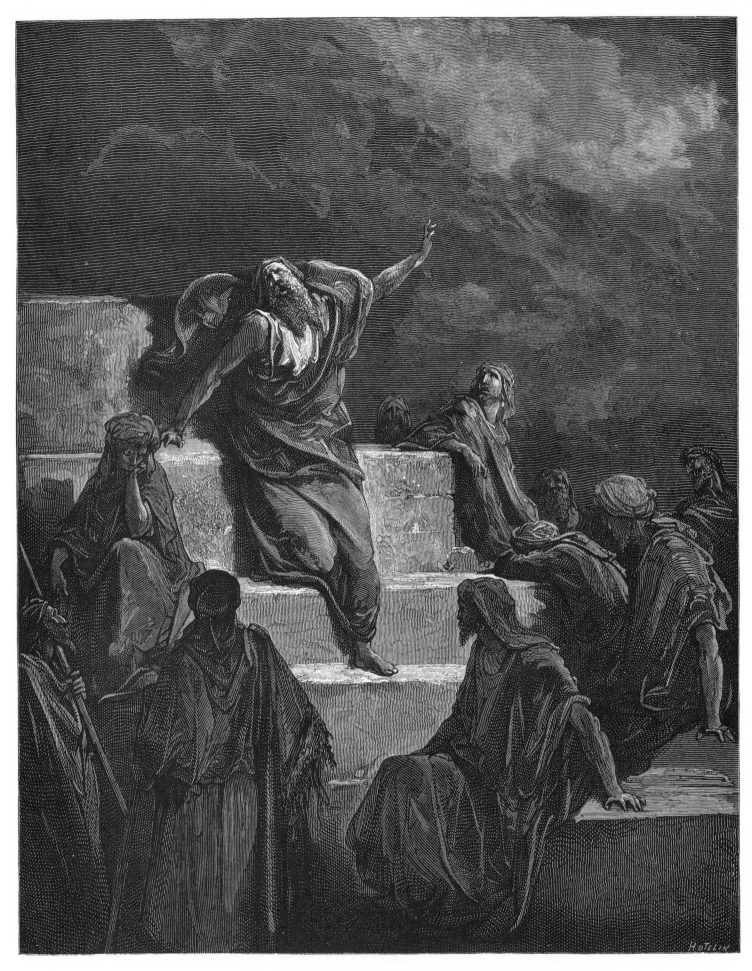

JEREMIAH

And the Lord said unto me, Behold, I have put my words in thy mouth. See, I have this day set thee over the nations and over the kingdoms, to root out, and to pull down, and to destroy, and to throw down, to build, and to plant . . .(Jeremiah 1: 9, 10)

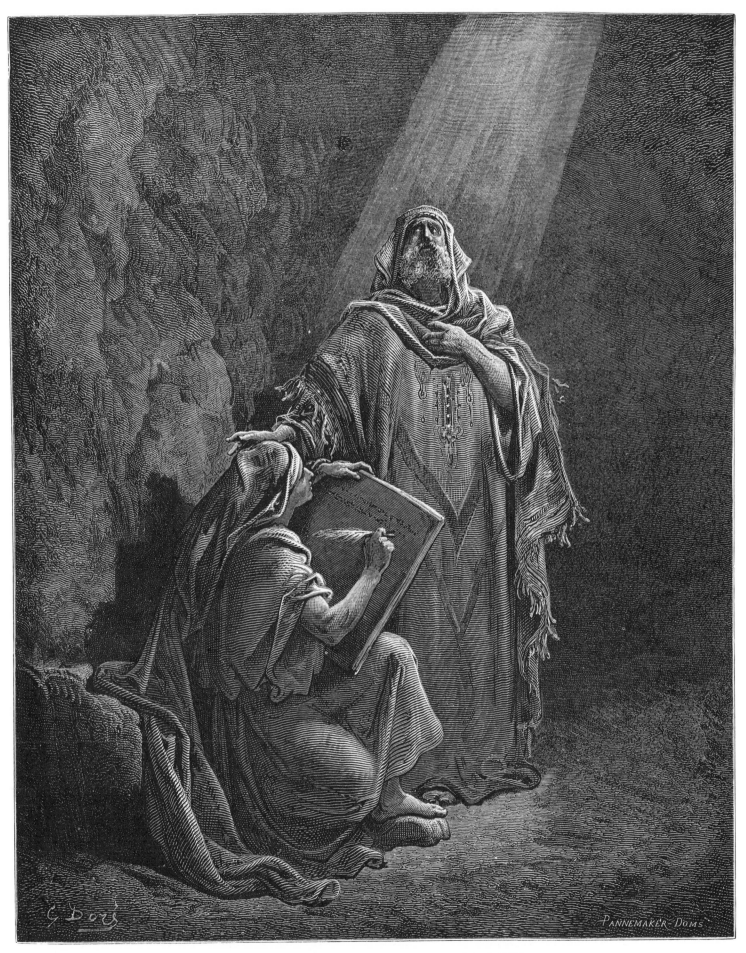

BARUCH WRITING JEREMIAH'S PROPHECIES

Then Jeremiah called Baruch the son of Neriah: and Baruch wrote from the mouth
of Jeremiah all the words of the Lord, which he had spoken unto him, upon a roll of a
book . . . (Jeremiah 36: 4)

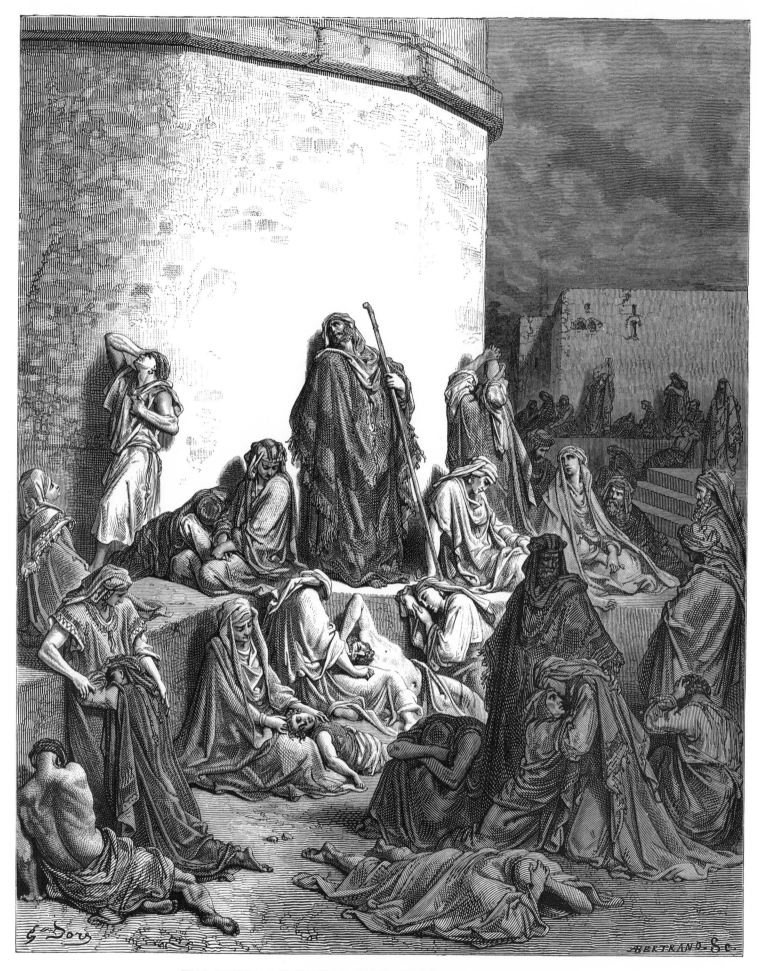

THE PEOPLE MOURNING OVER THE RUINS OF JERUSALEM

How doth the city sit solitary, that was full of people! how is she become as a
widow! she that was great among the nations ... (Lamentations 1:1)

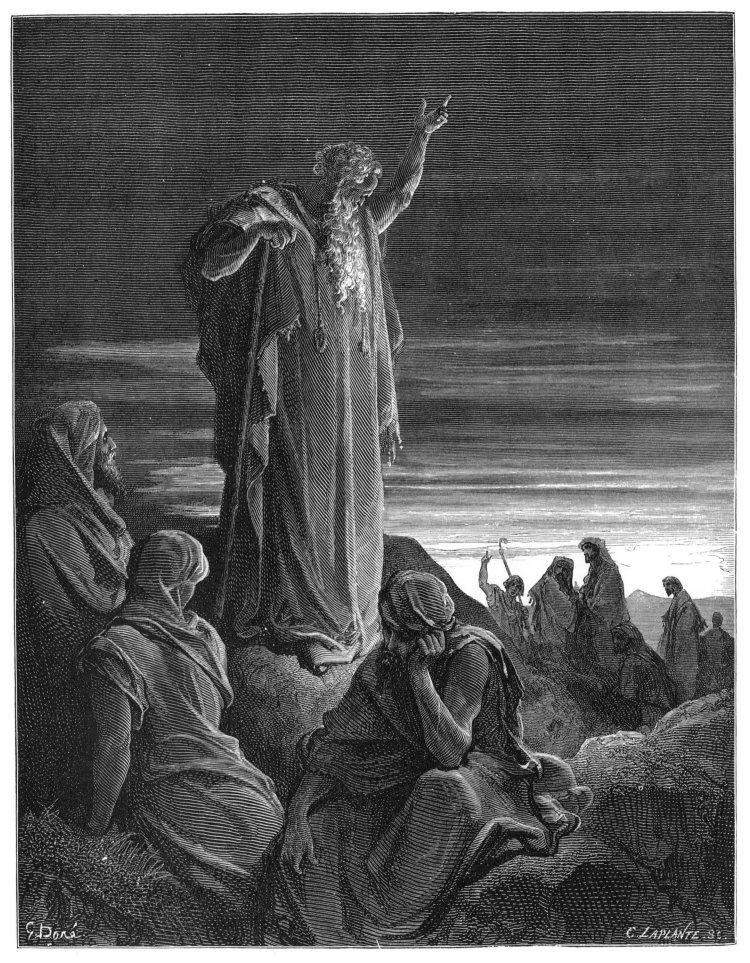

EZEKIEL PROPHESYING

Now it came to pass in the thirtieth year, in the fourth month, in the fifth day of
the month, as I was among the captives by the river of Chebar, that the heavens were
opened, and I saw visions of God . . . (Ezekiel 1: 1)

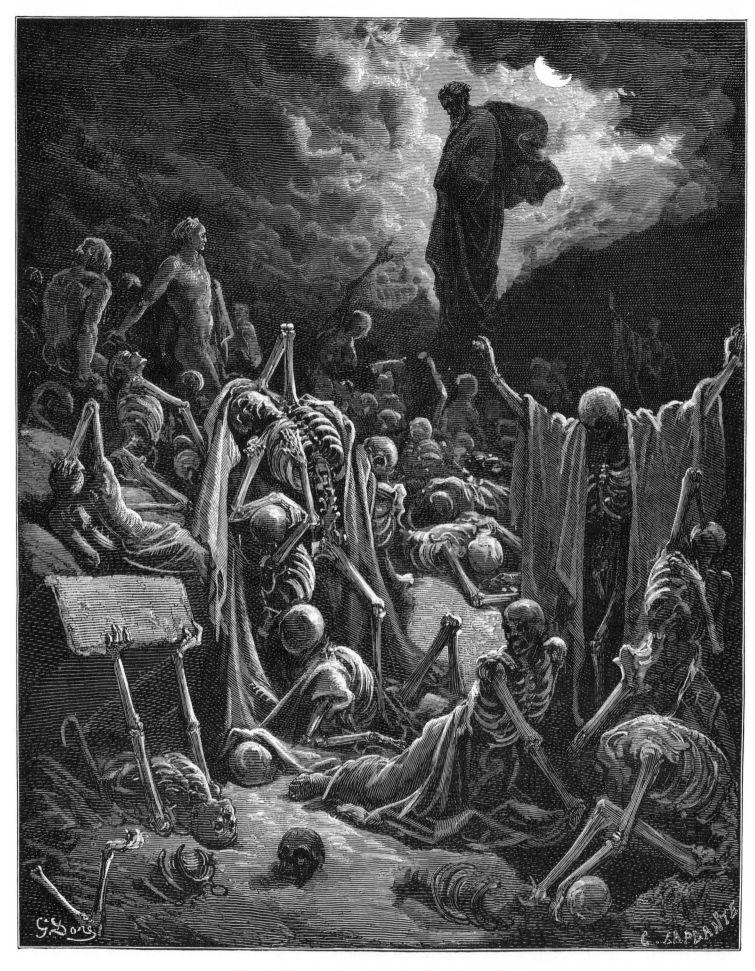

THE VISION OF THE VALLEY OF DRY BONES

And he said unto me, Son of man, can these bones live? And I answered, O Lord God,
thou knowest . . . (Ezekiel 37: 3)

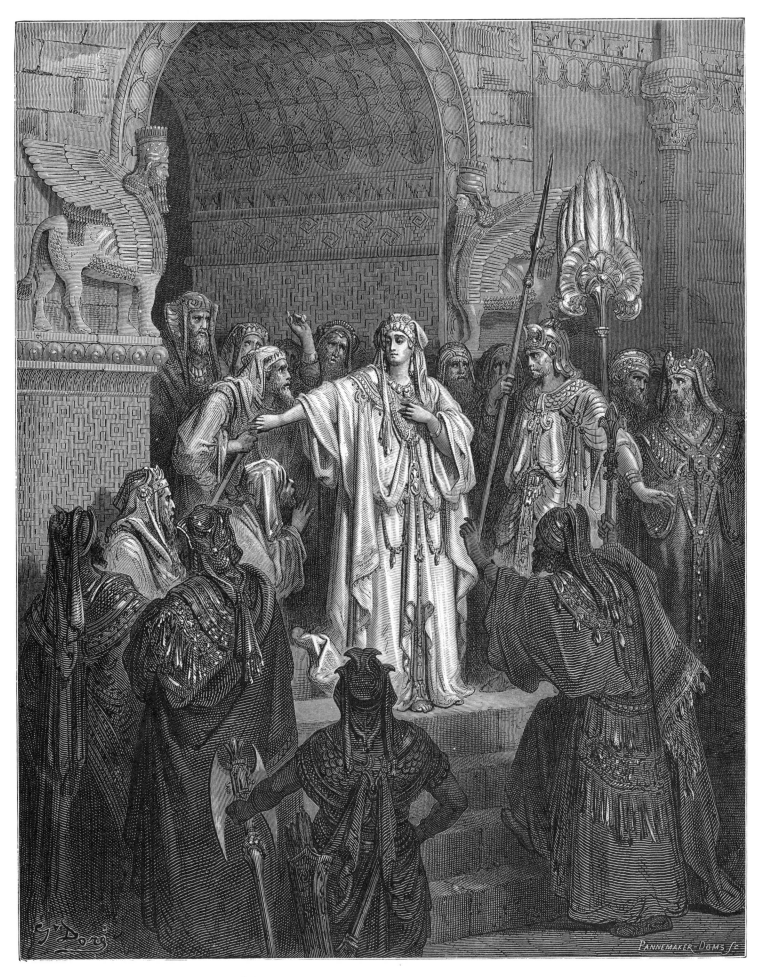

THE QUEEN VASHTI REFUSING TO OBEY THE COMMAND
OF AHASUERUS

On the seventh day, when the heart of the king was merry with wine, he commanded
. . . the seven chamberlains . . . to bring Vashti the queen . . . to shew the people and
the princes her beauty . . . (Esther 1: 10, 11)

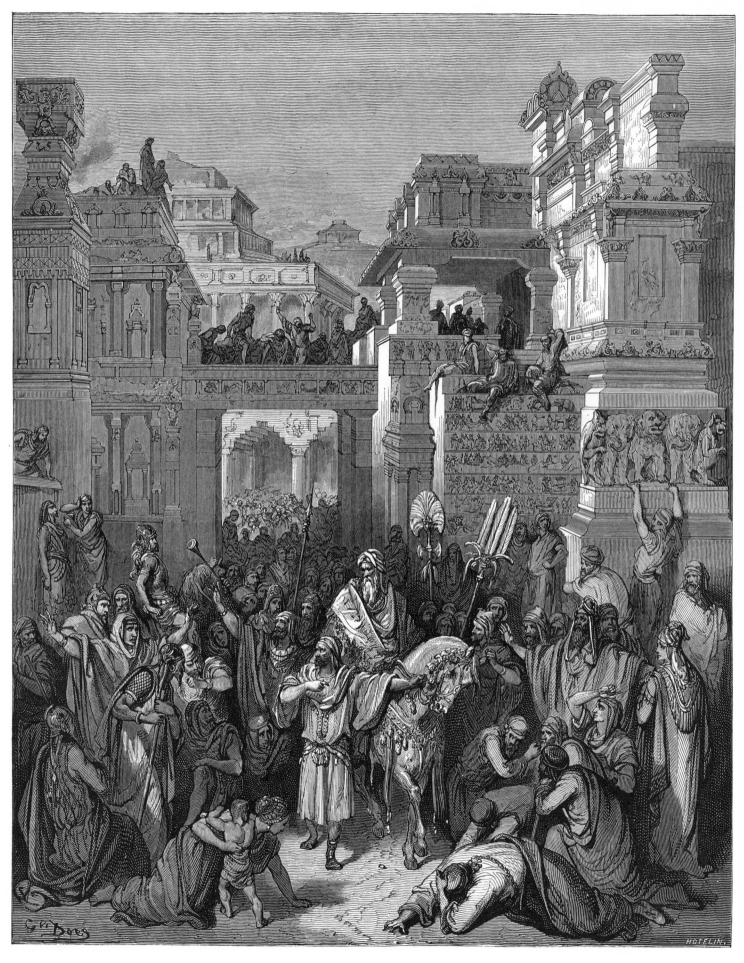

TRIUMPH OF MORDECAI

Then the king said to Haman, Make haste, and take the apparel and the horse, as
thou hast said, and do even so to Mordecai the Jew, that sitteth at the king's gate
. . . (Esther 6: 10)

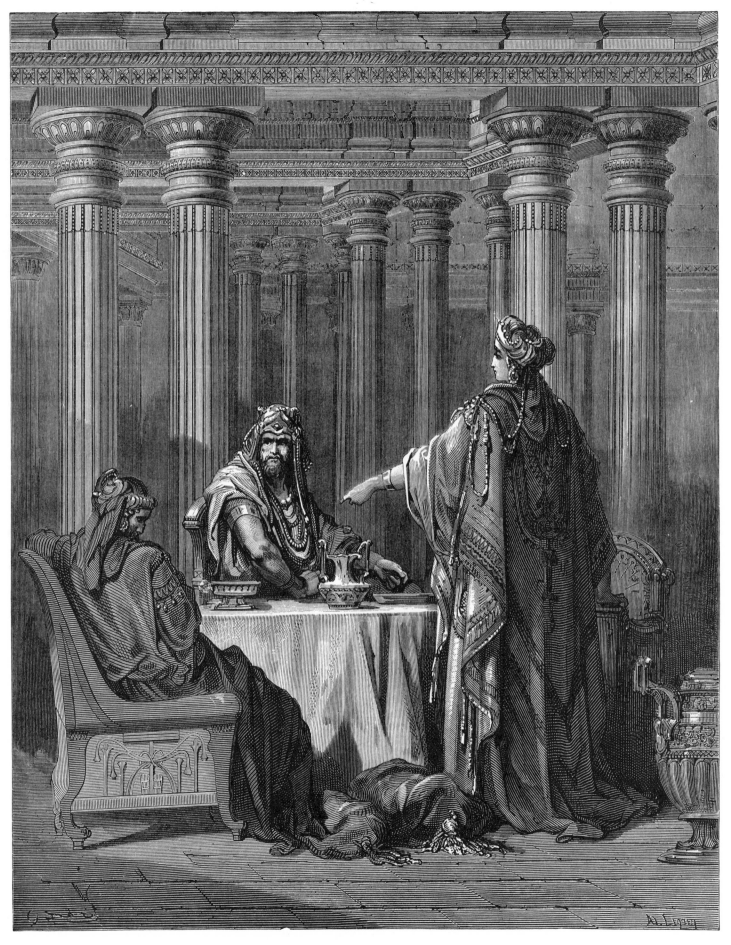

ESTHER ACCUSING HAMAN

For we are sold, I and my people, to be destroyed, to be slain, and to perish . . .
Then Haman was afraid before the king and the queen . . . (Esther 7: 4, 6)

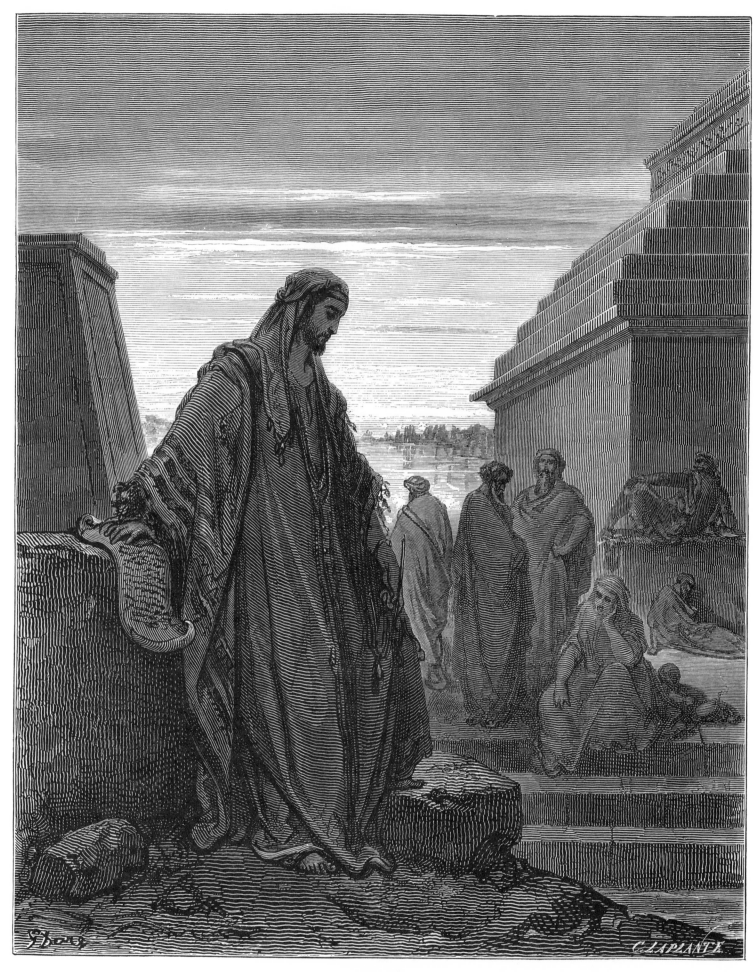

DANIEL

Then Arioch brought in Daniel...and said...I have found a man of the captives of
Judah... (Daniel 2: 25)

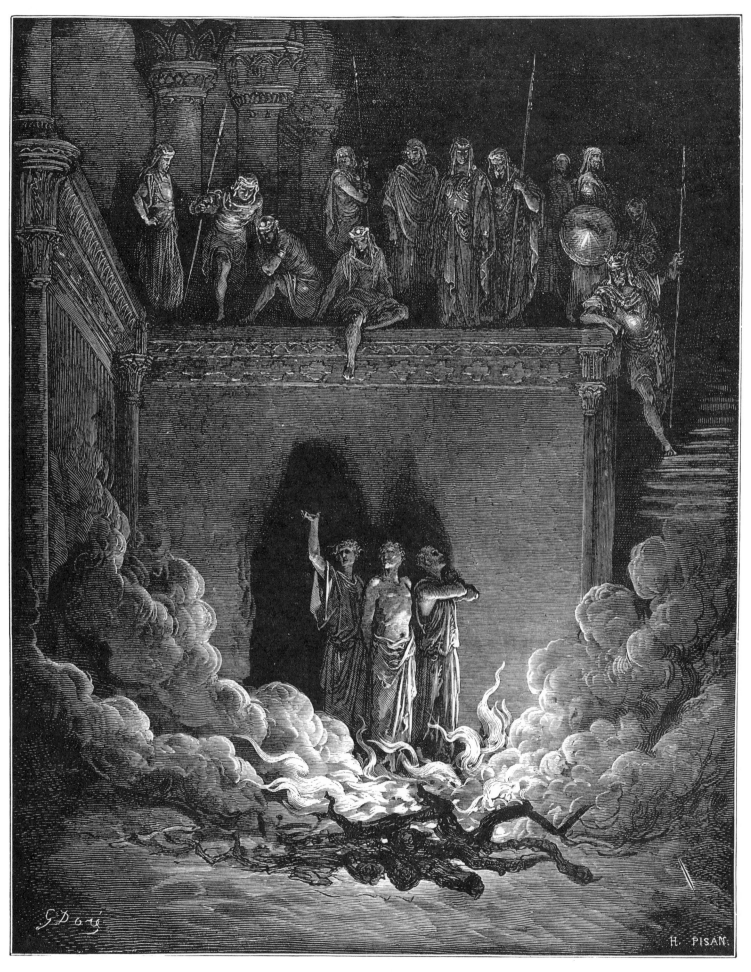

SHADRACH, MESHACH, AND ABED-NEGO IN THE FIERY FURNACE

Then Nebuchadnezzar the king was astonied, and rose up in haste, and spake, and
said unto his counsellers, Did not we cast three men bound into the midst of the fire?
. . . (Daniel 3: 24)

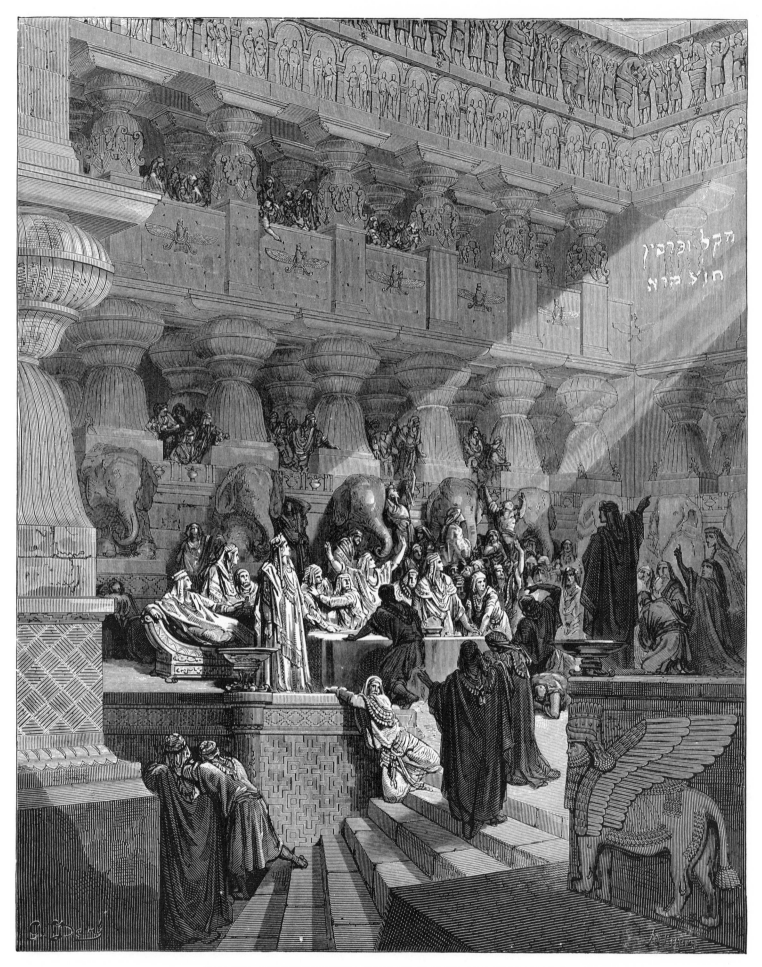

מנא מנא
תקל ופרסין

DANIEL INTERPRETING THE WRITING ON THE WALL

In the same hour came forth fingers of a man's hand, and wrote over against the
candlestick upon the plaister of the wall of the king's palace . . . MENE, MENE,
TEKEL, UPHARSIN . . . (Daniel 5: 5, 25)

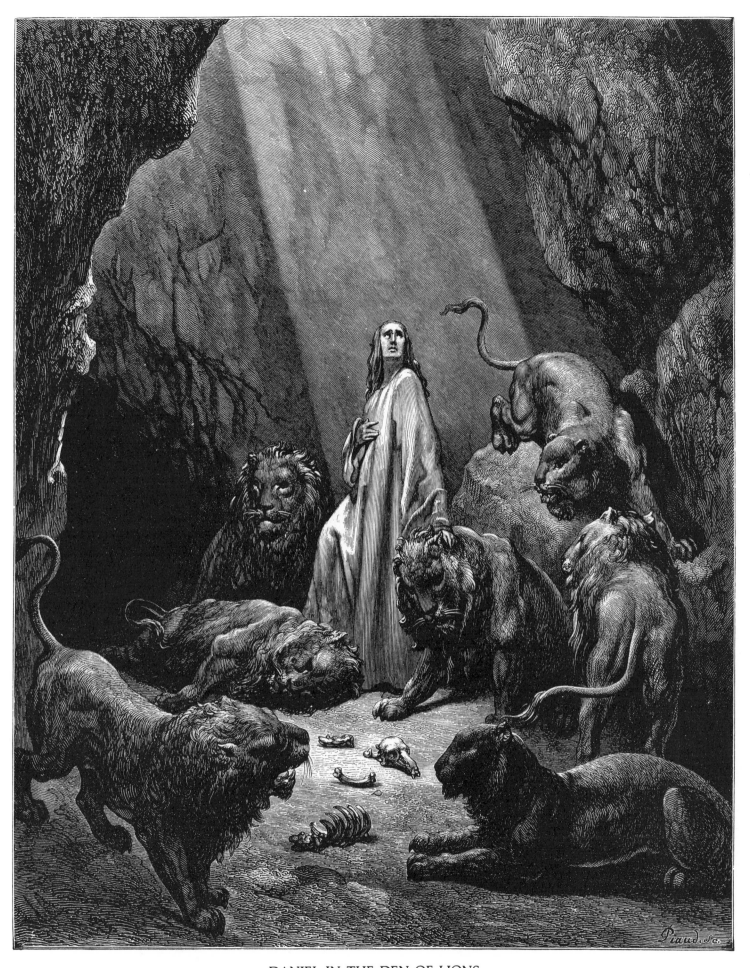

DANIEL IN THE DEN OF LIONS

My God hath sent his angel, and hath shut the lions' mouths, that they have not hurt
me . . . (Daniel 6: 22)

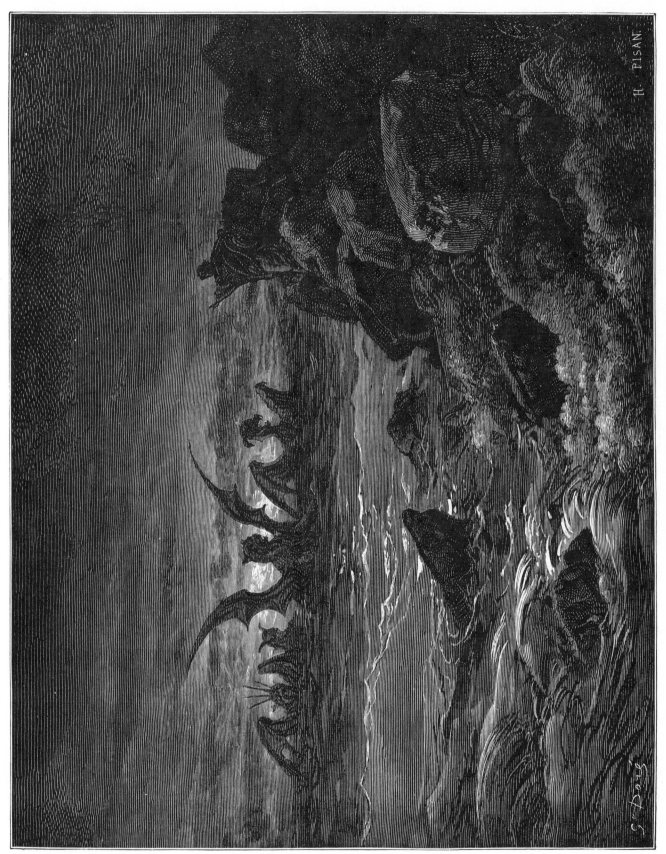

THE VISION OF THE FOUR BEASTS

Daniel spake and said, I saw in my vision by night, and, behold, the four winds of the heaven strove upon the great sea. And four great beasts came up from the sea, diverse one from another . . . (Daniel 7:2, 3)

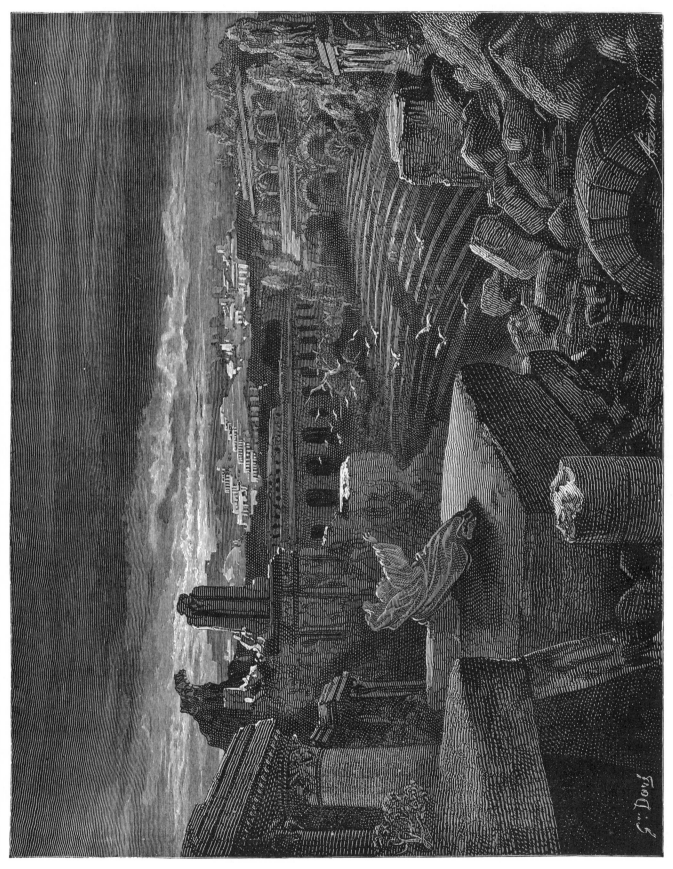

ISAIAH'S VISION OF THE DESTRUCTION OF BABYLON

It shall never be inhabited . . . owls shall dwell there . . . and the wild beasts of the
islands shall cry in their desolate houses . . . (Isaiah 13: 20, 21, 22)

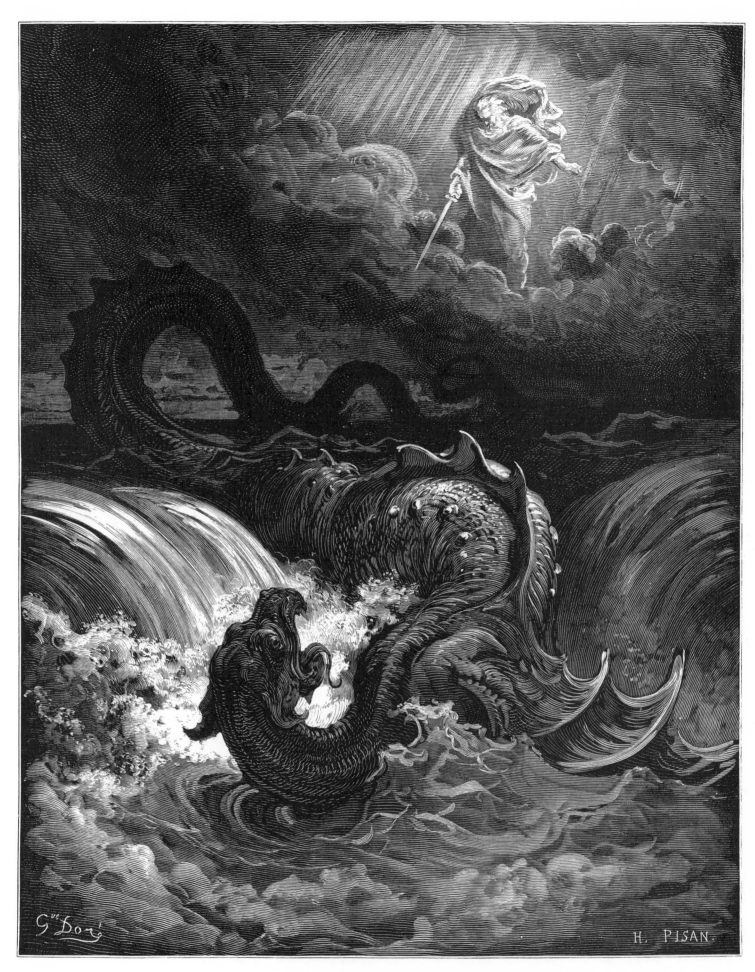

THE DESTRUCTION OF LEVIATHAN

In that day the Lord with his sore and great and strong sword shall punish Leviathan
the piercing serpent, even Leviathan that crooked serpent; and he shall slay the drag-
on that is in the sea . . . (Isaiah 27: 1)

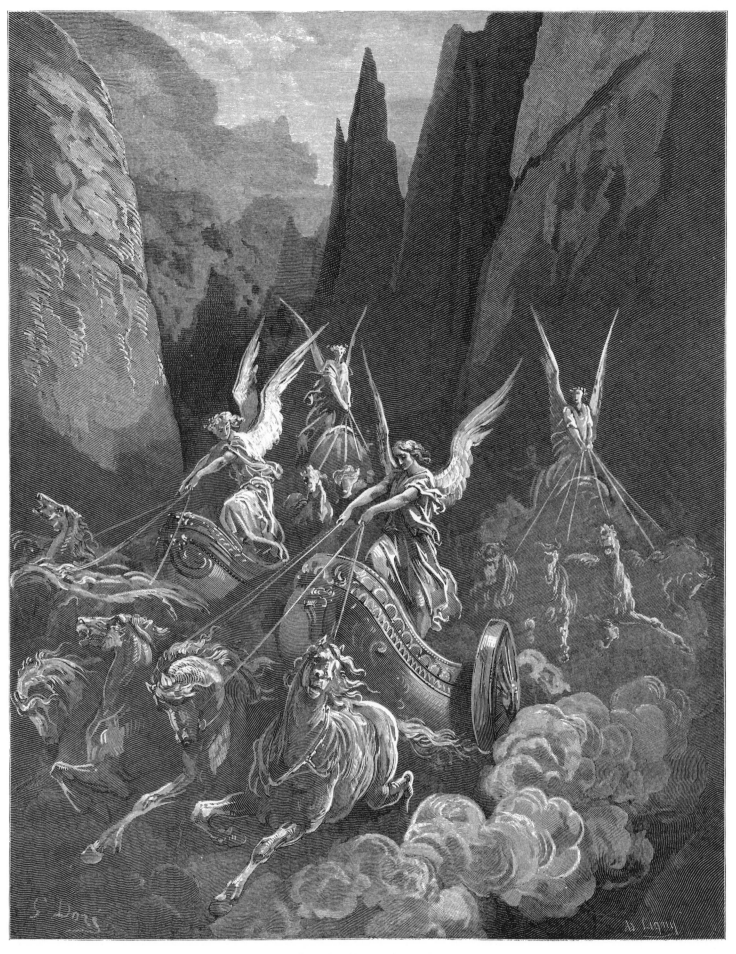

THE VISION OF THE FOUR CHARIOTS

And the angel answered and said unto me: These are the four spirits of the heav-
ens, which go forth from standing before the Lord of all the earth . . .(Zechariah 6: 5)

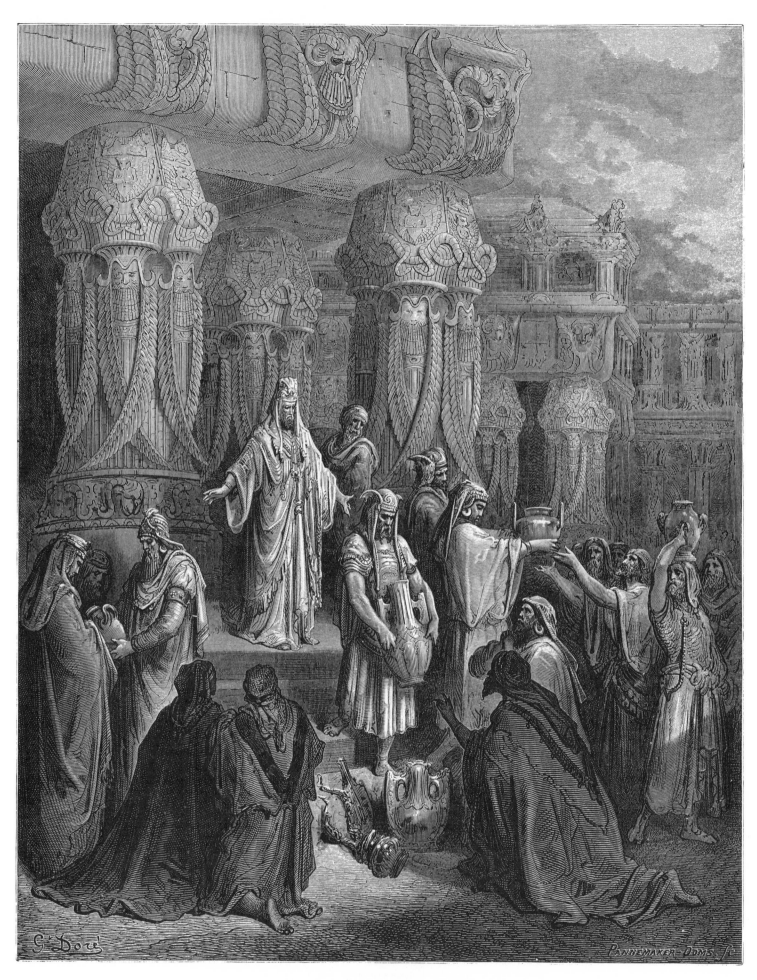

CYRUS RESTORING THE VESSELS OF THE TEMPLE

Cyrus the king brought forth the vessels of the house of the Lord, which Nebuchad-
nezzar . . . had put . . . in the house of his gods . . . (Ezra 1: 7)

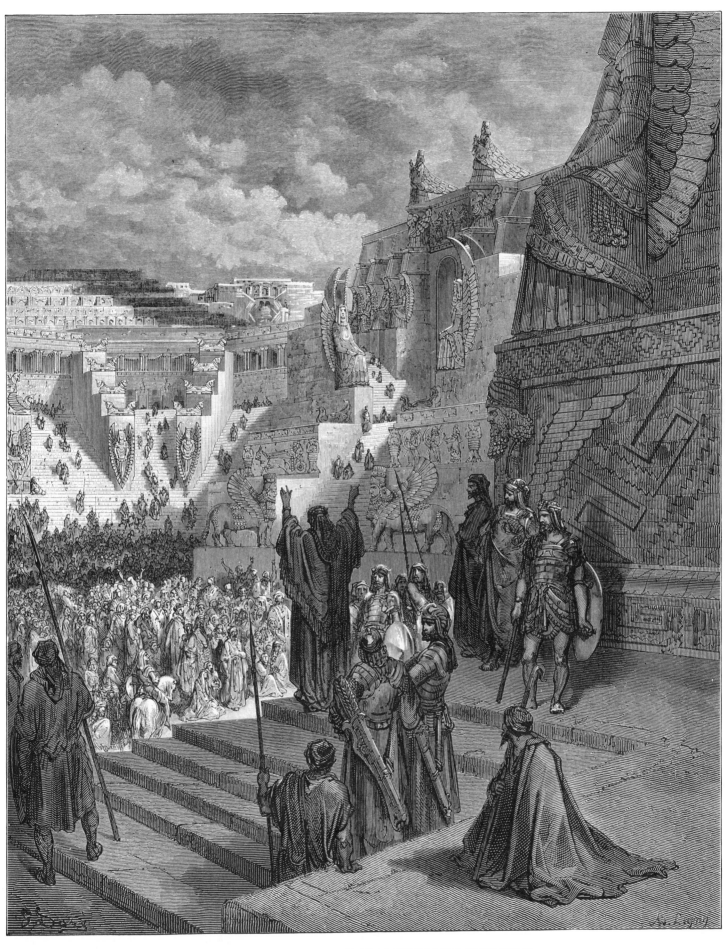

ARTAXERXES GRANTING LIBERTY TO THE JEWS

I make a decree, that all they of the people of Israel...which are minded...to go
up to Jerusalem, go with thee...(Ezra 7: 13)

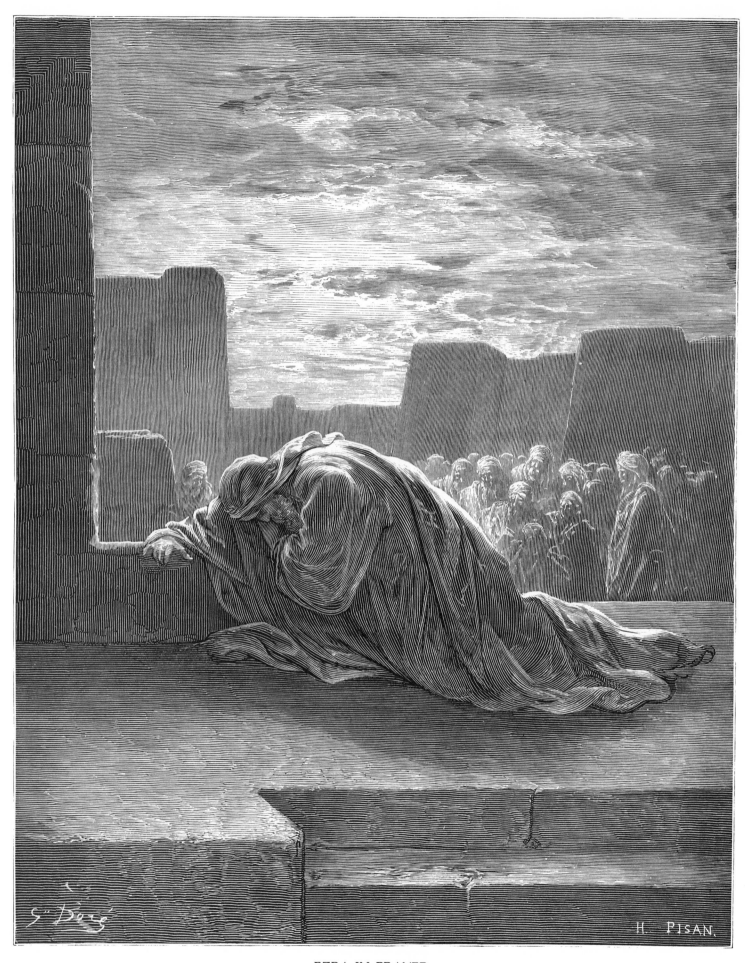

EZRA IN PRAYER

And at the evening sacrifice, I arose up from my heaviness; and having rent my
garment and my mantle, I fell upon my knees, and spread out my hands unto the Lord
my God . . . (Ezra 9: 5)

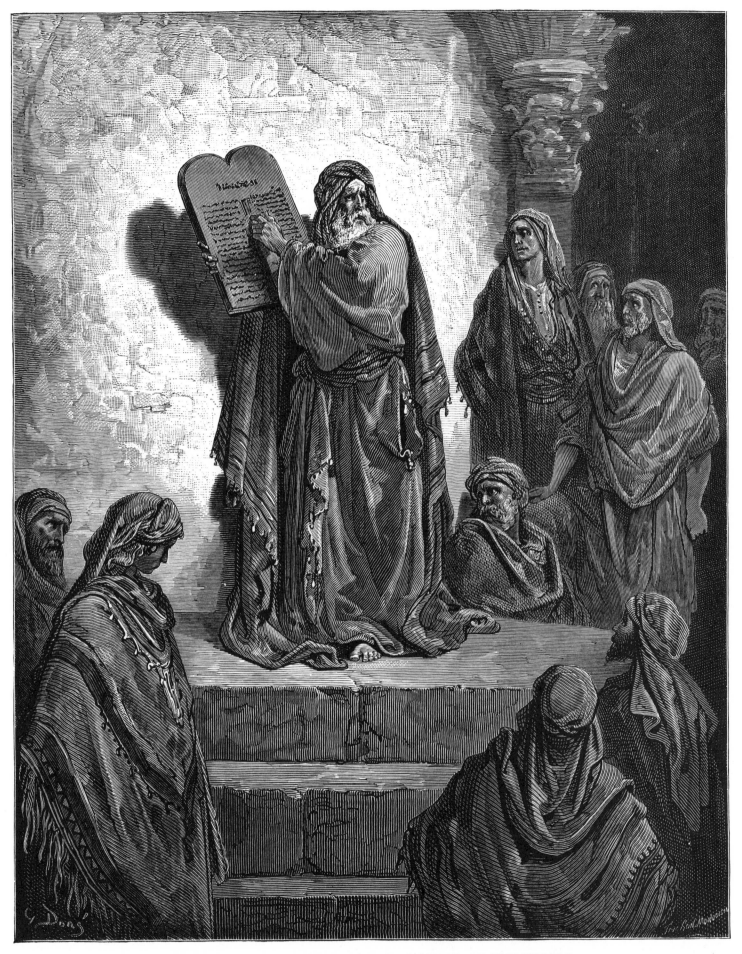

EZRA READING THE LAW IN THE HEARING OF THE PEOPLE

And Ezra opened the book in the sight of all the people . . . And Ezra blessed the
Lord, the great God. And all the people answered, Amen . . . (Nehemiah 8: 5, 6)

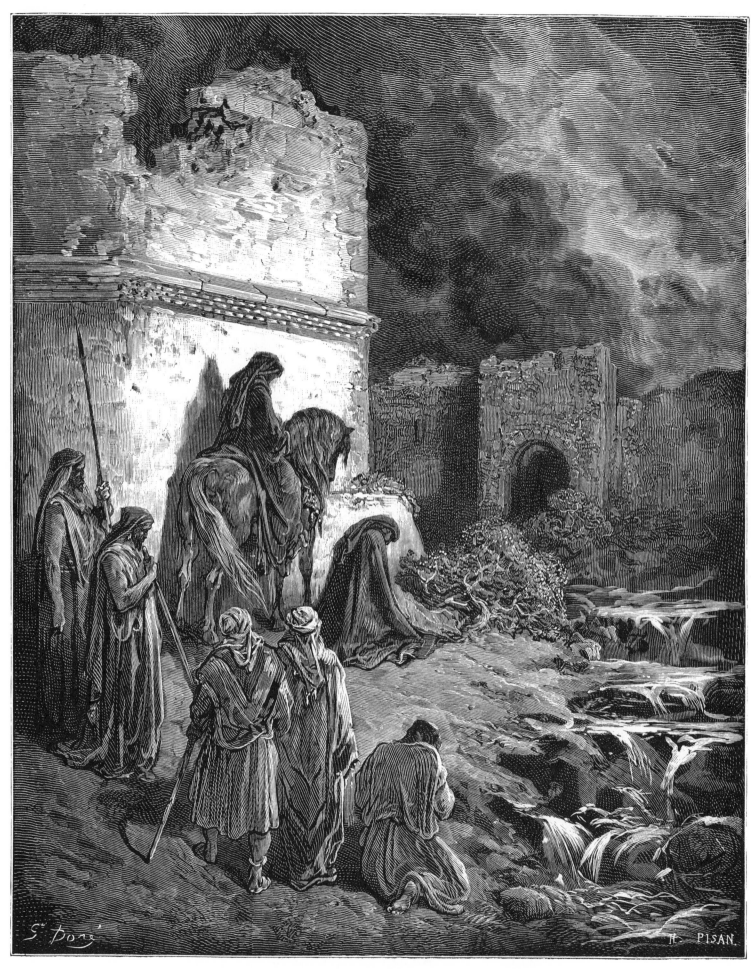

NEHEMIAH VIEWING SECRETLY THE RUINS OF
THE WALLS OF JERUSALEM

Ye see the distress that we are in, how Jerusalem lieth waste, and the gates thereof
are burned with fire: come, and let us build up the wall of Jerusalem . . .
(Nehemiah 2: 17)

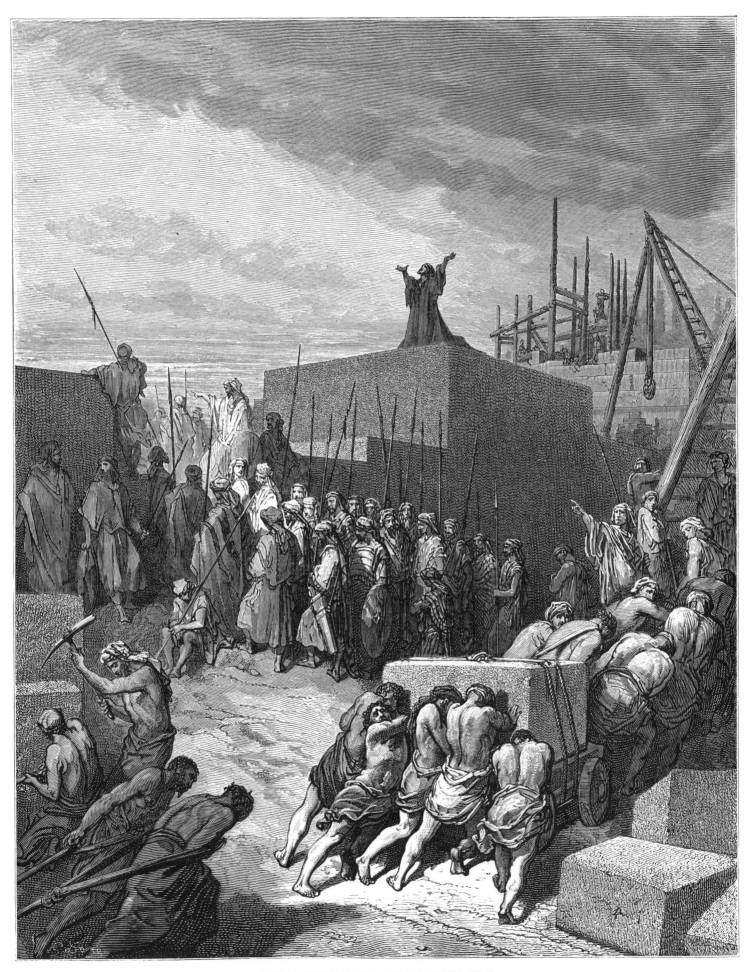

THE REBUILDING OF THE TEMPLE

Many of the priests and Levites and chief of the fathers, who were ancient men,
that had seen the first house, when the foundation of this house was laid before their
eyes, wept with a loud voice; and many shouted aloud for joy . . . (Ezra 3: 12)

135

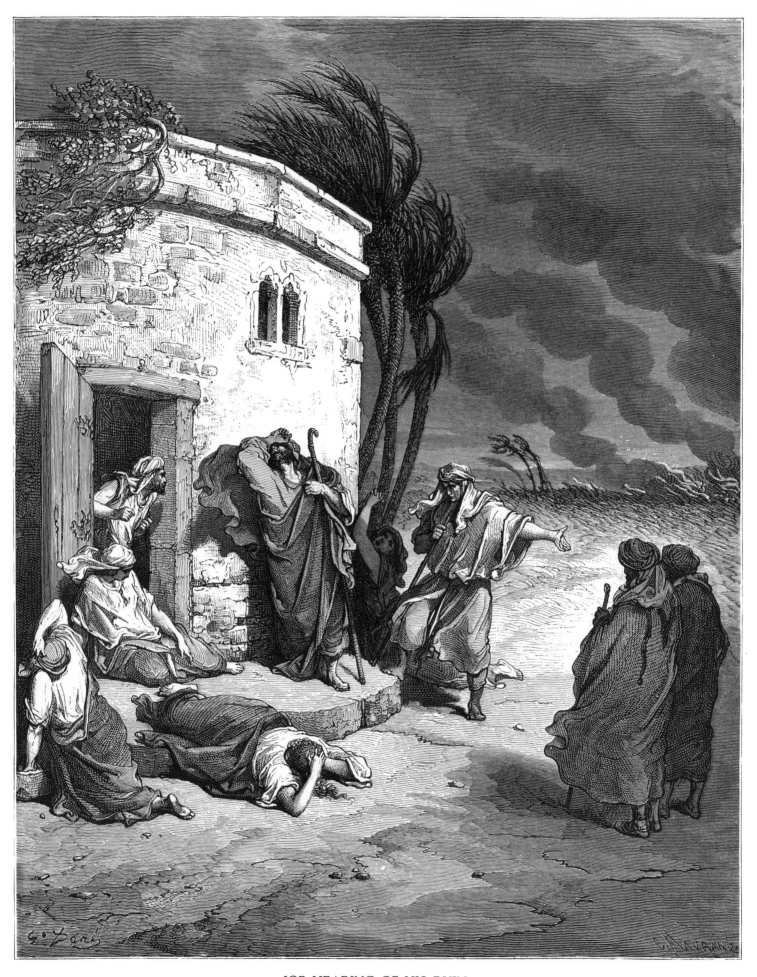

JOB HEARING OF HIS RUIN

Naked came I out of my mother's womb, and naked shall I return thither: the Lord
gave, and the Lord hath taken away; blessed be the name of the Lord . . . (Job 1: 21)

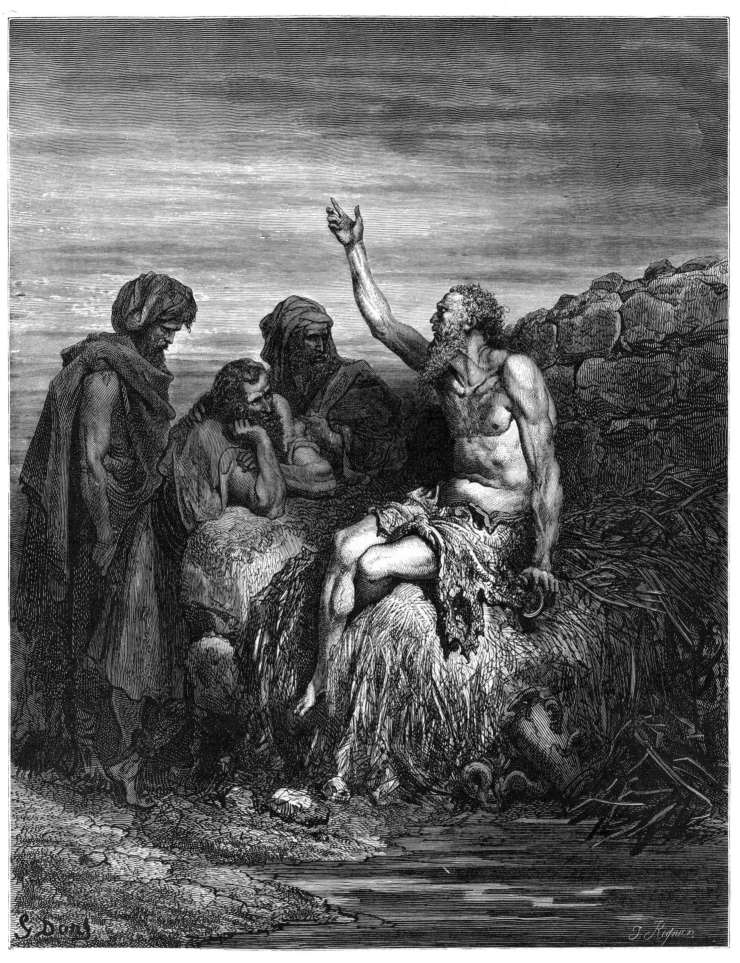

JOB AND HIS FRIENDS

Man that is born of a woman is of few days, and full of trouble . . . (Job 14: 1)

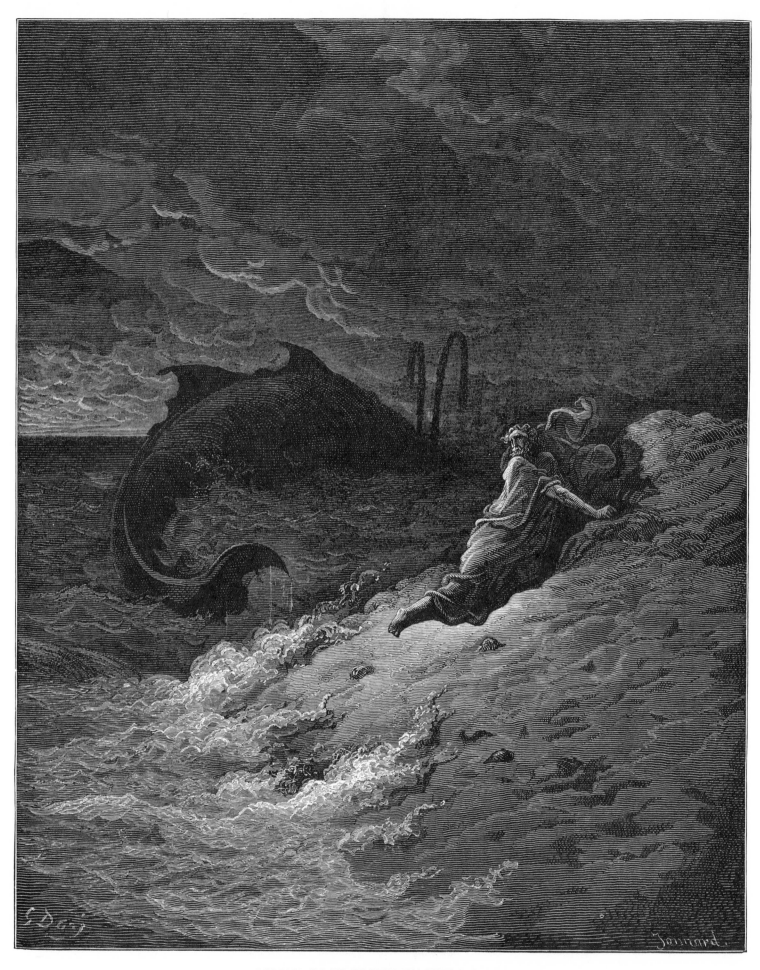

JONAH CAST FORTH BY THE WHALE

And the Lord spake unto the fish, and it vomited out Jonah upon the dry land
. . . (Jonah 2: 10)

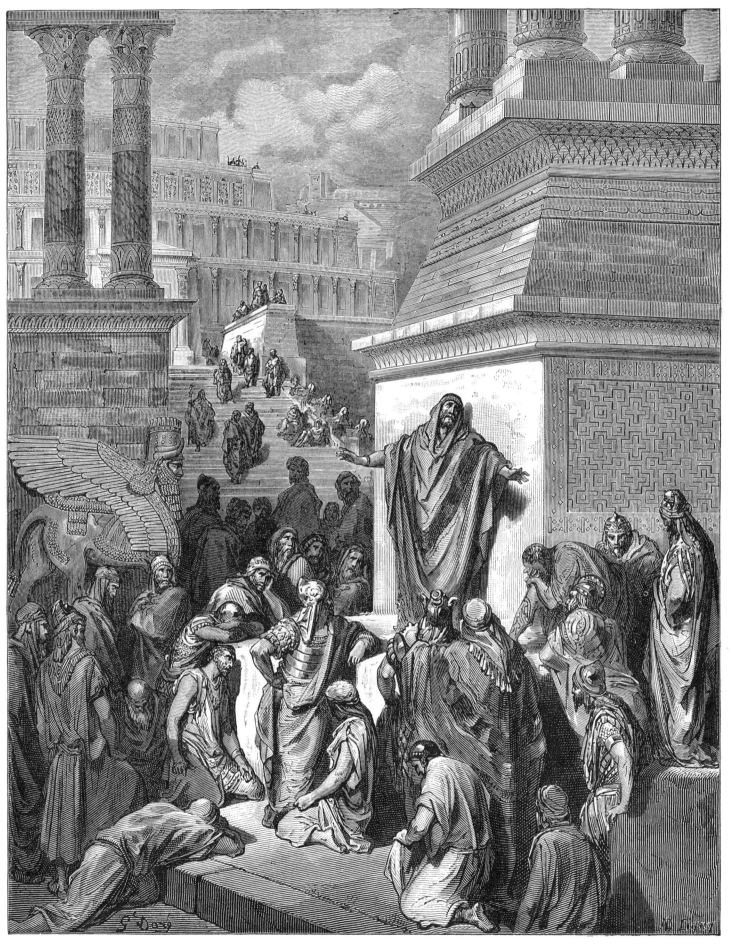

JONAH PREACHING TO THE NINEVITES

So Jonah arose, and went unto Nineveh . . . and he cried, and said, Yet forty days,
and Nineveh shall be overthrown . . . (Jonah 3: 3, 4)

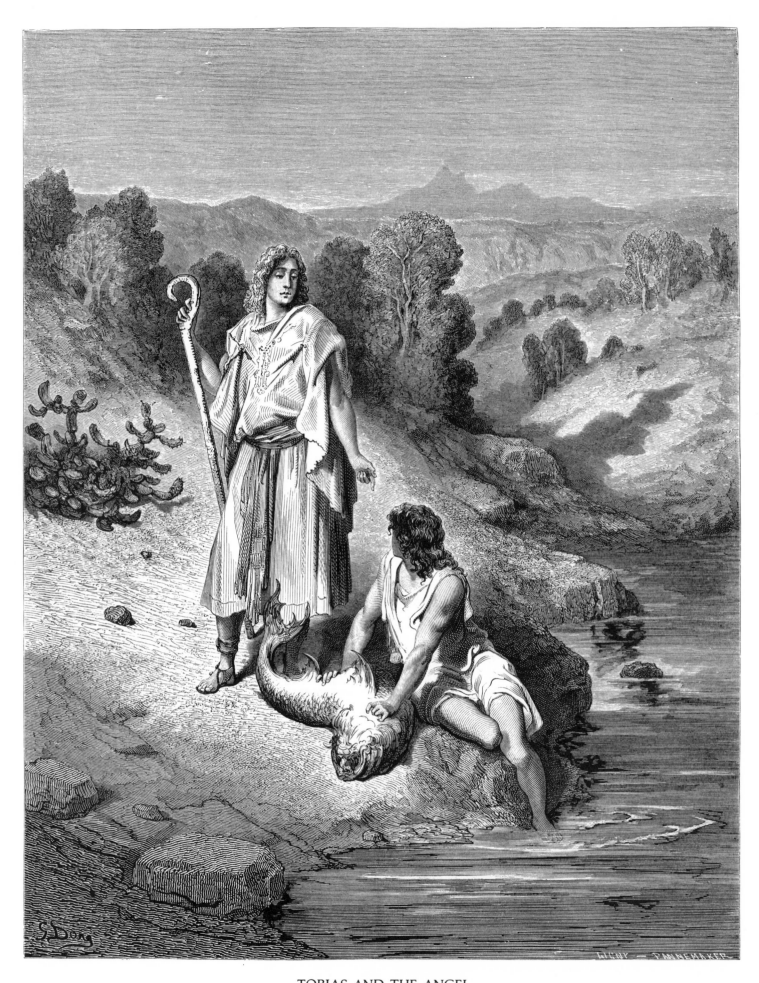

TOBIAS AND THE ANGEL

The angel said, Open the fish, and take the heart and the liver and the gall, and
put them up safely . . . (Tobit 6: 4)

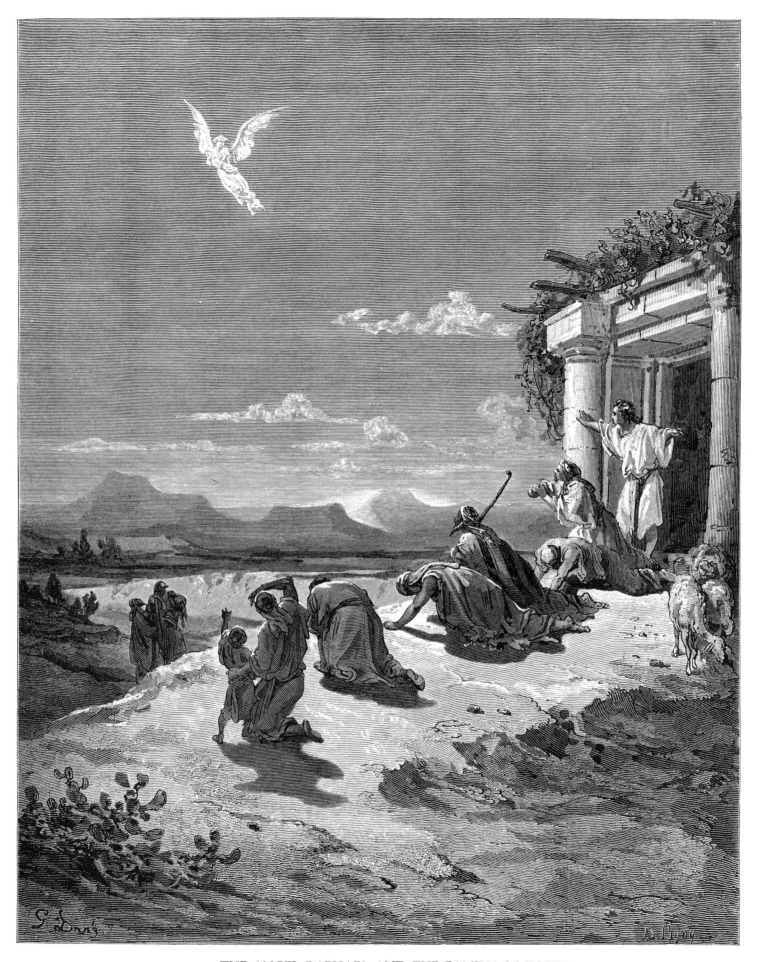

THE ANGEL RAPHAEL AND THE FAMILY OF TOBIT

I am Raphael, one of the seven holy angels . . . Now therefore give God thanks: for I
go up to him that sent me . . . (Tobit 12: 15, 20)

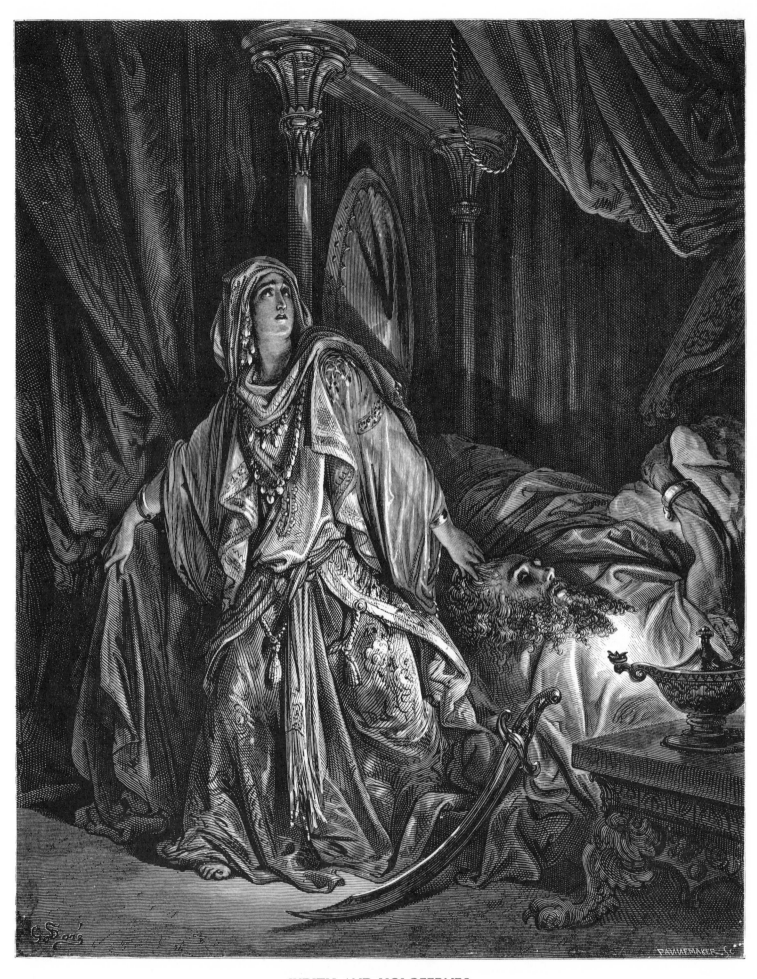

JUDITH AND HOLOFERNES

And she smote twice upon his neck with all her might, and she took away his head
from him . . . (Judith 13: 8)

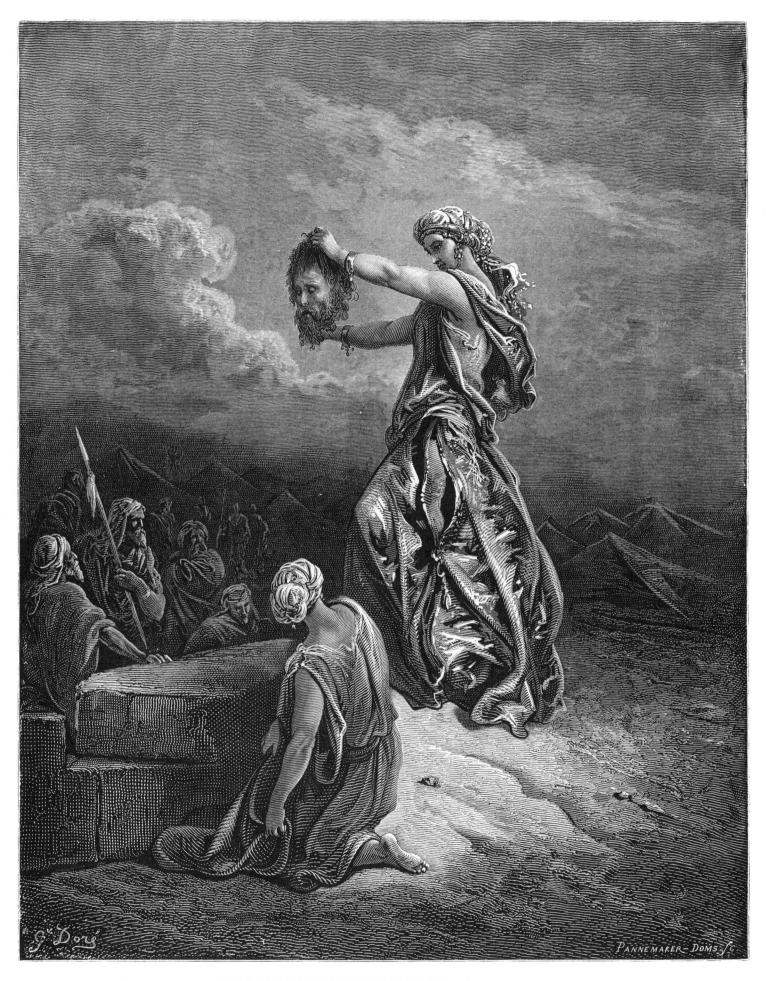

JUDITH SHOWING THE HEAD OF HOLOFERNES

Then she said to them with a loud voice, Praise, praise God . . . for he hath not taken
away his mercy from the house of Israel, but hath destroyed our enemies by mine
hands this night . . . (Judith 13: 14)

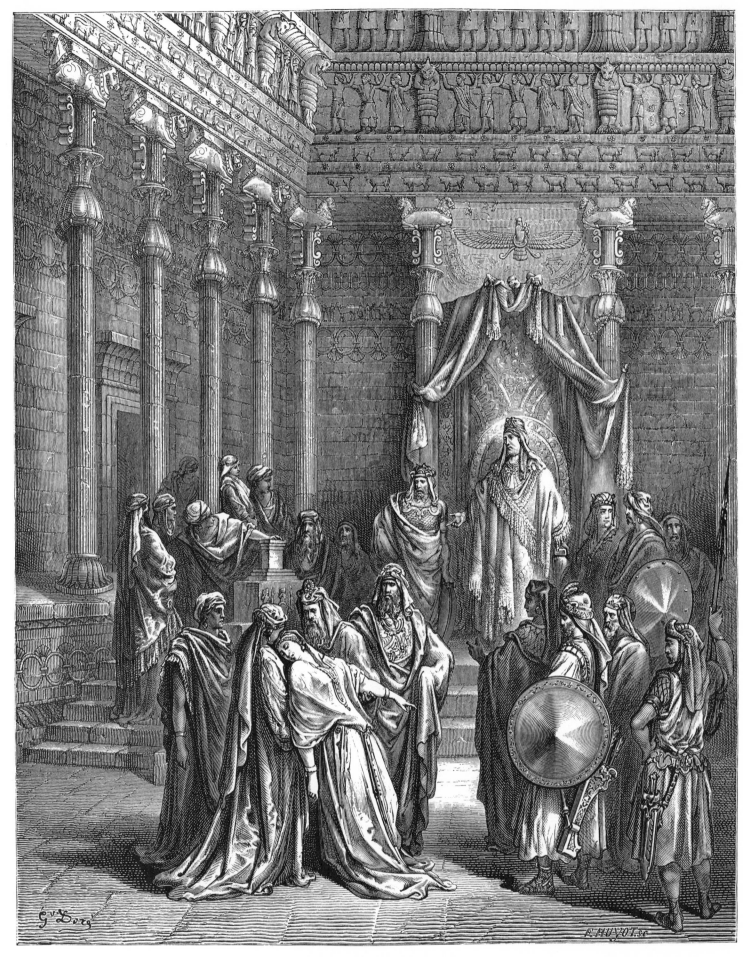

ESTHER BEFORE THE KING

Then . . . she stood before the king . . . and he was very dreadful . . . and the queen
fell down, and was pale, and fainted . . . (Esther [Apocrypha] 15: 6, 7)

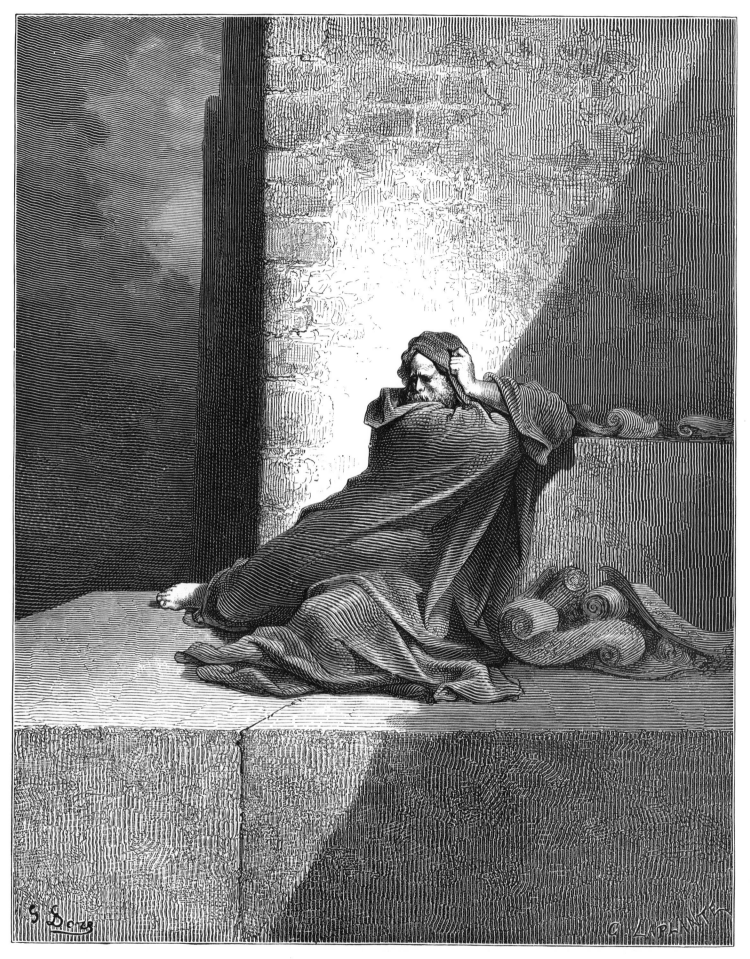

BARUCH

Learn where is wisdom, where is strength, where is understanding; that thou may-
est know also where is length of days, and life, where is the light of the eyes, and
peace . . . (Baruch 3: 14)

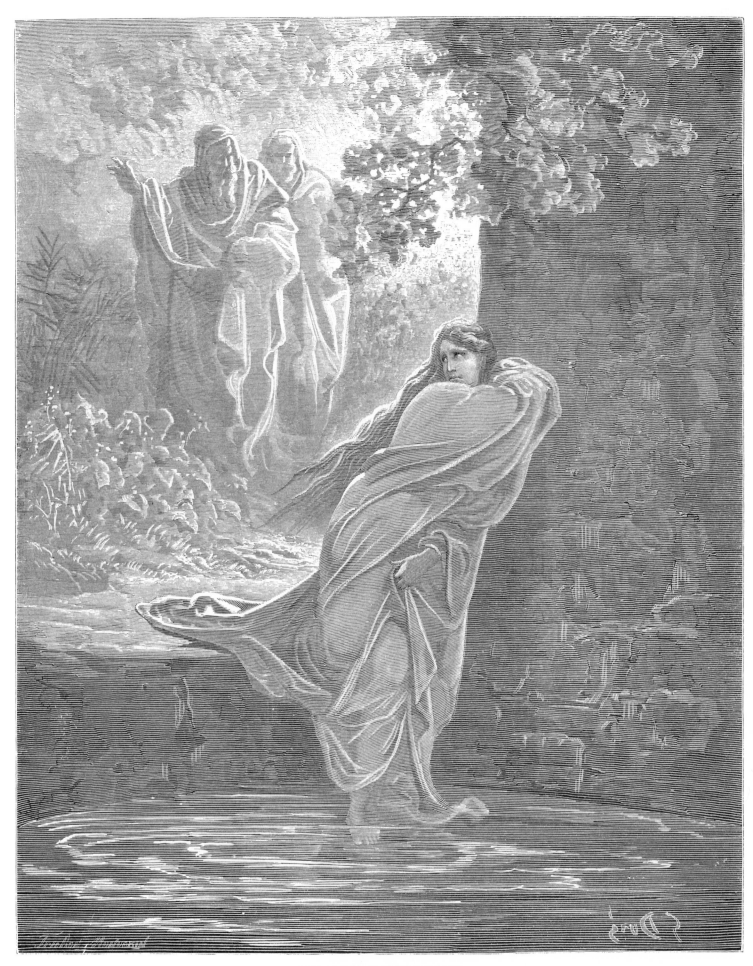

SUSANNA IN THE BATH

If thou wilt not, we will bear witness against thee . . . (The History of Susanna 21)

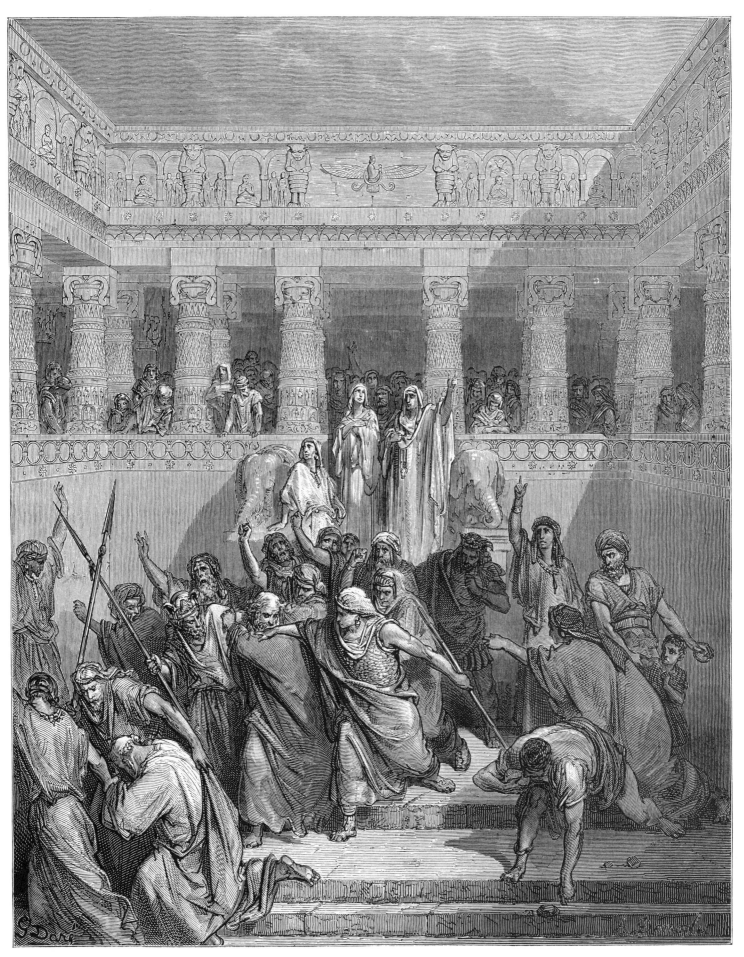

JUSTIFICATION OF SUSANNA

And they arose against the two elders . . . and . . . did unto them in such sort as they
maliciously intended to do to their neighbour; and they put them to death . . .
(The History of Susanna 61, 62)

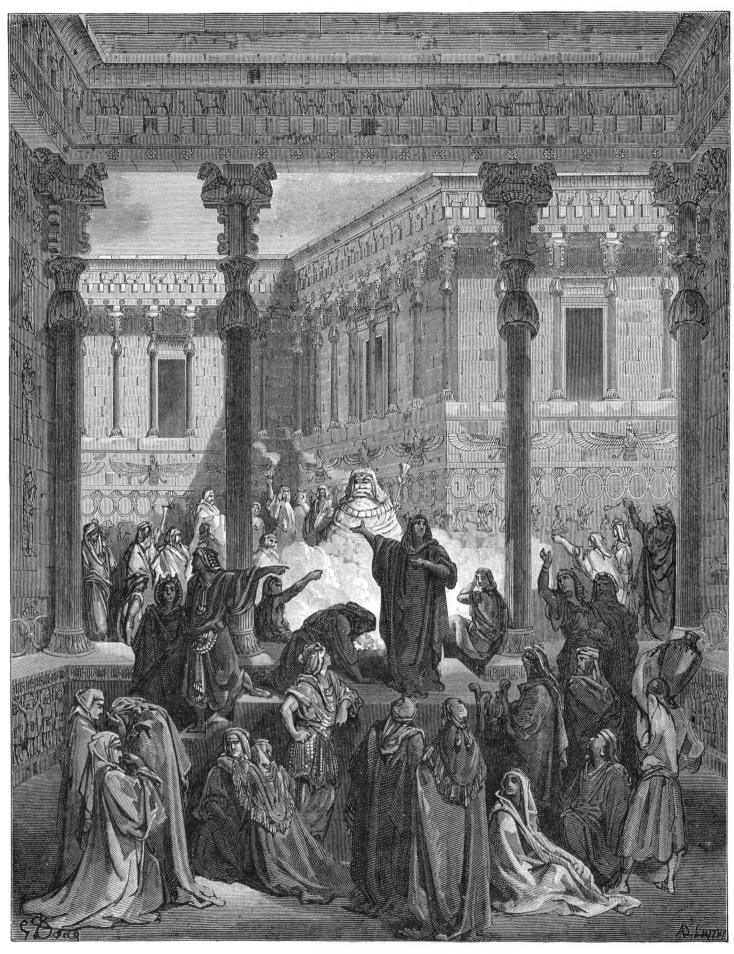

DANIEL CONFOUNDING THE PRIESTS OF BEL

Then Daniel smiled, and said, O king, be not deceived: for this is but clay within,
and brass without, and did never eat or drink any thing . . . (Bel and the Dragon 7)

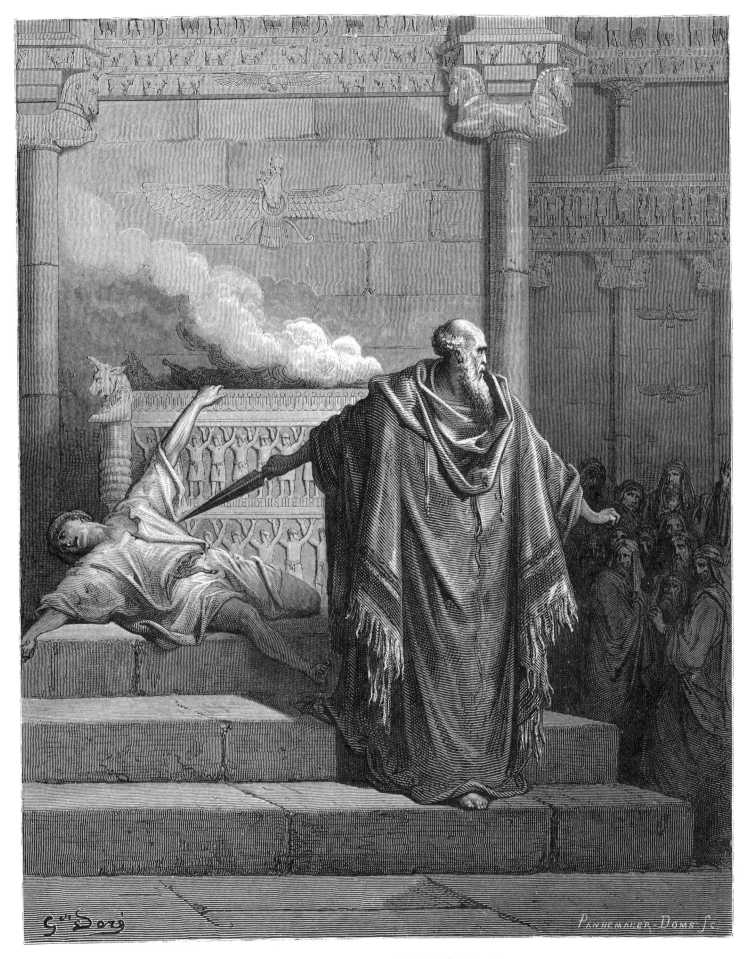

MATTATHIAS AND THE APOSTATE

There came one of the Jews in the sight of all to sacrifice on the altar which was
at Modin, according to the king's commandment. Which thing when Mattathias saw,
he was inflamed with zeal . . . and slew him upon the altar . . . (I Maccabees 2: 23, 24)

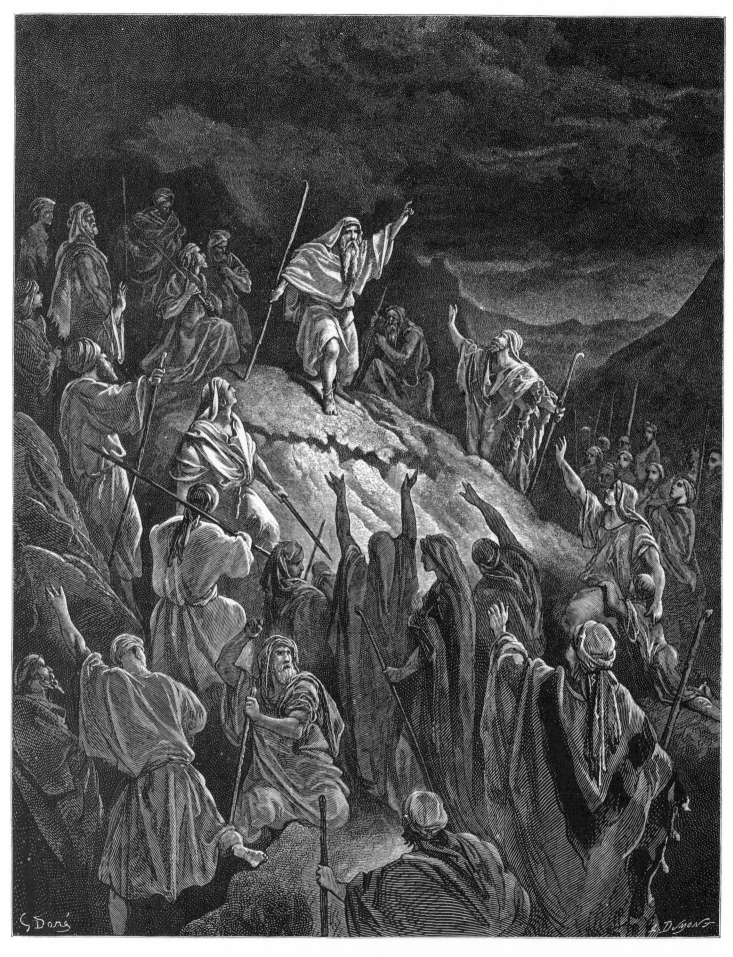

MATTATHIAS APPEALING TO THE JEWISH REFUGEES

Now therefore, my sons, be ye zealous for the law, and give your lives for the cov-
enant of your fathers . . . (I Maccabees 2: 50)

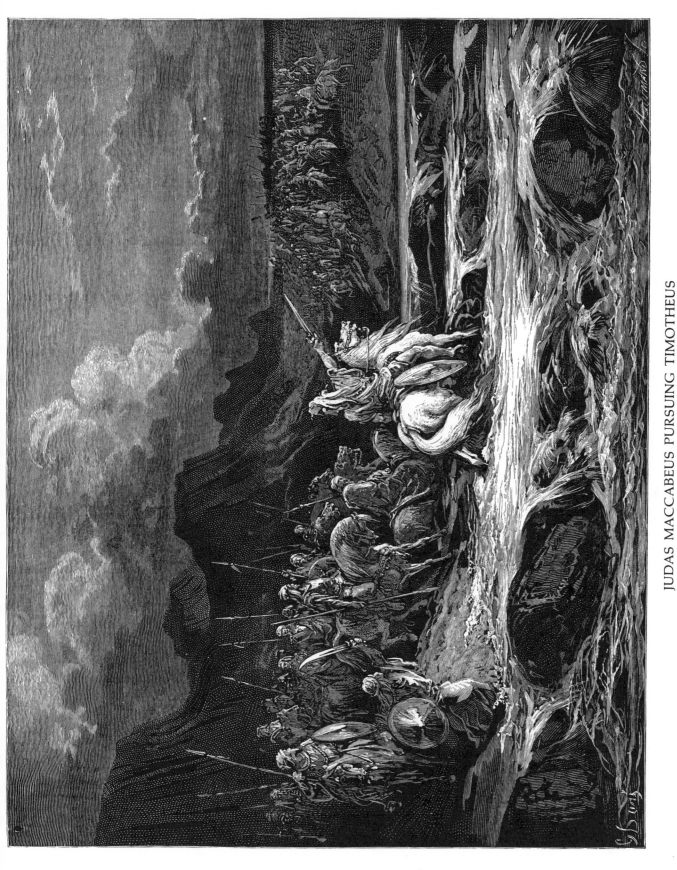

JUDAS MACCABEUS PURSUING TIMOTHEUS

Now when Judas came near the brook . . . he gave commandment, saying, Suffer no
man to remain in the camp, but let all come to the battle . . . (I Maccabees 5: 42)

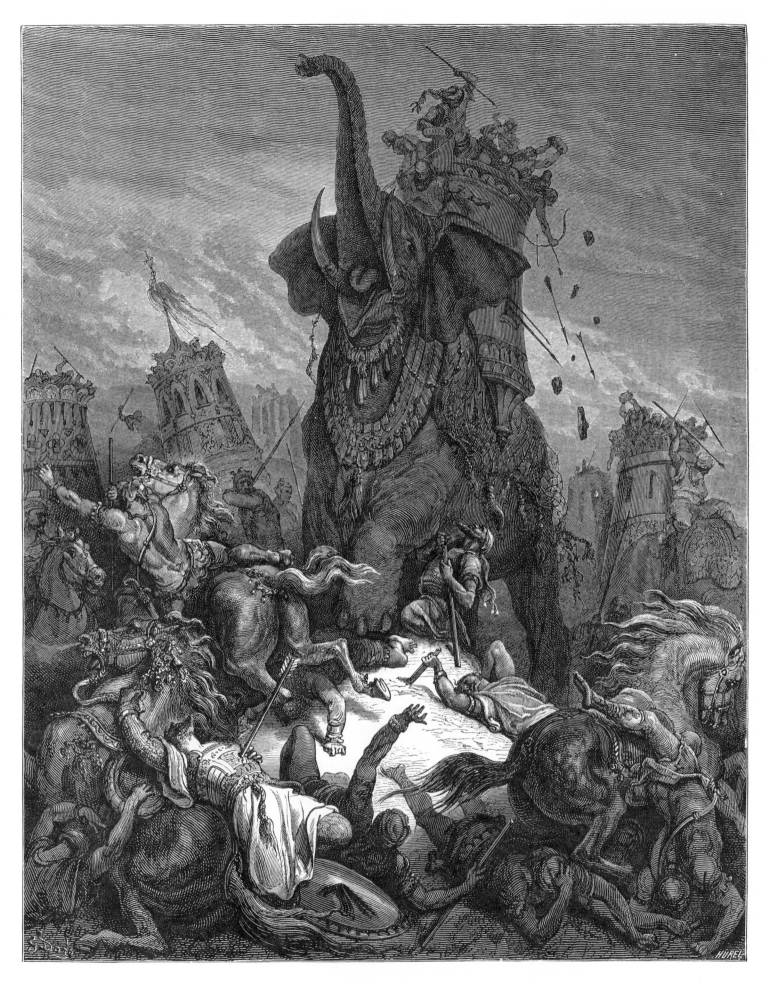

DEATH OF ELEAZAR

Eleazar . . . perceiving that one of the beasts . . . was higher . . . and supposing
that the king was upon him . . . crept under the elephant . . . and slew him: whereupon
the elephant fell down upon him, and there he died . . . (I Maccabees 6: 43, 46)

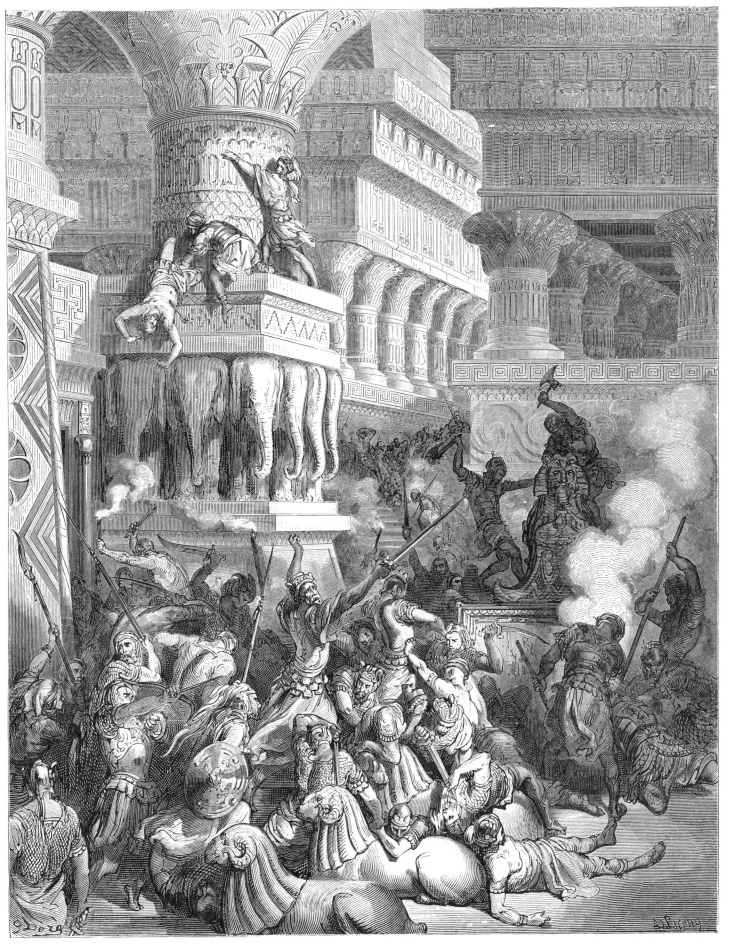

JONATHAN DESTROYING THE TEMPLE OF DAGON

But Jonathan set fire on Azotus, and the cities round about it . . . and the temple of
Dagon, with them that were fled into it, he burned with fire . . . (I Maccabees 10: 84)

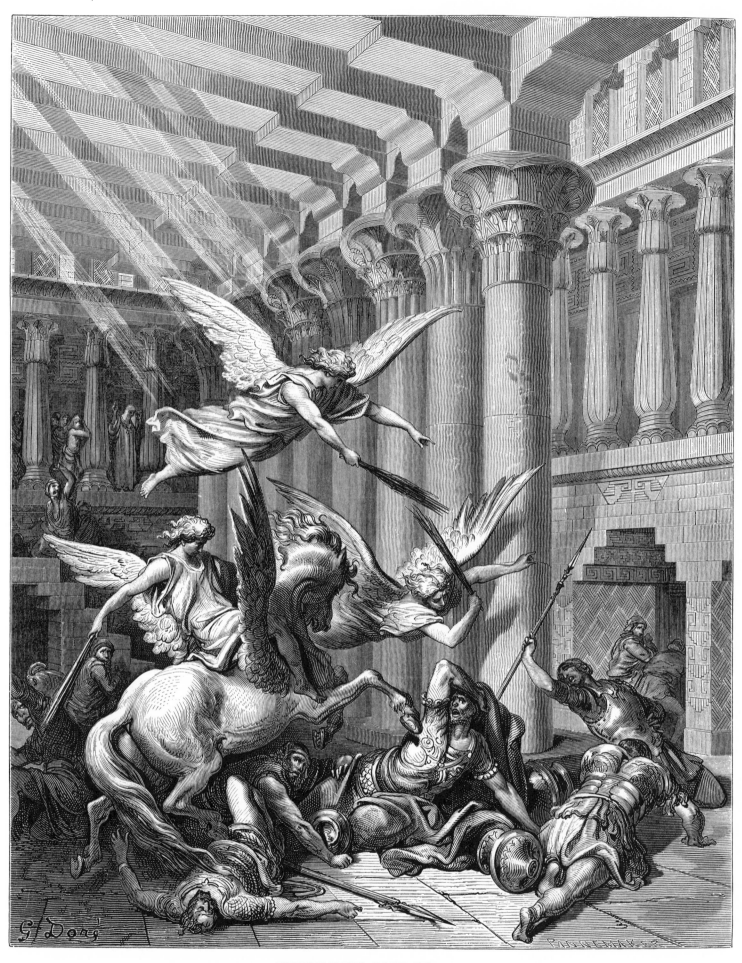

HELIODORUS CAST DOWN

There appeared unto them an horse with a terrible rider . . . and . . . two other young
men . . . notable in strength . . . And Heliodorus fell suddenly unto the ground . . .
(II Maccabees 3: 25, 26, 27)

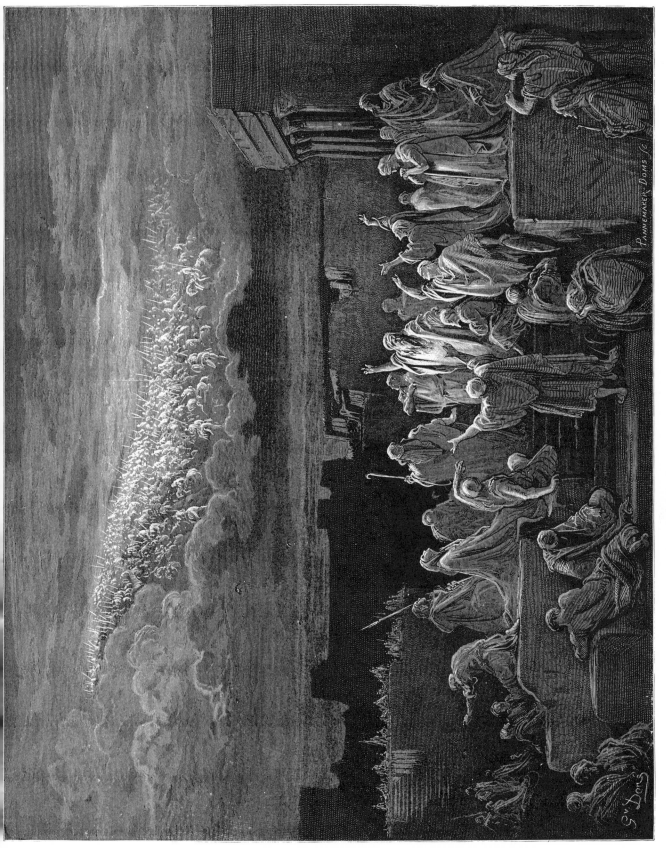

THE APPARITION OF THE ARMY IN THE HEAVENS

Through all the city, for the space almost of forty days, there were seen horsemen
running in the air, in cloth of gold, and armed with lances . . . (II Maccabees 5: 2)

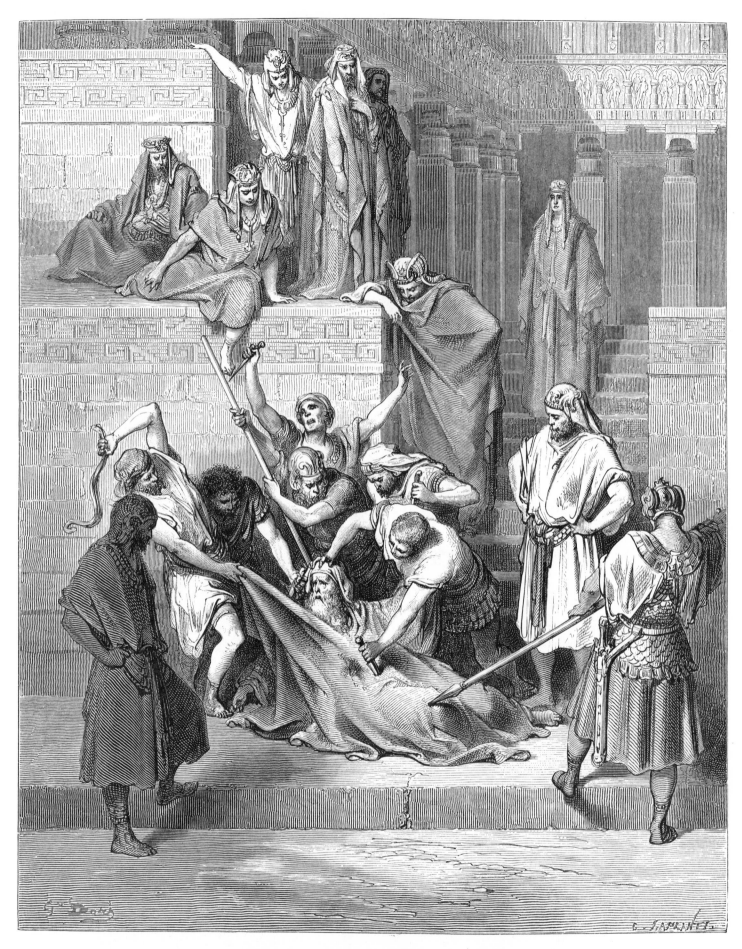

MARTYRDOM OF ELEAZAR THE SCRIBE

But when he was ready to die . . . he groaned, and said . . . whereas I might have
been delivered from death, I now endure sore pains in body by being beaten: but in
soul am well content to suffer these things . . . (II Maccabees 6: 30)

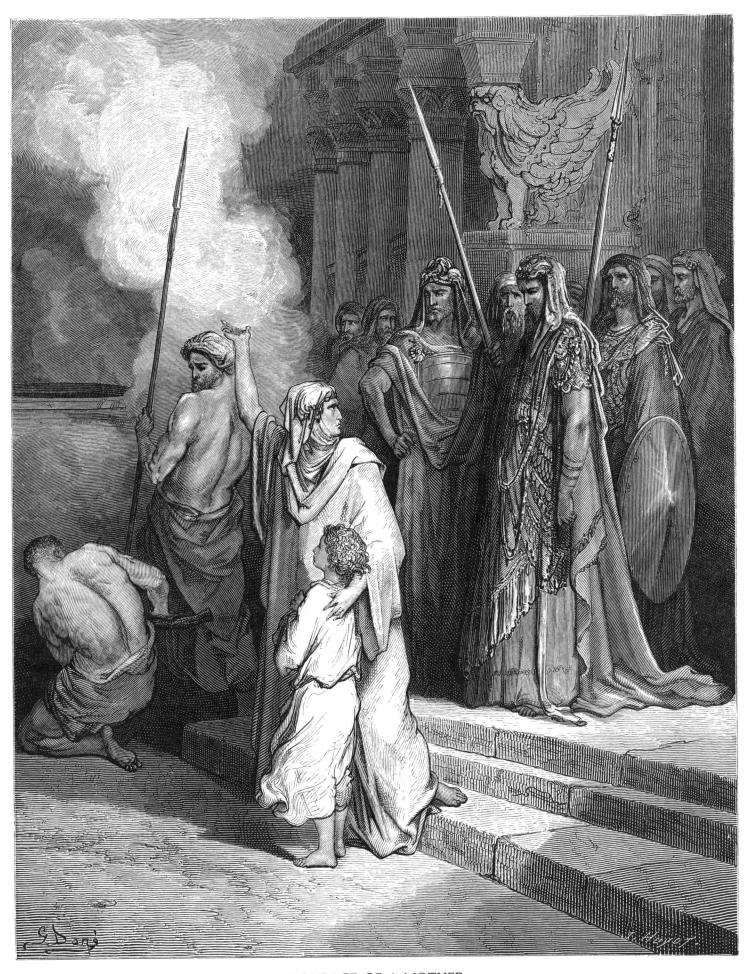

COURAGE OF A MOTHER

Fear not this tormentor, but, being worthy of thy brethren, take thy death, that I may
receive thee again in mercy with thy brethren . . . (II Maccabees 7: 29)

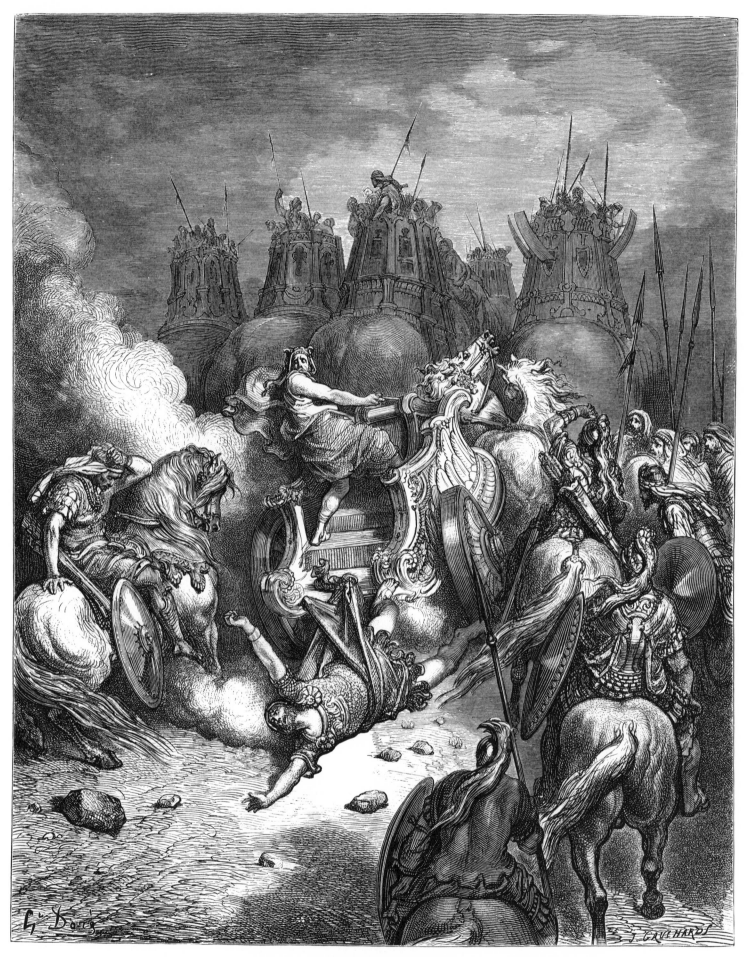

THE PUNISHMENT OF ANTIOCHUS

It came to pass that he fell down from his chariot . . . so that . . . all the members of his body were much pained . . . The worms rose up out of the body of this wicked man, and . . . his flesh fell away, and the filthiness of his smell was noisome to all his army . . . (II Maccabees 9: 7, 9)

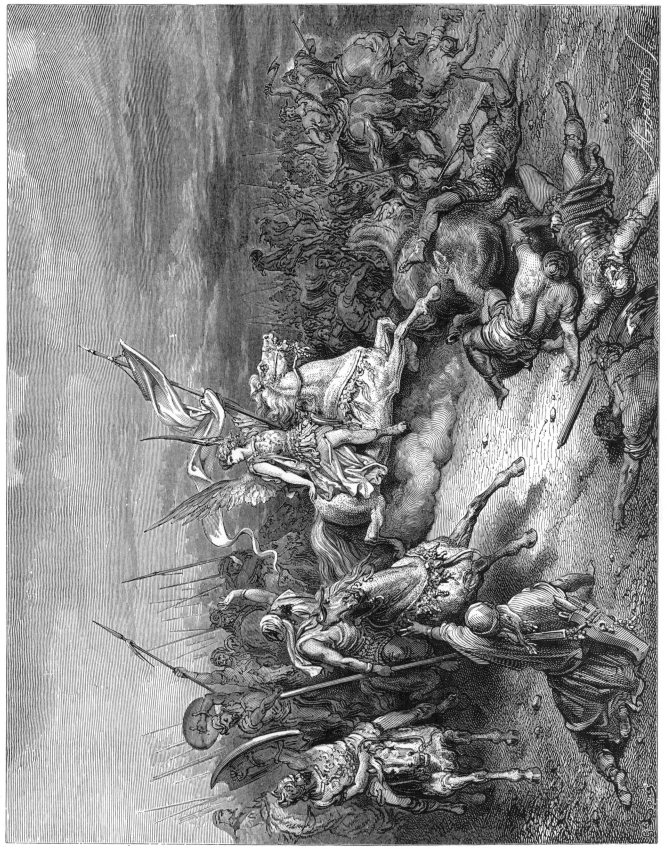

THE ANGEL SENT TO DELIVER ISRAEL

And as they were at Jerusalem, there appeared before them on horseback one in white clothing, shaking his armour of gold....(II Maccabees 11: 8)

159

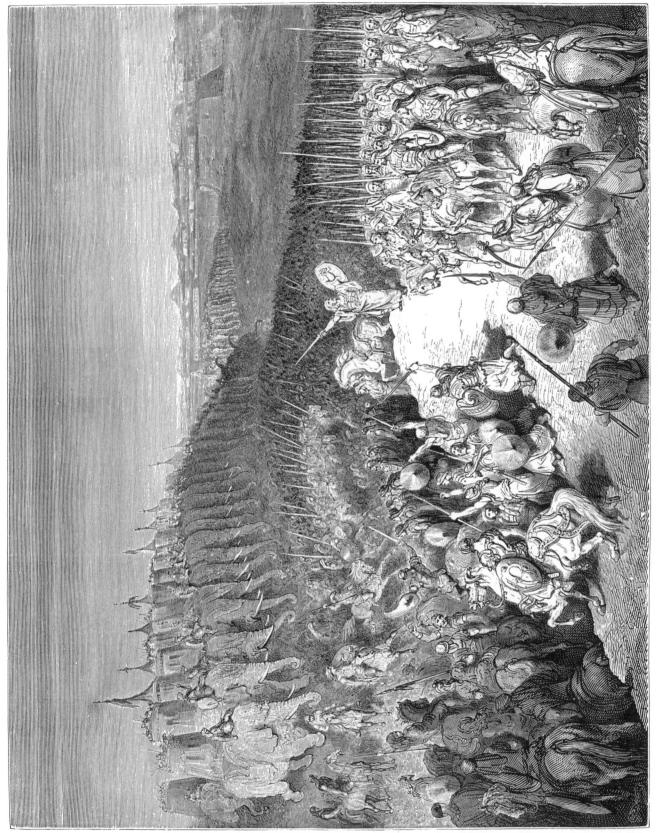

JUDAS MACCABEUS BEFORE THE ARMY OF NICANOR

Maccabeus seeing the coming of the multitude, and the divers preparations of armour, and the fierceness of the beasts, stretched out his hands toward heaven, and called upon the Lord that worketh wonders ... (II Maccabees 15: 21)

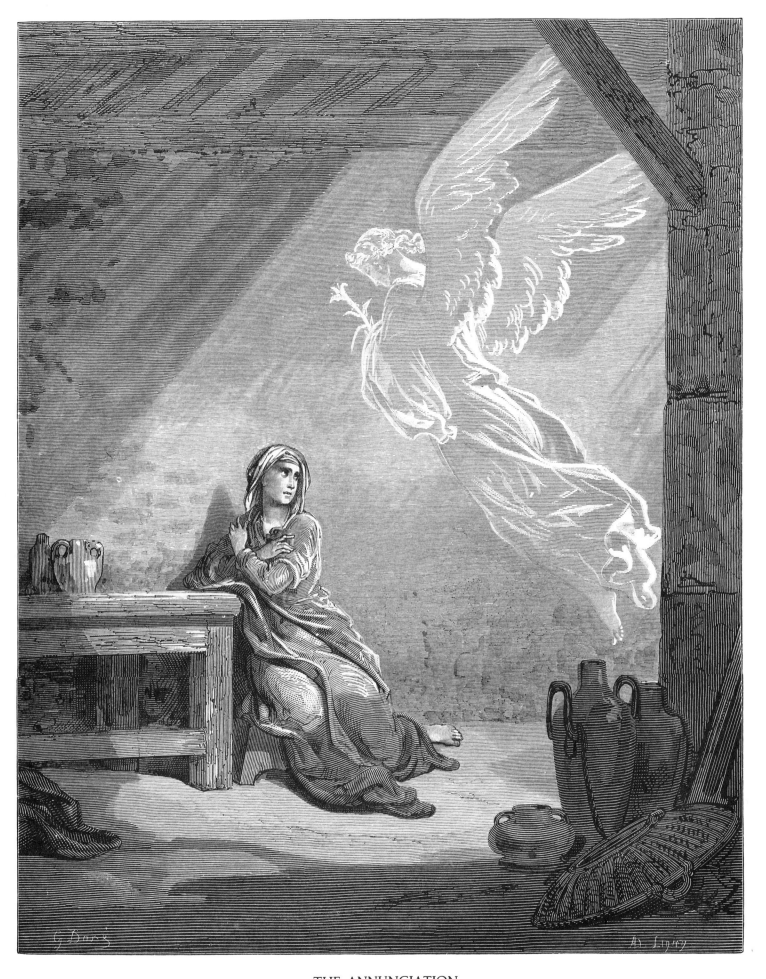

THE ANNUNCIATION
And the angel said unto her, Fear not, Mary: for thou hast found favour with God
. . .(Luke 1: 30)

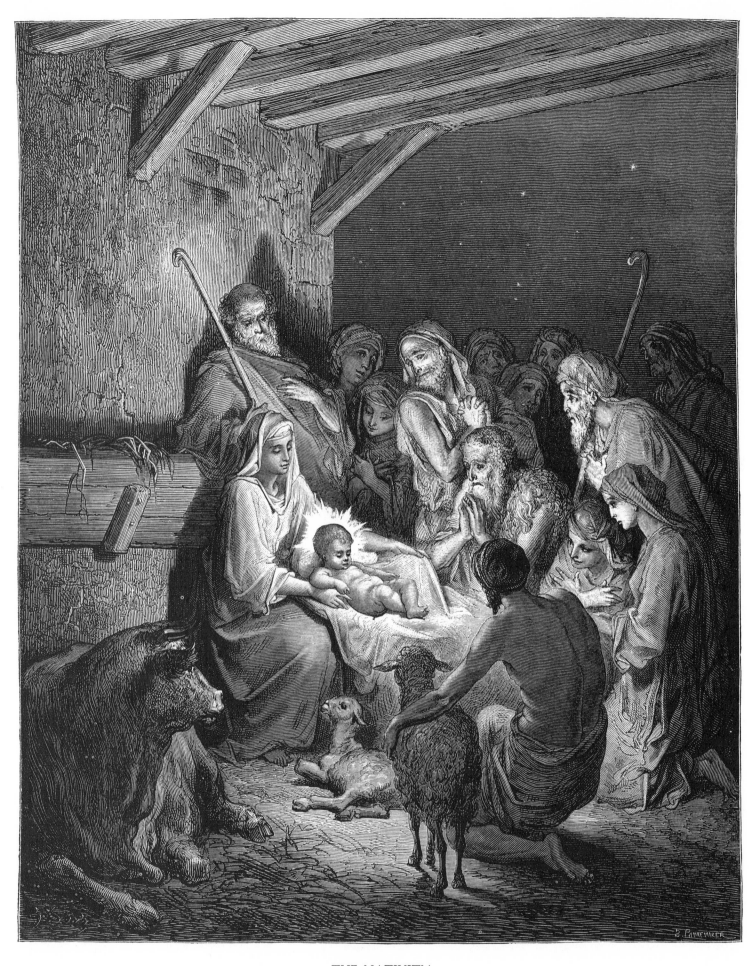

THE NATIVITY

And they came with haste, and found Mary, and Joseph, and the babe lying in a
manger.... (Luke 2:16)

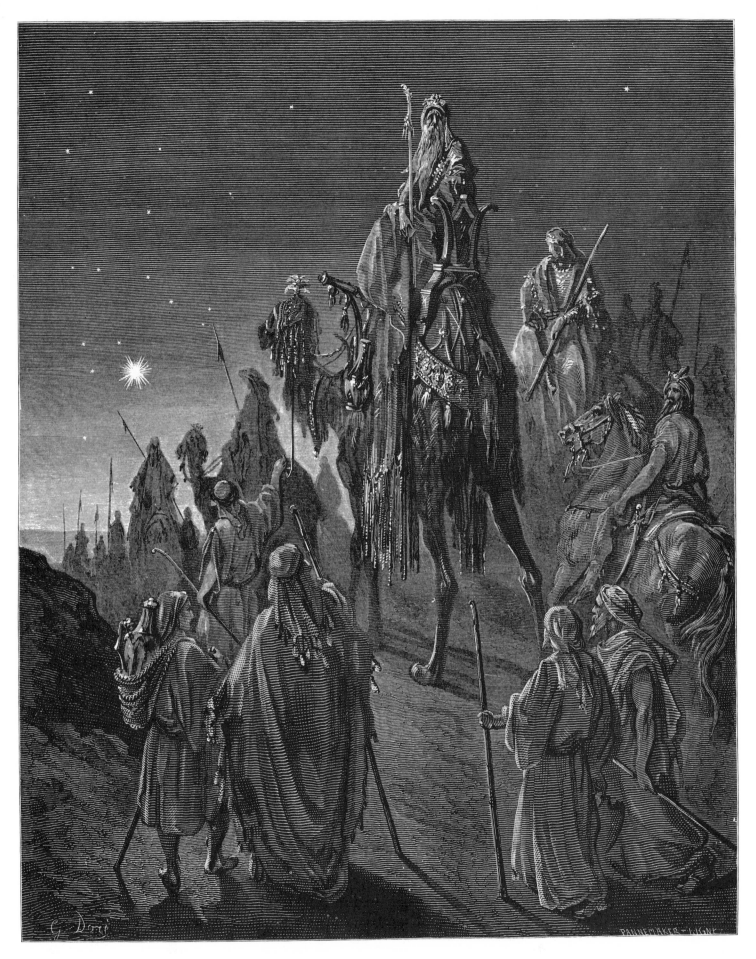

THE WISE MEN GUIDED BY THE STAR

And, lo, the star, which they saw in the east, went before them, till it came and
stood over where the young child was....(Matthew 2: 9)

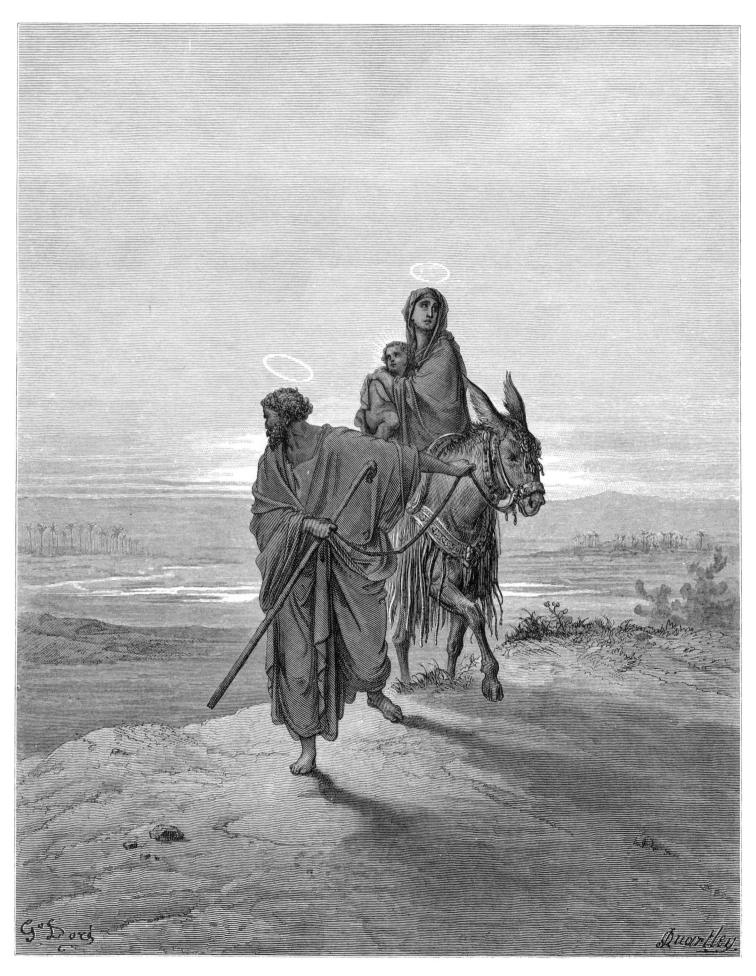

THE FLIGHT INTO EGYPT

Arise, and take the young child and his mother, and flee into Egypt, and be thou
there until I bring thee word: for Herod will seek the young child to destroy him.
...(Matthew 2: 13)

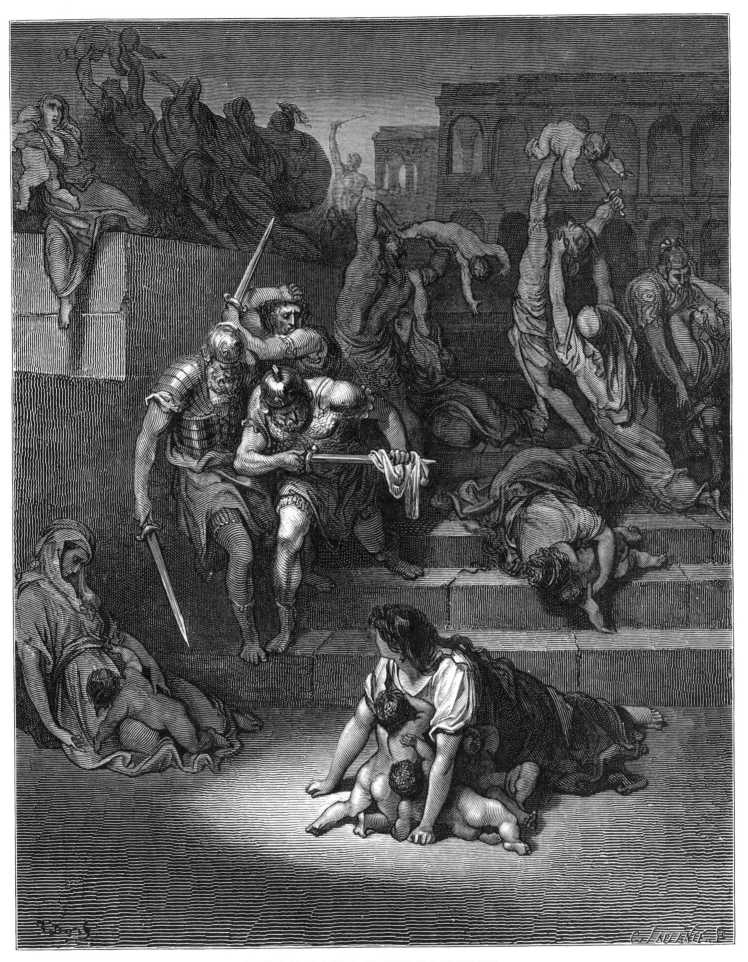

THE MASSACRE OF THE INNOCENTS

Then Herod...was exceeding wroth...and slew all the children that were in
Bethlehem, and in all the coasts thereof, from two years old and under...
(Matthew 2:16)

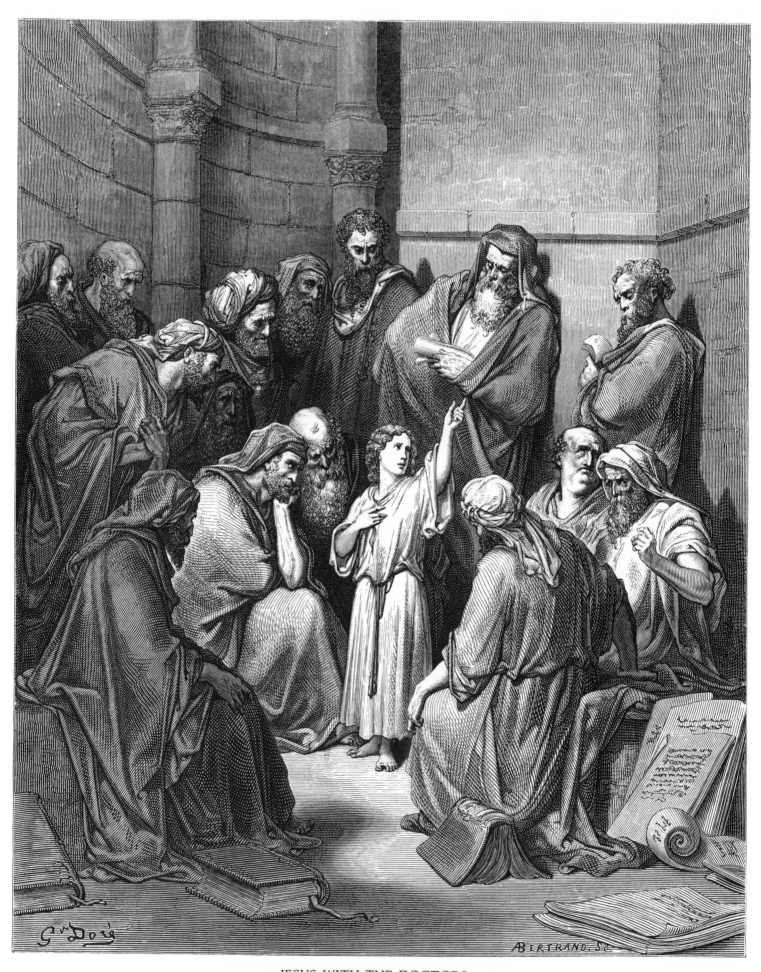

JESUS WITH THE DOCTORS

And he said unto them, How is it that ye sought me? wist ye not that I must be
about my Father's business?...(Luke 2:49)

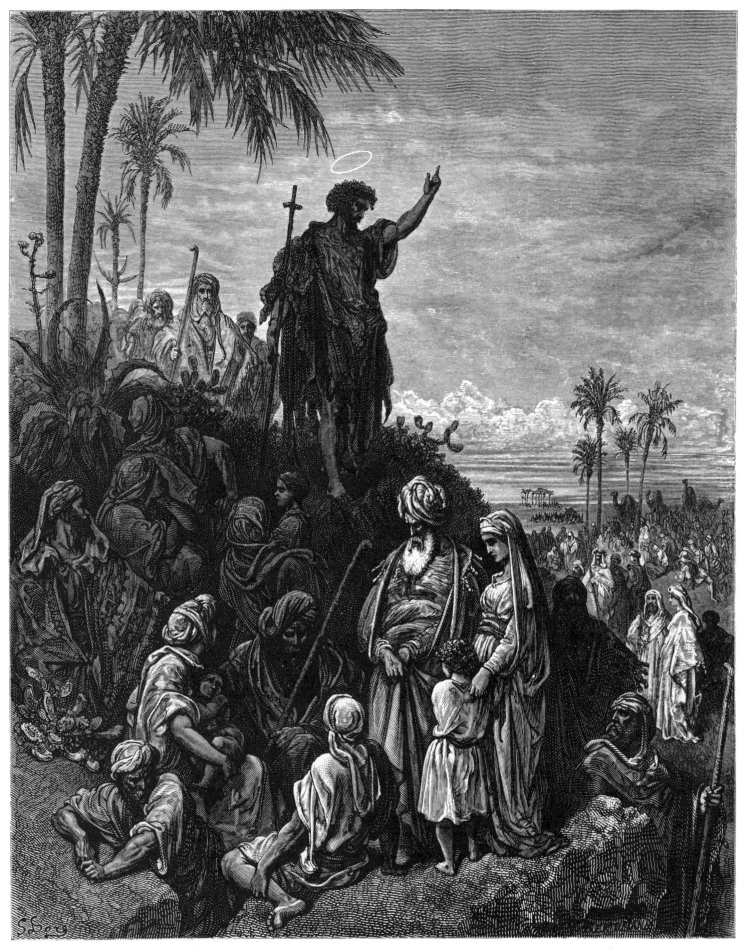

JOHN THE BAPTIST PREACHING IN THE WILDERNESS

John did baptize in the wilderness, and preach the baptism of repentance for the
remission of sins.... (Mark 1: 4)

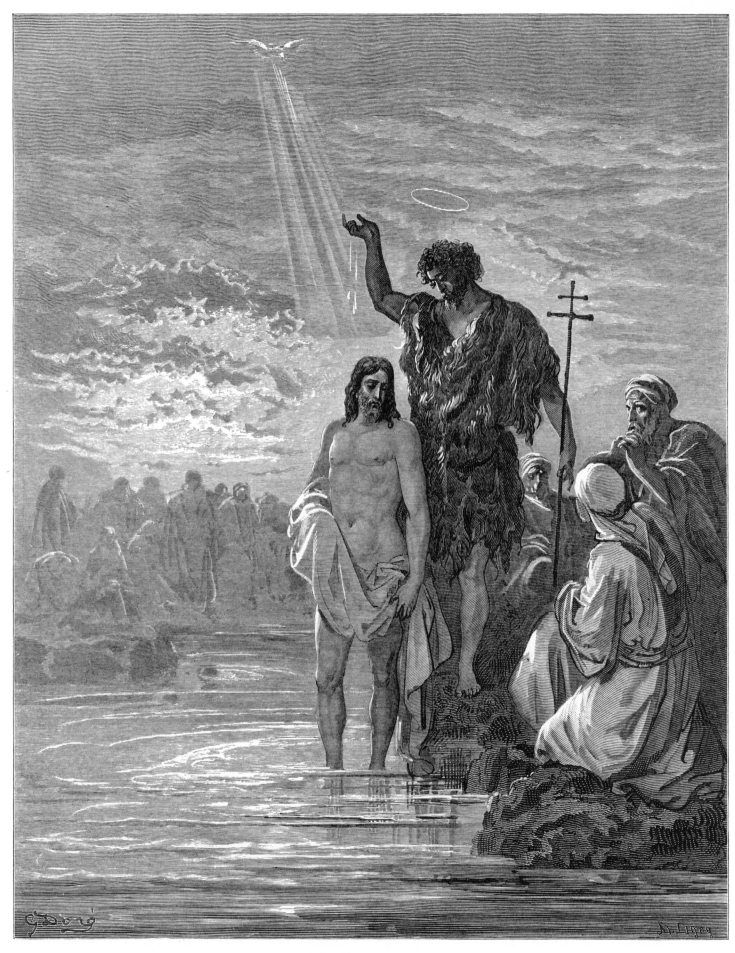

THE BAPTISM OF JESUS

The Spirit of God descending like a dove... And lo a voice from heaven, saying,
This is my beloved Son, in whom I am well pleased.... (Matthew 3: 16, 17)

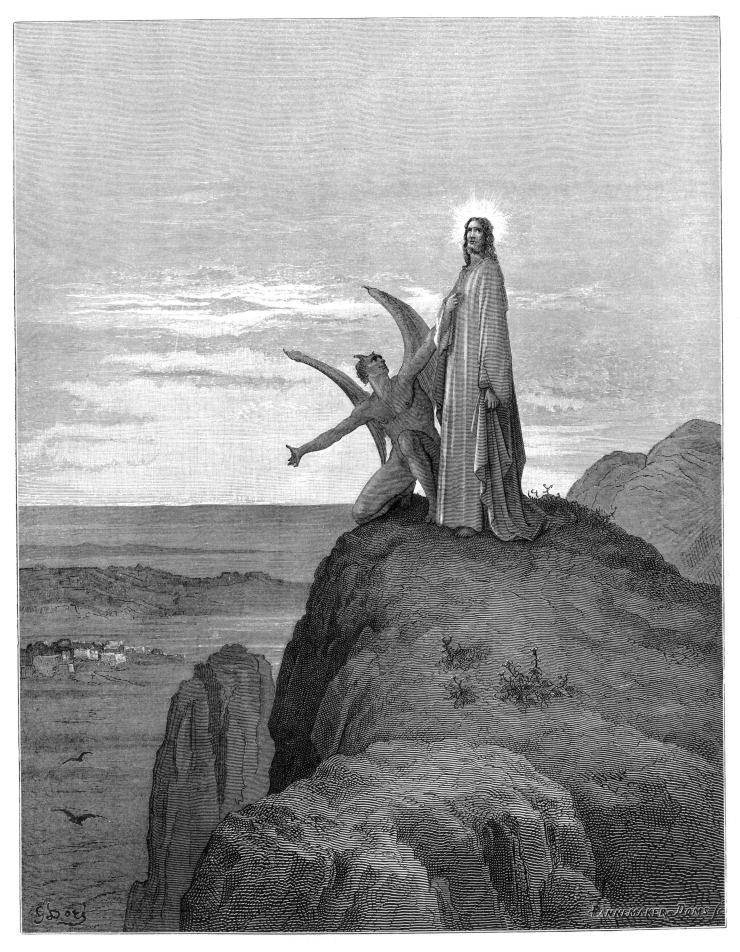

THE TEMPTATION OF JESUS

And the devil, taking him up into an high mountain, shewed unto him all the kingdoms
of the world in a moment of time... (Luke 4: 5)

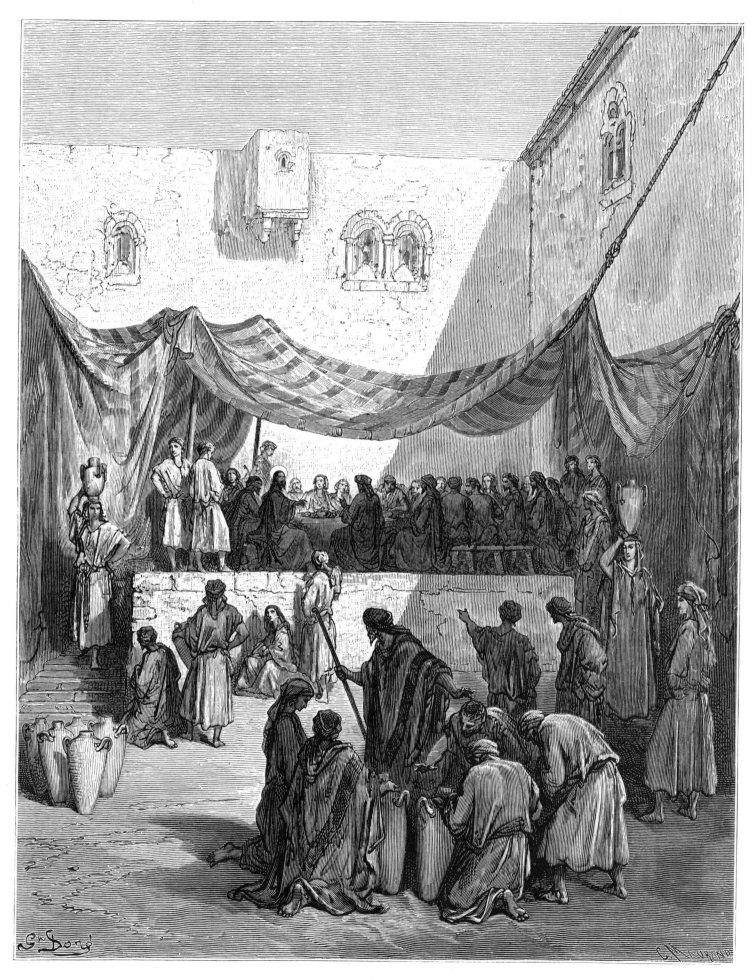

THE MARRIAGE IN CANA

Jesus saith unto them, Fill the waterpots with water . . . (John 2: 7)

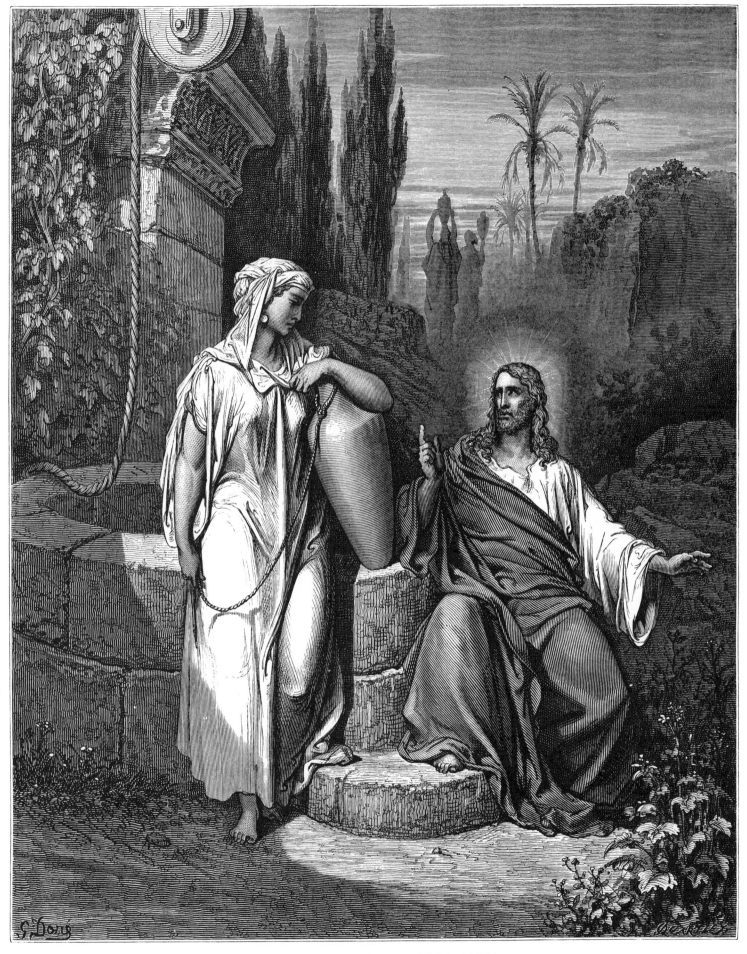

JESUS AND THE WOMAN OF SAMARIA

How is it that thou, being a Jew, askest drink of me, which am a woman of Samaria?
for the Jews have no dealings with the Samaritans.... (John 4: 9)

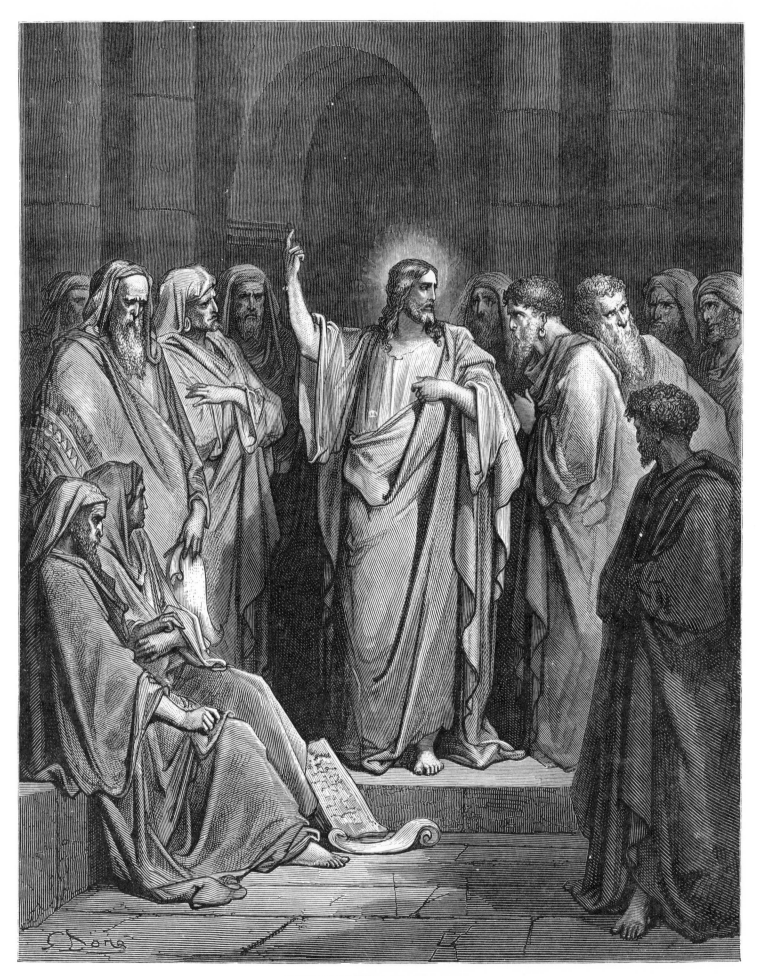

CHRIST IN THE SYNAGOGUE

And when he was come into his own country, he taught them in their synagogue, in-
somuch that they were astonished, and said,... Is not this the carpenter's son?
...(Matthew 13: 54, 55)

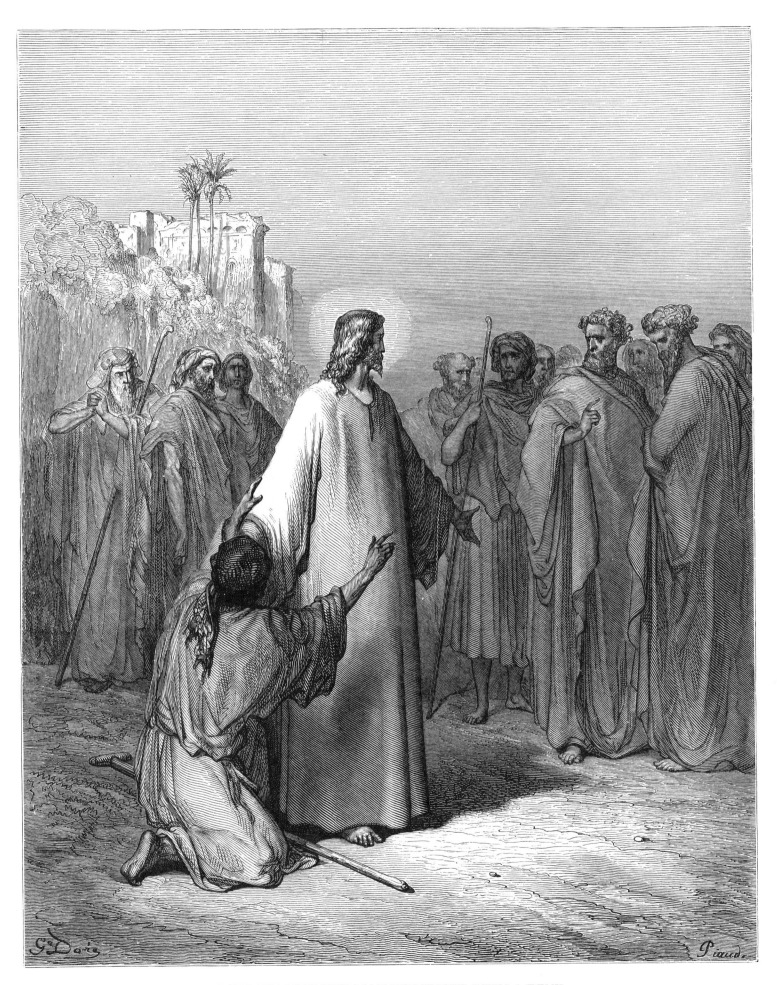

JESUS HEALING THE MAN POSSESSED WITH A DEVIL

And they were all amazed...saying, What a word is this! for with authority and
power he commandeth the unclean spirits, and they come out....(Luke 4: 36)

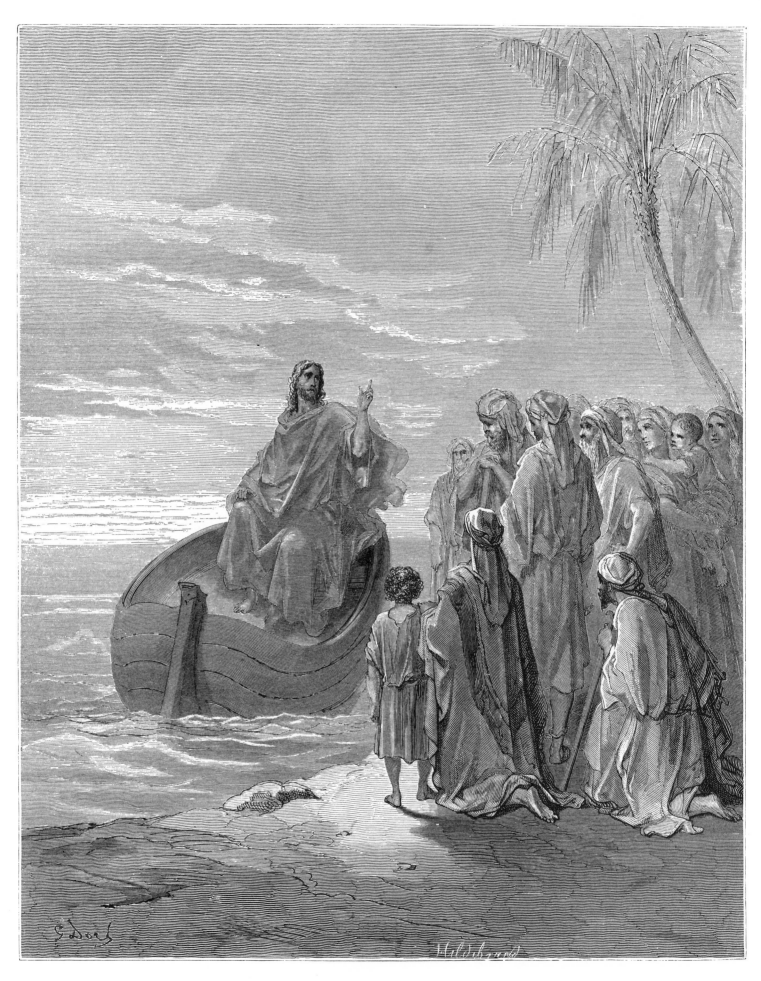

JESUS PREACHING AT THE SEA OF GALILEE

And it came to pass, that, as the people pressed upon him to hear the word of God
...he entered into one of the ships, which was Simon's...And he sat down, and
taught the people out of the ship....(Luke 5: 1, 3)

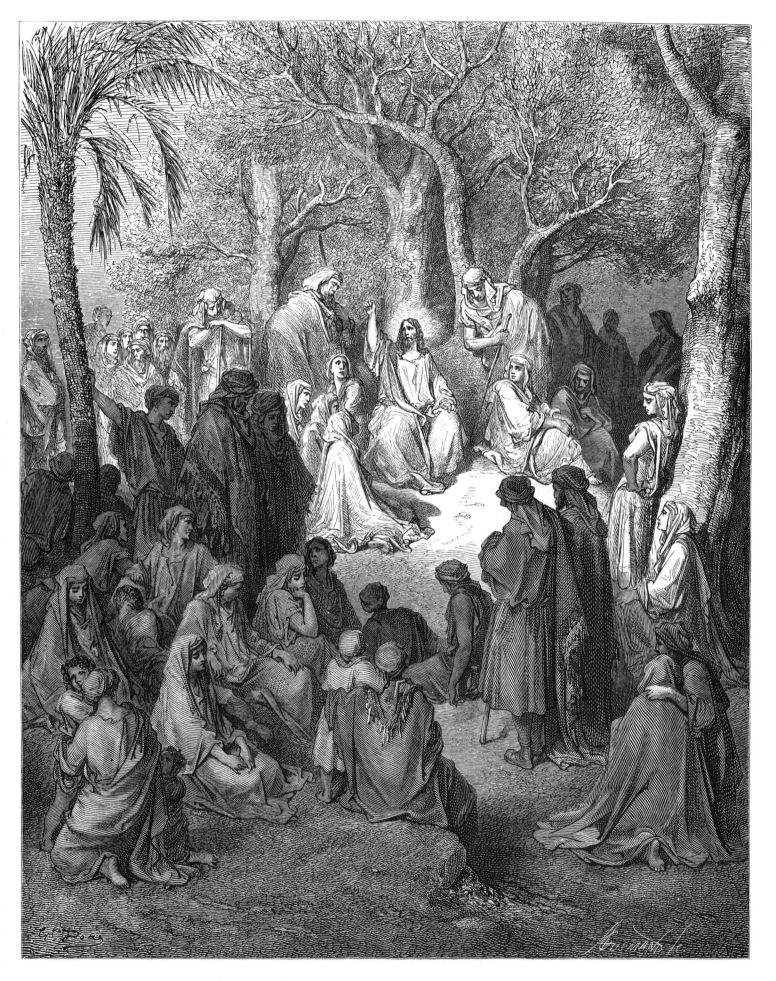

THE SERMON ON THE MOUNT

Consider the lilies of the field, how they grow; they toil not, neither do they spin:
And yet I say unto you, That even Solomon in all his glory was not arrayed like one
of these. . . . (Matthew 6: 28, 29)

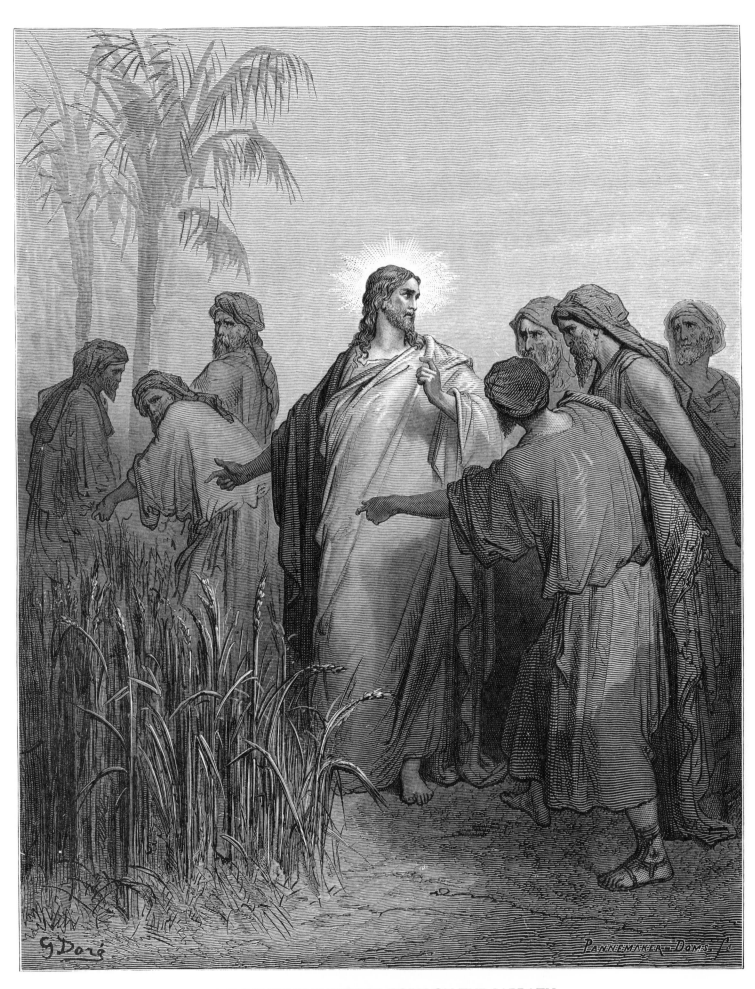

THE DISCIPLES PLUCKING CORN ON THE SABBATH

And he said unto them, The sabbath was made for man, and not man for the sabbath.
...(Mark 2: 27)

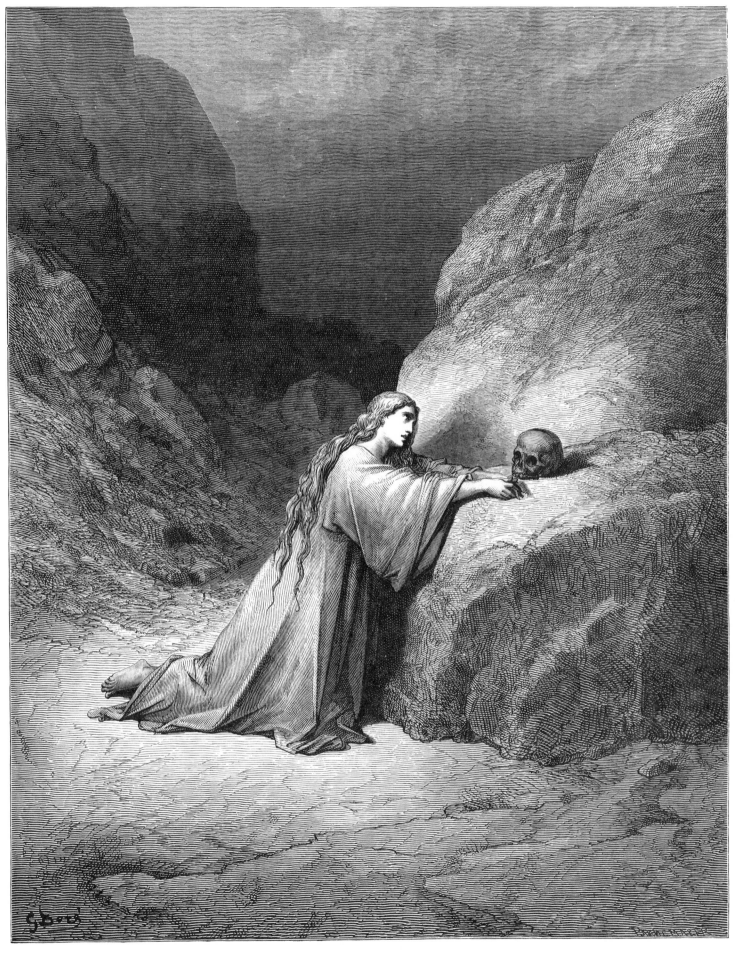

MARY MAGDALENE REPENTANT

Wherefore I say unto thee, Her sins, which are many, are forgiven; for she loved
much: but to whom little is forgiven, the same loveth little.... (Luke 7: 47)

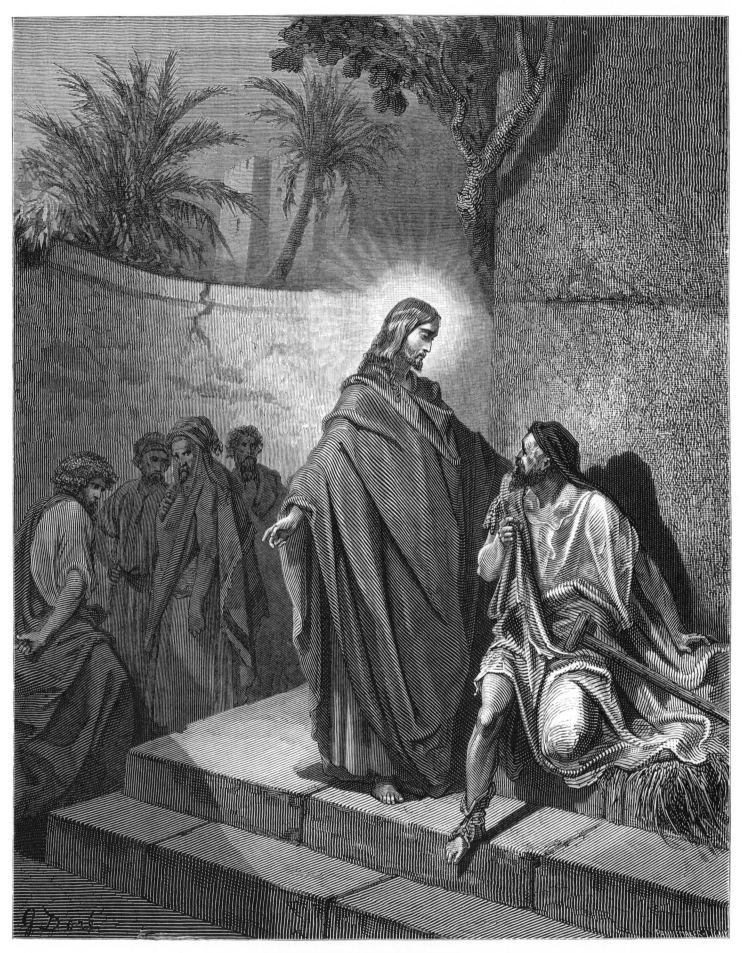

THE DUMB MAN POSSESSED

Then was brought unto him one possessed with a devil, blind, and dumb: and he healed him, insomuch that the blind and dumb both spake and saw.... (Matthew 12:22)

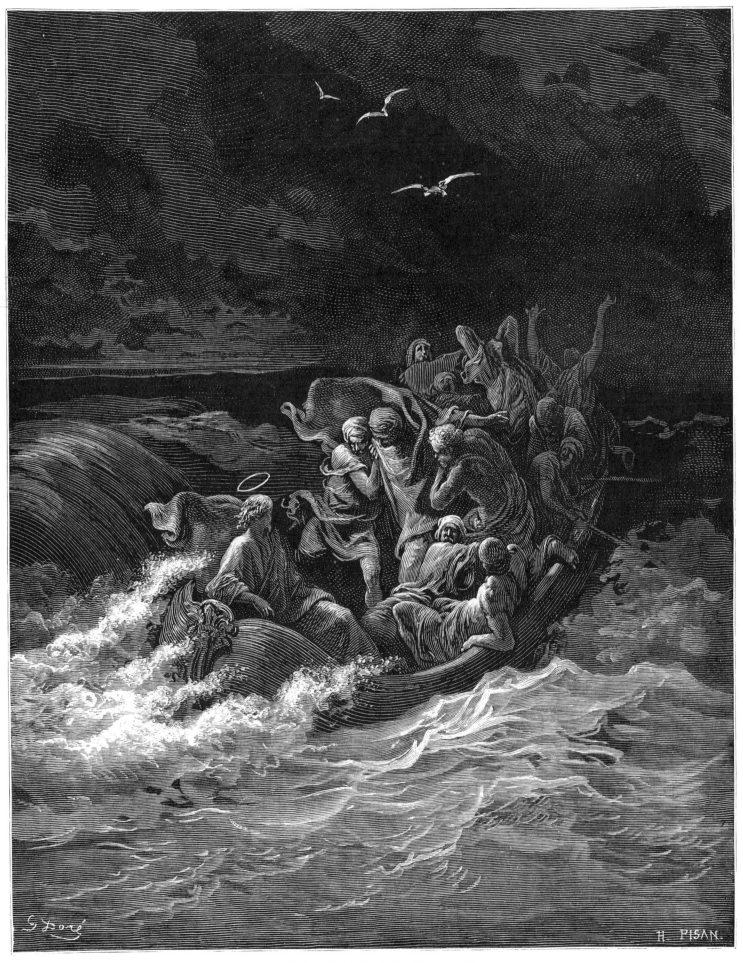

JESUS STILLING THE TEMPEST

And he arose, and rebuked the wind, and said unto the sea, Peace, be still. And the
wind ceased, and there was a great calm.... (Mark 4: 39)

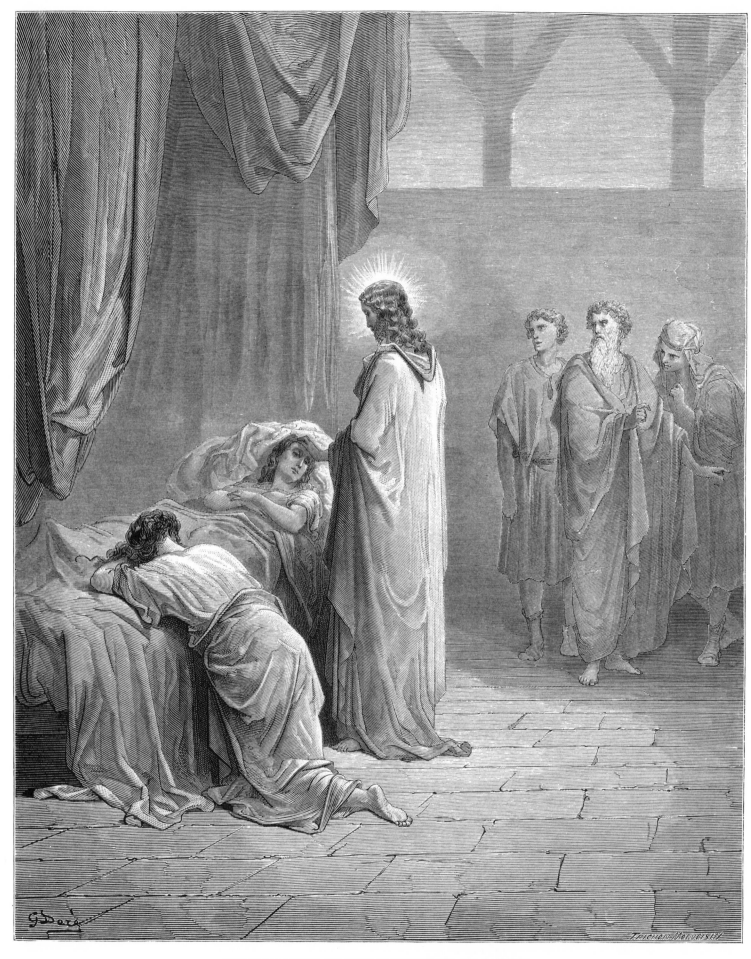

JESUS RAISING UP THE DAUGHTER OF JAIRUS

And he . . . took her by the hand, and called, saying, Maid, arise. . . . (Luke 8: 54)

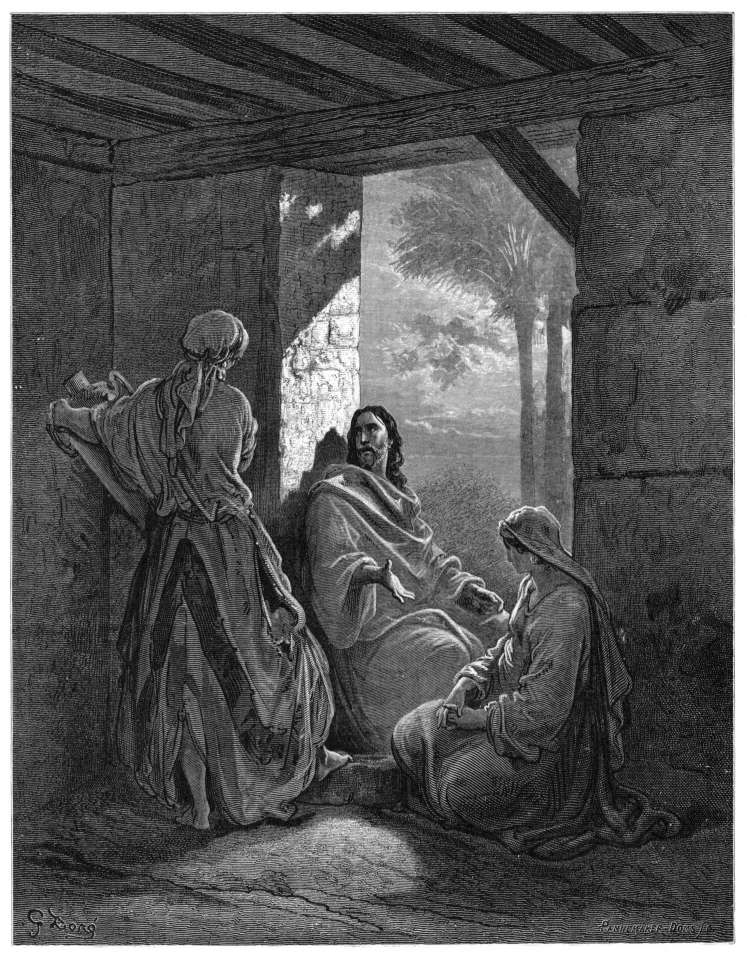

JESUS AT THE HOUSE OF MARTHA AND MARY

Martha, Martha, thou art careful and troubled about many things: But one thing is
needful: and Mary hath chosen that good part, which shall not be taken away from her
...(Luke 10: 41, 42)

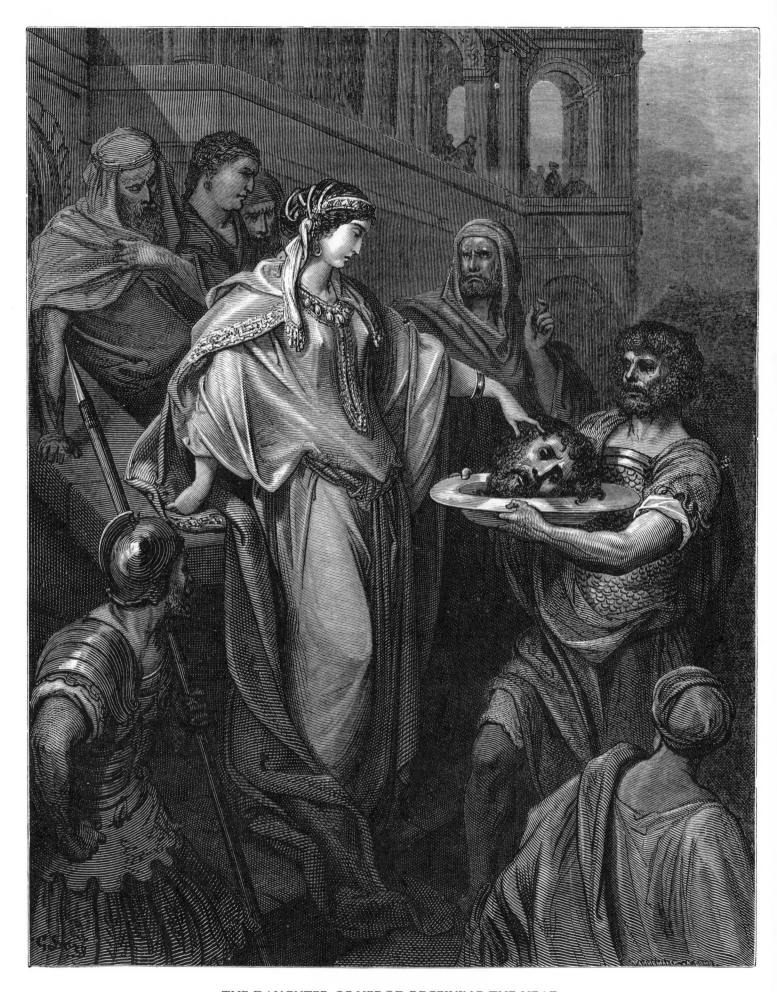

THE DAUGHTER OF HEROD RECEIVING THE HEAD
OF JOHN THE BAPTIST

But when Herod's birthday was kept, the daughter of Herodias danced before them,
and pleased Herod...And she, being before instructed of her mother, said, Give
me here John Baptist's head in a charger...(Matthew 14: 6, 8)

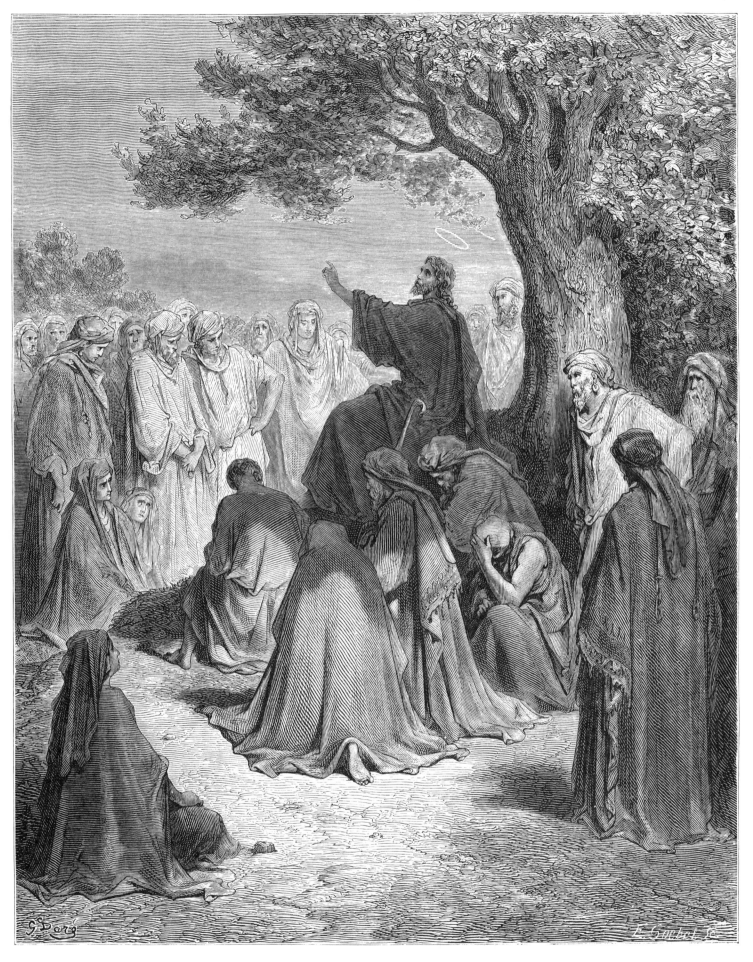

JESUS PREACHING TO THE MULTITUDE

The life is more than meat, and the body is more than raiment...But rather seek
ye the kingdom of God; and all these things shall be added unto you.
...(Luke 12: 23, 31)

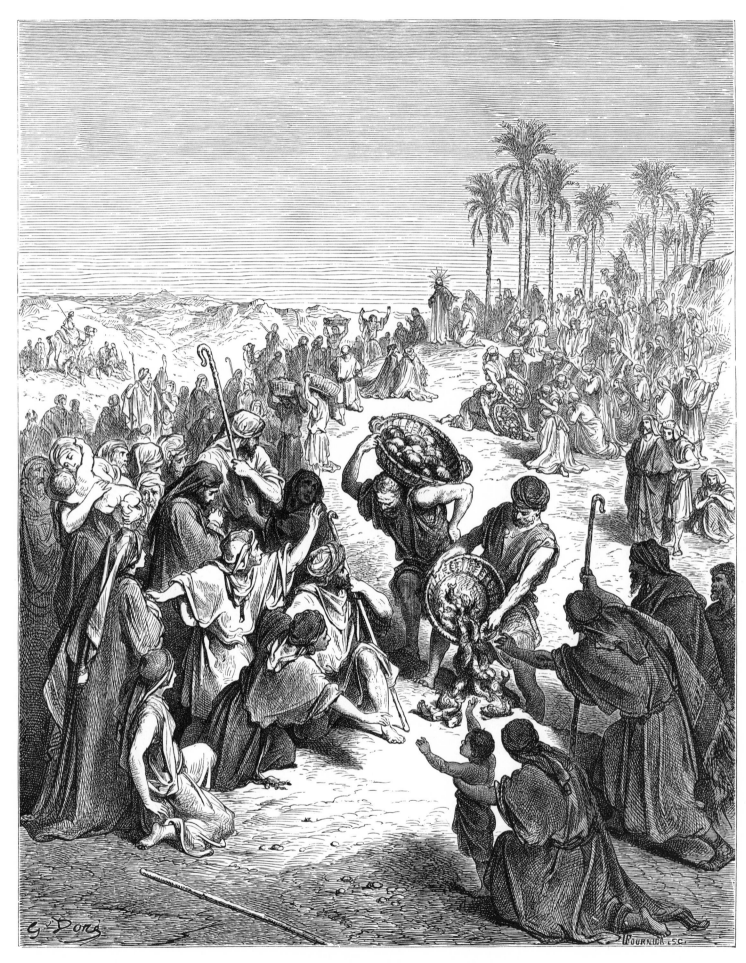

CHRIST FEEDING THE MULTITUDE

And they say unto him, We have here but five loaves, and two fishes. He said, Bring
them hither to me. . . . (Matthew 14: 17, 18)

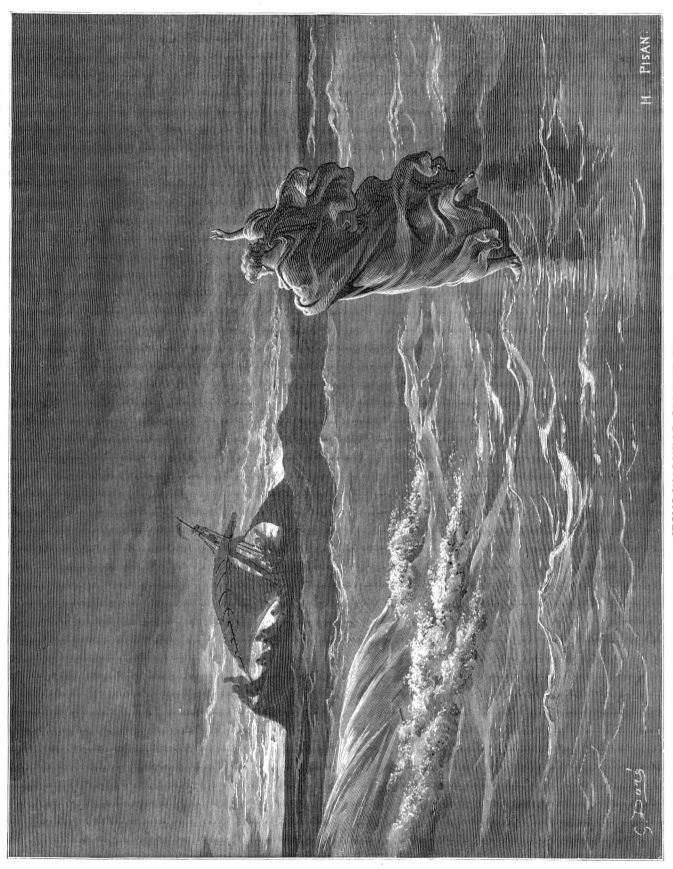

JESUS WALKING ON THE SEA

He saith unto them, It is I; be not afraid. . . . (John 6: 20)

185

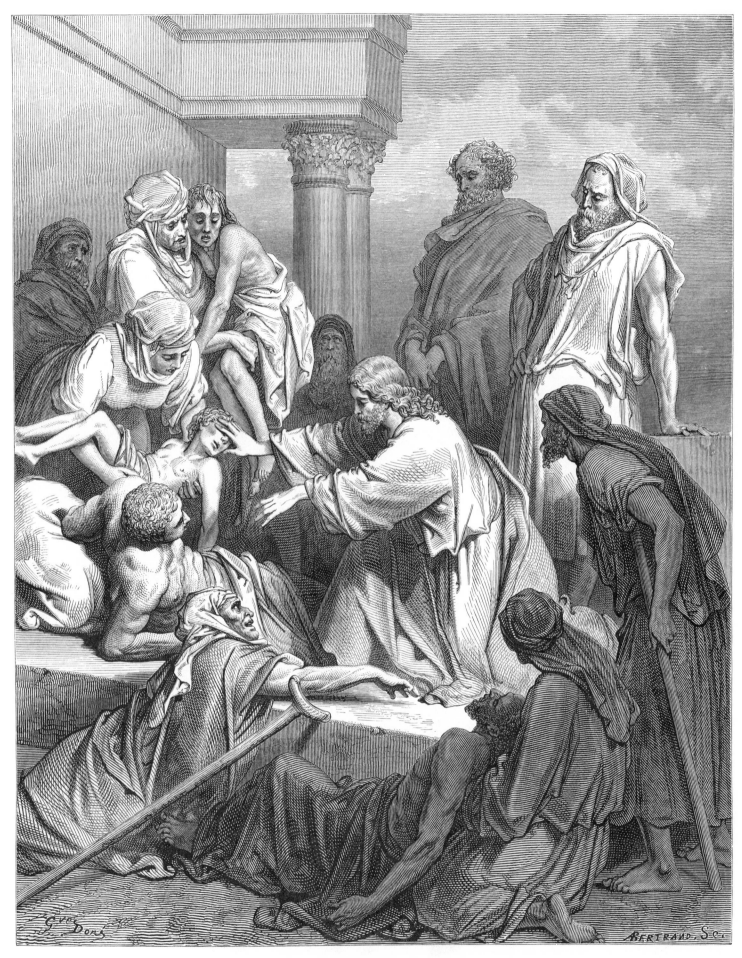

JESUS HEALING THE SICK

And great multitudes came unto him, having with them those that were lame, blind,
dumb, maimed, and many others, and cast them down at Jesus' feet; and he healed
them...(Matthew 15: 30)

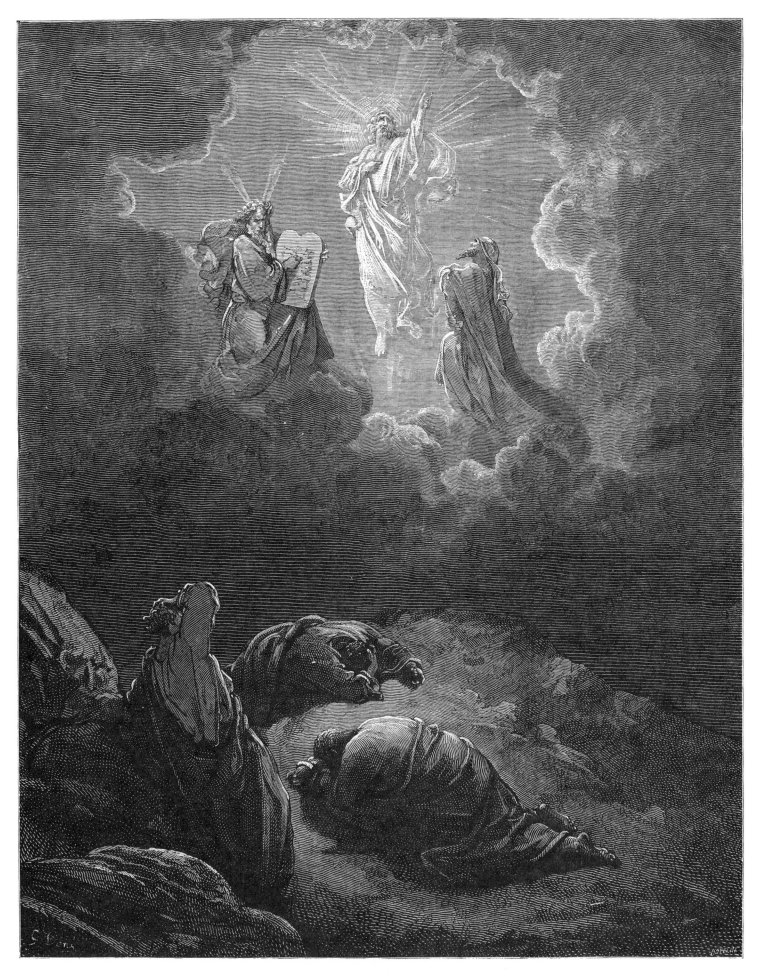

THE TRANSFIGURATION
And there appeared unto them Elias with Moses: and they were talking with Jesus.
. . . (Mark 9: 4)

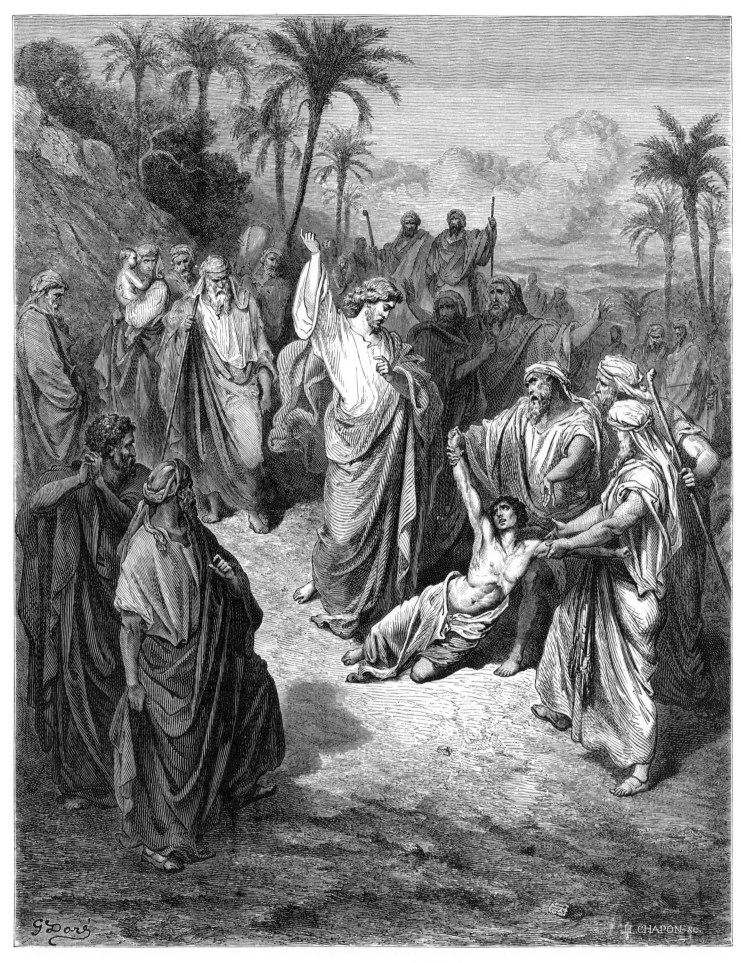

JESUS HEALING THE LUNATIC

Lord, have mercy on my son: for he is lunatick, and sore vexed: for ofttimes he
falleth into the fire, and oft into the water.... (Matthew 17: 15)

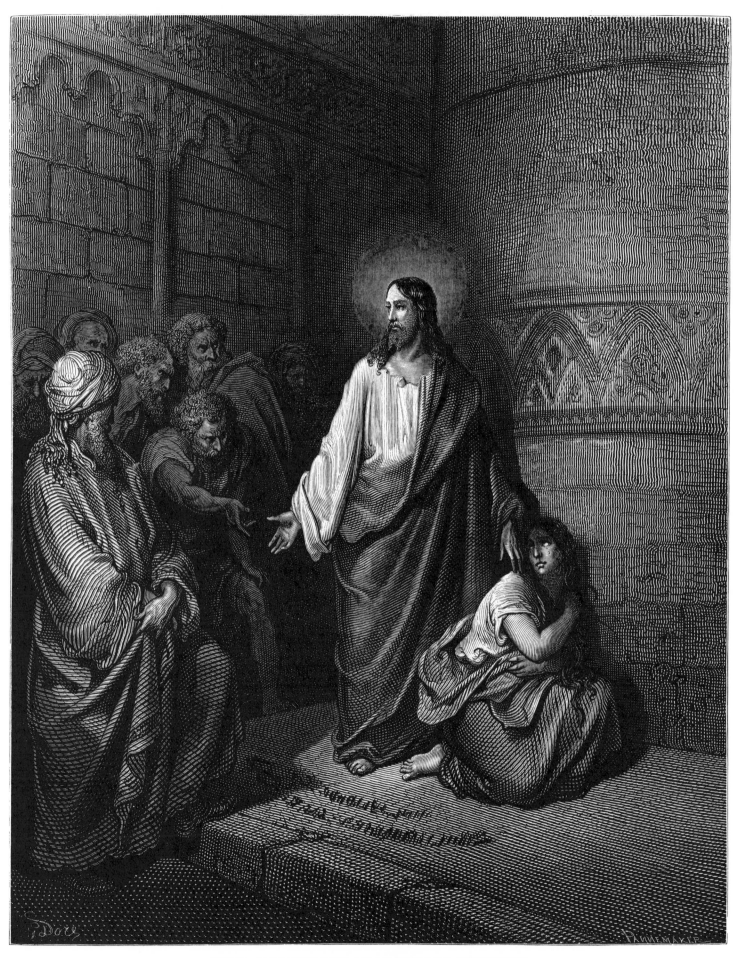

JESUS AND THE WOMAN TAKEN IN ADULTERY

Jesus stooped down, and with his finger wrote on the ground...and said unto them,
He that is without sin among you, let him first cast a stone at her....(John 8:6, 7)

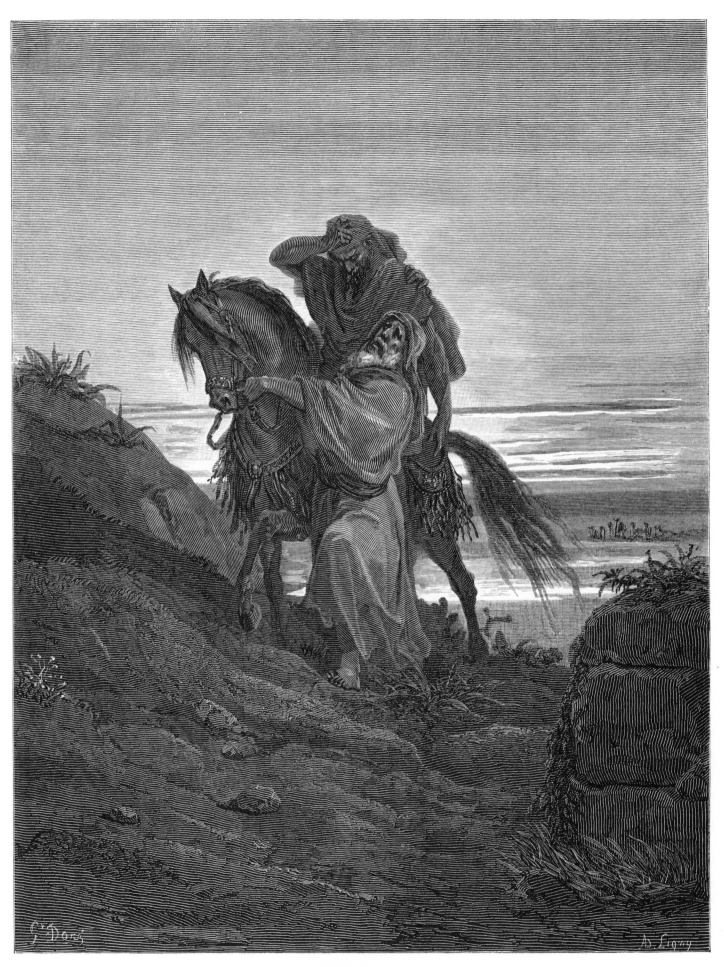

THE GOOD SAMARITAN

But a certain Samaritan...had compassion on him, and went to him, and bound up
his wounds, pouring in oil and wine, and set him on his own beast...(Luke 10: 33, 34)

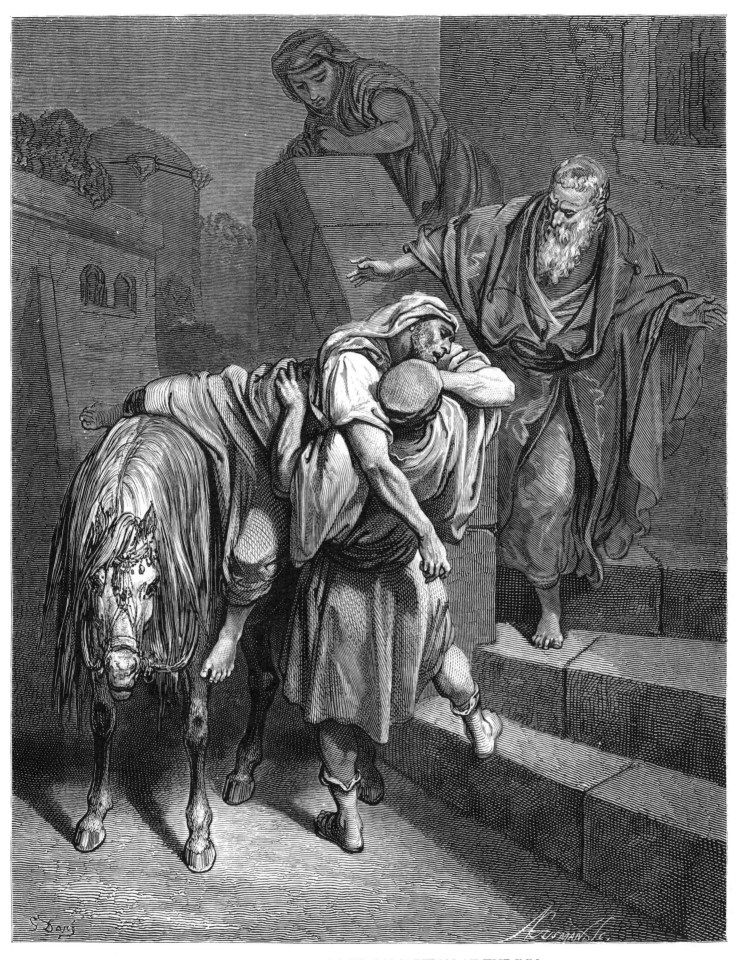

ARRIVAL OF THE GOOD SAMARITAN AT THE INN

[He] brought him to an inn, and took care of him . . . (Luke 10: 34)

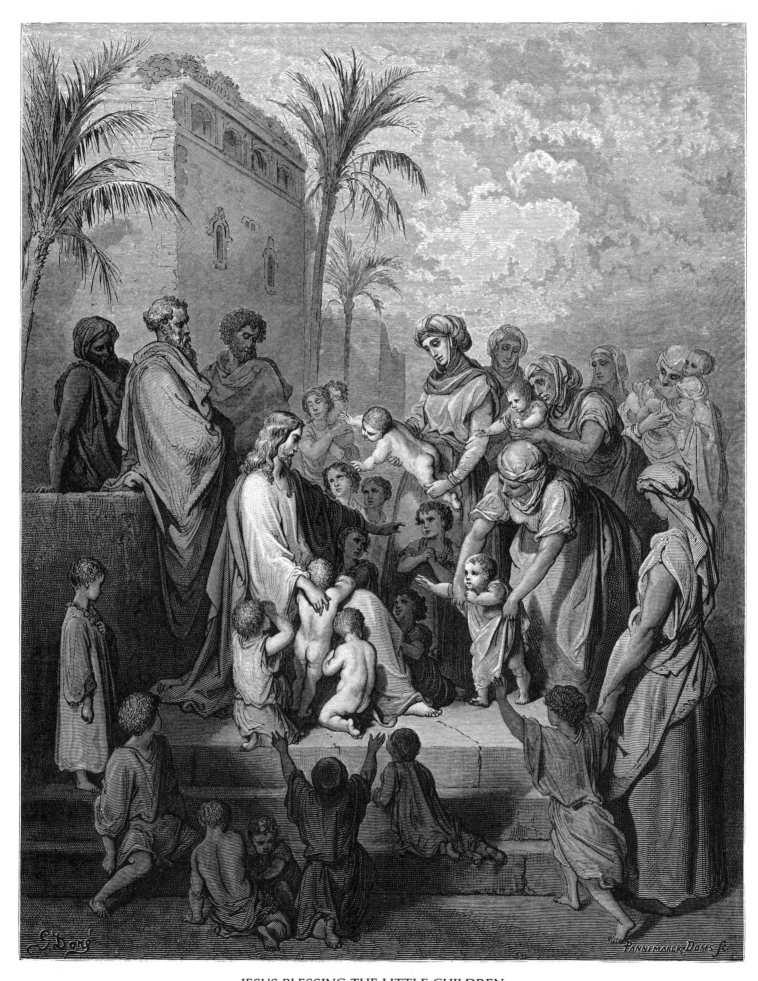

JESUS BLESSING THE LITTLE CHILDREN

Suffer the little children to come unto me, and forbid them not: for of such is the
kingdom of God.... (Mark 10: 14)

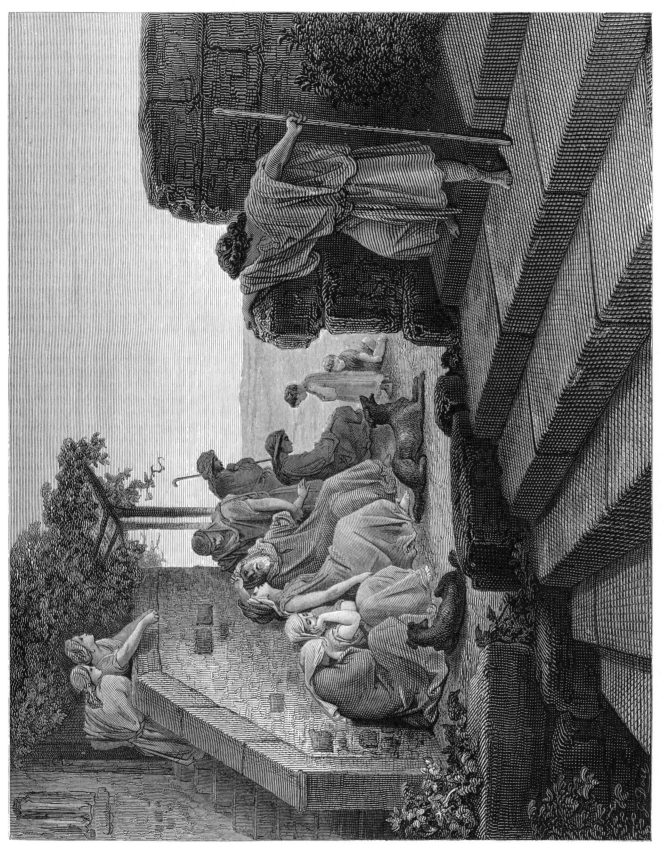

THE RETURN OF THE PRODIGAL SON

I will arise and go to my father, and will say unto him, Father, I have sinned against
heaven, and before thee, and am no more worthy to be called thy son: make me as
one of thy hired servants....(Luke 15: 18, 19)

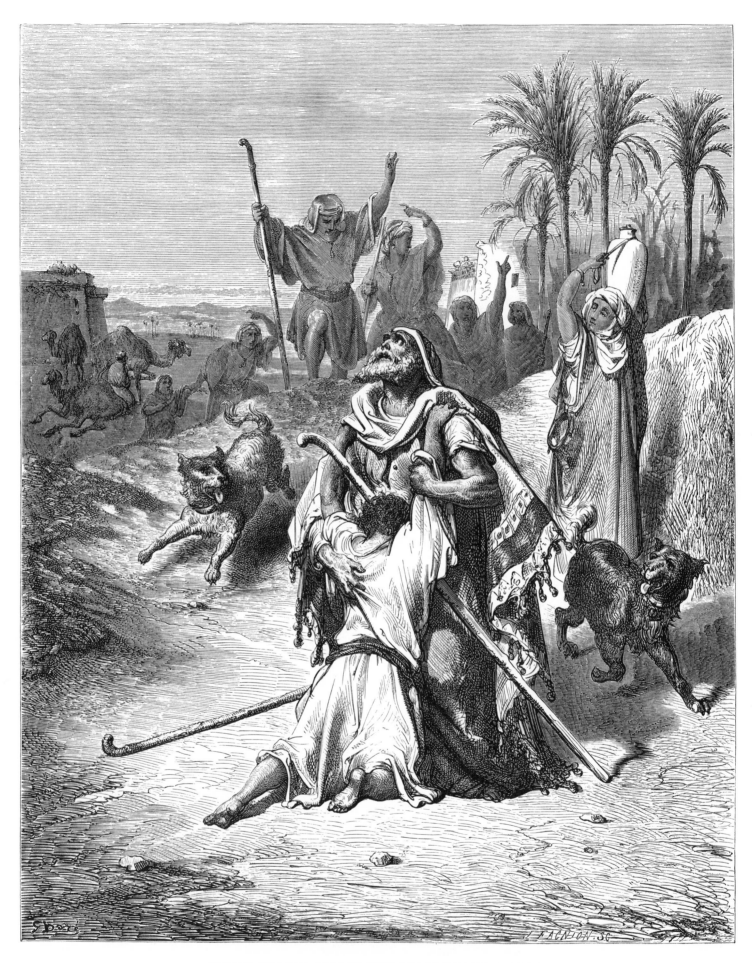

THE PRODIGAL SON IN THE ARMS OF HIS FATHER

But when he was yet a great way off, his father saw him, and had compassion, and
ran, and fell on his neck, and kissed him.... (Luke 15: 20)

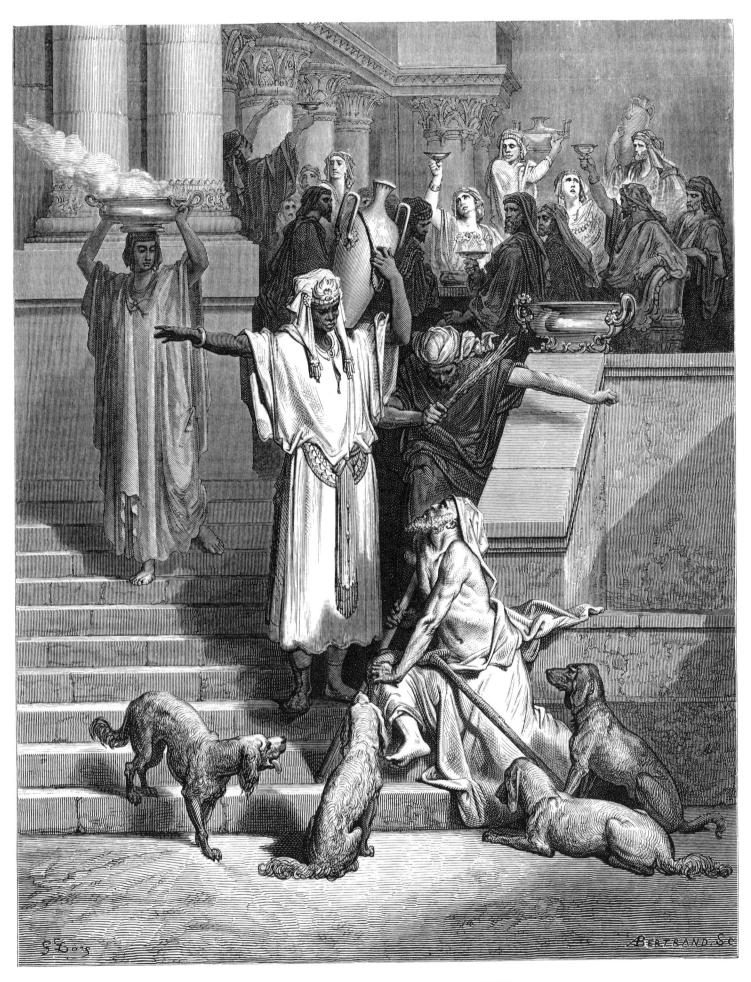

LAZARUS AT THE RICH MAN'S HOUSE

And there was a certain beggar named Lazarus, which was laid at his gate, full of
sores, and desiring to be fed with the crumbs which fell from the rich man's table:
moreover the dogs came and licked his sores. . . . (Luke 16: 20, 21)

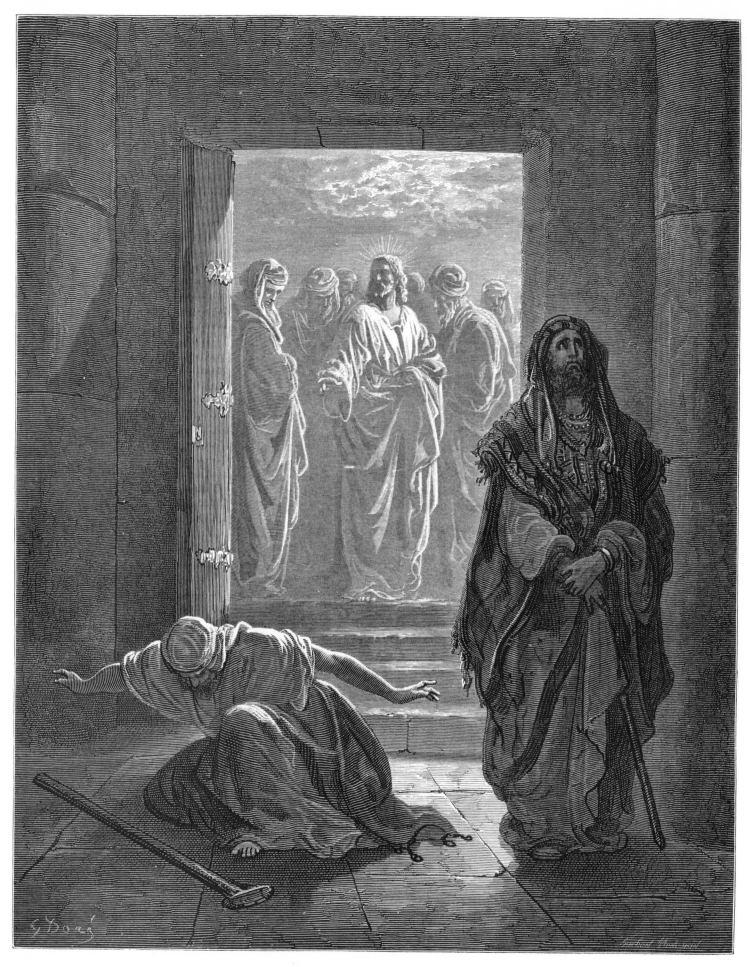

THE PHARISEE AND THE PUBLICAN

The Pharisee stood and prayed thus...God, I thank thee, that I am not as other
men are...And the publican...smote upon his breast, saying, God be merciful
to me a sinner....(Luke 18: 11, 13)

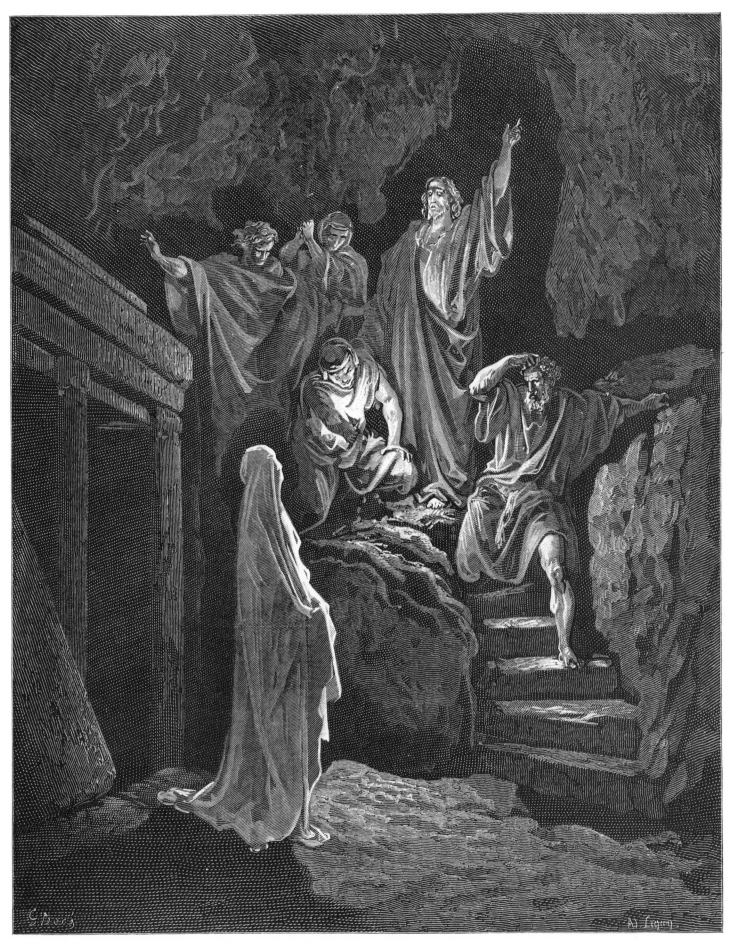

RESURRECTION OF LAZARUS

And when he thus had spoken, he cried with a loud voice, Lazarus, come forth....
(John 11: 43)

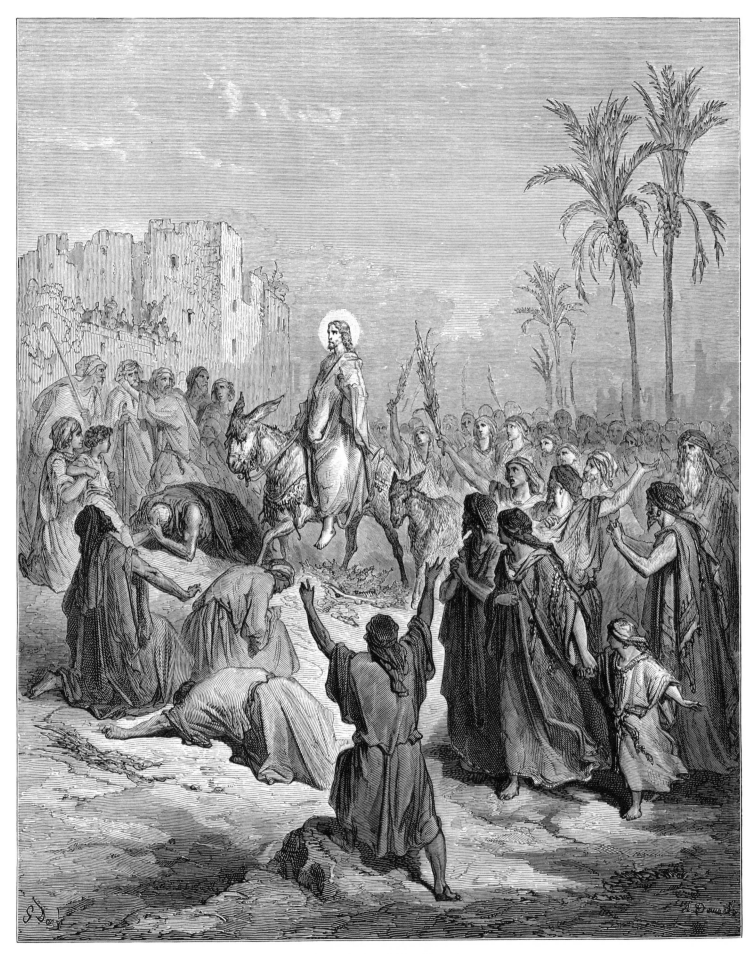

ENTRY OF JESUS INTO JERUSALEM

And the multitudes that went before, and that followed, cried, saying, Hosanna to the
Son of David: Blessed is he that cometh in the name of the Lord . . . (Matthew 21: 9)

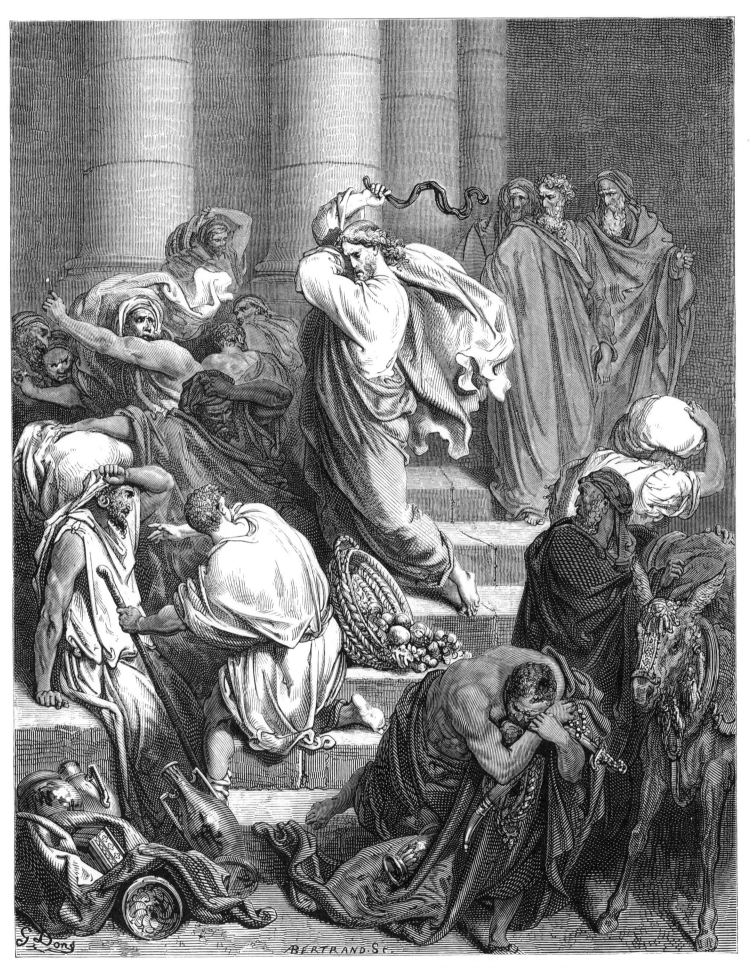

THE BUYERS AND SELLERS DRIVEN OUT OF THE TEMPLE

My house is the house of prayer: but ye have made it a den of thieves.... (Luke 19: 46)

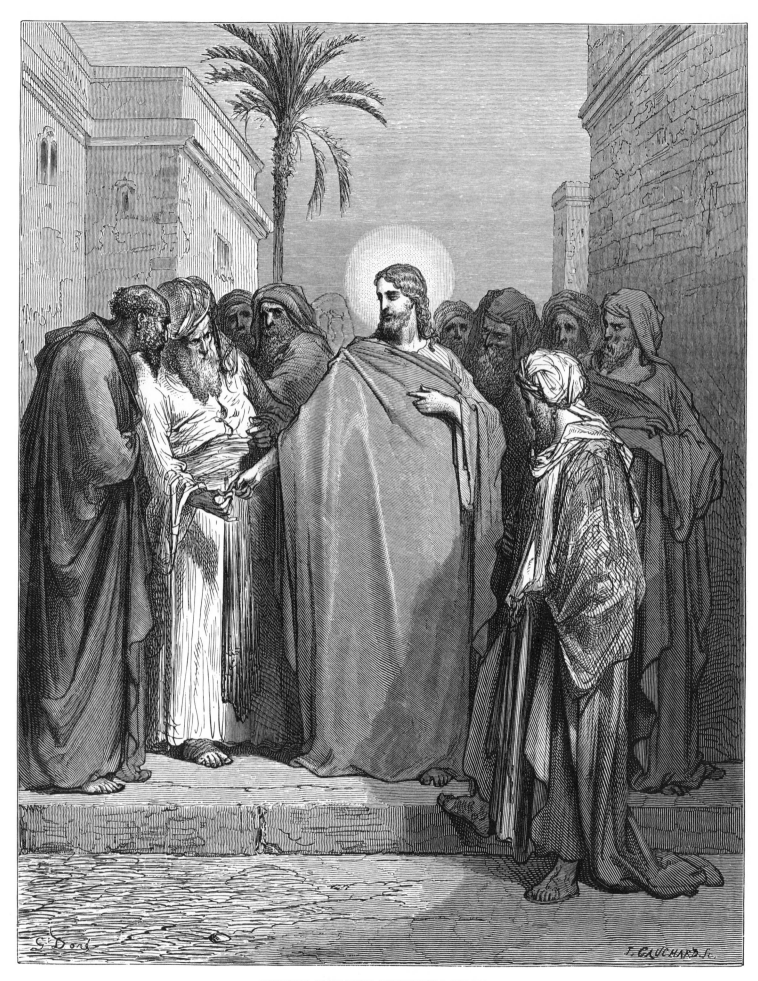

CHRIST AND THE TRIBUTE MONEY

Render therefore unto Caesar the things which are Caesar's; and unto God the
things that are God's.... (Matthew 22: 21)

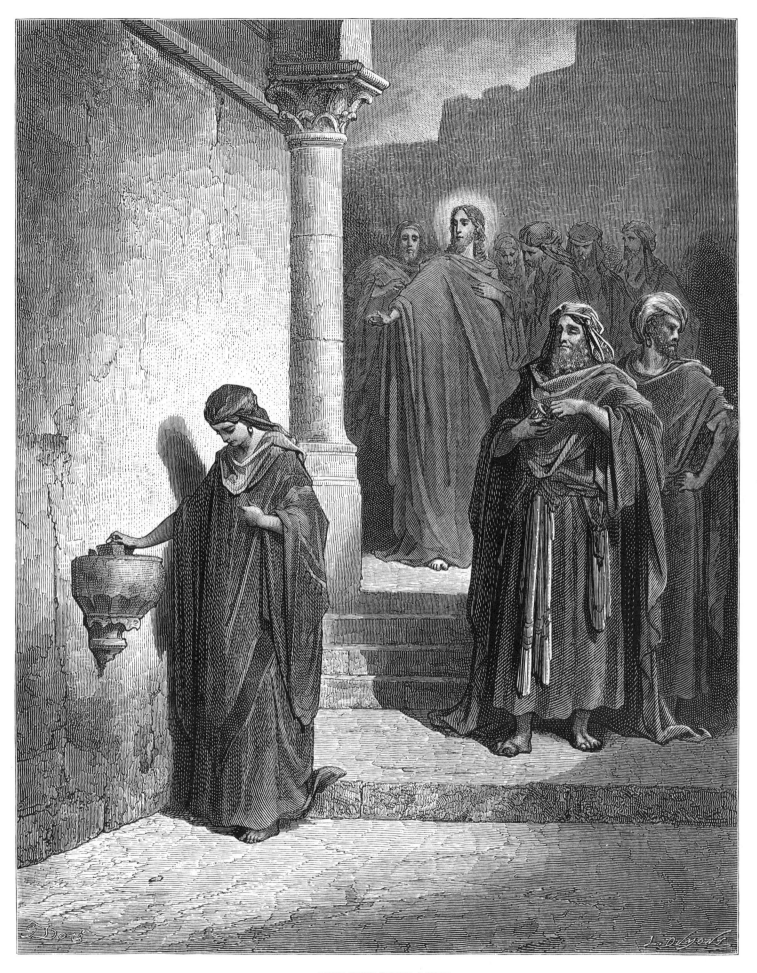

THE WIDOW'S MITE

And he called unto him his disciples, and saith unto them, Verily I say unto you,
That this poor widow hath cast more in, than all they which have cast into the trea-
sury.... (Mark 12: 43)

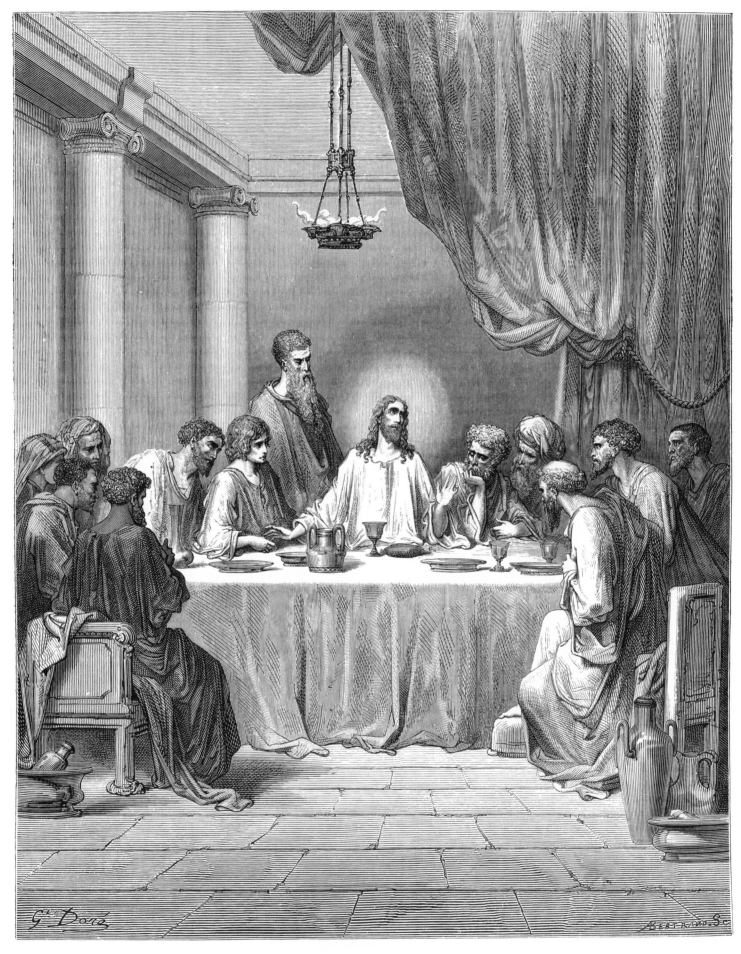

THE LAST SUPPER

Therefore, when he was gone out, Jesus said, Now is the Son of man glorified,
and God is glorified in him. . . . (John 13: 31)

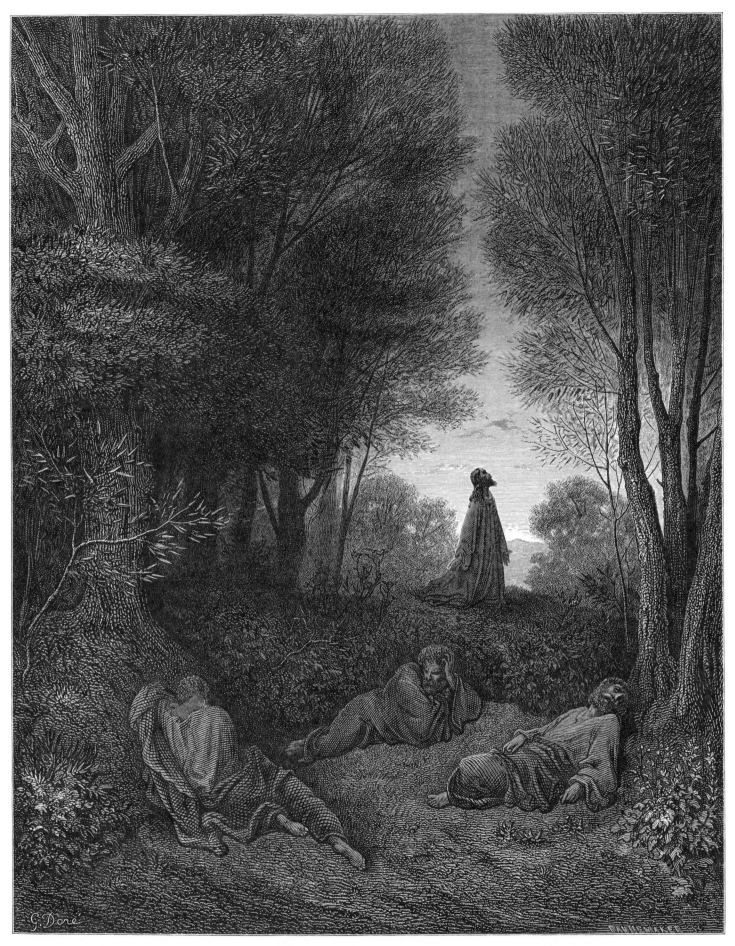

JESUS PRAYING IN THE GARDEN

And he went a little further, and fell on his face, and prayed, saying, O my Father,
if it be possible, let this cup pass from me: nevertheless not as I will, but as thou
wilt. . . . (Matthew 26: 39)

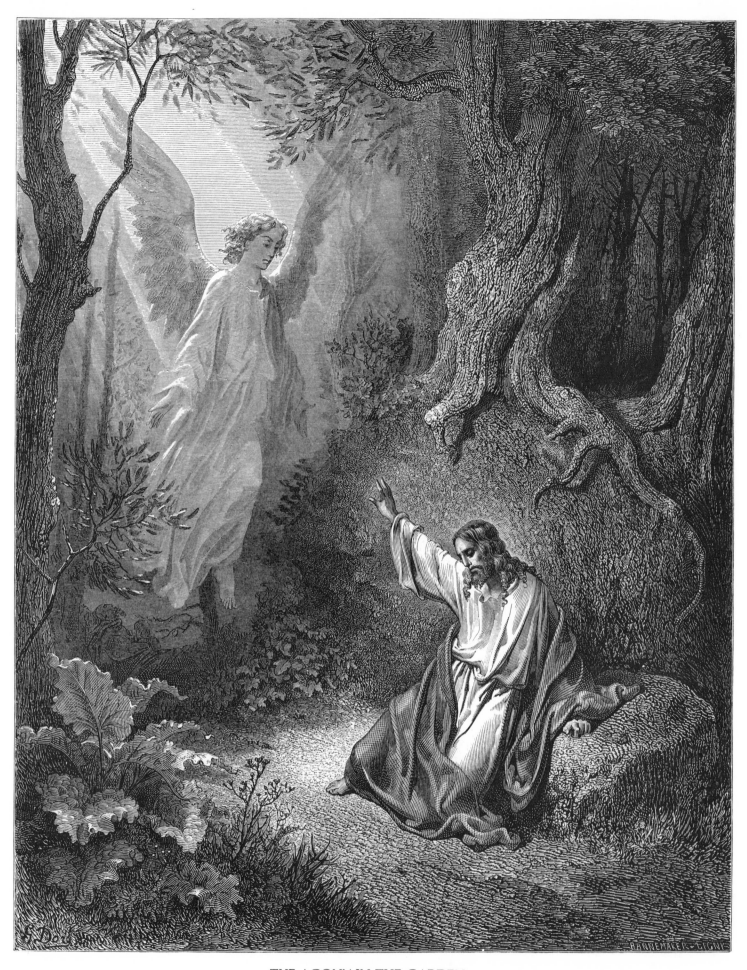

THE AGONY IN THE GARDEN

And there appeared an angel unto him from heaven, strengthening him.
. . . (Luke 22: 43)

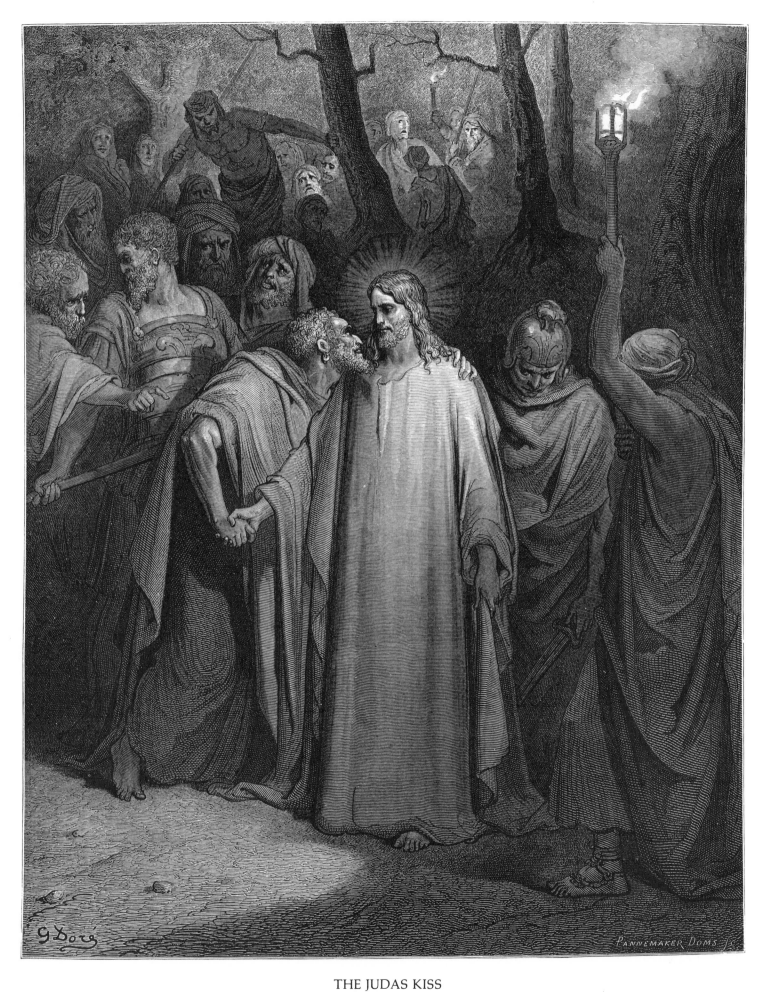

THE JUDAS KISS

And he that betrayed him had given them a token, saying, Whomsoever I shall
kiss, that same is he . . . (Mark 14: 44)

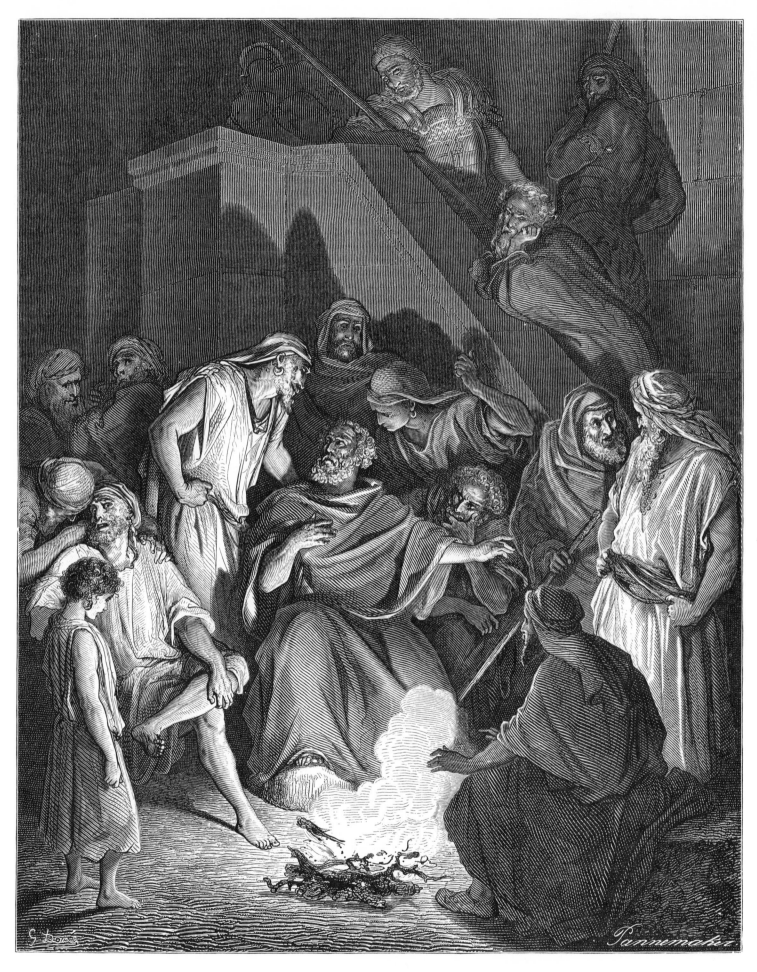

ST. PETER DENYING CHRIST

And Simon Peter stood and warmed himself. They said therefore unto him, Art
not thou also one of his disciples? He denied it, and said, I am not.
...(John 18: 25)

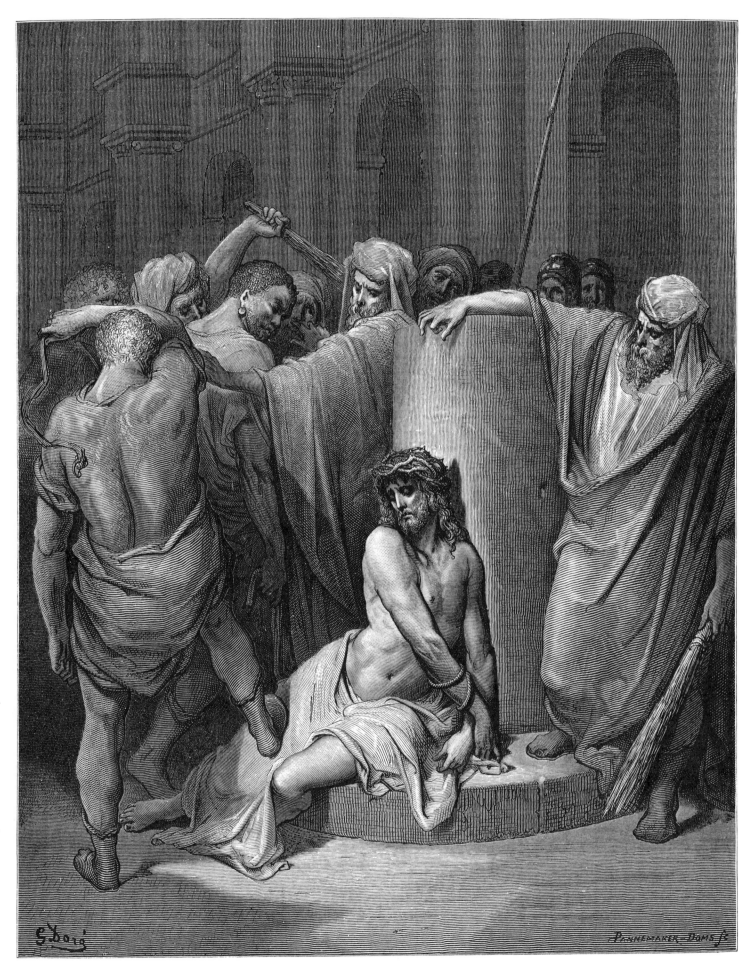

JESUS SCOURGED
And Pilate therefore took Jesus, and scourged him. . . . (John 19: 1)

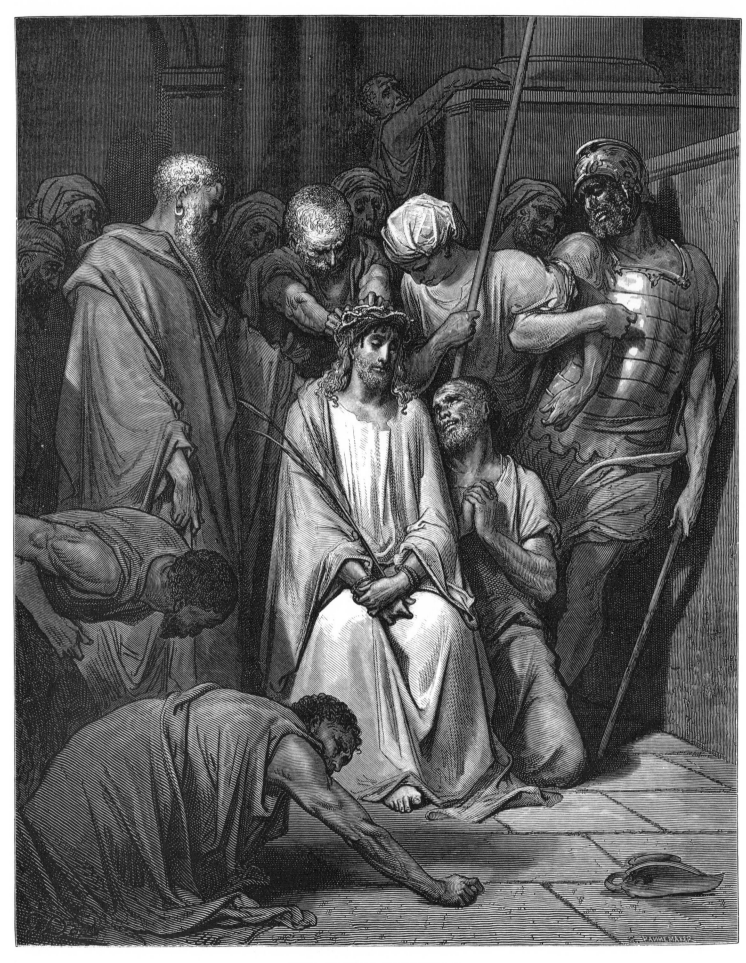

THE CROWN OF THORNS

And the soldiers platted a crown of thorns, and put it on his head, and they put
on him a purple robe. . . . (John 19: 2)

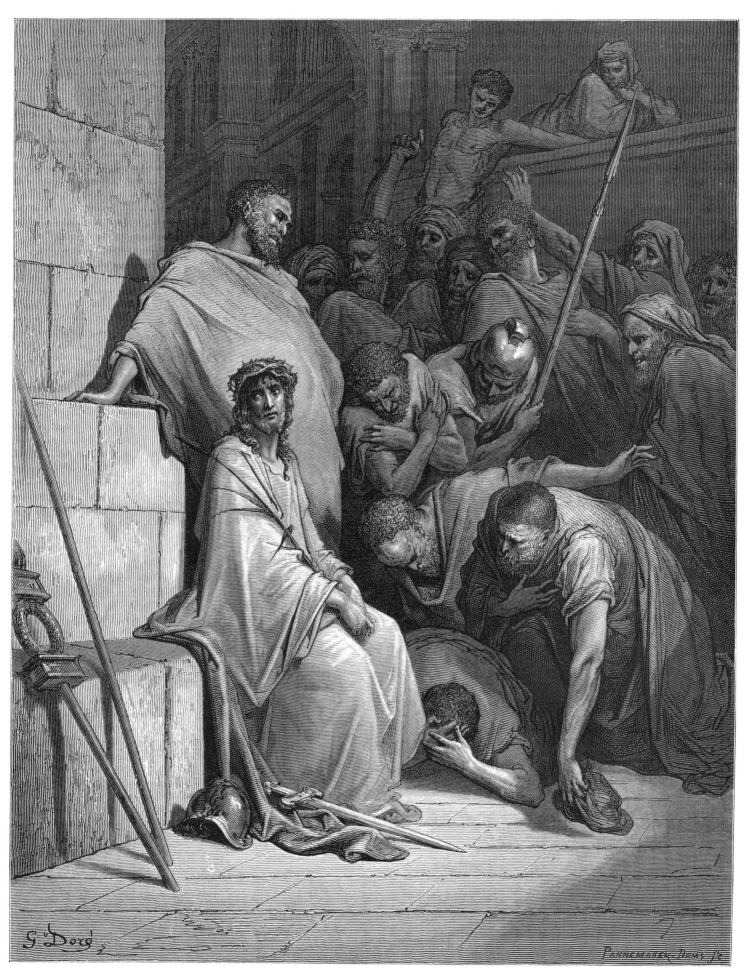

CHRIST MOCKED

They bowed the knee before him, and mocked him, saying, Hail, King of the Jews!
. . . (Matthew 27: 29)

209

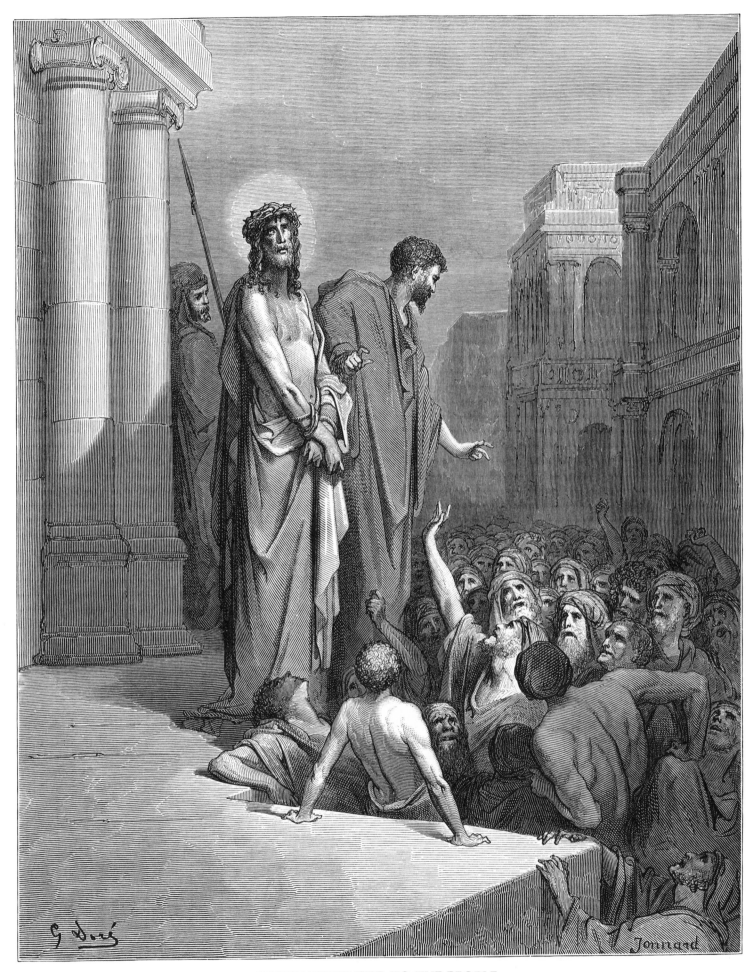

CHRIST PRESENTED TO THE PEOPLE

Pilate saith unto them, Shall I crucify your King? . . . (John 19: 15)

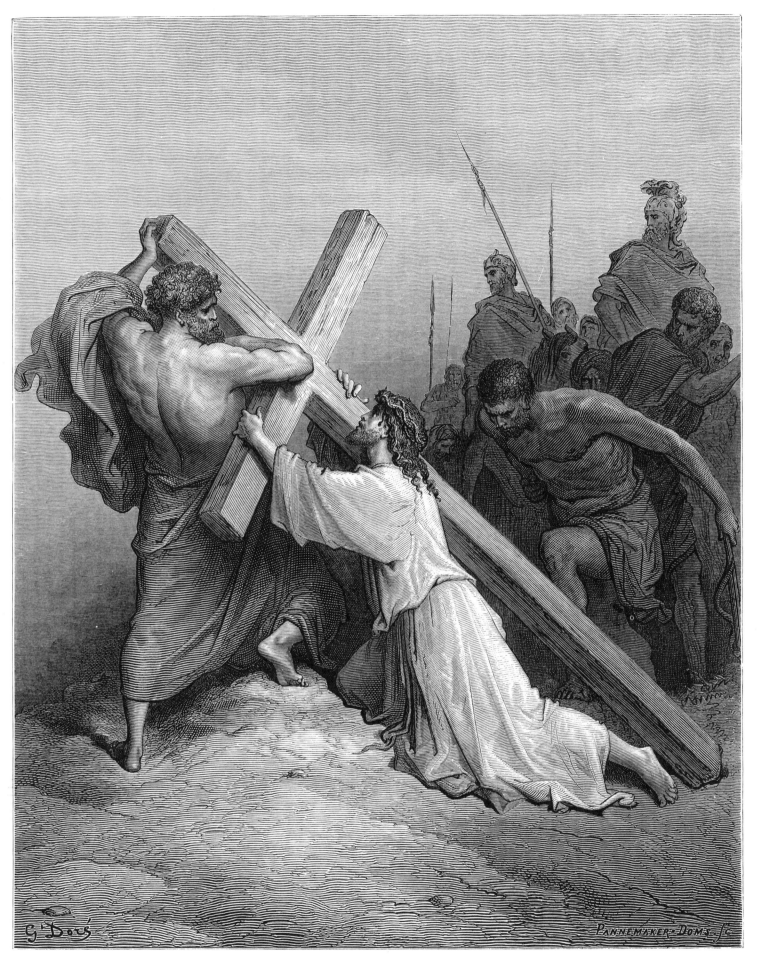

JESUS FALLING BENEATH THE CROSS

And they compel one Simon a Cyrenian, who passed by, coming out of the country, the father of Alexander and Rufus, to bear his cross.... (Mark 15: 21)

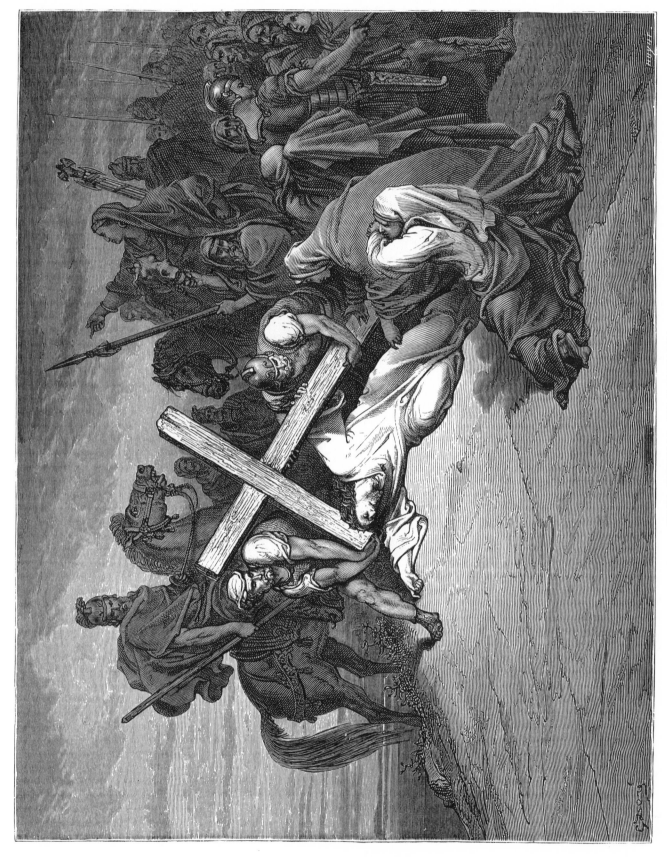

THE ARRIVAL AT CALVARY

But Jesus turning unto them said, . . . If they do these things in a green tree, what shall be done in the dry? . . . (Luke 23: 28, 31)

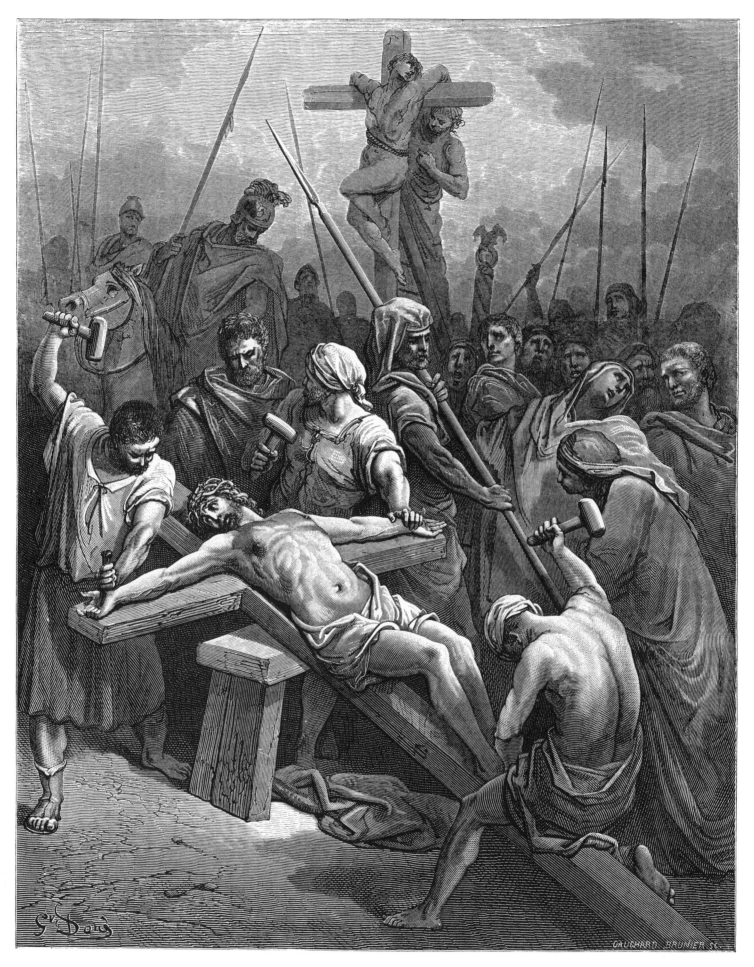

NAILING CHRIST TO THE CROSS

Where they crucified him, and two other with him, on either side one, and Jesus
in the midst. . . . (John 19: 18)

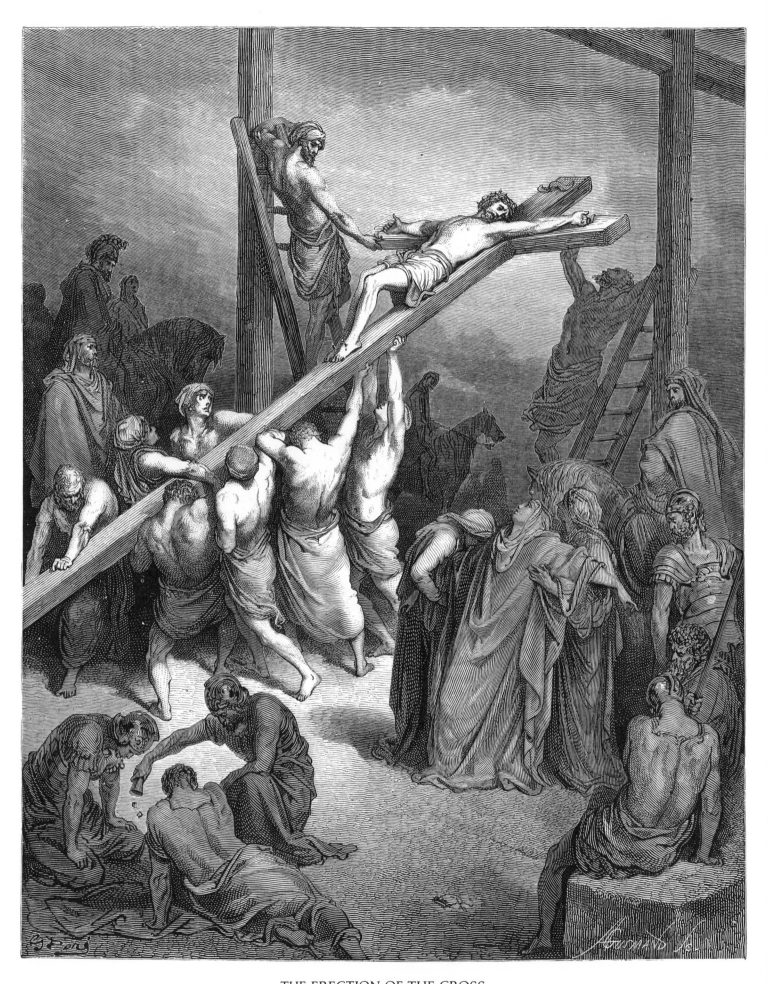

THE ERECTION OF THE CROSS

And they crucified him, and parted his garments, casting lots . . .
(Matthew 27: 35)

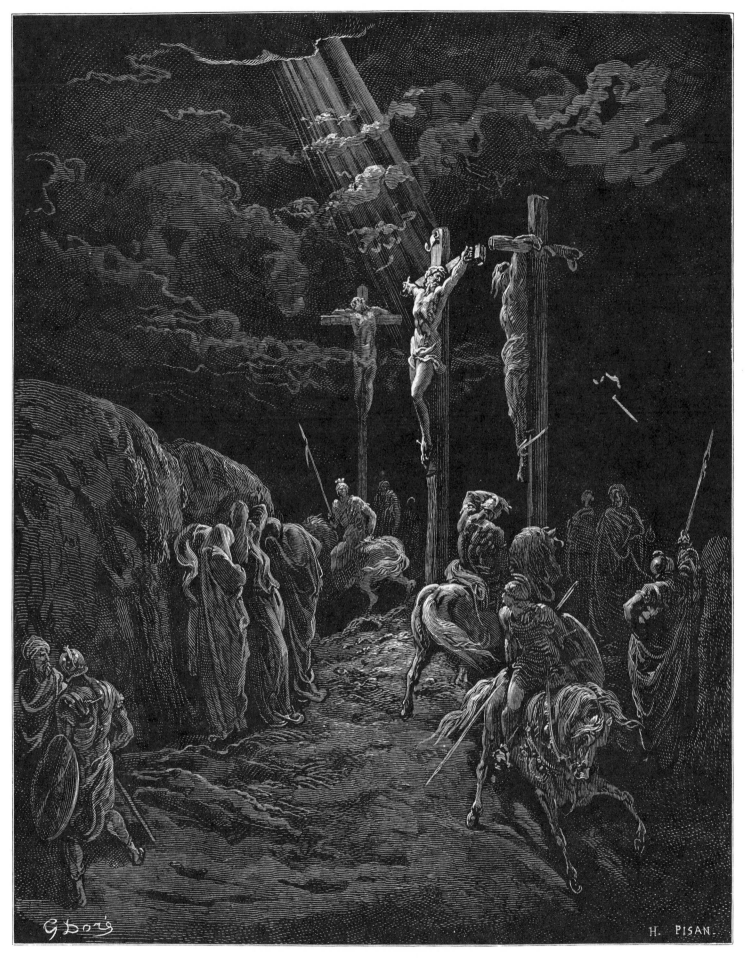

THE CRUCIFIXION

Then said Jesus, Father, forgive them; for they know not what they do. . . .
(Luke 23: 34)

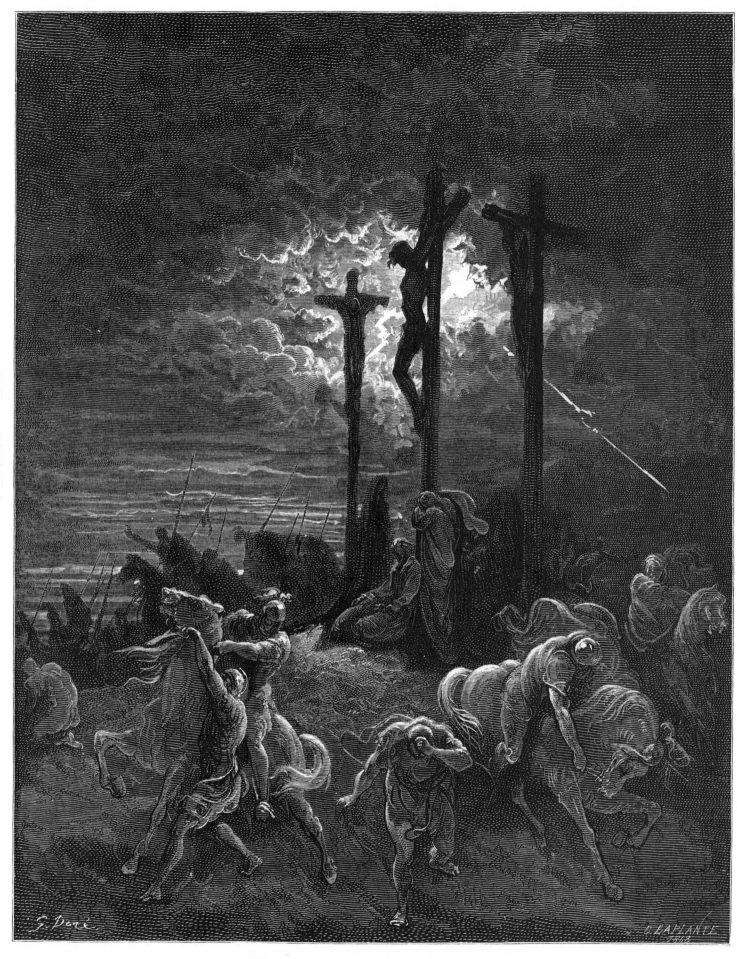

THE DARKNESS AT THE CRUCIFIXION

And it was about the sixth hour, and there was a darkness over all the earth until
the ninth hour. . . . (Luke 23: 44)

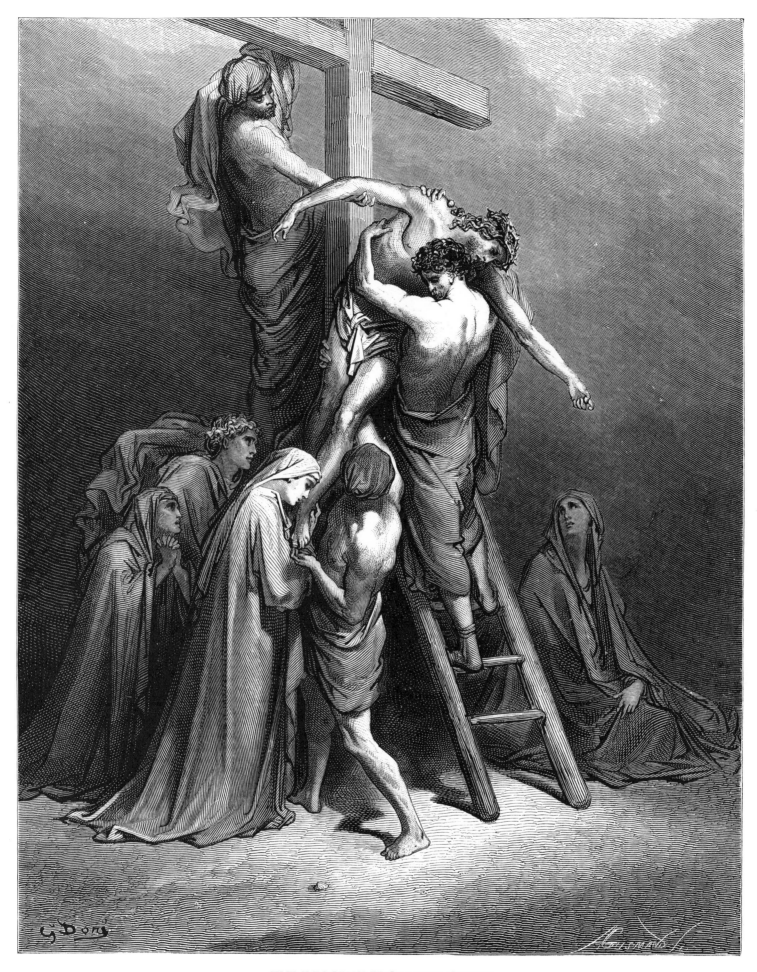

THE DESCENT FROM THE CROSS

Joseph of Arimathaea, an honourable counseller.... bought fine linen, and took him
down ... (Mark 15: 43, 46)

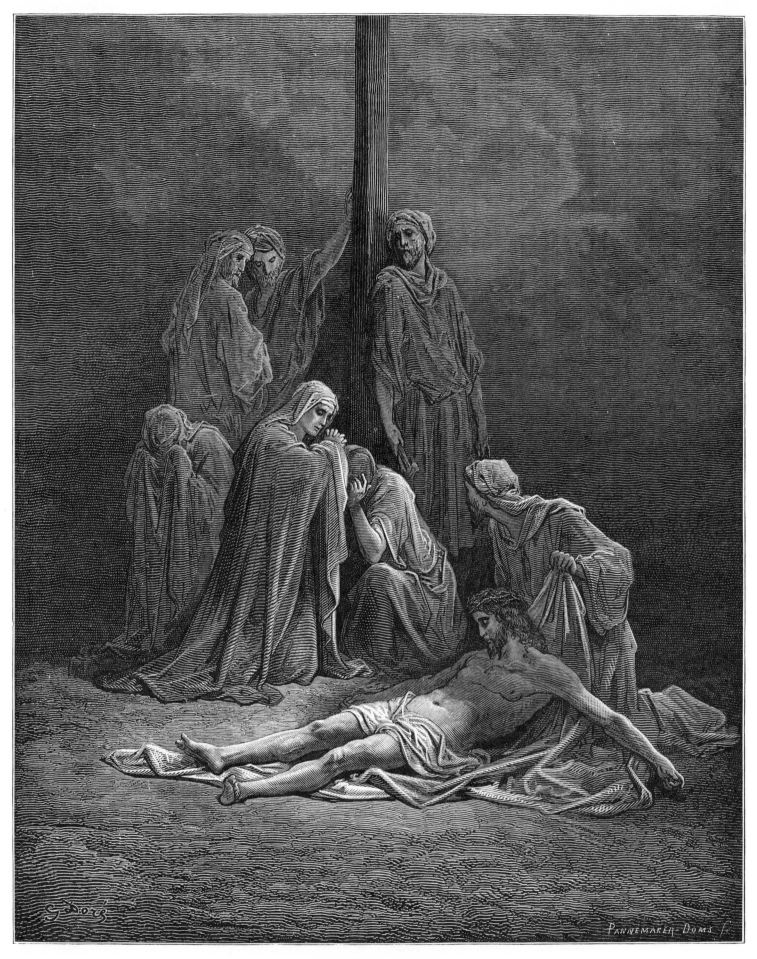

THE DEAD CHRIST

Then took they the body of Jesus, and wound it in linen clothes with the spices, as
the manner of the Jews is to bury. . . . (John 19: 40)

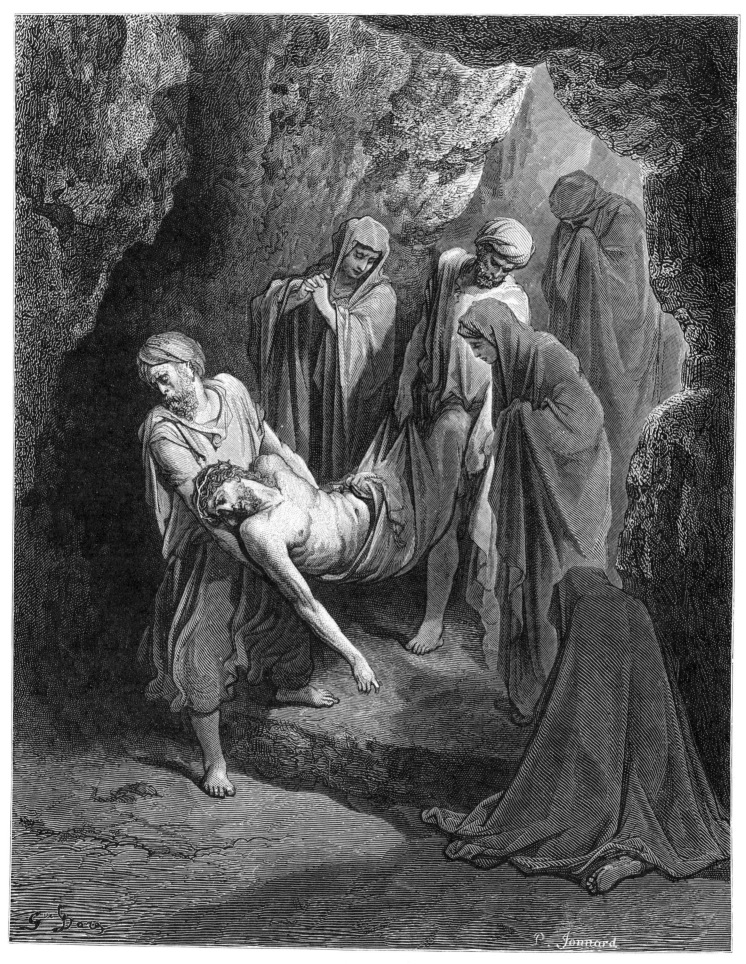

THE BURIAL OF CHRIST

Now in the place where he was crucified there was a garden; and in the garden a
new sepulchre, wherein was never man yet laid. . . . (John 19: 41)

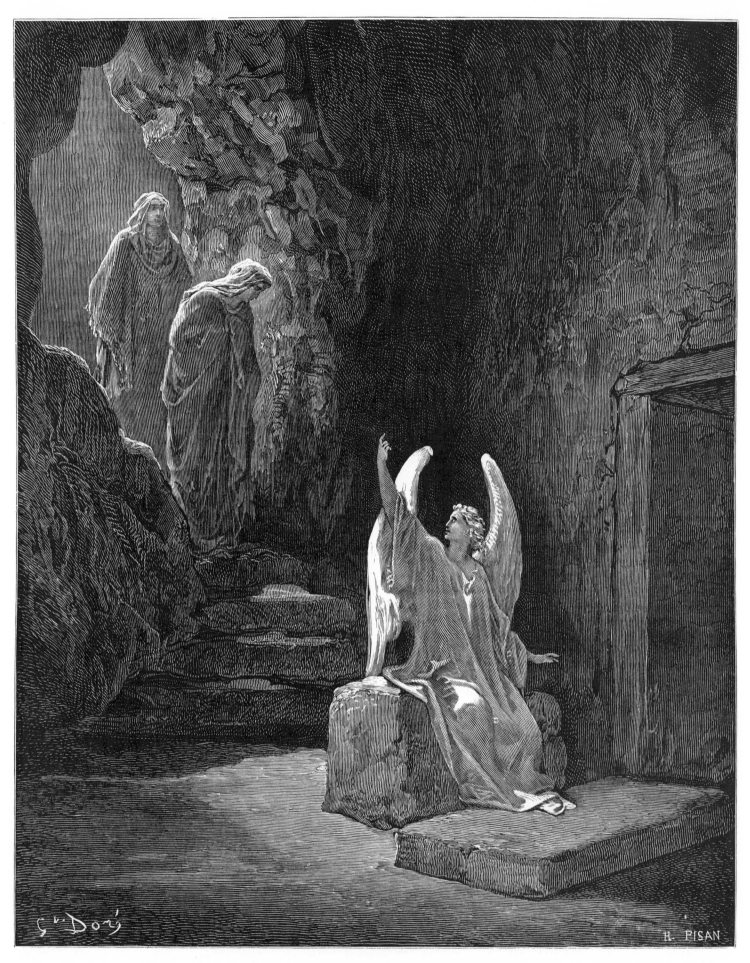

THE RESURRECTION

And the angel answered and said unto the women, Fear not ye: for I know that ye
seek Jesus, which was crucified. He is not here: for he is risen, as he said. Come,
see the place where the Lord lay. . . . (Matthew 28: 5, 6)

220

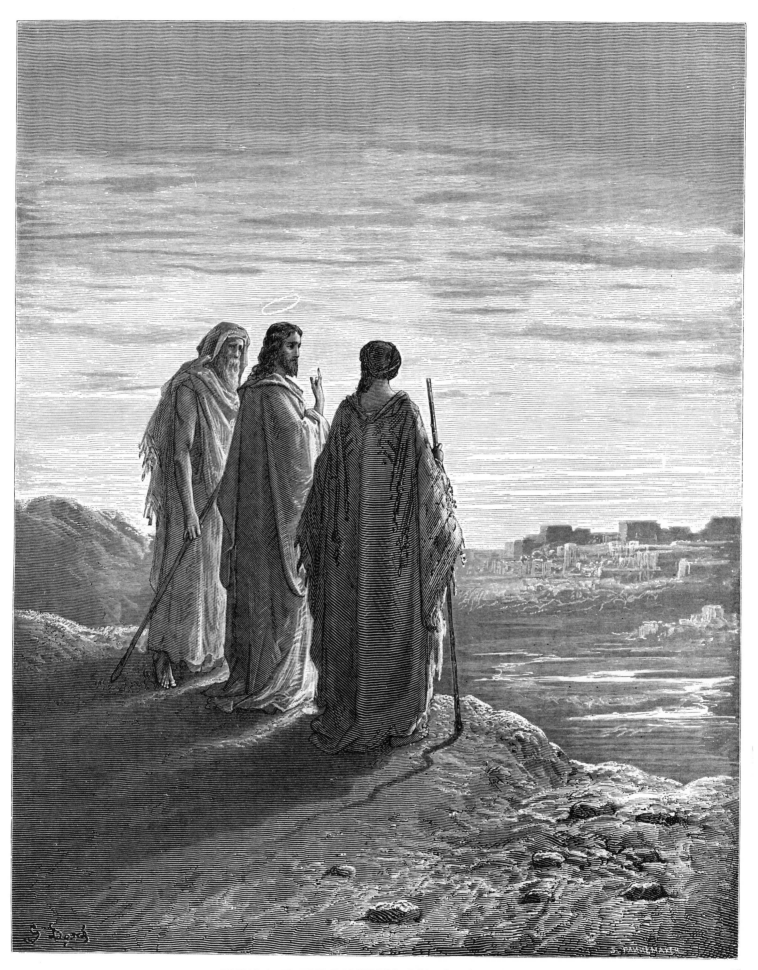

JESUS AND THE DISCIPLES GOING TO EMMAUS

And their eyes were opened, and they knew him . . . (Luke 24: 31)

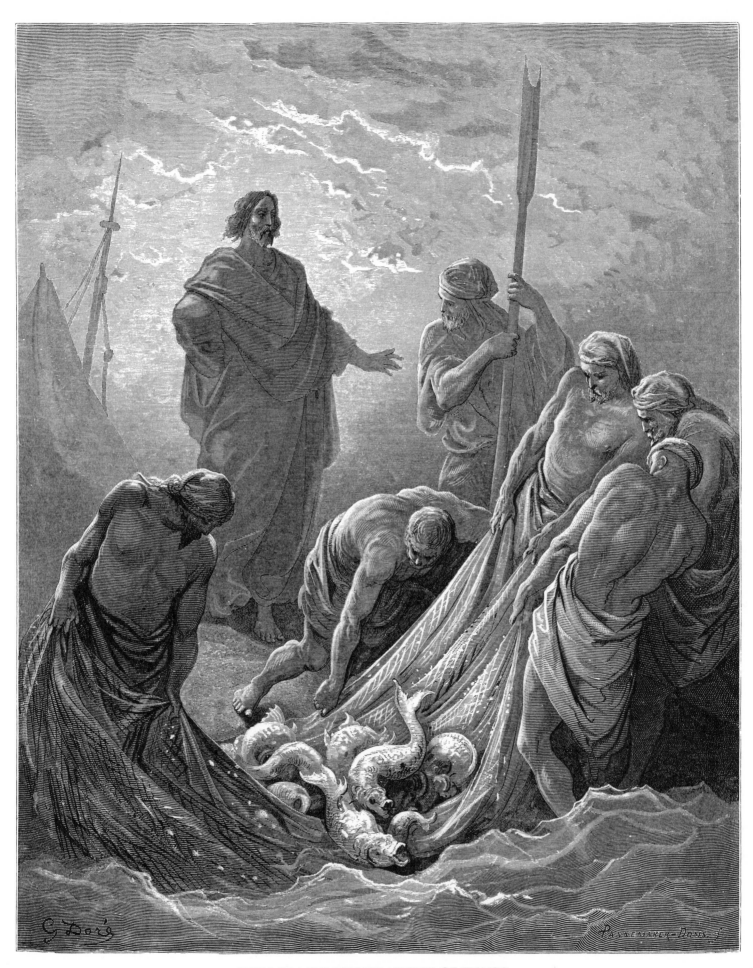

THE MIRACULOUS DRAUGHT OF FISHES

And he said unto them, Cast the net on the right side of the ship, and ye shall find. They cast therefore, and now they were not able to draw it for the multitude of fishes. . . . (John 21: 6)

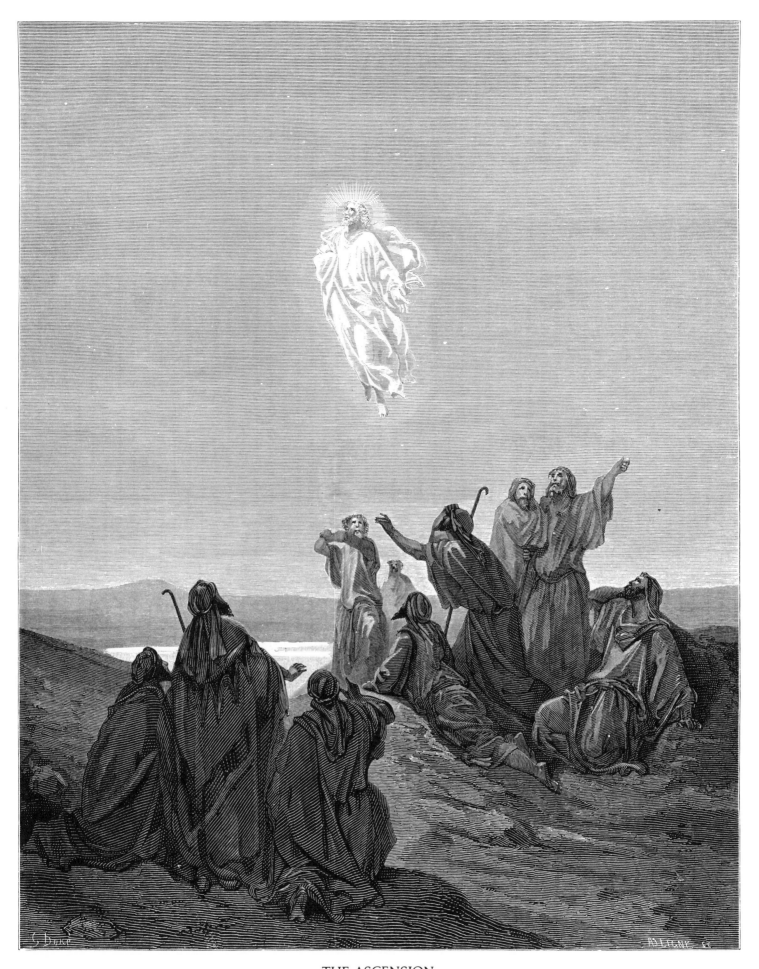

THE ASCENSION

And it came to pass, while he blessed them, he was parted from them, and carried
up into heaven. . . . (Luke 24: 51)

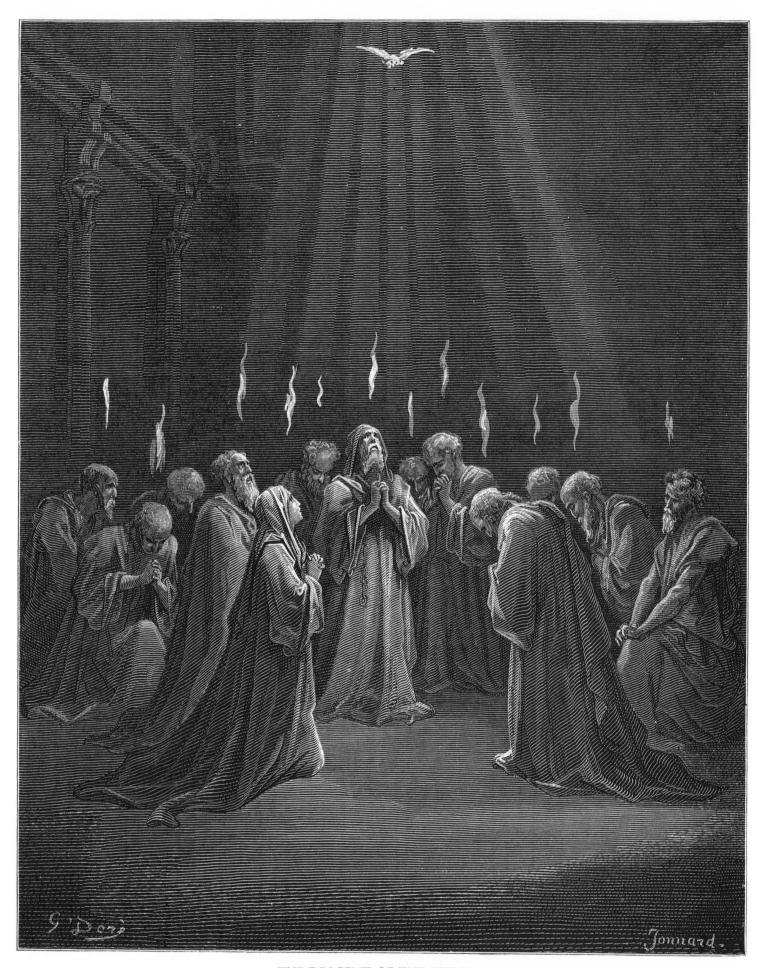

THE DESCENT OF THE SPIRIT

And they were all filled with the Holy Ghost, and began to speak with other tongues,
as the Spirit gave them utterance....(Acts 2: 4)

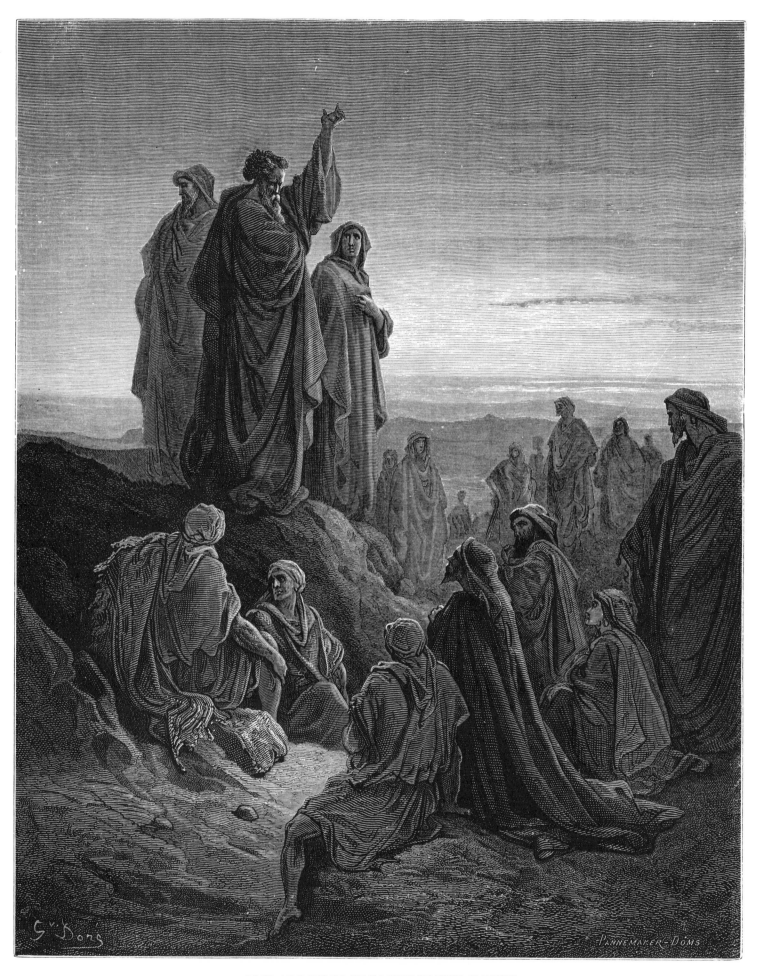

THE APOSTLES PREACHING THE GOSPEL

But Peter . . . said unto them . . . This is that which was spoken by the prophet
Joel . . . your young men shall see visions, and your old men shall dream dreams.
. . . (Acts 2: 14, 16, 17)

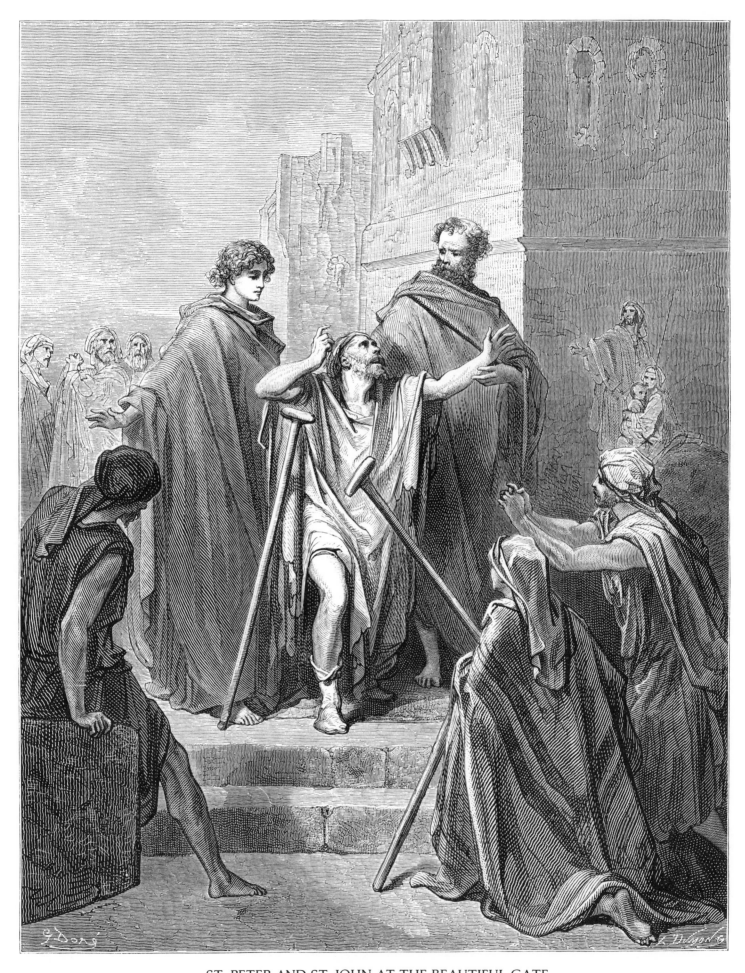

ST. PETER AND ST. JOHN AT THE BEAUTIFUL GATE

Then Peter said, Silver and gold have I none; but such as I have give I thee: In the
name of Jesus Christ of Nazareth rise up and walk. . . . (Acts 3: 6)

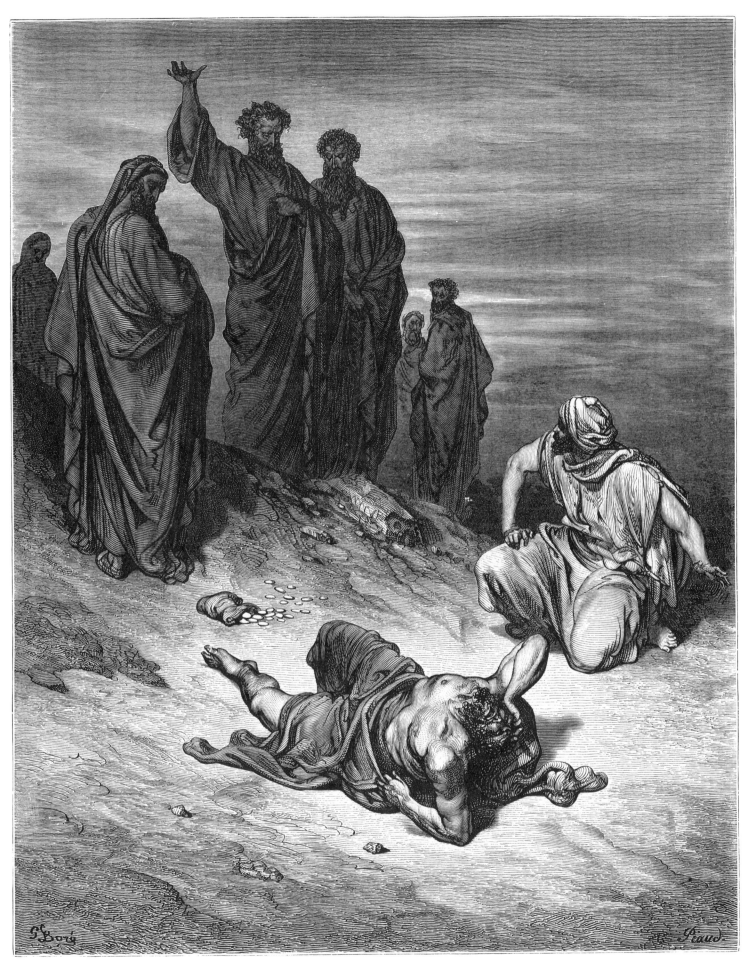

DEATH OF ANANIAS

And Ananias hearing these words fell down, and gave up the ghost . . .
(Acts 5: 5)

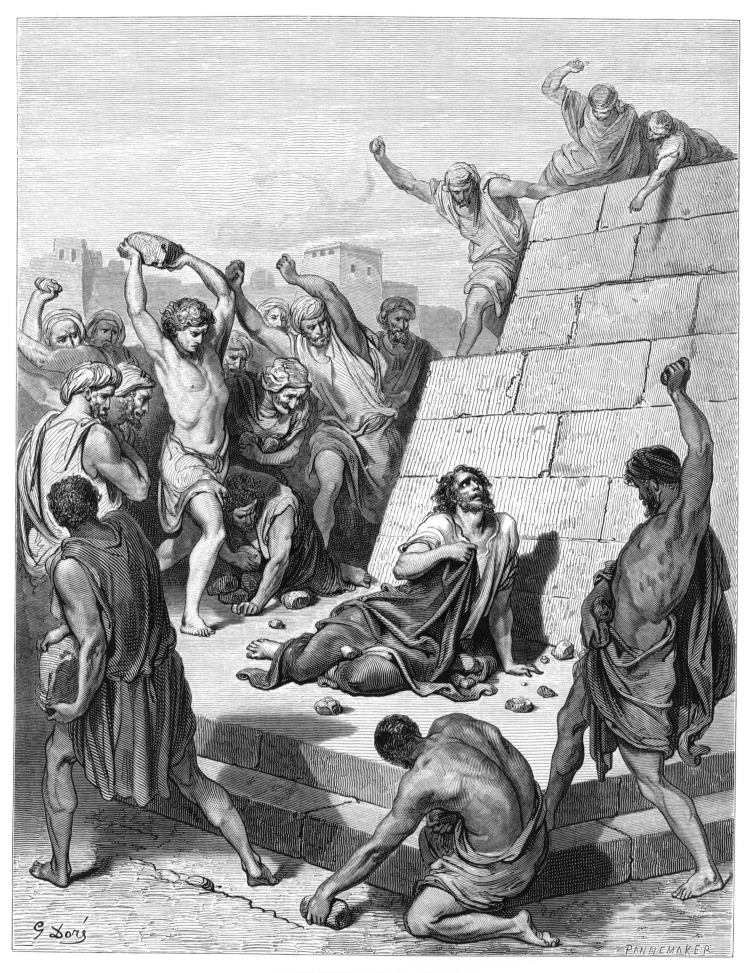

MARTYRDOM OF ST. STEPHEN

And he kneeled down, and cried with a loud voice, Lord, lay not this sin to their
charge. And when he had said this, he fell asleep. . . . (Acts 7: 60)

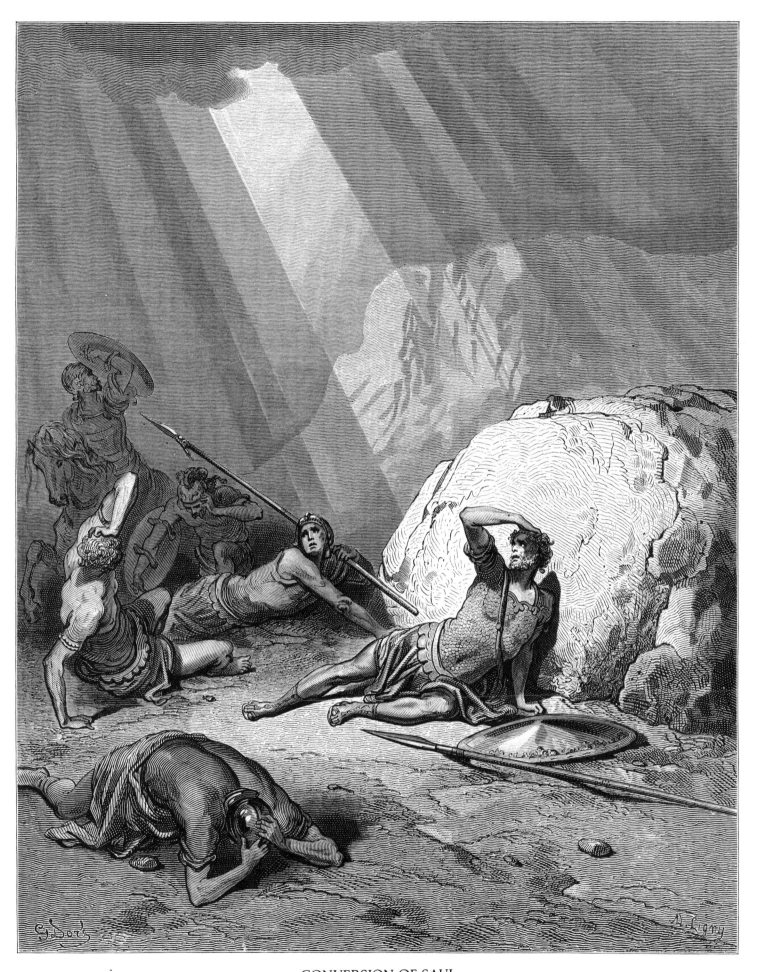

CONVERSION OF SAUL

And he fell to the earth, and heard a voice saying unto him, Saul, Saul, why per-
secutest thou me? . . . (Acts 9: 4)

ST. PETER IN THE HOUSE OF CORNELIUS

And as Peter was coming in, Cornelius met him, and fell down at his feet, and
worshipped him. But Peter took him up, saying, Stand up; I myself also am a man.
. . . (Acts 10: 25, 26)

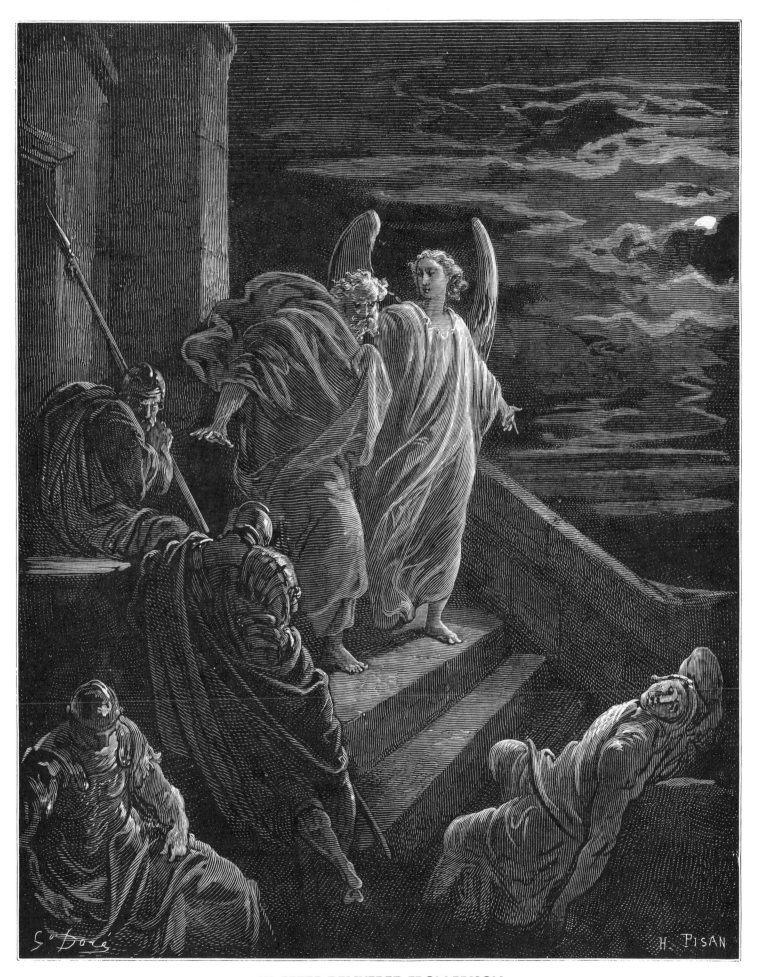

ST. PETER DELIVERED FROM PRISON

And, behold, the angel of the Lord came upon him, and a light shined in the prison:
and he smote Peter on the side, and raised him up, saying, Arise up quickly. And
his chains fell off from his hands. . . . (Acts 12: 7)

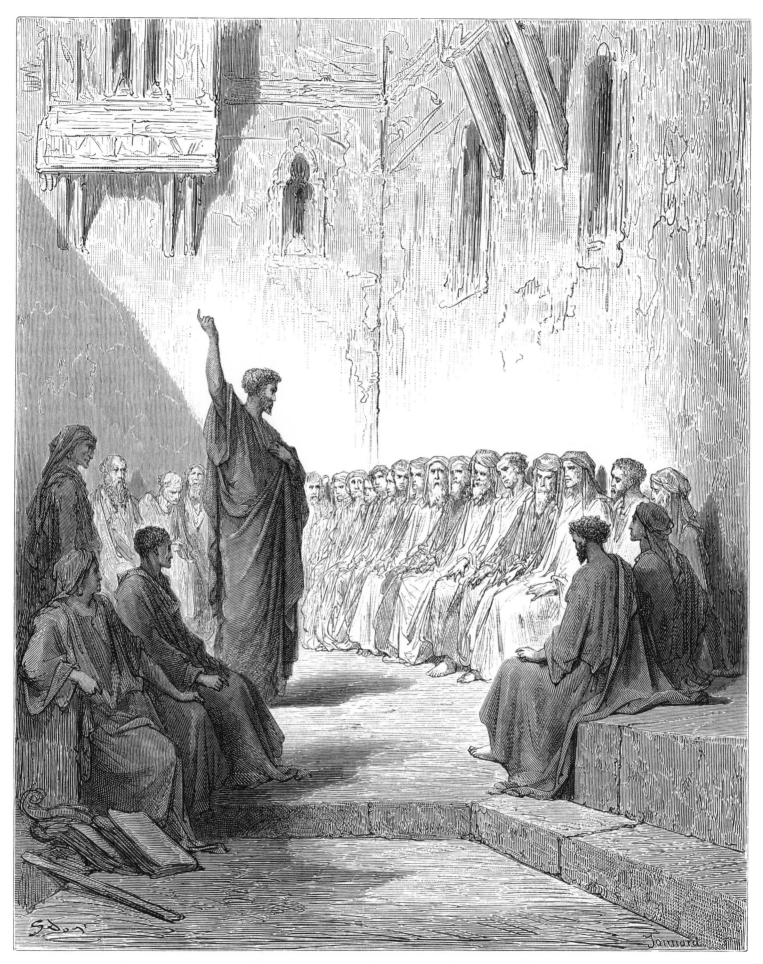

ST. PAUL PREACHING TO THE THESSALONIANS

For ye remember, brethren, our labour and travail: for labouring night and day
. . . we preached unto you the gospel of God. . . . (I Thessalonians 2: 9)

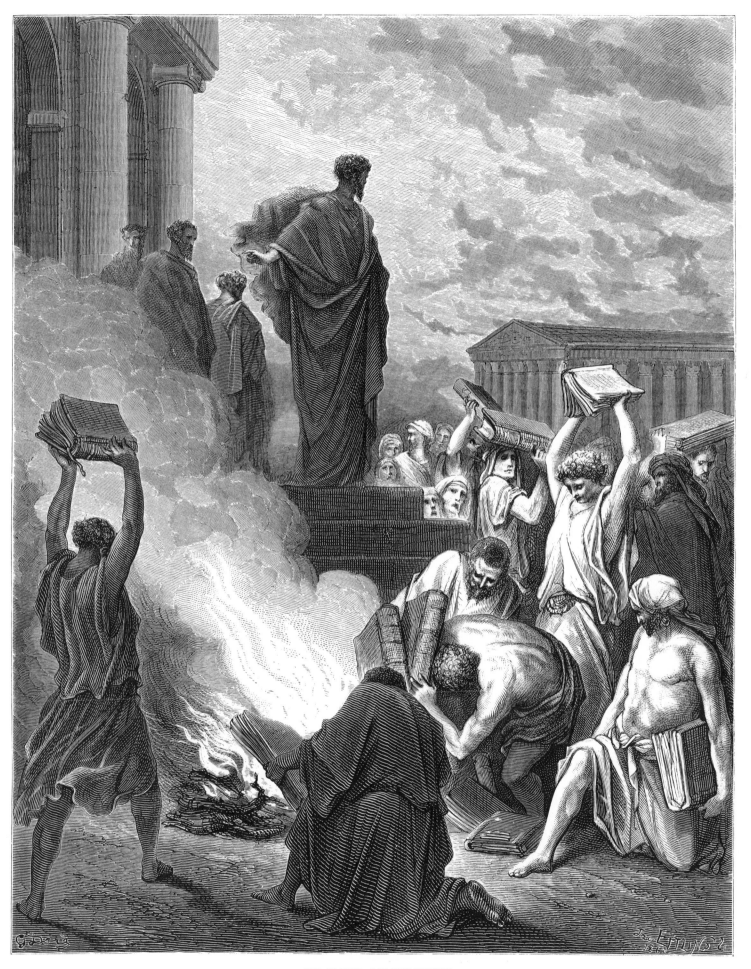

ST. PAUL AT EPHESUS

Many of them also which used curious arts brought their books together, and
burned them before all men . . . (Acts 19: 19)

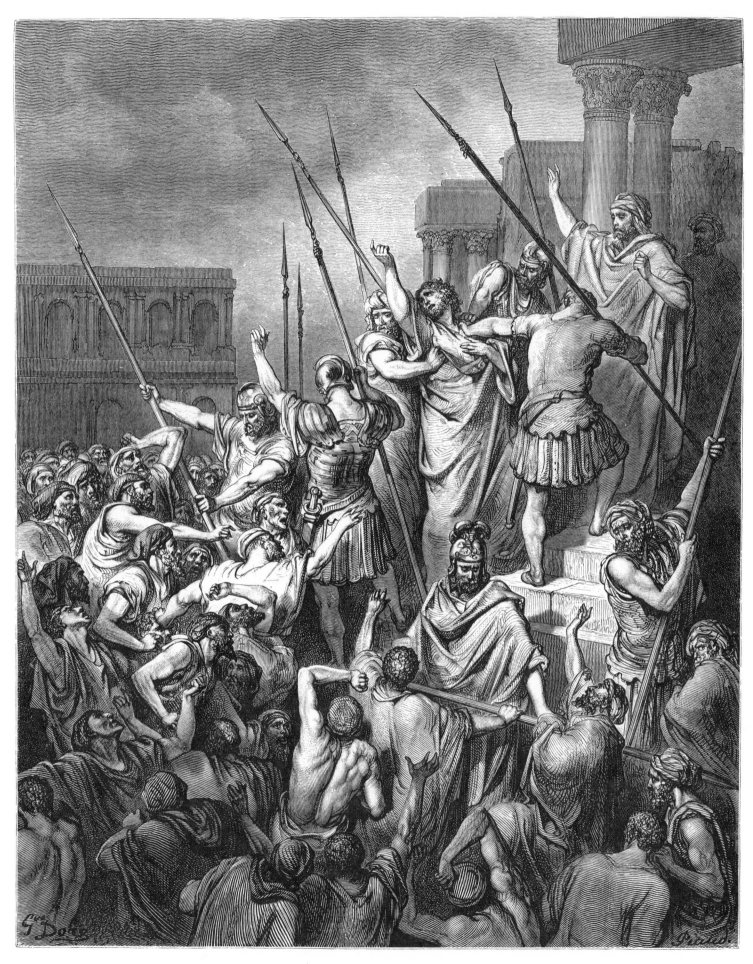

ST. PAUL RESCUED FROM THE MULTITUDE

Paul said, I am a man which am a Jew of Tarsus, a city in Cilicia, a citizen of
no mean city: and, I beseech thee, suffer me to speak unto the people. . . . (Acts 21: 39)

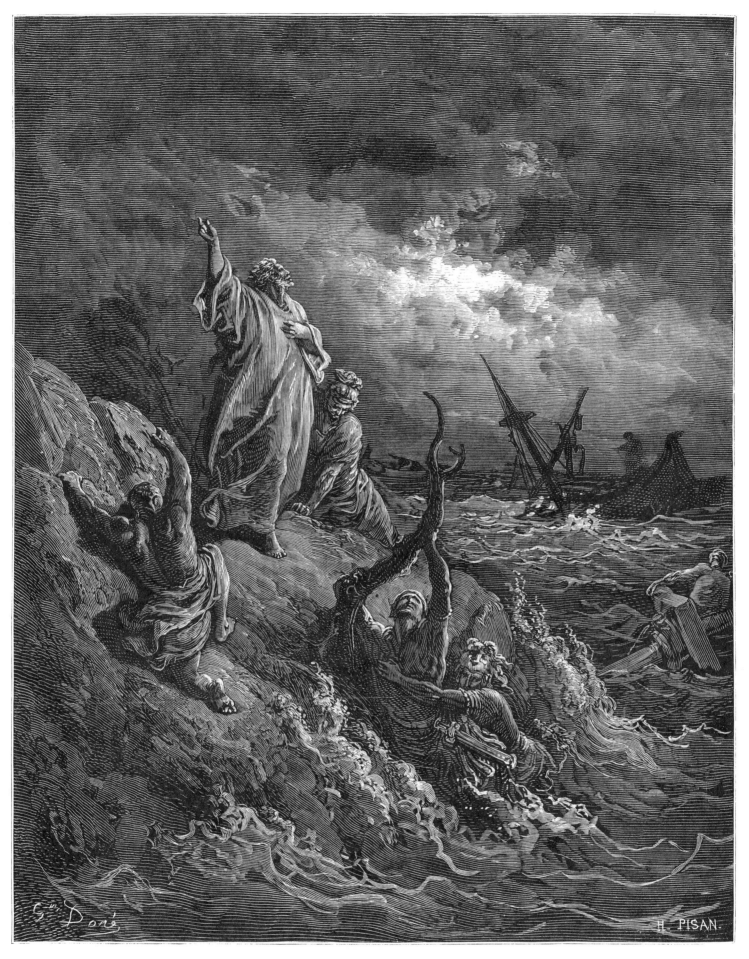

ST. PAUL SHIPWRECKED

And the rest, some on boards, and some on broken pieces of the ship . . . escaped
all safe to land. . . . (Acts 27: 44)

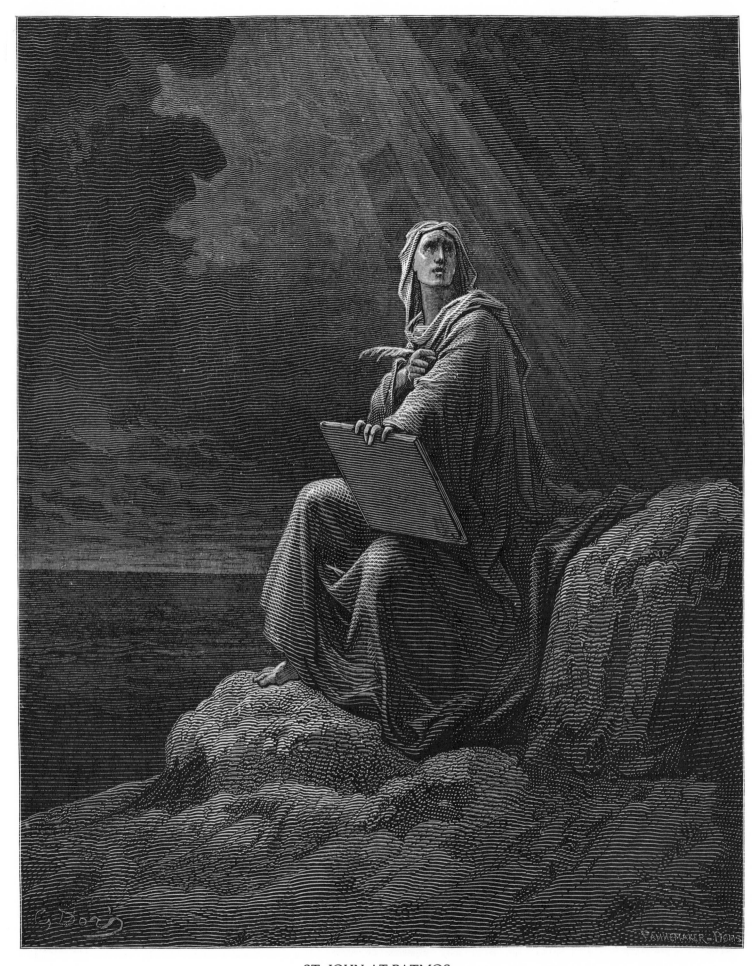

ST. JOHN AT PATMOS

I John, who also am your brother . . . was in the isle that is called Patmos . . .
(Revelation 1: 9)

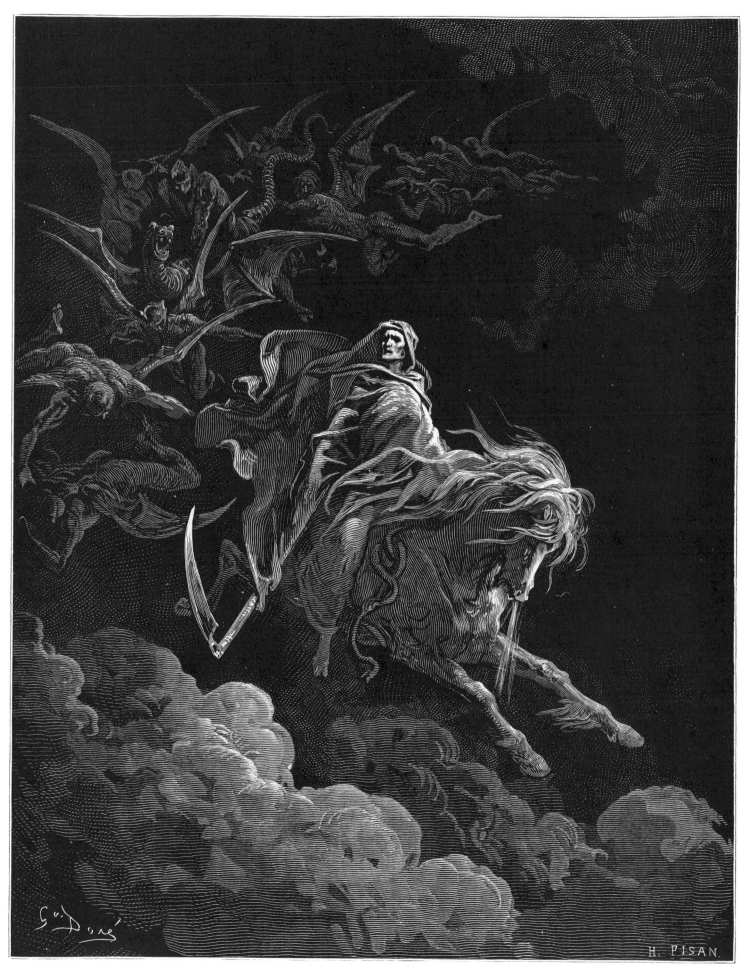

THE VISION OF DEATH
And I looked, and behold a pale horse: and his name that sat on him was Death
. . . (Revelation 6: 8)

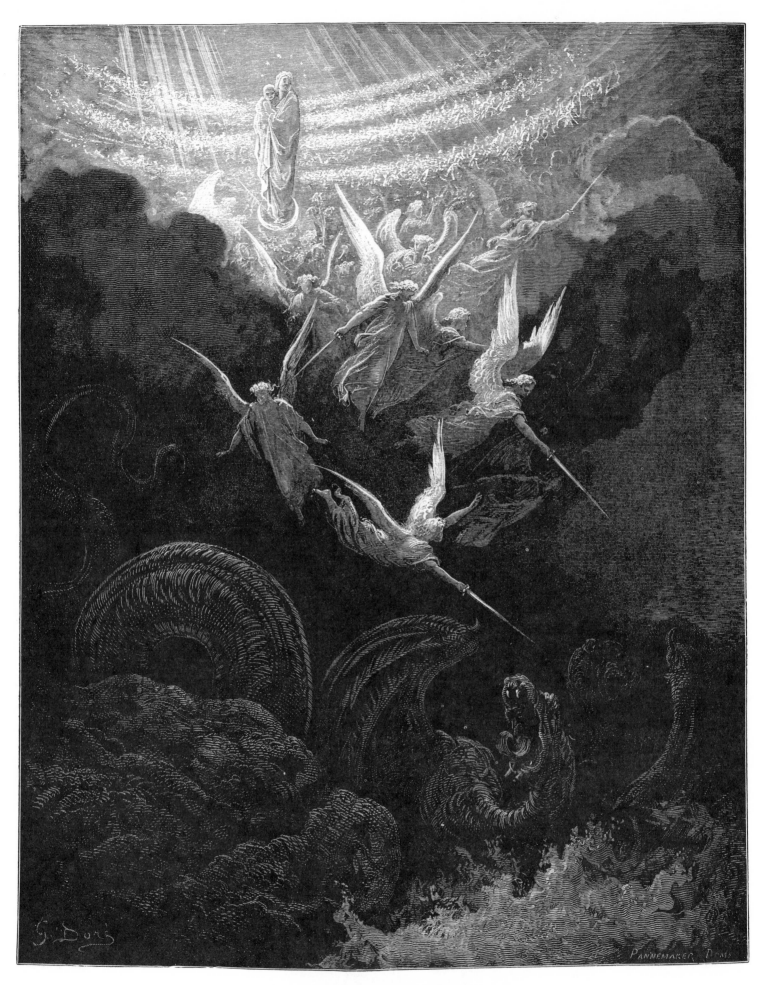

THE CROWNED VIRGIN: A VISION OF JOHN
And there appeared a great wonder in heaven; a woman clothed with the sun, and
the moon under her feet, and upon her head a crown of twelve stars. . . .
(Revelation 12: 1)

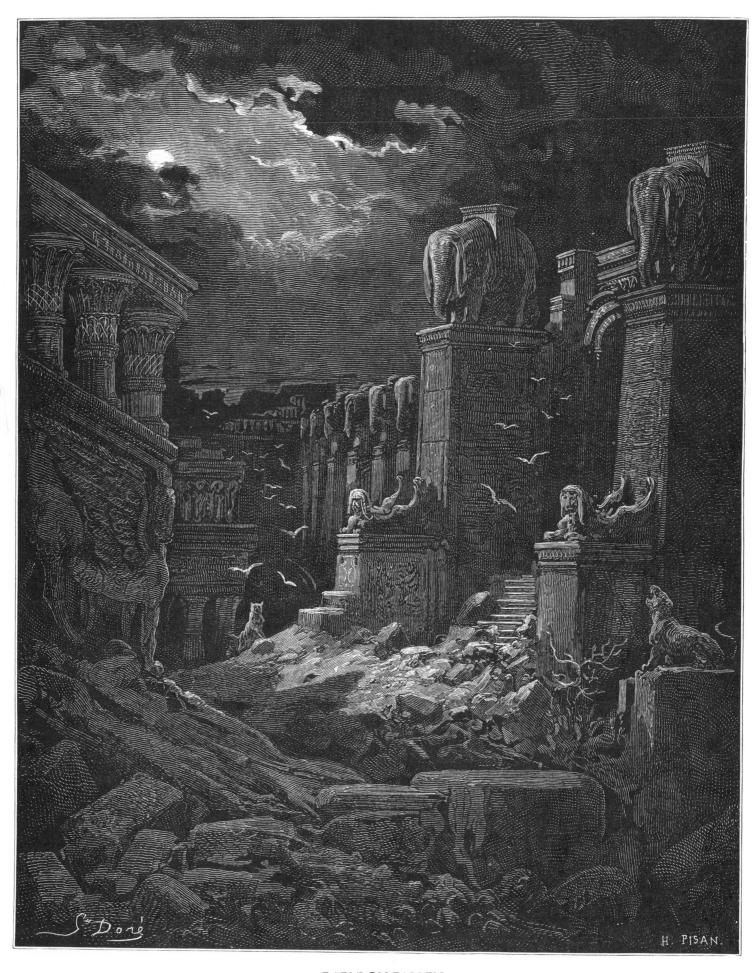

BABYLON FALLEN

For her sins have reached unto heaven, and God hath remembered her iniquities.
. . . (Revelation 18: 5)

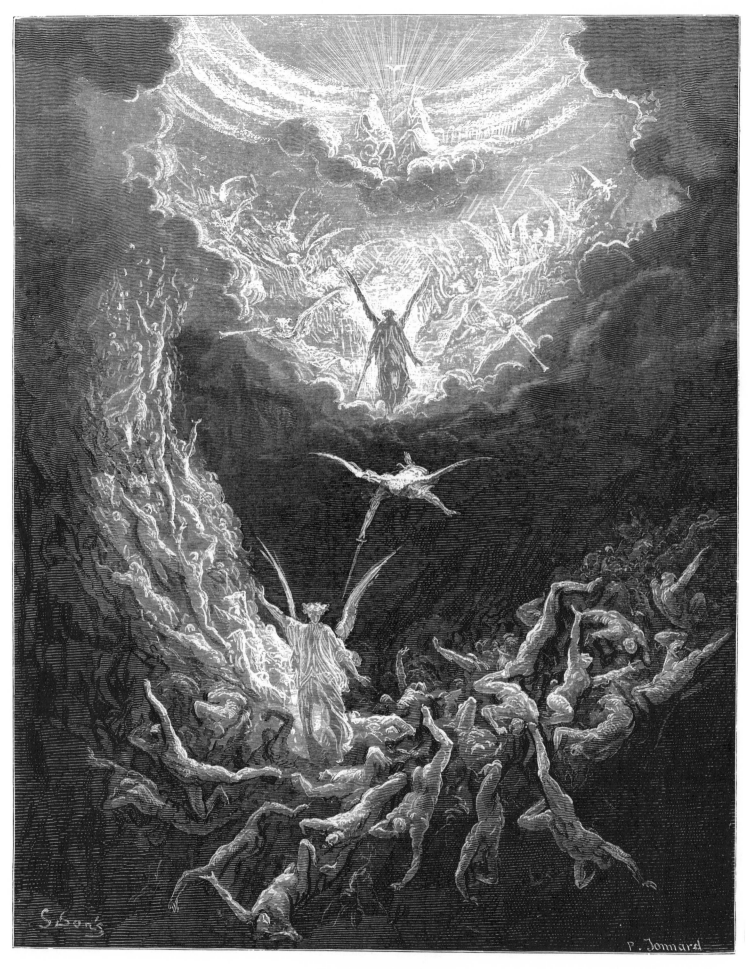

THE LAST JUDGMENT

And I saw the dead, small and great, stand before God; and the books were
opened: and another book was opened, which is the book of life.... (Revelation 20: 12)

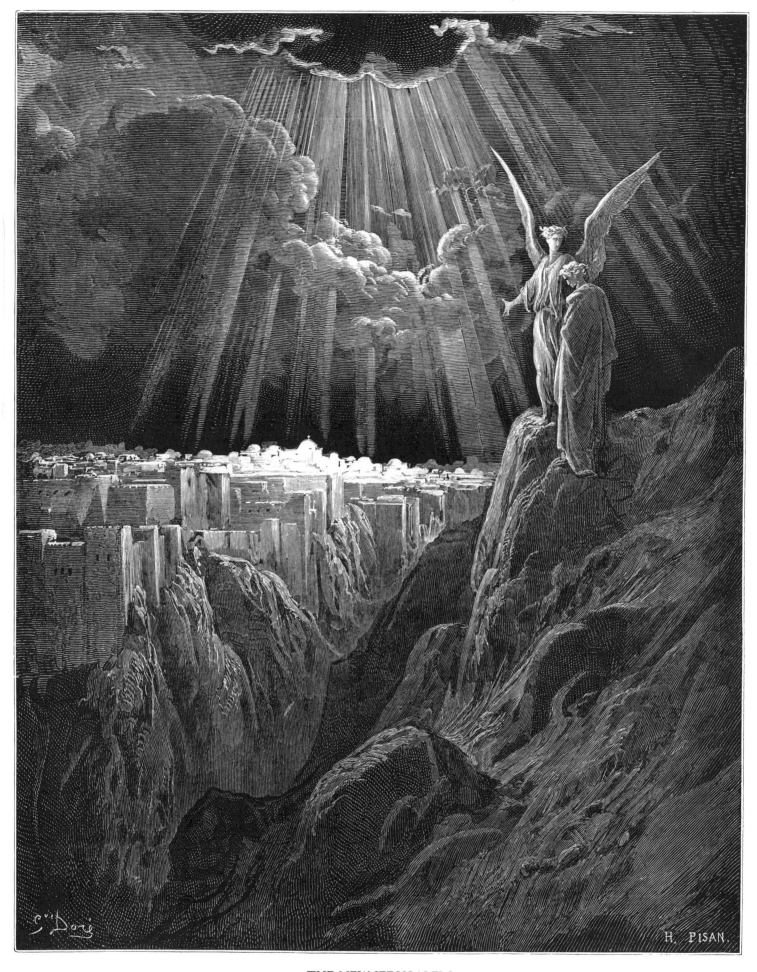

THE NEW JERUSALEM

And I John saw the holy city, new Jerusalem, coming down from God out of heaven,
prepared as a bride adorned for her husband. . . . (Revelation 21: 2)